PO5498

duchamp : passim

a marcel duchamp anthology edited by anthony hill

duchamp : passim

a marcel duchamp anthology edited by anthony hill

GORDON AND BREACH
ARTS INTERNATIONAL

First published in 1994 by G+B Arts International Limited

Distributed internationally through the following offices:

ASIA
International Publishers Distributor
25 Tannery Road
Singapore 1334
Republic of Singapore

AUSTRALIA
Craftsman House
20 Barcoo Street
East Roseville NSW 2069
Australia

EUROPE
International Publishers Distributor
St Johanns-Vorstadt 19
Postfach
4004 Basel
Switzerland

USA
International Publishers Distributor
820 Town Center Drive
Langhorne
PA 19047
USA

ISBN 976 8097 78 7

Printed in Singapore

Contents

Autorisation / Authentique

Ex Libris

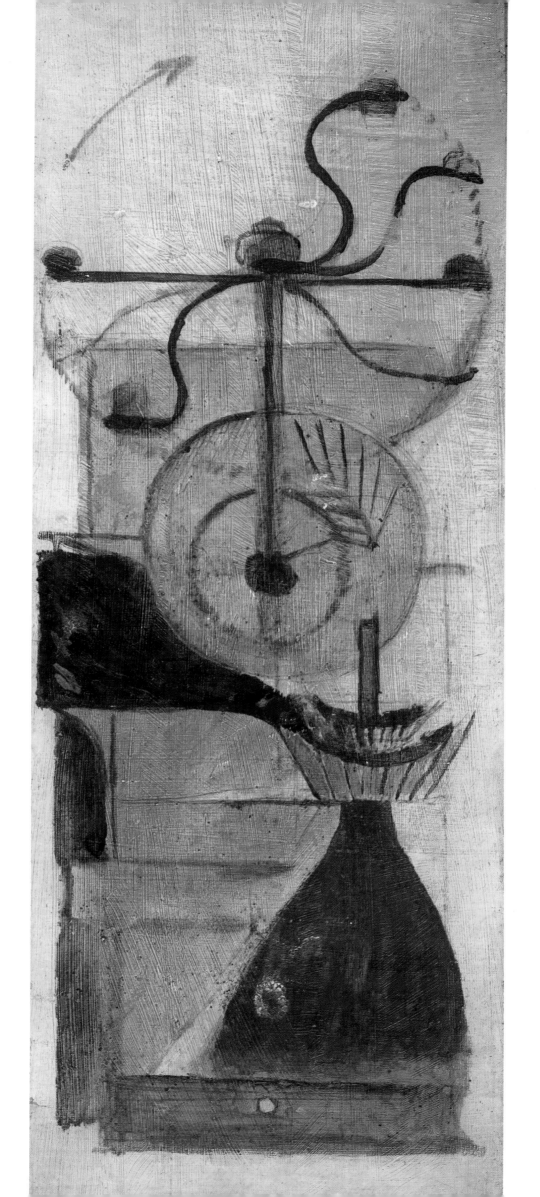

Works reproduced in colour
to the same size as the originals

Introduction

The words, thought and life of Marcel Duchamp are each the subject of enormous interest, certainly to artists and historians, and for philosophers of art. This fact is evident from the number of publications making their appearance and the scrupulous research that has gone into Duchamp documentation.

The art historiographer can divide Duchamp's career more or less concisely, by making a flow chart which shows Duchamp's activities and those of the writers on him, interviews etc. One can note the period in the Thirties in which chess was to predominate; this was the 'de facto escape from art'. But earlier, in 1922, in one of the first texts to be written about Duchamp, André Breton comments 'Duchamp now does little else but play chess, and for him it would be enough one day to appear unequalled in the game. Therefore you would say that he is resigned to intellectual equivocation; or if you wish that he agrees to be considered as an artist, even, in that sense, as a man who has not yet produced much *because he could not do otherwise.*'

Breton died in 1966, and therefore had no way of knowing about *Etant donnés* in his study of the *Large Glass*, written in 1935 and amongst the first of its kind.

The historiographer will find that as late as 1977 the *Fontana Biographical Companion to Modern Thought* confirms that in 1920 Duchamp 'renounced artistic activity' (i.e., no mention of *Etant donnés*). The Larousse *Dictionnaire de la peinture anglaise et américaine* 1991 has Duchamp as '*peintre américain d'origine française*' and as dying in New York.

Is Duchamp to be classed as French or American? In fact he is the most notable case of 'dual nationality'. As for abandoning art, why not? One can always say such things and it is certainly the case that Duchamp never painted again. So in that sense it is quite true, the last painting being *Tu m'* dated 1918, a work which has been cast during his lifetime as one of his masterpieces along with the *Nude Descending a Staircase* and the *Large Glass*. *Etant donnés*, started in 1946 and finished in 1966 but unveiled after his death in 1968, is for some his major work and ironically it is the only work about which Duchamp made no public statement; nor—as far as we know—is there any auto-exegesis to accompany it, as the *Green Box* was to some extent for the *Large Glass*; instead there is the publication of his 'instruction manual'.

In *Aimez-vous Duchamp?* I explain something of the origins of the present compilation. It is fragmentary, pieces from the various mosaics that go to make any version of the complete, rather than the composite, Marcel Duchamp. The subject is Marcel Duchamp approached, glanced and variously focused upon through an anthology. In the centre is Duchamp himself, four of his many interviews, with some of the seminal texts and surrounded by writings from enthusiasts. The illustrations in black and white no more reflect Duchamp's wide range of work than do the colour plates chosen so as to be reproduced at a size as near as possible to the originals. In the case of the rotoreliefs and *Fluttering Hearts*, they are amongst the early examples of Duchamp's interest in limited mass production (limited editions) of which the best known are the *Boîte en valise* and the *Green Box*.

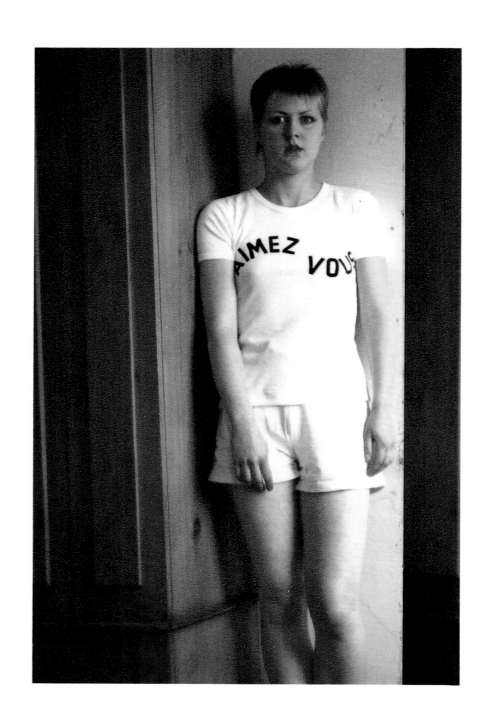

T shirt 1981
Model: Clio Heath

Anthony Hill

Aimez-vous Duchamp?

Marcel Duchamp is a hero in his own country, but is feared (as a threat) outside. And which is Duchamp's country? It is the terra firma of modern art.

In those territories you will find his detractors for whom, of all the one-time Dadaists, he is seen as the one who remained inflicting irreparable damage to art; replacing art by a highly personal form of arcane perversity.

Is it true? There is a certain logic to this stance, it is entirely understandable! What is comic is to watch the 'level headed' come out with their 'balanced' assessments and one notices how the ground shifts from generation to generation and how they are forced (at the end of their day) to come down on the side of the detractors; that is understandable too. It is indeed ironical when you consider how involved Duchamp was in the promotion of modern art; how in demand he was as advisor to collectors, museums and organizers. Duchamp's patronage and open-mindedness was a permanent feature seldom found amongst artists.

From the late Fifties onwards Duchamp could be said to have gone public. He was the twentieth-century inventor/artist who gave the most interviews and was in demand to speak at symposia. After his death the full impact of his thought (options but not a system or theory as such) could no longer be resisted, his ideas passed into facts resulting in various interpretations.

Duchamp's answers and notions—seen always as 'disinterested' —show a remarkable humane logic as against his image (often deliberately calculated) as a recalcitrant iconoclast. It was this humane logic which he brought to bear upon those crucial questions we might call simplistic complexities which previously nearly all twentieth-century artists had failed to see or wished to solve.

So, if Duchamp 're-defined the whole notion of art', what is his 'Gödel's theorem'?

There is a certain consensus (a subset of the consensus *vis-à-vis* pro-modern art) which seems pressed into *accepting*, that is to say *refusing to reject*, the most reasonable but concise of Duchamp's views.

When he is focusing upon *The Creative Act*, his version of an 'in/completeness proof' (the text of 1957) answering questions he must have put to himself throughout his life, a 'philosophy of art' crystallizes out, but—and this is the catch 22 for all interested—it cannot be taken to contradict the more playful element in his 'dialectic'. For example, having stated in 1961 'I'm nothing else but an artist, I'm sure and delighted to be'[1]; some years later he would contradict himself and tell an interviewer: 'Oh, yes, I act like an artist although I am not one'[2]; in the same interview he had warned: 'I make it up differently every time.'

Duchamp's 'dialectic'—if we choose to use that term— resembles a set of Chinese boxes, as many as we can find (he leaves us to count them) and while manipulating them is unpacking Duchamp, we find that he has invented conditions for art which work both retrospectively and for the future.

The present anthology has its origins in the core material of the Duchamp Supplement I put together for *Studio International* in 1975. It was planned as a centenary tribute to appear in 1987 and I had decided to call it *Aimez-vous Duchamp?*

With that title one might have expected voices for and against, with the inevitable *J'accuse*. Re-reading some of the astringent attacks I was struck by the view expressed by the American sculptor Robert Smithson, in an interview in 1973: 'Duchamp is really more in line with postmodernism in so far as he is very knowledgable about the modernist traditions but disdains them.'[3]

I had considered having a *contre-dossier* similar to that in the special '*Duchamp et après*' issue of *Opus International* in 1974, the 'loudest' feature there being the eight-panel *La fin tragique de Marcel Duchamp* painted by Aillavd, Arroyo and Recalcati and exhibited in Paris in 1965. I decided to mock the idea of a *contre-dossier* and do it differently, and in that context to mention only one example, a novel from 1986 entitled *The Bachelor's Bride* by the American author, Stephen Koch.[4]

Mr Koch, who is an admirer of Andy Warhol, had written an unusual kind of *roman à clef* (but featuring both Marcel and Teeny Duchamp) and it seemed to function for the author as a *mea culpa*. In Mr Koch's novel the tortured first person tells us: 'It was there I had seen for the first time, glowing on the wall, the anonymous slogan spray-painted by one of Art's lost children: THE SILENCE OF MARCEL DUCHAMP IS OVERRATED.' The year is 1967, and Koch is reading the words, only in German in the original, *written by Joseph Beuys, three years earlier.*

Does all that sound like the nightingale that would sing no more, in the story, and had to be replaced for the pleasure of the king by a clockwork bird? The novel ends after the death is announced of Marcel Duchamp and the hero is signed up to do a big show at the Pompidou, by which time he would have been in a tremor of excitement to learn of *Étants donnés* . . . but no, he just scribbles a note to himself 'I HATE MARCEL DUCHAMP'.

'Duchamp, in 1950, occupied a lowly rung on the ladder of Modernism.'[5] Eighteen years later we read: 'The story of the Avant Garde in the twentieth century, whether in America or in Europe, seems largely to be the story of Duchamp.'[6]

A curious state of affairs!

It was in 1950 that the editor of this anthology reached a decision about the importance of Duchamp.

I was rewarded. In 1951 at the Galerie du Dragon, in Paris, I bought a *Green Box* for a mere 700 (old) francs. A year later I decided that no-one should profit from further transactions and I persuaded the Victoria and Albert Museum to purchase no. 88/300, complete and in perfect condition, and it became the first work of Duchamp to enter a British public collection.

Modernism . . . that's the ladder. But since Duchamp's death they have put up a new ladder, it's called post-Modernism and what that actually leads to is: anti-Modernism and neo-painting—our two *missionary positions* in present-day Art!

1. Conversation with Richard Hamilton on BBC Radio.
2. Interview with Jeanne Siegel, 1967, published in *Arts*, Summer 1969.
3. *Marcel Duchamp*, The Artist in Perspective Series, Prentice Hall, 1975.
4. Stephen Koch, *The Bachelor's Bride*, Marion Boyars, New York-London, 1986.
5. Robert L. Herbert, Eleanor S. Apter, Elise K. Kenney, *Catalogue raisonné of the Société Anonyme and the Dreier Bequest at Yale University*, Yale University Press, New Haven and London, 1984.
6. American philosophy professor Arthur C. Danto reviewing Steven Watson's *Strange Bedfellows: The First American Avant Garde*, Abbeville, New York 1992, in the *Times Literary Supplement*, 31 January 1992.

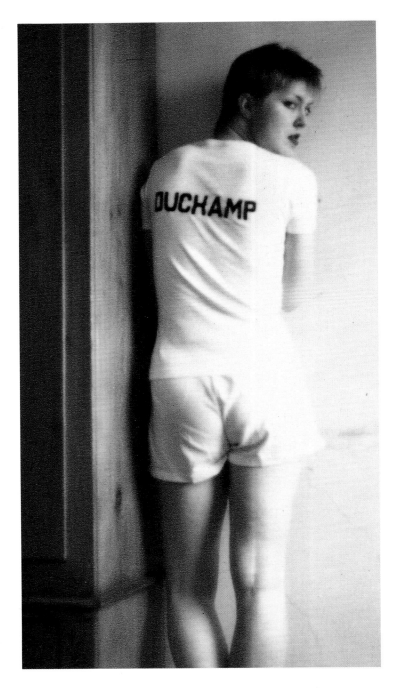

Études

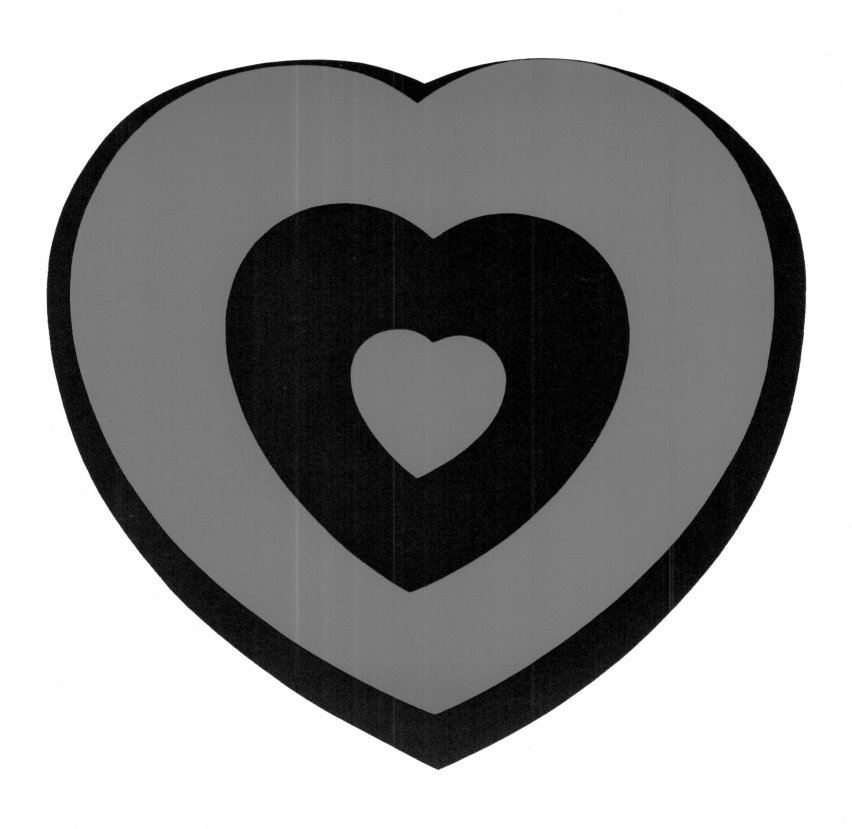

Marcel Duchamp
Fluttering Hearts 1936
Cover for *Cahiers d'art*, vol. xi, nos. 1–2

Gabrielle Buffet-Picabia

Marcel Duchamp: Fluttering Hearts

Translated by Nigel Gearing
Originally published as 'Coeurs volants' in Cahiers d'Art, vol. xi, nos. 1–2,
1936

Any work by Marcel Duchamp is always, even for the best-informed of his friends, a source of surprise and speculation. No exception to this are the optical discs, the *Roto-reliefs*, which he has just published and which I'll take as a point of departure from which to retrace an evolution that has remained unclear to many of his contemporaries. These discs are the result of a deliberate confusing of the values and arbitrary limits by which, as is our wont, we separate the concrete from the abstract, Art from the Commonplace. They are everyday gramophone records on which Duchamp has traced, in colour, flat geometric designs: spirals and circles. The optical illusion created by their rotation produces unexpected forms, objects perceived in relief: a boiled egg, a fish-tank with goldfish, a champagne-glass etc., a sort of picture-puzzle closely related to verbal puzzles. They provoke the same sort of surprise and ambivalence and as such are of a piece with the kind of humour frequently found in his work. But what is most remarkable is that whilst seeking to produce no more than these visual puns he should have stumbled upon a whole new visual formula for the eye in general, a new method by which to give the impression of 'relief' — for relief is the property of touch and not sight, and the eye can only get a sense of this through a series of psychological phenomena with the memory acting in the role of translator. Such an illusion therefore implies the close collaboration of certain sensory functions and certain cerebral ones; and I find it admirable that it should be here, in a varied and complex scientific domain, at the interface of psychology and physics, that Duchamp — a man who's always liked the intermingling of esoteric values with all their diverse implications — should have managed to bring off such a hitherto untried optical experiment.

Moreover, from the point of view of their origin, the case of the discs is much more complicated than one might suppose; they are not the result of scientific curiosity, but rather of their author's inexplicable predilection for circles. This need for a form mysteriously dependent on the conceptual faculties could take us so far from our main concern that here we'll merely acknowledge one very characteristic instance of it, for never was there a predisposition more consciously armed and ready than Duchamp's to resist appropriation by natural or arranged appearances. The obsession with circles can be traced to his earliest work: in the mechanisms of *Le moulin à café* (destined to decorate the kitchen of his brother R. Duchamp-Villon), in the *Bicycle Wheel*, in the optical designs of the *Large Glass*. His first film, dating from 1920 (and one of the earliest to be dubbed 'abstract'), uses only circles and spirals; and in 1920 he constructed a complicated device made up of different-sized glass blades fixed to a metal axis set in motion by an engine — a truly 'infernal machine' which all but killed Man Ray when the engine got out of control and ejected the blades. Since the glass could not be seen, given the speed of rotation, all that remained visible was a sort of flickering, vibrating circle formed by black grooves scored on the edges of the glass blades. In 1925, he made another film with Man Ray and Marc Allegret: *Anémic-cinéma*, another black-and-white

variation on the circle and the spiral where he established for the first time that illusion of relief which he's developed in the *Roto-relief*.

But this retrospective digression is more than just an interesting footnote — biographical or unexpectedly scientific — to his researches: the purpose of such researches was above all innovation in the materials to be used, the definitive rejection from his work-arsenal of traditional weapons (tubes of paint, the canvas and brushes); results were to be achieved mechanically and not through the expression of a personal dynamism inherent in a particular individuality; technical worth was to be substituted for expressive worth (I should note in passing how this way of conceiving things might be compared to that of the marvellous artisans who worked on Middle-Age cathedrals). It's on account of this attitude, the attitude of a benevolent technician, that Marcel Duchamp has displayed his *Roto-reliefs* at the Concours Lépine, notwithstanding the fact that they cannot be assimilated to any special object of current or commercial interest. Hence the impossibility of classifying them if one is in pursuit of aesthetic theses and immediate reasons; hence their lack of public accountability, and that confusion I referred to earlier and which I'm at some pains to emphasize, since I find in it not merely what characterizes an individual but, in equal measure, an overt symptom of the present state of human thought whereby the pressing nature of questions of a more general kind deflects interest away from the specific and artificial. In the face of problems which at such a time trouble the very foundations of our world, what price the anxieties, the emotions, the egotism of the romantics, indeed even the quite recent revolutions of Impressionism, Cubism and their counterparts? Marcel Duchamp has resolutely labelled them 'ethnographic documents.'

It seems that certain leading spirits are gifted with antennae thanks to which — from their birth on and with the sensitivity of a seismograph — they can experience and register the first waves of human evolution. They are of a piece with that general gestation, rendering it impossible to discern where they are reacting to a movement, where exactly they are accelerating it . . . but their development creates between them and their generation a state of dissidence which is perhaps the key to Duchamp's work. We might say that since his earliest work, nearly thirty years ago now, he has been at the flash-point of great currents of thought, likely to culminate in the general devaluation of what, socially and vitally, we have come to take for granted. The very materials used in his work are the result of a conscious elimination of everything that, ritualistically, constitutes and exalts the *raison d'être* of the arts: the Sensitive self, the Emotional self, the Remembering self. A strict discipline necessary to this self-control, to this self-denial (established not only towards the habitual aesthetic procedures but also towards all the notions accepted in everyday life) was to stamp him with a singular and inexplicable attitude which, in fact, sprang quite naturally from the imperatives of an imperious reason, from a logic sustained

and carried through to its ultimate consequences and which at their furthest horizons could well, at some point, have encountered those of the most rigorous mysticism. Each phase of composition corresponds to a long process of reworking and stripping away. His dominant urge ceaselessly to control each element of his work, implacably to track down everything it might harbour of a traditional nature explains why it's proved sparse and slow. He only lets go of it or gives his name to it when he's completely freed it of all reflex expression.

Pushed to its limit, this stripping away finishes in the very negation of artistic realization. There's no point in fashioning the work from special materials, in giving it a definite stamp or image, in recreating for the benefit of the senses a subject conceived in the mind. The visual world becomes a dictionary of subjects which he isolates and names by the mere act of choosing them; to represent them, to interpret them is no more than to dress them in borrowed clothes — clothes which are pointless, outmoded; the special status conferred on the objects, the differentiation of these from all others will suffice. Herein lies the principle of the *readymade*.

This is also the period in which Duchamp lived in a sort of lumber-room, surrounded by chosen objects, dust-sweepings which he photographed, a weathercock, bicycle wheel, snow-shovel and other things just as odd — for the act of selection is also one of strict elimination. There are highly complex reasons for this extremist theory which exalts the transcendent personality and denies it a visual materialization. Above all, here we can find an ironic rationale for the masterpiece conceived from inspiration and divination, for an art which is trance-like and mysterious.

The references best able to enlighten us on this decisive period of Duchamp's life, situated at the time of his stay in the United States, are to be found in the notes he gathered together last year; notes which pave the way for the work which is most important — *La mariée mise à nu par ses célibataires, même* — and also his last, for since then he has renounced all creation of a purely ritualistic nature. This piece is unknown in Europe. He worked on it in New York from 1915 to 1923, but it was entirely conceived and partially executed in Paris from 1913 onward, as is borne out by the documents written at that period — and which after twenty-two years he has decided to present to the public.

Formulated and arranged as they progressed, these notes were written at random on scraps of paper, while their author was in cafés or out walking; they are reproduced in their original form by a process of collotype which creates the illusion of ink and pencil.

Presented along with these are some reproductions of the different stages of this work and several sketches which were firstly executed in paint on canvas, then on glass (the drawing done in lead threads stuck together) before they were finally recopied on glass 2.70 metres high, itself worked on every day for ten years like the fulfilment of some sacred vow.

This picture on glass which he terms a 'delay in glass' just as one might speak of a poem in prose or a spittoon in silver became the property of Walter C. Arensberg well before its completion, then was exhibited in the Brooklyn Museum in 1926, then . . . was broken! (which once and for all allowed him to forego finishing it . . .)

We should note that all the early glasses saw the same fate, but although they could have been repaired and salvaged with no great damage their fragility willed them to a rapid destruction which is part and parcel of that system from which all values of durability and longevity are banished. (*La glissière*, a glass, is in the Arensberg collection in Hollywood, *Les célibataires*, a glass, is in Paris in the H-P. Roché collection.)

These different documents — about a hundred in number — collected together in a box which Duchamp fashioned himself and which was executed with the meticulous patience that he brings to all the work he undertakes are still of immediate interest at the present time and constitute the best means for investigating and studying that development which, at first focused on the plastic arts alone, went beyond purely aesthetic research and culminated in Dada and Surrealism. Through his brothers, the sculptor Duchamp-Villon and the painter Villon, he was introduced as a very young man into Cubist circles where new theories of abstract painting were discussed with some vigour; and, himself a devotee of dialectic and controversy, he was to be imbued with Cubism and Futurism without, however, ever abandoning his own personality . . . as can be borne out by *Le roi et la reine* and *Nu descendant un escalier*.

This last picture, which no group wished to include in the Independents' Exhibition of 1912 (the same year as the *Salon d'or*), was sent to the United States to the first exhibition of modern art in 1913 and acquired extraordinary prestige and fame for its author. But, possessed by a need for absolute logic, ceaselessly anxious for a perfection of which he is the only source and arbiter, this demanding spirit could only come to rest at the further extreme of its deductions and arguments. For him, it was no longer a question of decomposing objective forms in a more or less logical way, of mixing together the representative and dynamic elements of the subjects, but of creating from top to bottom another code of representative values, a signification of values and forms. He thus began to elaborate this enormous work, *La mariée mise à nu par ses célibataires, même*, which figures forth the recreation of a visible world which is totally new, where elements of machinery operate according to their fan-belt logic whilst living out adventures which (as the title suggests) are nonetheless totally human.

Not one single item is left to chance; he seeks out, tracks down and ruthlessly eliminates everything which seems a remnant of show, emotion, sensation, personal sensitivity (I think of Cézanne who painted not apples but sensations). And if Chance should intervene it's because it's permitted, indeed called upon, to act in place of taste and personal choice. Thus to compose this code's primordial indispensable signs (signs which

Duchamp calls an 'invisible-mending standard') he allows a metre-length horizontal thread to drop at random from a height of one metre. A note informs us that this invisible-mending standard is also *canned chance*. Furthermore, it indicates that to increase his repertoire of forms the artist must pick up a Larousse dictionary and copy out all the abstract words, that's to say all those which have no concrete reference, compose a schematic sign which will designate each of these words . . . use colours with a watchmaker's precision. There appears on the immense glass the silhouette of this ideal machine which serves a fictional, gratuitous utilitarianism put together from bits and pieces and allowing no considerations of an emotional or aesthetic kind.

For example, we see a waterfall powering *La glissière* which, in turn, moves giant scissors, toboggan-shaped chutes, hydraulic pistons . . . these functioning as telegraph-relays to the bride etc. But the mechanical description only constitutes the graphic part of the work. Each set of wheels, each movement corresponds also to a psychological or physiological structure for its characters. The *Mariée* is an engine-complex which runs on love: 'In general the *Moteur-mariée* should appear as an apotheosis of virginity . . . a metal arm can simulate the virgin's attachment to her friends and to her parents, former and latter corresponding graphically to a firm basis of masonry on solid ground like the *Machine célibataire* etc.' There follow numerous details on the psychology of the *Moteur-mariée*.

Let's also note the lubricity of the lead-coloured red which is that of the *Malic Moulds* representing the bachelors, whose group is reproduced in colours at the back of the box.

This tyrannical work, whose wish for disembodiment, for rationalization is evident in its tiniest details, is for all that stamped with an irreducible personality which chooses to assert itself with no other explanations given. In spite of its obvious obscurity and the need of anyone encountering it to have already done some arduous homework, it never diminished the popularity of its creator at the time, which no doubt explains why his activity is more and more rare, appearing in unforeseen guises—wilfully scandalous, disapproving, even cruel—in a spirit one might term 'the search for the anti-masterpiece'. He exhibited a urinal at the Independents in New York in 1917 (which got him into some trouble); he signed a photograph of the *Mona Lisa* which he'd defaced with a moustache, a beard and the punning capital letters *L.H.O.O.Q.*; he developed the somewhat humorous quid pro quo's, the spoonerisms with which he adorned objects; *Anémic-cinema* is a series of variations on geometric forms mixed in with punning inscriptions. But, lest we be deceived, these games are not innocent, Duchamp's humour is one of merry blasphemy; such usurping of a masterpiece's status by way of the pun destroys its prestige more effectively than any number of theses could do.

It would be tiresome if this decision to produce no more work were interpreted as a sort of abdication: a decision owned to his

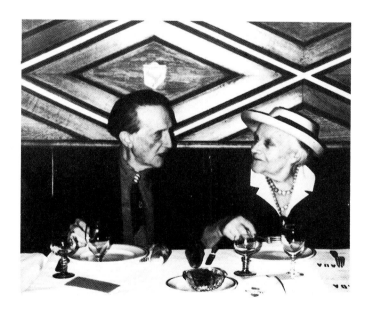

Marcel Duchamp and Gabrielle Buffet-Picabia
as guests of honour at the Rrose Sélavy dinner,
Restaurant Victoria, Paris, 15 May 1965

retreat from all normal activity and, above all, the artistic life with all its ambitions. Forced nonetheless to outstrip this extraordinary need for controversy and machination, he suddenly changes tack and falls silent, becoming—to the great despair of his friends—an obsessive chess-player.

I should add that M. Duchamp's retreat into the fictional world of chess, not seeming sufficiently incurable, led him to fashion for all other occasions a second personality, choosing for the purposes of this reincarnation a feminine appearance. Thus was born (in New York in 1920) *Rrose Sélavy*—which, for lack of space, we cannot pursue here. We might note, however, that this enigmatic figure took up residence in a bank, that she publishes books, signs 'readymades'; that sometimes she still haunts the soul of her contemporaries, and even inspires them with strange dreams.

Gabrielle Buffet-Picabia (1881–1985)
aged 102

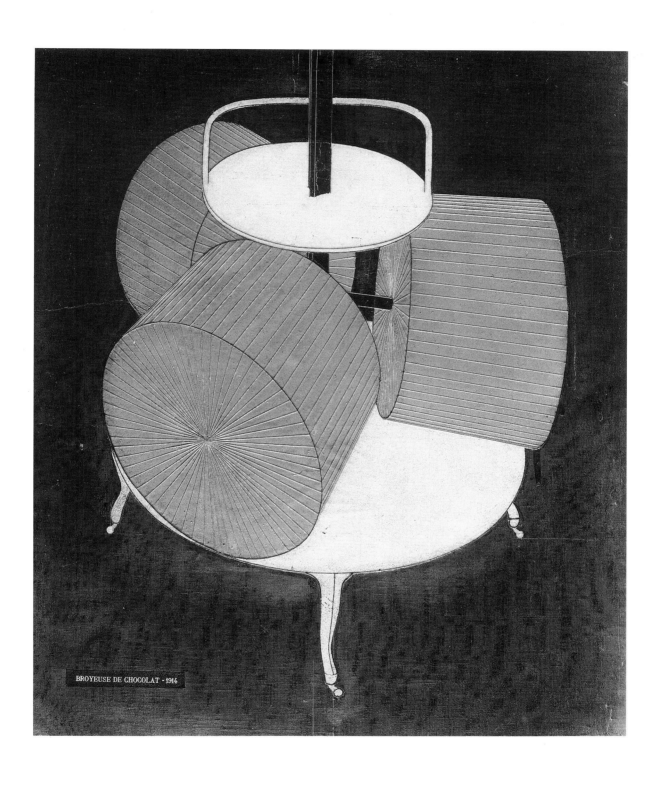

Marcel Duchamp
Chocolate Grinder No. 2 1914

Page from
Circle: International Survey of Constructive Art
Edited by Naum Gabo, Leslie Martin and Ben Nicholson,
Faber, London, 1937

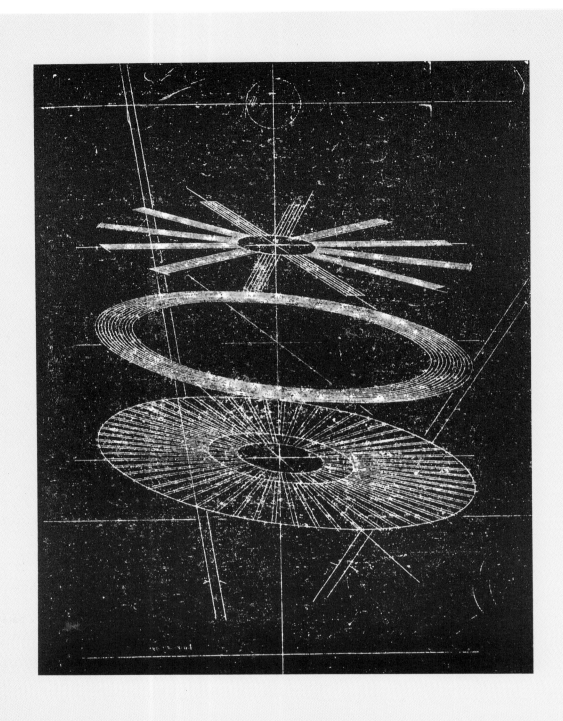

10. DUCHAMP

R. C. Kenedy

Wortgebilde durch Spiel und Kombinatorik
or
Why the Marchand du Sel Loved Words

First published in *Art International*,
vol. xvii, no. 8, October 1974

Due to the needs of a peculiar historical moment, Marcel Duchamp has become the legendary originator of the present. Maybe not the whole of it but the best part of what passes for experimentation. Nothing can diminish his stature in this respect. He was undoubtedly there; and his work has survived to supply the stimuli sought by a later generation of rebels when the more acceptable means of opposition or resurgence were found to be either ineffective or exhausted. It is, in this context, largely irrelevant whether there is still room for protest by protesting against the arts or for trying to undo societies by whatever faith they may have in their creative impulse. Brecht, for one, sought alternative traditions instead of destruction and he was a no less practised revolutionary than Joseph Beuys; it could also be argued that Brecht was more urgently motivated than Beuys and that his ethical fervour pushed him towards sympathies with the morality play as a logical result of commitment. In the circumstances it seems strange that Duchamp's fame has reached its apogee through the influence which he exerts; strange and possibly unjust as well—because Duchamp's work is, obviously, anti-traditional and it is certainly not inspired by pragmatic considerations or by ethical imperatives.

No man can be utterly exonerated from responsibility for the meaning read into his work and it is certainly true that in Duchamp's case his posthumous legacy must be considered as an essential part of his contribution. His heritage is an ineluctable part of his myth but the confusion, which comes about when causes and effects are intermingled, is far from helpful, and accurate historiography does demand that one should make an attempt to separate the initial evidence from the interpretations derived from it. Nor is it difficult to envisage such a clearcut distinction. It is simple to return to rudiments and to use them illustratively. The basic facts reveal fundamental requirements and their purposes may not coincide with the demands made upon them by successive moments of exegesis. Accretions of an involuntary kind intervene between the observer and the observation when the so-called insight records an event in the past which acquires new meanings by being dragged into the alien coordinates of a different moment—and these supererogatory connotations often obscure the objective substance of an objective statement. It is in fact very strange why movements cannot do without these retroactive judgements (reappraisals?) and without alleged discoveries which happen to have little or no connexion with the ancestral fact's inbuilt purposes. Their arrival in a subsequent context and their appropriateness for unplanned exploitation seems a matter of fortuitous accidents often enough. The prophetic qualities which we attribute to the resurrected instance is only for ventures of dubious validity—and they are often addressed to the self rather than to the public at large. The public at large has no interest in the professional's soul-searching quibbles. Nevertheless, in Duchamp's case, there may well be grounds for trying to locate the machinery of this dominating impact in his own contribution. The connexions are direct—even if most of them have paradoxical, ironical and wilfully unforeseen

implications. Thus there are in fact good reasons to suppose that too much effort has been spent on the campaign to display the propaganda values of the direct connexions which happen to exist—but apologies of this kind are at the expense of serious investigations which must stress the component forces of paradox and irony; and it is equally impossible to explore these without a confrontation with the uncorrupted evidence. Mercifully and at long last the documentation is almost complete. We have the record of Richard Hamilton's *Almost Complete Works of Marcel Duchamp* (Tate Gallery, 1966) and now it is partly at any rate superseded by Anne d'Harnoncourt's and Kynaston McShine's *Marcel Duchamp* (New York Museum of Modern Art, 1973).[1]

It is extraordinarily useful to have the second publication for it presents a symposium of conflicting studies and tributes by a large number of hands. Richard Hamilton's exemplary study-catalogue of the oeuvre can only be faulted for what happens to be its outstanding merit; it is too authoritative and it imbues its subject with the classic's air, which conveys unchallenged and unquestioned conclusions. This happens to be a disservice in Duchamp's instance because his triumph rests on the controversial nature of his bequest and the vitality of it is lost to a very great extent if it is deprived of the more or less calculated mysteries which cling to his deliberately constructed riddles. This is not to say that every one of Duchamp's gesturally conceived compositions was primarily intended to present a conundrum but it can be safely asserted that the preponderant majority of them do, in fact, wear the enigma's uniform—and it is part of their deliberate stratagem to vaunt the artificial contrivances of the puzzle.

It is certainly no accident that Arturo Schwarz finds it possible to compile a magnificently entertaining and scholarly study of some length which lists the alchemical parallels supposedly built into the *Large Glass* while Richard Hamilton asserts with impunity that

> Ulf Linde first observed that the drawing bears a resemblance to an illustration in a treatise by Solidonius—an insight which proliferated into the fashionable notion that alchemy provides a key to the iconography of the Glass. Ingenious and amusing as the later crossreferencing with esoteric texts and images may be, it must be said that Duchamp gave this no credence.

All this within the covers of the same publication.[2] Nor is this an isolated example of disagreement. Duchamp's art caters for diametrically opposed interpretations and it becomes uninteresting if it is divested of controversy. Almost every later opus has evoked similar patterns of dispute—although a great many of them may not be fitted into a simple scheme of positive assertion and negative disclaimer. Fortunately, however, the *Large Glass* occupies a central position in Duchamp's career and therefore it is doubly auspicious that it provokes this symbolically direct opposition of mutually exclusive readings. The unresolved doubts are working components of the oeuvre and they maintain

the potency of it. The deliberately introduced uncertainty is the motive energy of Duchamp's rhetorically constructed works and it is certainly not in vain to dissect the component elements of this structural ambiguity if we are to have valid conclusions. The anti-aesthetic inspiration of Duchamp's activity is too well documented to need repetition. Hence the terms of another discipline must be substituted for the traditional artist's aesthetic preoccupations when one begins to look for unities in Duchamp's oeuvre and in his case it can be safely asserted that he elected to replace conventions with the formal framework of rhetorical principles. His memorable works are declarations and they adhere to the principle of declamatory statements. In their own right they are exclamation marks disguised under various-seeming pretexts.

They appear on a stage-like platform[3] to recite a monologue allotted to them by the artist and it is worth stressing the point that almost every one of Duchamp's concatenations is given a speaking part in addition to the costume-like conception of what is substance. There is an initial ambiguity. Both the found and the made object are pushed into a dramatically conceived context which ignores their original identity; but it does not simply overlook self-evident discrepancies. The *Bicycle Wheel* (1913) and the urinal *Fountain* (1917)[4] reproduce the operatic prima-donna's predicament when they perform a part written for them; they represent without surrendering their own initial identity — and the measure of their triumph depends to a very large extent on their capacity to excel in a dramatic performance: the performance of what is their anti-aesthetic assignment. In this sense, and in this sense only, Duchamp's role may be compared with the playwright's. He has created character-like concepts and it was not his duty to substantiate the springs of their eloquence (some actors are, after all, better than others). Nevertheless, he could put words within their reach much like any other author when he writes words for a character and he was thus in a position to present conceptually complete dramatic propositions. His success combines the coordinated result of three interrelated factors. There is the object which is subdivided between being itself and not itself and the split speaks after the actor's fashion (who is an independent being as well as a part) and Duchamp's written message-complement reunites the disparate ingredients on Racine's own terms — which obey even the three categorical unities of a half-forgotten tradition. There is the *Snow Shovel* (1915) which says '*In advance of the broken arm*'; the comb which satirizes a latterday Hamlet: '*3 ou 4 gouttes de hauteur n'ont rien à faire avec la sauvagerie*' (1916) and characteristically the speeches grow in complexity as Duchamp begins to master the comic possibilities of his medium.[5]

Obviously, Duchamp did not reach this terminal phase without a long history of experimentation. A responsiveness to the calling of an innate bent produced the stance — but no account of it can be meaningful unless it is clearly intended to demonstrate why the verbal commitment is an essential component in Duchamp's make-up. Only a much longer study could prove the

contentions in this essay and a great deal of these preliminaries must be taken on trust; but it may not be necessary to trace the course of Duchamp's dualizing thought throughout the entire oeuvre. It may be taken for granted that the quasi-schizophrenic separation is present in the latent ambiguities of the earlier work without instancing every stage of it. A phenomenological enquiry can be circumvented by a quasi-philological approach to the iconographical problems of the fine arts. It is self-evident that the fine arts are involved in attempting to specify their own semantics once one is ready to admit that recognition is implicated in any encounter between the artist's work and his public (which happens to take place around the art object). Communication of a kind does occur and the artist's intent is declared in a work in order to be transmitted. The processes of interchange are ineluctably quasi-lingual. In this light it is irrelevant whether the aesthetic content is narrative, descriptive or simply auto-indicative. Duchamp's use of the icon's own semantics is very special and in any discussion of his oeuvre the act of examining the basic ideas admitted by iconic communication is no less revealing than the cataloguer's running commentary on the individual product's peculiarities. There is something unprecedented that has happened at the beginning of this century and Duchamp's part in it conformed to the historical pattern for a very long while.[6]

After Cézanne exact correspondences between visual observations and their pictorial record were replaced by the graphic signals of pictorial programmes. The simplest way to talk about the original naturalistic correspondences must invoke the spectre of translation — and no translation is possible without a grammar of one kind or another. There is no pictorial or sculptural realism which does not accept the basic ingredients of a visual grammar and every realist design transmits messages which can be reformulated in structurally meaningful words — although, needless to say, the translation is bound to show a contemptuous lack of regard for aesthetic values. But aesthetic values are not at issue in this argument for the time being. The grammar of the statement is the gist — without which no pictorial thesis could be formulated; without which pictorial argument would be impossible. It is of paramount concern that the image arranges its constituent forces in accordance with the rules of its own grammar. Perspective, colour and graphic forms are only the rudimentary manifestations of these rules and others may supplant them in different cultures or in changed cultural climates. The Persian miniature employs a set of formulae which seems, at first sight, incompatible with the structural principles of the High Renaissance but it is no less successful in presenting a communicatively valid record of a communicable statement; a story — to put it succinctly.

In Cézanne's wake the twentieth century revolutions moved along a path which advocated a progressively reductive use of the picture's language. It is possible to maintain that the ideals of a purer painterliness inspired the attitude and that they justified it. From the linguist's point of view, which is metaphorical in this

case, it would seem that working components of the imagist's grammatical machinery were abandoned either for giving greater emphasis to the remaining apparatus or for the artificial system's sake—which could, in fact, be superimposed on the left-overs. The Cubists, for instance, removed not only complete optic perspectives; they did away with curvatures and their associative correspondences as well. But their action was by no means negative. They admitted and exploited non-referential rhythmic quantities which replaced loss with a measurable gain—although the newly acquired impulse came from a different discipline. Musical concepts, and in their wake, quasi-musical structures combined with the remaining set of pictorial technology to create an artfully renewed context for pictorial communication. Kandinsky's obsessive search for analogies between aural and visual harmonies was a logical extension of advancing along predetermined lines—which have never been intended to quarrel with the notation of a grand, symbolic, all-embracing syntactic superstructure. A magnificent semantic hypothesis haunts every creative impulse—because only an unconscious assumption of this kind can bridge the gap between the statement the artist makes and his audience receives. Certain basic formal relations cannot be denied. Structural coordination conveys informatively potent signals.

It would certainly be possible to study these structural details of communication in elaborate detail but for the purposes of this essay it is sufficient to establish the relevance of a few basic concepts. Languages burst into meaning in two ways; both the syntactic rules of the statement and the metasyntactic apparatus of (say) metaphor and allegory are capable of conveying semantic values. In this sense rhythmic and chromatic echoes are quite obviously metasyntactic features of communication.[7] However, for the purposes of this argument it is more convenient to regard these surface phenomena as the physical and the metaphysical properties of a given medium. Imagery conveys physical and metaphysical properties and they correspond with the verbal statement's verifiable patterns exactly enough to be of practical use. Nor is it essential to dwell on metaphysical constituents; there is very little room for them in Duchamp's oeuvre—in the conventional sense at any rate. Symbolic or quasi-symbolic ways did not appeal to his imagination; nor, indeed, are there many examples of the indirect mode in his oeuvre. No allegory, no metaphor; no allusive use of a medium.[8]

There remains the physical side of the problem and a similar division is evident in every syntactic sign. In every coherent statement syntactic signs occupy a structurally allotted situation in order to fix meaning—which is derived from the combined forces of verbal or quasi-verbal content and activation (and 'activation' is achieved by the structural forces indicated by context). Two extremes characterize the attitudes one can assume towards these concepts. In Saussure's view the two extremes are governed by common principles manifested by the terms '*lexical*' and '*arbitrary*' on the one hand and '*grammar*' and '*relative motivation*' on the other:

The two extremes are like poles between which the whole system moves, two opposing currents which share the movement of language: the tendency to use the lexicological instrument (the unmotivated sign) and the preference given to the grammatical instrument (structural rules).[9,10]

Throughout the history of the fine arts in Western Europe the attitude of 'relative motivation' takes precedence over 'arbitrary' decisions and there are very good grounds for this during settled periods—since creation takes place within given modes whenever traditions provide for a firm framework; however, this observation remains true, at any rate generally speaking, even during periods of unrest. The grammatical stance is evident in Cubism no less than in Abstract Expressionism.

The syntactic machinery of an Expressionist tendency is highly reductive; but, in the case of Constructivism, we have a total experiment which attempts to engineer the pictorial equivalent of a new language like Esperanto. In both instances the notion of interrelated quantities predominates without obstruction from externally conceived forces. Looked at with Saussure's principles in mind, the Constructivist attitude is of special interest—for the declared aim of every Constructivist trend is a new notation which is significantly indebted to the ancient magical script of geometry and mathematics. It is certainly no accident that the great Russians attempted to base the vocables of their iconography on Pythagoresque principles just when modern theories of syntax have begun to succeed in evolving mathematical formulae which represent the formal dynamics of significant speech. Schematic interpretations are beginning to disentangle the workings of the superstructural and symbolic processes which unite the communicative processes of human groups—and the newish theories do tend to suggest that the emblematic gulf which separates these seemingly separate disciplinary processes is merely a hair-crack. The Constructivists' goal is a script of universal validity, accessible to the masses and embracing the distinct functions of painting, architecture and sculpture; inevitably their programme employs a sign-language which expresses the communicative code of a foregone conclusion.

This is not to say that exceptions cannot be found to show examples of an 'arbitrary' stance. Every mannerist inclination is, to a certain extent, tainted with arbitrary solutions and Arcimboldo's instance demonstrates how far this tendency could go during periods of seemingly settled traditions—but, as Arcimboldo's work suggests, the arbitrary is superimposed on a framework of accepted references in mannerist objects and it performs the role of a highly esoteric metaphor in them—which happens to be deliberately quite meaningless in many cases; nevertheless, this arbitrary (metaphoric) discrepancy specifies the precise circumstances of a shock. It specifies it in spite of or because of the inbuilt semantic incompatibilities of an arbitrary opposition and the raw material of the shock has a relative motivation once again, as in Arcimboldo. But Duchamp's characteristic contribution explores the extreme case exclusively; indeed, it is so uncompromising in its reactionary radicalism

that his use of every verbal value is emphatically lexicological. There was to be no meaning in his oeuvre over which he did not exercise control. The abstract sentence was his ideal and nothing could deter him from reaching its self-designated precincts — within which individual meanings were exposed to the symbolic equivalent of genocide; and the mass murder of significances was obviously designated to indicate the absolute power the artist exercised over subordinate subject matter. In the artist's case these harsh realities do, of course, undergo some modification — for the accidents exposed to his whims submit only to gesturally motivated vanities — and they tend to be without lethal consequences.[11]

The arbitrary and the lexical aspects of Duchamp's programme cannot be accepted without further clarification. The distinction between the Found Object and the Readymade is best fitted to illustrate the syntactic distinction between the two attitudes implied by the far from hairsplitting antithesis. Picasso's *Bicycle Saddle*, which represents a bull's skull, is an ideal instance of the grammatical meaning through which the found object establishes points of contact with a communal reservoir of knowledge and recognition. Duchamp's *Fresh Widow*, 1920, on the other hand, presents a categorical denial of relative motivation in accordance with the Readymade's automythopoetic principles. It is a miniature French window in a painted wood frame with eight panes of glass covered in black leather. The title of this work perpetrates a very weak pun indeed but the undergraduate humour of it is rescued by the first appearance of the artist's alter ego in the pseudonymous signature — and this compensates for the low dig in the ribs with the pen-name's double-entendre.[12] Pun is heaped upon pun at the verbal instigation of a representationally meaningless object and every indicative connexion stresses only the dictionary's fortuitous co-ordinates — the alphabetically determined correspondences which counterrelate incompatibles in order to cancel out the emotive, the logical, the narrative and the intuitive clues which prompt recognition. Only the vocabulary's quantities survive and their survival is subordinated to the signification of the lexicographer's metempiric game with imaginary figures; figures of speech merely, as often as not. (Duchamp's valedictory self-portrait which shows his bronze-cast head pensively examining an abandoned knight on what is, in the circumstances, a deliberately absurd chessboard may have been intended as a commentary on all anti-rational games.[13]) Every phenomenal representation of the disconnected instance serves this type of lexicalism in Duchamp's oeuvre. The objects serve an illustrative purpose and in this context it is neither here nor there that they portray the analytical presence of the artist instead of specifying cognitively valid and satisfactory realities. Duchamp's aesthetics invoke the arbitrary in order to claim that it is the artist's right to define art and in order to deny the communally determined factors of judgment. But one does not have to be a Marxist to entertain gnawing questions of doubt faced with this proposition. Art shares the predicament of every productive occupation and cannot do

without a need for it — which must come from the communal area of the marketplace, however specialized the merchandise may be; and the ethics of interchange stipulate recognizable terms for transactions between partners in a contract. The contract between the artist and his audience may well be unwritten but its reality, even if it is a changing reality, cannot be dismissed for all that. Duchamp represented anti-aesthetics consciously enough but the distinction between conservative aesthetics and his own brand of anti-aesthetics is admirably designed to fit into the unifying co-ordinates of Saussure's oppositive scheme.[14]

Max Bill was, in fact, probably the first to understand the linguistic nature of Duchamp's oeuvre: ['*Es gibt ein] weites Gebiet . . . auf dem Duchamp Leistungen aufzuweisen hat, deren Tragweite noch nicht genügend erkannt ist: die Sprache. Duchamp hat durch Spiel und Kombinatorik Wortgebilde geprägt.*'[15] 'A verbal imagery inspired by games and the theory of combinations.' (Or maybe 'coined' — which is a more exact translation than 'inspired'.) But Max Bill does not follow up the truth of his axiomatic observation with an enquiry which could clarify the nature of such an imagery although his use of the word '*Kombinatorik*' gives emphasis to his awareness of the fact that Duchamp represents quasi-mathematical, schematic abstractions and that realities are rigorously excluded from this oeuvre; and the realities excluded embrace, of course, every verifiable constituent of the universe, colour-shape-form-and-force included. With these remarks in mind it is striking to observe that the only pictorial example of Duchamp's maturity depicts its icons on glass. *The Large Glass* provides a transparent stage for its cast and this ensures it the independence of dialogue — which takes place in an equivocal environment; an environment — through which and within which unpredictable, uncontrolled forces operate without let or hindrance. Imagery on glass operates like words in the objective environment. Duchamp fixed the absurdity of verbal coincidences and the French window's fortuitous echo of Fresh Widowhood typifies his objectivation of callous accidents. He abhorred the poetic potency of the metaphor and there is no example in his work of, say, 'Bats in the Belfry', or 'The Grapevine' — which could have supplied him with similar puns, puns whose content might have seemed no less concrete in a literal translation. But the secondary and emblematic potency of a proverbial phrase was certainly not to his liking. It would have admitted the shades of poetic allusion; and connexions of any kind would have adduced the otherness of a reality which his work forswore. E. M. Forster's motto ('*Only connect*') was replaced by its opposite in his contribution ('*Make sure there are no connexions*').

Unfortunately, Richard Hamilton's very comprehensive notes in the Tate Gallery catalogue were not meant to probe intellectual implications. They were designed to evidence the rather academic presence of aesthetic values in works meant to deny them.[16] Hamilton tends to think that

indifference provides a beauty unintended by Duchamp. His search for an object without aesthetic merit, one with the least

virtue that he could find to allege his conviction that taste is the enemy of art, has proved futile. For the Duchamp personality, his essential artistic genius, has defeated him'.[17]
This, of course, is criticism of the metaphysical kind which ignores every tangible and demonstrable quality of the work itself in order to entrench its claims behind the unassailable concept of sheer genius. Even journalists are expected to do better than that but the exercising bent of his argument is not surprising in a man of Richard Hamilton's outlook: he is an image maker in the grand tradition and his sympathies are utterly heritage committed.[18] He is certainly ill-equipped to show intellective sympathies with Duchamp's *'enigma'* (the word 'enigma' is taken from Hamilton's own text). He has tried to discover in Duchamp's readymades *'a hallowed aspect that welds them into a vision of implausible unity'*,[19] and the sacral requirements of Hamilton's ideals kept him from recognising a unity which was neither implausible, nor indeed related to the faculty of vision.

Thus, the task to demonstrate the verbal nature of Duchamp's highly mixed techniques was left in abeyance until it was attacked, at long last, by David Antin. Antin's essay on *Duchamp and Language*[20] is a masterpiece of its kind and it is likely to remain one of the cardinal texts of modern criticism. It documents a legitimate conception of language which shows very welcome signs that it was compiled after Wittgenstein's and Rudolf Carnap's findings have gained a degree of currency;[21] and it illustrates the application of linguistic principles to the practical problems of everyday psychology. With premises such as these he sets out to apply the theoretical concepts to Duchamp's puns. He dissects and demonstrates their features after the fashion of the anatomy lesson. But at this point he stops short. Indeed, Antin's study is in many ways the equivalent of a doctoral thesis on a new disease. He lists symptoms without relating his account of them to a general, quasi-biological context. His observations are beautifully accurate;

> I would say that what Duchamp does as an artist is to create a series of kinetic art works in which a language field defines the action of something that's put in the middle . . . why do I say 'linguistic significance?' Because there is no other kind of significance . . . Duchamp manipulates language structure and he manipulates it mechanically . . . he intended to create a kind of syntactical unit that has no clearly anticipated semantic consequence.

Antin achieves, in fact, in a brilliant series of diagnostic insights what criticism has significantly failed to provide — but his revelations survey the surface and this obscures his interest in the precise questions of the historian. He has no use for parallels and counterparallels. Nor can he be blamed for the omission — for the new in Duchamp is new, and Antin sets out to specify its special characteristics. Inebriated with the discovery of unknown facts, he enumerates accurate observations which display the precision of the gem's facets; but his approach is disciplined by principles of description and these imply the need to forego value judgements. Every note of approval or disapproval is consequently

absent from this account — and, while science must remain tied to the so-called rock of impartiality, history cannot be recorded without references to the stage upon which it is enacted — and its boards evoke their own ethical principles.[22]

Bill's and Antin's observations must, therefore, be transposed into a contextual framework.[23] The fact that Duchamp's contribution is based on a special use of language would be of no practical interest if artists refused to admit that art is a special kind of language.[24] Only the generally assumed validity of this axiom gives the remarks a degree of truth and it follows this hypothesis that the language-like nature of the arts has kept them alive over the centuries. Every aspiring painter and sculptor conforms to a pictorial syntax when confronted by the problems of practice. Michelangelo was schooled to acquire a fluency in a traditional script and so were nearly all his predecessors and successors. The practice of art requires structurally designed processes of learning because they are intended to reveal means of communication which must take place within the fixed coordinates of conscious or unconscious instruction. There is always a model and its didactic nature survives in every valid experiment.[25] The aspiring painter learns his craft from a conceptual ideal much as a child learns to speak from the adults around him — although there is a difference of some significance. The child is an uncritical subject of the environment which teaches him the rudiments of speech. No artist is uncritical. Even the student approaches his task in the academies critically. It could in fact be maintained that mature art cannot help reviewing the evidence of the model before it. The artist is a mature being and his analytical preoccupations may be measured on a scale which embraces the entire spectrum of attitudes between wholesale acceptance and censoriousness. Duchamp represented the latter extreme uncompromisingly but in every other respect he remained typical.

The painter brings a schizophrenic duality to the task of enlarging the sphere of his profession. He is an adult who exposes himself to the discipline of the nursery whenever he attempts to acquire new knowledge which fits into a traditional scheme and he has the means of superimposing the poet's arbitrary schemes on a pre-existent outline. He can come up with personal rhythmic specifications and harmonies in order to obscure the hidden content or the latent traditions in his own work; and, of course, he is free to indulge in discourse. Nor is it surprising that childishness is a temptation when the nursery's ways of advancement are consciously re-enacted. The superficially infantile graphics of a Miró or a Dubuffet are ineluctably connected with memories of learning and relearning. (Duchamp's iconoclasm is also not wholly unrelated to the spirit of juvenilia . . .) In Chomsky's terms

> the structure of particular languages may very well be largely determined by factors over which the individual has no conscious control and concerning which society may have little choice or freedom.[26]

The artist's control over them is also strictly limited. It cannot go

beyond the limits of a James Joyce without exposing itself to incomprehensibility.

In the circumstances the interest this study shows in structural features will seem self-explanatory. The contention that language is the concept which embraces the arts seems to be axiomatic and it follows from this premiss that personal predilections are in fact revealed by preferences for certain kinds of syntactic features. In a pictorial script characteristics of this sort are much more sharply polarized than in speech — which is easily corrupted by unconsciously employed allegory, metaphor or loose colloquialism. Iconographies tend to represent the deliberate phenomena of diction. It is therefore reasonable to suppose that oppositions reveal basic cultural sympathies. Consequential analytical parallels establish a scale of values. Values of this type are, of course, emotively charged — but within their own passionately determined coordinates, they are exact. They are not meant to settle the question of hierarchies — but they enable one to take sides. And — from a practical point of view, the horizon's earthy and lateral distinction between left and right does seem to be more exciting than the vertical's absurd calibration — for the measures of height and depth are arbitrary; at any rate, in isolation. It is just possible that the technical information of linguistics may turn out to provide the best tools for fixing the stations of this plane opposition. It so happens that nothing could be further removed from David Antin's point of departure than such a method-based approach and the coincidence of his conclusions with the present enquiry's seem all the more striking.[27]

But there is an additional reason for invoking the spectre of language-learning. There is a need for stressing the communal resources of the artist's language and it is best served by adducing evidence to show that the artificiality of art reflects a model which is imprinted in the unconscious structures of the social group or grouping.[28] The machinery of making statements can only be explained with the help of this supraindividual concept — and

> On the basis of the best information now available, it seems reasonable to suppose that a child[29] cannot help constructing a particular sort of transformational grammar to account for the data presented to him, any more than he can control his perception of solid objects or his attention to line and angle. Thus it may well be that the general features of language structure reflect not so much the course of one's experience, but rather the general character of one's capacity to acquire knowledge.[30]

The emphatic allusion to solid objects, line and angle help to underline the obvious that recent findings do not distinguish between art-perception and language-learning. On the other hand, matters remain in a state of suspension even in such a much-simplified arrangement. Language carries forms as well as content and the 'arbitrary' stance towards forms does not go beyond implying authoritarian inclinations; it most certainly does not implicate the message's content in totalitarian ideo-

logies. Only in the extreme case, where form replaces content altogether, is there some justification for expressing a degree of dislike. Duchamp's mature work, with its insistence on ignoring meaningful content, does in fact belong to the province of such formalist experimentation and hence the grounds for dwelling on classificatory principles.

Certainties are scarce in deliberately meaningless statements. As for conclusions, only one axiomatic inference can be asserted with a degree of reasonable confidence. It is a symbolically potent fact that expression seeks a transformational grammar. It is the task of art to transform and if it replaces grammar with lexical principles, it implies the negation of one's capacity to acquire correlative knowledge. The arbitrary autism of a work, such as Duchamp's, posits an egotistical sublime which must perforce lead to the absurd. Knowledge is acquired and disseminated through points of contact, confrontation and conflict; and the absence of such points fosters an autonomy which proposes the authoritarian values of mere self-esteem. The person's cult of the personality — whose radicalism is wholly reactionary.

1. References to *The Almost Complete Works of Marcel Duchamp* are indicated simply by the word *Tate* in the subsequent paragraphs. Similarly; the abbreviation *MOMA* signifies citations taken from the work edited by d'Harnoncourt and McShine. Incidentally, the Tate Gallery catalogue was published under the auspices of the Arts Council of Great Britain — which must be given due credit for the pioneering work of Richard Hamilton.
2. *MOMA*, pp. 58 and 81–98.
3. Exhibitions of any kind are platforms. The showcase is a miniature stage.
4. Significantly, the bicycle wheel and the urinal fountain are turned upside down in being presented as art-objects. The inversion is intended to help them not to be themselves. The Mona Lisa's moustache, *L.H.O.O.Q.*, 1919, is a similarly theatrical prop — shown up by the ease of its removal in 1965. The rather smutty humour of the coded letters beneath the Mona Lisa is exceptional, on the other hand, for it replaces the more usual monologue with words from Duchamp's own mouth. Even Duchamp has failed to find a motto appropriate for a Leonardo's lips. The masterpiece does tend to have sufficient power to exact unconscious reverence — at any rate, in certain circumstances. When it confronts, for instance, an artist.
5. It is an open question whether Duchamp's textual contributions can compete with Shakespeare's or Racine's and it is equally uncertain whether a speaking shovel or contemplative comb is ideally suited to replace a Garrick or a Caruso — however imaginary the stage one provides for them.
6. According to Richard Hamilton, Duchamp's 'roots' are 'in the bohemian art of Montmartre. We are thrown almost immediately into a group of paintings of brilliant assurance. The canvases of 1911 must be rated amongst the greatest products of a period that will be marked as one of the most distinguished in the history of French art' (*Tate*, p. 5). The superlative, as applied to Duchamp's canvases, strikes one as slightly exaggerated — especially in view of Duchamp's contemporaries; but Hamilton is well-qualified as well as right to recognize the central merit of these compositions.
7. In Duchamp's *Nu descendant un escalier*, 1911, the rhythm is an allegorical substitution for time — and his later dissatisfaction with his own traditional resolution of a linguistic problem is highly characteristic. (It is odd to observe that *The Staircase Nude* reproduces a great many rhythmic features which seem to have inspired Wyndham Lewis during his Vorticist period — and these stress-patterns seem to be reinforced by echoes of Lewis's preference

for buffs and browns. Lewis became a later Lewis as Duchamp became a later Duchamp and it is just possibly not too far-fetched to argue that their divergent paths were motivated by a similar dissatisfaction with similar beginnings. If so, the similarity of the dissatisfaction could be used as an additional piece of evidence to suggest related intellectual attitudes.)

8. The *Large Glass, The Bride stripped bare by her bachelors, even* (1915–23) is, admittedly, replete with iconic symbols, allegories and metaphor. In 'The Bride's domain' the bride herself appears as a mixture of cloud and caterpillar and the 'Milky Way' is part of her dubious appeal. 'Nine Malic Moulds' represent her suitors and their silhouettes are about to be ground down into anonymous malehood by the torture instruments (of desire?) before them. In this context 'The Water Mill's' outline is less ironic than 'The Chocolate Grinder's'—but be that as it may. The pattern of these allegories is mapped out. Their poetry is unsatisfactory—only their aesthetics work. The imagery has the elegance of transposition but it is without the magic which works on a semantic level. The use of the word 'malic' may help to illustrate the prosodic failure—and it is worth demonstrating because, as far as I know, it has not yet been pointed out that the term denotes an acid obtained from the apple *'and several other fruits'* (Brande). In English as well as in French. It means nothing else and Duchamp's use of it in a key position, in order to refer to Eve's apple and to the male, is forced as well as imprecise. The exploitation of the direct allegory which characterizes this work is unique in Duchamp's oeuvre. The difficulties he encountered in its application speak for themselves and the sweat of many years does hang uneasily over the beauty of his masterpiece.

9. F. de Saussure, *Course in General Linguistics*. Translated by L. Baskin, 1960, pp. 133–134.

10. The Latin *inimicus*, for instance, refers directly to its etymological origin; in the French *ennemi* there is only an echo of *ami* and *amicus*; and in our own English 'enemy'—not a trace of the foe who opposes the *friend*. The Latin is relatively motivated and the English arbitrarily. The derivation of meaning is enacted within the co-ordinates of this dialectical framework—in every instance. Exceptions do not exist—only stations of compromise, and the French word *ennemi* is a good example of it. *Mutatis mutandis*, the same attitudes are evident in syntactical features of greater complexity as well: not merely in the isolated word. Their role is especially interesting in the metasyntactic apparatus where ideal connexions and psychology begin to exert a powerful influence of their own.

11. The *Rendez-vous du dimanche 6 février 1916* displays a typed text on four postcards and Duchamp's commentary on it clarifies the lexical nature of it: 'The construction was very painful in a way, because the minute I did think of a verb to add to the subject, I would very often see a meaning and immediately I saw a meaning I would cross out the verb and change it, until, working for quite a number of hours, the text finally read without any echo of the physical world . . .' The exclusion of structurally motivated semantic relations substitutes the lexical activity of the artist's self-signifying presence for the concept of communicative meanings.

12. The work is attributed to Rose Sélavy who developed into the later Rrose Sélavy. There is a prophetic note of sadness in the assertion that *'Éros, c'est la vie'*.

13. *MD Moule Vif*, Editions Claude Givaudan, 1967. See *Art International*, vol. XI/7, p. 72.

14. Nor is it insignificant that the logic of Duchamp's lexical extremism leads directly to Kosuth's tediously repetitive, conceptual dictionary entries via the puns and that Manzoni's samples of artist's crap (tinned/canned) helped to perpetuate the Urinal Fountain's autistic ethos.

15. Zurich, Kunstgewerbemuseum, *Wegleitung 234*, 1960, p. 10.

16. Hamilton's resolve to imbue Duchamp with beauty can go to extreme lengths. His preliminary experimentation to reproduce the *Large Glass* provided him with the left-overs of laboratory material,

designed to attest techniques and he included a glass version of the *Témoins oculistes* in his exhibition—although the piece has no authority as an independent work in the Duchamp canon. He justifies the decision with reference to beauty: 'Since time was limited for the Newcastle reproduction of the *Large Glass* a short cut had to be found. A drawing was made, using no. 139 as the model, to prepare a silk screen . . . Richard Hamilton's experiments with this technique gave us an object too irresistible to exclude from the exhibition.'

17. *Tate*, p. 5.

18. As for Hamilton's traditionalism, it is rather obvious that the motor car replaces in his iconography the stages and the sheep of the nineteenth-century landscape painting; and Hamilton imbues the aspect of steel with Samuel Palmer's mystic light in his compositions.

19. *Tate*, p. 5.

20. *MOMA*, 1973, pp. 99–116.

21. As for the reference to Wittgenstein and Carnap, it may well be overemphatic or mistaken. Antin's 'U.C.' peroration preserves its improvised nature in print and remains, rather tantalizingly, unaccompanied by footnotes. In the circumstances the identification of some of his sources should not be taken too seriously.

22. 'In Clio's domain the past's ghosts rattle their ineluctable chains according to the dictates of the interpreter's moral philosophy.' (Johann Dieb, *Briefwechsel mit Friedrich Engels, 30 April 1868*, Leipzig 1974.)

23. Most of the notes for this study were in fact written well over two years ago, for a course of lectures in the University of Illinois but it would be ungrateful to deny the debt which the present cast of these pages owes to Bill and Antin. There is, certainly, the wish to arrive at conclusions and in the light of this wish Antin's magnificent exegesis does seem like a running commentary on Max Bill's contention although he does not quote it; but it would be very misleading indeed if the inferences in this article pretended to be a continuation of the beginnings so stimulatingly put in their work. Paradoxically, the propositions put forward in this essay stem from very different sources. Their formulation owes a good deal to evolutionary ideas—which are inextricably involved in any critical argument. A relative motivation is an essential component in historical and analytical writing. No scrutiny can be devoted to isolated occurrences. Examination takes place within a context and information is of no value unless it is referentially intended. Any genuine commentary aims to locate new items of knowledge in a fixed scheme of given data in order to stress relationships. These relationships provide observations with meaning.

24. It is surely to the point that William Tucker's new book on sculpture between 1860 and 1965 is called *The Language of Sculpture* (Thames & Hudson 1974); titles of this kind, which identify one of the arts with a concept of language, come by the dozen.

25. Even the extremist revolutionary tries to fit himself into conventional aesthetics. Body artists stain papers and picture surfaces with the body's juices and are on record in claiming that the 'human body is being substituted for the role of the paintbrush'; it has even been asserted that the tints thus obtained 'provide more natural pigments' than the paint factory.

26. *Aspects of the Theory of Syntax*, MIT 1965, p. 58.

27. David Antin's thought processes follow the cues of the inspiration exclusively.

28. Duchamp enthusiasts and the proliferating schools of Neo-Marcelianism, which pander to their taste, are at liberty to maintain that semantic absurdity reflects the meaningless which societies attribute to art.

29. The word 'learner' (or 'artist'?) is a legitimate substitution for the word 'child' in this sentence and the statement gains a good deal of forcefulness in its applicability to the artist's special problems if in fact it is reread with the amendment in mind.

30. Chomsky, *ibid*.

Study for the Nude Figure
in 'Etant donnés . . .' c. 1950
Gouache on transparent perforated plexiglass

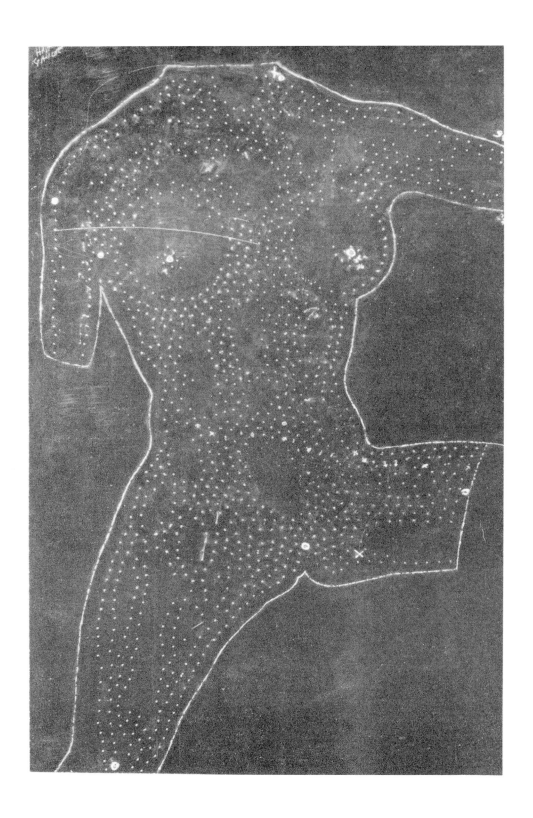

Jindřich Chalupecký

Nothing but an Artist . . .

First published in *Studio International*, vol. 187, no. 963,
January–February 1975

'I am nothing else but an artist, I'm sure, and delighted to be'
MARCEL DUCHAMP, 1961[1]

1.

It is perfectly true that an experienced anthropologist, visiting a 'new' primitive society for the first time and working with the aid of competent interpreters, may be able, after a stay of only a few days, to develop in his own mind a fairly comprehensive 'model' of how the social system works, but it is also true that if he stays for six months and learns to speak the local language, very little of that original 'model' will remain. Indeed the task of understanding how the system works will by then appear even more formidable than it did just two days after his first arrival.

So wrote Edmund Leach in his well-known book on Lévi-Strauss, and he adds: 'Lévi-Strauss himself has never had the opportunity to suffer this demoralizing experience and he never comes to grips with the issue involved.'[2]

It is somewhat the same with art criticism. Today, contemporary art is receiving an unprecedented amount of publicity while, at the same time, the number of people who actually see the works remains minimal. Lawrence Alloway, writing in *Artforum* about the function of art in modern society, points out that it is rare for more than a thousand people to view a gallery exhibition, and art reaches a wider public almost exclusively through the Press. In this context, he says, 'the works of art become part of the lively flow of signs and symbols that populate the environment', and this 'saturation by information' is one of the factors producing the 'sophistication without depth' that is a characteristic of the modern public's reaction to art. Moreover, art conveyed by the Press comes into collision with the great social problems of our time, thus making its status even more doubtful and difficult to assess.[3]

Here Alloway is pointing to an important truth. No amount of publicity, no matter how competently or critically presented, can take the place of direct contact with a work of art. The art critic can tell you that his experience in studios and galleries is similar to that of the anthropologist *in situ*: he must be continually ready to find his theories on modern art inadequate to deal with the new work; he must always be prepared to be taken aback or surprised by something and to adjust his ideas accordingly. But from this it follows that art criticism can never lead to definitive conclusions. It must remain open; it must pose questions rather than give answers.

Today, however, people are used to having the media provide them with predigested information so that they won't have to bother thinking for themselves, and art journalism has had to adapt itself to this attitude. Until recently, it was enough to dismiss modern art with ridicule. Today, it is treated as nonsense and humbug by only a very few backward writers. For in the meantime it has become clear that journalistically, modern art can be exploited far more profitably: it can be presented as

something out of the ordinary, but for that very reason, entertaining as well. On the other hand, this presentation must be as readable as possible. Thus the content of modern art is compressed into a few easily remembered catch-phrases: Pop Art, Op Art, Minimal Art, Conceptualism, Hyper-realism, and so on. These phrases are coined quickly, as the occasion demands and, rather than explaining, they tend to confuse the meaning and value of the works. What in fact does Lichtenstein's Pop Art have in common with that of Segal? Or can Pearlstein, Estes and de Andrea really be grouped together under the same heading? The work of some artists lends itself especially well to journalistic treatment, and many go out of their way to be obliging in this regard; other artists may seem far less effective, and thus a quite special scale of values is created. Think of all that goes on under the label of conceptual art! A sculptress who in New York exhibits a series of nude photographs of herself as documents of her successful reducing cure, and the dilettantish questionnaire action organized by Hans Haacke in a museum, are given worldwide publicity in the art press. The reader no longer need view the new work directly: reproductions and commentaries are enough. But if he goes on to an exhibition, he is prepared in advance by what he has read and, moreover, the organizers of these exhibitions go half way to meet him by selecting and arranging the shows along journalistic lines. Harold Rosenberg has called this 'novelty art', and it is this novelty, rather than the art itself, that attracts the new viewer.

Here we have come to a dangerous point. Where is the artist — perhaps in vain — making a genuine sacrifice, and where is he merely indulging in exhibitionism? Where is he seeking — desperately and perhaps unsuccessfully — a place for his art in our history, and where is he simply succumbing to his own naivety? Where are the limits, where is the measure, where is the meaning of all this? We need a criticism that would reject sensational generalization and genuinely deal with the artist, his concrete situation in concrete history and his reaction to the times in which he lives. Perhaps there is nothing to be done but abandon theories and return in art criticism to that investigation *in situ* that Leach and his British colleagues advocate in anthropology; instead of theorizing, to return to the works themselves. For today we are witnessing an increasing tendency to escape from facts, the advent of a new Alexandrian age. It is no longer the censor, but rather the theorizing journalist or the theoretician who is becoming the artist's most dangerous enemy.

2.

One of the most striking examples of this tendency is the fate of Marcel Duchamp's work. As long as Dada remained a living force, Duchamp was considered a fringe phenomenon, if not an

artistic clown. When Dada was allotted a dignified place in the history of art, however, Duchamp's work began to be interpreted as the result of historical forces. Look, for example, at the opinion of Grégoire Müller:

There has not appeared a single critical analysis of his work that has succeeded in pinpointing its basic orientation, simply because there is no basic orientation other than refusal to have an orientation. Duchamp is an alchemist. Duchamp is an optical artist. Duchamp is a Futurist. Duchamp is a chess player. Duchamp is a Dadaist. Duchamp is an erotic poet He negated everything and opened the way for new directions in art.[4]

The contradictions in this statement are clear: how could anyone with no basic orientation 'open the way for new directions in art'? According to Müller, Duchamp was nothing more than an epiphenomenon in the history of art: a futurist, a dadaist, an op artist. The man and the artist are absolutely separated. While the man necessarily retains his identity throughout his life, the modern artist lacks this identity. He no longer makes his art from his life; it seems that he could be an artist without living a human life at all. He remains content with 'negating everything' and through this consistent nihilism, he opens up new perspectives for art. It is interesting that in this regard, the modern artist is similar to the critic, for the modern critic is not, or should no longer be, a personality. He is an observer, a documenter, a journalist. He is no longer committed to anything: in short, he too is a nihilist.

This nihilistic historicism appears in an even more distorted form in Jack Burnham. According to his latest interpretation (the latest of several, each of them different) Duchamp's *La Mariée mise à nu* 'liberates Duchamp because it symbolically foretells the evolutionary pattern of future art'[5] and is 'a coherent allegory of the devolution of modern art in terms of Duchamp's own psychosexual catharsis'[6] — in other words, it is simply a kind of pictorial essay waiting for a critic to translate its visual language into conceptual terms. If this were true, it would be possible to make art scientifically: the evolutionary model is ready, and it remains only to fill it out with the appropriate artifacts or activities. Art theory is a science; art is technology.

According to some others, art is simply the handmaiden of political history. Ursula Meyer offers a very simple explanation of Duchamp's work:

At the eve of World War One, Duchamp coined the term anti-art, implying his disdain for the establishment's inept practices in art and politics. The ready-mades were sarcastic jibes against an elitist art world According to Hans Richter, the meaning of Duchamp's *Fountain* was that he was pissing on the establishment's aesthetic values [etc.].[7]

In this interpretation, the relation of modern art to history is stood on its head and art appears in fact as something of no use.

3.

An artist naturally lives in his own time and is even formed by it, and of no one is this perhaps truer than of Duchamp. Cubist art remained in the pre-industrial world, and Futurism took from the industrial world its external features: its dynamism and its forms. But while the futurist depicted the industrial world, as Duchamp said, impressionistically, Duchamp discovered its symbolic significance. He proved ready to become a citizen in this new world, to accept it as a new kind of nature, to make it a part of his own inner world.

It began with Duchamp's memorable automobile trip with Picabia in 1912 from Etival in the department of Jura to Paris, along with Apollinaire and Gabrielle Buffet. Duchamp included a poetic record of that journey among the preparatory notes for the *Large Glass* with good reason. It is one of the earliest of those notes and the key to everything that followed. It is also very likely that this trip and the conversations connected with it explain Apollinaire's famous sentence in his short text on Duchamp in *Les peintres cubistes* written in that same year, 1912, according to which Duchamp was to 'reconcile art and the people'. For modern urban man, the machine *is* a new form of nature and Duchamp's relationship to the machine was the same intimacy felt by an engineer, a chauffeur or a worker towards his machine: he feels it to be a living being, his 'mechanical bride'. (It is significant that from the beginning of the machine age, the English have given their machines feminine names like the 'Spinning Jenny'.) Gabrielle Buffet, who was a witness to all this as well as a participant, writes in her *Aires abstraits* (1957) of the importance that all of them at that time had attributed to the machine, that

new arrival, the offspring of the human brain, truly a *fille née sans mère* I recall a time when its rapid proliferation was taken as a calamity, a time when every artist felt it his duty to turn his back on the Eiffel Tower in protest against the architectural blasphemy which it proclaimed in the sky. The discovery and rehabilitation of these strange beings of iron and steel that were distinguished from the familiar aspects of nature by their construction and by the dynamism inherent in the automatic movements they gave rise to, were in themselves a bold, revolutionary act . . .[8]

What Gabrielle Buffet wrote about her journey with Picabia in 1913 applies equally well to Duchamp's introduction to New York two years later.

It was a voyage of discovery full of surprises. The appearance of the city, the streets, the neon signs — unknown back home — and the often grandiose architecture, such as the iron and steel bridge on 59th Street, were a source of really new impressions and wonder for us.

Human relations were no less unexpected, being void of all the traditions of culture and civility of the Old Europe. They were almost brutal but at the same time simple and warm, something that did not displease us in the least.[9]

Duchamp was always resolutely against having his art con-

nected with Futurism. In fact, Futurist pictures could not have directly influenced him, because until the Futurist exhibition in the Gallery Bernheim Jeune et Cie in 1912, not even photographs of these works were available[10] and Duchamp had already painted *Jeune homme triste dans un train* and *Nu descendant un escalier* in 1911. Nevertheless, he had almost certainly read the *Futurist Manifesto* as it was published in *Le Figaro* on 20 February 1909; practically everyone read it then and its radical anti-traditionalism spoke directly to the spirit of many. Even Frantisek Kupka had it tacked to the door of his studio: the young Czech poet Richard Weiner saw it there when he visited Kupka in July 1912. He wrote an article about his visit shortly afterward for a Prague newspaper,[11] and in it he mentions Kupka's studies of motion. According to Weiner, Kupka did not agree with the Futurists' attempt to capture 'simultaneity of sequences' (which was, of course, more a theory of *simultanéisme*), but rather he tried in his painting to represent a 'shifting'. As a document of this Kupka showed Weiner a picture of riders in the Bois de Boulogne that was an attempt to illustrate motion in successive phrases. Two drawings by Kupka on this subject have been preserved, but they are unsigned. In the catalogue for the last Kupka retrospective in Prague (1968), Ludmila Vachtová quite illogically dates the first, a pencil drawing (no. 128) at around 1911 and the second, in ink (no. 129) between 1900 and 1902; but we must clearly unify the dating and shift it to the period between 1909 and 1912. Nevertheless, what Weiner saw in Kupka's studio were not drawings but a painting on the same theme. In her monograph on Kupka (1968) Vachtová shows that *Amorpha* (1912) was also based on a study of the movement of a red and blue ball, and she draws attention to a picture entitled *The Bow*, also dated 1912, with its 'fan-like shapes the sub-text of which is nothing other than the gesture of bowing separated into its phases'. A similar example, perhaps somewhat older, is an ink drawing *Woman Picking Flowers*, reproduced in the catalogue *Kupka avant 1914*[12] and dated by Denise Fédit, apparently too early, at 'around 1908'.

The principle of Kupka's *The Bow* is identical to that of Duchamp's *Jeune homme triste* and *Nu descendant un escalier*, and if Futurist pictures did not and could not have influenced Duchamp, it seems very probable that Kupka's speculations and experiments did. In the introduction to Picabia's catalogue in 1926[13] Duchamp writes that 'my aim was a static representation of movement' and even in his lecture 'Apropos of Myself' delivered in 1964, he speaks, commenting on *Nu descendant un escalier*, in the same way as Kupka once did. Cubism was closer to him than Futurism, he recalled, but he was very much taken by Balla's *Dynamism of a Dog on a Leash* because it depicted 'the successive static positions of the dog's legs and leash'.[14] Duchamp's brothers had their studios in Puteaux next to Kupka's; they frequently met with Kupka and Duchamp, who lived in nearby Neuilly, often walked to Puteaux. It seems more likely, therefore, that Duchamp saw Kupka's pictures, rather than the other way round. Of course Duchamp was influenced

by analytical Cubism and its lack of colour and his phasing of motion became a dramatic, spatial event, whereas Kupka, who was ten years older and still drawing on the tradition of Art Nouveau, tended rather towards colouristic decorativeness.

There is one more interesting link between Kupka and Duchamp's circle. In Weiner's article from August 1912, Kupka is quoted as saying that he was attempting 'amorphous painting'—that is, painting without form, created from the pure colour—and in the Autumn Salon in 1912, he exhibited his two *Amorphas*. One of Kupka's key paintings, *Nocturne*, most probably from 1910, is in that sense 'amorphous'. A year after Kupka's conversation with Weiner, in July 1913, Picabia published his manifesto *Towards Amorphism* in the New York *Camera Work*. In it, he carries the idea of amorphism to its ultimate conclusions: 'it is time to do away with colour after having gotten rid of form.' He illustrated his thesis with two black squares entitled *Bain* and *La mer*, leaving it to the viewer to create the pictures in his own mind.[15] Picabia at the same time refers to a number of contemporary artists but oddly enough he does not mention Kupka. The reason is most probably to be found in the fact that Kupka had lost contact with the other Parisian painters. He was a cyclothymiac; after the euphoric elan of the years from 1909 to 1912, he began to experience severe depressions and in those decisive years before the war, he lost interest in his work and in contact with people. In 1914, he volunteered for the army and disappeared from the art scene until he returned in 1921—as a personality who by that time seemed antiquated. The picture *The Bow*, according to Vachtová,[16] was not exhibited until 1957.

4.

At that time Robert Delaunay also belonged to the same circle as Duchamp and Kupka. In 1912 he was interested in 'rhythmic simultaneity' and beyond that, in a new theme: 'the sky above the city, zeppelins, towers, aeroplanes' and he painted a cycle of pictures of the Eiffel Tower. But while in Delaunay's mind, all this meant 'the poetry of modern life',[17] Duchamp's importance lies in the fact that he discovered a great deal more in this modern civilization than mere picturesqueness. In another study on Duchamp[18] I have tried to demonstrate that the usual interpretations of his ready-mades are unsatisfactory. Such interpretations are based on André Breton's famous statement about ready-mades as 'manufactured objects raised to the dignity of art objects through the artist's choice'. But this explanation explains nothing. The artist is no magician who, by a mere gesture, can transform something that is not art into art. Here Breton is really paraphrasing the interpretation given in an editorial in the second (and last) issue of *The Blind Man* (New York, May 1917). The article is not signed, but Duchamp himself was certainly its co-author. It was published in defence of the provocative ready-made *Fountain*. Breton, who did not know English, made use of only the first part of this explanation and thus missed its meaning. *Fountain* was signed, as is well known, 'R. Mutt'.

Whether Mr Mutt with his own hands made the fountain or not has no importance. He CHOSE it. He took an ordinary article of life, placed it so that its useful significance disappeared under the new title and point of view — created a new thought for that object. Duchamp's operation was truly more complex than Breton supposed. In the first place, the ready-mades were not simply chosen; they were also placed in a setting that had nothing to do with their original function, and usually in an inappropriate position — hung, or turned on their sides. In the second place, regardless of how much Duchamp's interpreters may insist on it, they were not chosen randomly. Duchamp always emphasized his absolute indifference, but it was indifference of a special kind: just as one speaks of methodical doubt in Descartes, so one may speak of methodical indifference in Duchamp. What he was trying to do was to eliminate any conscious, volitional motivation whatsoever, be it practical or aesthetic, and in this way, to release other motivations: let us call them symbolic in the sense that Mallarmé and especially Baudelaire understood symbolism. For whereas Mallarmé sought his symbolic material, in keeping with the style of the end of the century, in distant cultures and long extinct times, Baudelaire felt that 'a *painter*, a genuine painter, will be one who is capable of discovering the epic nature of contemporary life', as he wrote in his *Salon* 1845; and in his last *Salon* 1859, he adds that the key to this new discovery of reality will be the imagination — the imagination that 'decomposes everything created, and with the materials that it gathers and treats according to rules whose origins we must seek only in the deepest levels of the spirit, creates a new world.'

I would go so far as to say that the significance of Duchamp's *Large Glass* and the ready-mades from the same period lies in the fact that they reveal the source of the modern world's fascination for us: its symbolic value. It is true that Duchamp has emphasized that he wanted his work to appeal first of all to 'the grey matter of the brain', and even that he wanted to renew the old allegorical type of painting. A detailed analysis may in fact reveal allegory in the *Large Glass*: we may conceive its forms as signs and for these signs find a lexical meaning. But the work is effective before one can explain it, and the explanation scarcely adds anything to its impact. For before the work is allegory, before it appeals to the 'grey matter', it speaks (to maintain the metaphor) to the subcortex, to archaic levels of awareness, to the area of moods, intimations, to the unstructured or the just structuring awareness of the world, to those 'deepest levels of the spirit' that Baudelaire speaks of. And the same applies to Duchamp's ready-mades: they are not things that belong to our rationally organized world, but rather they have been lifted out of it and have ceased to be useful. They have been subjected to a process of 'ostranenie' (defamiliarization) — a term coined by Viktor Shklovsky in the same period to explain the aesthetics of Russian Futurism. Marcelin Pleynet is quite wrong to ascribe a 'transgressive ideological structure' 'to Duchamp's *Fountain*, which according to him consists in the fact that one could have urinated into the pissoir at the exhibition.[19] He failed to notice that Duchamp placed the pissoir on its back, thus removing it from its practical context. Duchamp's ready-mades are the same as they would be in a shop window, separated from us by glass, untouchable, just as his *La mariée* is untouchable. One might even speak of the 'myth of the shop window' so typical for our modern world. Some of Duchamp's remarks from 1913, published in the collection *A l'infinitif*[20] relate directly to this:

From the demands of the show windows, from the inevitable response to shop windows, my choice is determined. No obstinacy, ad absurdum, of hiding the coition through a glass pane with one or many objects of the shop window. The penalty consists in cutting the pane and in feeling regret as soon as possession is consummated. QED.

The ready-made 'chooses you, so to speak', he replied many years later when he was asked how in fact he chose them.[21]

Octavio Paz, in one of the most penetrating analyses of Duchamp's work which forms the second part of his *Apariencia desnuda* (1974 — the English translation was printed in the catalogue for Duchamp's American retrospective: * *Water Writes Always in * Plural*)[21a] warns against a fossilized, lexical interpretation of Duchamp's symbols where, for example, 'gas' always means exclusively the male principle and 'water' the female principle. He suggests using the term 'signs', which are 'moveable pieces of syntax' that 'change their meaning . . . according to the context'. Unfortunately, however, the very term 'sign' implies that unambiguity, that rigid welding of a meaning to its material container, that Paz wishes to avoid. A sign at least has a relative stability within a given system, context or code. A symbolic system, on the other hand, *a priori* excludes all such stability; a symbol not only *can*, but in fact always *does* mean everything. What is most typical of a symbol is its polysemantical nature. In the words of Paul Ricoeur:

What we call quite simply ambiguity as compared with the need for unambiguity in logical thought means that symbols only symbolize something in groups that limit and articulate their meaning.[22]

If we read the symbolic interpretations of Duchamp's work, we may be surprised at how absolutely arbitrary these interpretations seem — anything may, in the end, mean anything. I am thinking in particular of the most recent interpretation by Arturo Schwarz in the excerpt from his forthcoming book *L'alchimiste mis à nu chez le célibataire, même* that appeared in the Italian review *Data*.[23] But that, in fact, is how it is. A rational interpretation of symbols is impossible. Symbolic discourse has a place precisely where rational discourse ceases to be possible. A work of art cannot be deciphered like a rebus. Our understanding of it comes from another and deeper source. Jung, for this reason, argued against Freud's rational interpretations — if we are to understand a symbol, we must admit that it means no more than what it in fact is:

I doubt whether we are justified in assuming that a dream is something other than what it appears to be . . . I would tend

rather to invoke another Jewish authority, namely the Talmud, which says that a dream is its own interpretation.[24]

To reduce a symbol to a definable meaning is in fact to rob it of its real meaning. To read the world symbolically, we must grasp the fact that everything is present in everything. In symbolic thinking, the presence of the universe is actively felt in each of its parts, everywhere; anything whatsoever can manifest it.

For Karl Jaspers, symbols are the 'language of transcendence', its 'ciphers', endlessly and arbitrarily ambiguous:

> Visible symbolics do not permit the separation of sign and meaning, for both are contained in one. If we wish to clarify for ourselves what the symbol refers to, then we *do* separate them, but only with the help of new symbolics, and not by explaining them in terms of something different. What we have already had will merely be clearer. We return and look into new depths.[25]

Mallarmé's maxim 'to evoke in a specific shade, the silenced object by allusive words, never direct',[26] is not a set of instructions for deliberately concealing meaning. Mallarmé's symbols cannot be explained. His poetry is extremely precise and clear, writes Wallace Fowlie in his extensive analysis, but, he adds, 'its meaning deepens and changes with each reading until one realizes that its total or its absolute meaning is not attainable'.[26a] The cosmos is a universal synecdoche. In a symbolic understanding of the world, we go from symbol to symbol without ever escaping their charmed circle. Even sexual symbols cannot be reduced to their rational meaning: they are once more only symbols of symbols. Symbolics is not semantics.

5.

Duchamp several times recalled the decisive importance that seeing Raymond Roussel's *Impressions d'Afrique* in 1912 had for him. 'It was fundamentally Roussel who was responsible for my glass, *La mariée mise à nu par ses célibataires, même,*' he told J.J. Sweeney. 'Roussel showed me the way.'[27] For Jean Schuster, he clarified the importance of Roussel's 'attitude to machines, an attitude not at all one of admiration, but rather of irony'.[28] In his conversations with Cabanne, he claimed that Roussel inspired his linguistic experiments even though, he added, he did not and could not have known Roussel's system of writing—Roussel first revealed it in his book '*Comment j'ai écrit certains de mes livres,* which was published posthumously in 1935.

Roussel was ten years older than Duchamp and his ruthless radicalism, paying no heed whatsoever to any artistic conventions, could well have been an example to him. Roussel was immensely wealthy and thus could afford to produce his *Impressions d'Afrique* without compromises. The performance must have had a tremendous impact, but if it so strongly impressed Duchamp at that decisive moment in his development, it does not seem enough to explain that he felt it merely as 'a mad carnival of frenzied action and delirious language', as

Sanouillet suggests.[29] The way to the *Large Glass* did not lead from here.

Impressions d'Afrique was a fantasia that was neither proto-dada nor proto-surrealist. It was created by unconventional means. Michel Leiris explains that Roussel's texts went through three phases: the first consisted in seeking puns or sentences with double meanings; the second involved setting up a logical framework linking these disparate elements together; and the third was as strict and realistic a revision of the final text as possible.[30]

Duchamp, it seems, realized that Roussel's fantasia was not an act of caprice, but a special order of its own, with its own logic. In fact, Roussel's poetic method is very close to the manner in which the *Large Glass* came into being, and Duchamp's attraction to it is quite in keeping with his interest in puns. Duchamp knew *Impressions* very well (Sanouillet is wrong to think that he knew the verbal version only superficially from having seen the performance—see Cabanne's *Entretiens*, p. 56: 'After I had read the text . . .') and he clearly felt a deep kinship between his own intentions and what Roussel had in fact done. There is, by the way, another parallel here, roughly contemporary and no less interesting. It was Velemir Chlebnikov, certainly one of the greatest figures in poetry in this century, who wrote: 'Words are especially powerful when they have two meanings, when they serve as a living sense of sight for mystery and when, through the dim light of the common meaning, a second meaning shines.'[31]

These puns, of course, are not merely puns: as rhyme or alliteration are not just poetic devices. They belong to the very essence of poetry. The blurring of the semantic borders of words and sentences reaches a climax here—the word, if not the whole sentence, has two disparate meanings, or more exactly, the meaning oscillates between the ambiguity. Roussel himself gives an example from a poem by Charles Cros:

> *Dans ces meubles laqués, rideaux et dais moroses,*
> *danse, aime, bleu laquais, ris d'oser des mots roses.*

It is still the concern of poetry to call in doubt the semantic value of language and return its symbolic validity, to reveal through language that aspect of the world in which everything is interrelated, everything mingles, everything means everything. It is that microcosm of inner reflection in Mallarmé's poetry, where

> words—which are so much themselves that they no longer receive any impressions from outside—reflect off one another until they no longer seem to possess their own colour but rather to be gradations within a spectrum.[32]

Duchamp, and Satie as well, went further when they confronted words with a work of art or a musical composition: Duchamp, who provided his ready-mades (and pictures) with titles or texts that had no connection with the work and often made no sense, and Satie, who gave his compositions titles like *Embryons desséchés* (1913) and wrote absurd texts between the lines of his score for *Heures séculaires et instantanées* for piano (1914).

It is all the same deliberate calling in doubt of meaning, the meaning of things, words, musical phrases. When the semantic unambiguity of words is blurred by the creation of an irresolvable tension between various unconnected meanings, we are forced to leave the world of defined meanings and enter meaninglessness, a pre-semantic state where there is neither *significans* or *significatum*, an area that Peirce called 'firstness' and considered the true domain of the aesthetic.

This is also a condition of the ready-made: the deliberate removal of a thing's meaning. Thus the objects are brought into the area of the aesthetic or, what is the same thing here, the symbolic. 'I took it out of the earth and onto the planet of aesthetics', said Duchamp in a conversation in 1953.[33]

6.

From the end of the Second World War on, Duchamp gave a number of interviews in which he spoke in detail about his life and work. But the observant reader soon begins to suspect that Duchamp spoke so extensively and clearly so as *not* to say something. The warning is in how cleverly he succeeded in pretending that he was a mere '*respirateur*', whereas in fact he spent two decades working clandestinely on his last work. Given his ascetic reserve, he certainly never wanted to have his private life exposed to public scrutiny; his wish was to appear, if not as a balanced and self-possessed man, then at least as an artist who makes a sharp distinction between his private life and his art, between 'the man who suffers and the mind that creates' (Duchamp quoted these words of T. S. Eliot at the very beginning of his important statement *The Creative Act*[34]). He even liked to talk of his art as a mere 'game', 'amusement', 'distraction', and people believed him. 'Nothing seems more *natural*, transparent and clear than the life, the work and the person of Duchamp himself', concludes Pierre Cabanne after a series of conversations in which Duchamp gradually related the course of his whole life and work.[35] And yet behind a work so intellectual and a life so formally disciplined was a man who suffered and, what is more, created from that suffering his work.

Among the technical, poetic and philosophical fragments from the period when the *Large Glass* and the first ready-mades were conceived, which Duchamp gathered together into his *Boîte 1914*, and which existed only in three copies, we find the unexpected admission: 'Given that . . .; if I assume that I suffer so much . . .'

The formula 'Given that' (*Etant donné*) accompanied Duchamp until the end of his life, and with it, that hidden impulse that had once driven him to an extreme artistic radicalism, just as it later reduced him to a long period of artistic inactivity. His work was in fact his most private affair, and that was the reason for the uncertainty and the reluctance with which he made it public. What he could not clarify in life, he attempted to make clear in art, and thus to overcome his distress, his helplessness, his despair. It was a road that took him from the pictures of his sisters—the first is from 1903—through the pictures of Virgins and Brides to his last work, *Etant donnés*, finished in 1966. Duchamp's symbolism is not merely a reading of the universe, but also a reading of human destiny in this universe—of destiny of the universe in human life.

The consistent artistic radicalism with which Duchamp evaded all the usual criteria, and at the same time the personal reticence that more than once led him to assume the role of a mystifier, resulted in his work gaining the reputation of being something deliberately enigmatic and hermetic. And this is the source of the Duchamp legend.

In its simplest form, Duchamp's hermeticness is explained as clever dissembling. According to this version, Duchamp was never concerned with art; he was an 'aesthetic nihilist' while at the same time being a tireless showman who made subtle use of the modern means of publicity.

According to another version Duchamp was an initiate in the occult sciences. The original source of this theory lies in the Surrealist circle and Breton's interest in occultism, and its most recent appearence is in the literary activities of Jack Burnham. In *Artforum*[36] and in the French magazine *VH 101*[37] we may read that Duchamp went to Munich in 1912 ostensibly because he was looking for an alchemistic manuscript, and that the wild 'erotic and alcoholic excesses' of his years in New York in Arensberg's company were in fact a compulsory part of gnostic practice. In the chapter devoted to Duchamp in his book *The Structure of Art*,[38] Burnham mixes alchemist theory with echoes of his reading of Lévi-Strauss and Barthes. Here is Burnham's interpretation of Duchamp's text about the Jura-Paris trip with Picabia in 1912:

> The 'machine with 5 hearts' is the Alchemist's Stone, the Great Pyramid, or the semiotic structure including AETHER, FIRE, WATER, AIR and EARTH. In reality the Jura-Paris road runs from the Jura mountains at the Swiss border to Paris. Moreover, there is a Jura Mountain range on the Moon. The Moon being a symbol of the female and the natural, it seems likely that Duchamp is implying that the evolution of art' is the traversal from the completely cultural to the totally natural. The 'chief of the five nudes' refers to Picasso and his pivotal cubist painting of 1907, *Les demoiselles d'Avignon*.

And so on. And there is more:

> A comet with 'its tail in front' is the trajectory of Duchamp's work between 1911 and 1926.

The temporal clairvoyance with which Duchamp in 1912 foresaw the course of his own work up to 1926 corresponds to the spatial clairvoyance with which he saw Picasso's *Demoiselles*. It is true that Picasso showed it to his closest friends when he had finished it (Duchamp was never one of them) but then he rolled it up and left it lying in his studio until sometime in 1920. It was first reproduced in 1925 and exhibited in 1927.

Naturally the whole legend of Duchamp's alchemism hasn't the slightest basis in fact and Duchamp himself quite clearly told Robert Lebel long ago, in response to a direct question: 'If I have

ever practised alchemy, then I have done so in the only way admissible in our times, that is, without knowing it'.[39]

7.

Burnham has now made his legend scientific. By the very title of the book just quoted, Burnham has announced his affiliation with the tradition of rationalist structuralism, and not of surrealist hermeticism. The importance of structuralism in the history of modern art is extraordinary. Its beginnings are in the enormously stimulating environment of Russian avant-garde art in the first quarter of this century. The most outstanding exponent of structuralism is still Roman Jakobson, and he began among the Russian Formalists and at the same time published Futurist poetry. It might be said that his entire theoretical work was carried by the inspiration he felt as a twentieth-century poet. In 1934, in the Prague art review *Volné smery*, Jakobson published a study entitled *Co je poesie* (What is Poetry).[40] It is only a few pages long, but it has remained in the back of my mind since it first came out. The study turns on the curious dichotomy in the work of the great Czech romantic poet Karel Hynek Mácha. In his poetry, love is an almost disembodied event that belongs to all being, an endless flow of tones, colours and smells:

Of love the moss purled in the gloom,
The flowering tree feigned love's fond woes,
His love the nightingale sang the rose,
While rosebush sighed its soft perfume.
The lake's smooth face in quiet murmur
Told of a dark and secret ache.[41]

In the intimate passages of Mácha's diary, written at the same time (1835), love is nothing more than a physiological act described again and again with brutal openness:

Once again I took Lori home to my flat in Truhlárská Street. There I fucked her on the chairs by the window. She cried out for me to stop. 'It hurts. Lord Jesus.' When I asked her why, she answered, 'Because you went deeper than before.' Then she went to the WC. And I held her dress.[41a]

How is one to reconcile this diary and that poetry? Jakobson replies:

Both aspects are equally truthful; they are merely different significations or, in scholarly terms, different semantic plans, of the same subject, the same experience. Mácha's diary is just as poetic a work as his *Máj* or *Marinka*; it contains not a trace of the utilitarian; it is pure *art pour l'art*; it is poetry for the poet. But if Mácha were alive today, he would perhaps have left his lyrics for his own intimate purposes and published his diary instead. We would have to rank him along with Joyce and Lawrence.

The whole of Jakobson's essay deals with such complex relationships between biography and oeuvre. A poet's life and work cannot be separated. True, poetry is autonomous and the poetic cannot be reduced to something outside itself, but at the same time it is not cut off from the rest of the world and life. It is 'a mere component of a complex structure, but a component that necessarily re-forms the other elements and determines the nature of the whole'. The poetic consists in the fact that 'words and their composition, their meaning, their inner and outer form, are not an indifferent pointing to reality, but rather they take on their own weight and value' — and with them, I would add, the reality to which these words are a far from indifferent reference. Jakobson's conclusion suggests this idea:

It is not until a period has died away and the obscure relationships between its various components has decayed, when we stand upon the legendary graveyard of history, that the 'monuments of poetry' tower gloriously above the manifold rubble of archaeology. Thus we first espy the human skeleton in the grave, when it is no longer of any use. As long as it was doing its job, it evaded observation, unless of course we were to X-ray it, unless we were persistently to seek to know what a backbone is, what poetry is.

This essay by Jakobson leads us to the very sources of structuralist thought. Structuralism was conceived in the womb of modern poetry and modern art. It had no intention of interpreting and replacing the artistic fact with some logical construction; quite the contrary, it pointed out that a work of art originates inside life and comes out of the life of its creator and its time as an autonomous formation capable of containing, illuminating, making conscious and, in its own way, forming human experience. As far as the artistic structure itself is concerned, it is no more than a 'skeleton' that stands high above 'the graveyard of history' as something no longer of any use, something without life.

8.

Since that time structuralism has become an independent discipline, a kind of general morphology, if not a new *ars magna*, purporting to reveal the intelligible laws governing all being — from genetic systems to Baudelaire's sonnet. It is still used, however, to explain works of art, but if the structure of a work becomes a mere analogy of everything that exists, then structuralism cannot be used to explain its specificity, its aesthetic character. Nevertheless Claude Lévi-Strauss suspects that the key to 'mystical thought' and to the deepest structures of human consciousness and behaviour lies in art: art in our civilization remains the last preserve of 'primitive thinking',[42] but living art appears to be beyond him. In his mind Richard Wagner is still the greatest artist, and the manifestations of modern art remain quite unintelligible to him. He feels that the ready-mades

are sentences constructed of two objects that have a single meaning, and not the object alone, no matter what it may have been intended to do or mean.[43]

and he considers Picasso's art like the rest of abstract painting, to be a blind alley because, as he says, it has lost its 'signifying function'.[44] Concrete music is just as incomprehensible to him.[45] His ideal in art corresponds to his old-fashioned Wagnerianism: he awaits the advent of

an anecdotal and superlatively figurative painting . . . that
. . . would strive, using all the techniques of the most tradi-
tional forms of painting, to reconstitute around me a more
habitable universe than the one I find myself in . . .[46]
Lévi-Strauss's thinking as a whole moves within the dimensions
of nineteenth-century thought, combining Hegelian rationalism
with mechanistic determinism. At the very beginning of his four-
volume *Mythologiques* we encounter the obligatory assertion that
freedom is an illusion beneath which is hidden necessity, and that
what we call spiritual life is a mere mechanism.[47] And in the
conclusion, we are once more assured that everything is governed
by a 'pre-existing rationality' which is the same in the universe as
it is in the human mind.[48]

Just as for all dogmatic rationalists, so for Lévi-Strauss the
existence of art is disturbing, even when he accepts only anti-
quated forms. 'The role of the aesthetic imagination,' he assures
us at first, is only 'in the elaboration of classificatory systems',[49]
and poetic inspiration consists in games of combination, in a
'mechanism': any other point of view is 'extremely ancient
mysticism'.[50] But this does not prevent him from thinking that
a composer is 'a being equal to the gods'[51] and that through
his work we may attain 'a sort of immortality'.[52] After having
denied any aesthetic meaning to the symbolism of myth (or
rather having removed it through his interpretation), he comes
to the surprising conclusion that the very fact that myth 'is
attracted towards meaning . . . as if by a magnet' results in 'a
virtual vacuum of sound' which the narrator fills with prosodic,
declamatory or theatrical aesthetic elements.[53] Thus we have
arrived once more at the theory of 'poetic devices'.

Structuralism was the analysis of a work of art; neo-struc-
turalism banishes art from the world. For Jean Piaget, structure
has become a mere

> system of transformations . . . that maintains or enriches itself
> by the very play of its transformations . . . without these
> themselves going beyond its limits or appealing to external
> elements.[54]

The whole universe is now a mechanical automaton in which
all becoming is no more than a regrouping of structural con-
figurations, a gigantic kaleidoscope. Man is merely one of the
many signs in a linguistic schema, an object among objects, and
with his subjectivity disappear as well his wonder, joy, fear, love,
poetry, creation, consciousness—everything that makes him a
man.

Burnham faithfully continues in this neo-structuralism and its
objective, scientific interpretations:

> Effective art analysis must presuppose that the historical con-
> sistency of art (call it aesthetics) is due to a highly sophisticated,
> but hidden, logical structure observed without exception by all
> successful artists.[55]

The origin of structuralism in the milieu of modern art has
escaped him: with the exception of one doubtful reference to
Jakobson as an 'anthropologist', I cannot find a single mention
of either the Russian formalists or the continuation of their work

in the Cercle linguistique de Prague. On the other hand, he com-
bines Lévi-Strauss's doctrine with Barthes's semiology and the
algebra of sets and occultism. Using the resulting method, he
analyses forty-five works and compiles the results in imposing
charts. For Burnham, Duchamp remains the central figure of
modern art ('*magister ludi*') and he analyses his *Fountain*. It is
astonishing how meagre the results of such a pretentiously com-
plex method are. In the chart, *Fountain* is described seven times
in different words and its content is finally explained in a single
sentence: it is, we learn, 'some kind of modernist sculpture
involving projection of water', and all we hear about it further is
that its structure does not relate to 'aether' but rather to the
'water' of hermetic doctrines. There is no argument; the asser-
tions are quite arbitrary and extremely doubtful ('modernist
sculpture'? 'projection of water'?—Burnham apparently does
not know the range of meaning covered by the French word
'*fontaine*').

The reader might also be interested to know why, in *Boîte-
en-valise* there are, according to Burnham, 68 reproductions.
Burnham's answer: because there are not 69. He claims that the
absence of the sixty-ninth symbolically reveals the 'human sexual'
meaning of the collection. This meaning can be found on page
83 of Burnham's book. (In fact there are 71 reproductions; and
in the final version 83.)

9.

Leonardo liked to draw attention to the difference between
painting and sculpturing. The sculptor, he said, 'by the strength
of his arms and his hammering removes the exterior from marble
or other stone . . . while his sweat and the grit mingle into
mud, his face is grimy, and he is quite white with dust'. But the
painter 'sits in complete comfort before his easel, handsomely
dressed . . . and often works to the accompaniment of music or
readings from many excellent works, to which he listens with
great delight, undisturbed by the clanging of hammers or other
loud noises'.

Leonardo's description of work in a painter's studio is
undoubtedly fictitious. He was trying to rid painting of the
derogatory aura of an 'ars vulgaris' or craft, as it was considered
then, and to gain for it the dignity of an 'ars liberalis' like
grammar, mathematics or music.

Today, the exact sciences have triumphed and many artists
might wish for the same respect as scientists have, and for art to
be considered a branch of scholarship. Joseph Kosuth leads the
visitors to his exhibitions to a table where paperback literature
or files with documents are laid out: the gallery has become a
reading-room. Bernar Venet exhibits enlarged pages of abstruse
scientific books. The magazine *Art-Language* is laid out like a
scientific report; it overflows with references to the theory of
logic; it tells us that Duchamp's *L.H.O.O.Q.* may be transcribed
as $A(x)(y)$, Picabia's replica as $(A(x)(y))(\sim y)$ and Duchamp's
Rasée as $(A(x)(y))(\sim x)(\sim y)$—without, unfortunately, anything

having been clarified by this. The magazine does not deign to use illustrations.

Kosuth finds his justification in Duchamp. His ready-mades, he writes, meant a 'change from "appearance" to "conception"'. 'All art (after Duchamp) is conceptual (in nature) because art only exists conceptually.'[56] After Duchamp, then, the method of art is one that is purely scientific. 'Aesthetic systems are designed, capable of generating objects', says Victor Burgin.[56a] 'Artwork may not need to be denoted physically and may be a study of premises governing this denotation', claim Ian Burn and Mel Ramsden.[57] The work of art itself is no longer necessary; in fact, we need to declare a sort of 'moratorium of things'.[58] The hypothesis that is put forward on the first page of the first issue of *Art-Language*, then, logically follows from their position that:

This editorial, in itself an attempt to evince some outlines as to what 'conceptual art' is, is held out as a 'conceptual art' work.[59]

Several members of the *Art-Language* group today deny that they were ever interested in the meaning of Duchamp's ready-mades.[60] But one of the group's basic theses is the reduction of artistic creation to propositional logic: 'Artwork is a propositional factor rather than a non-propositional entity', that is, one can make the proposition '. . . is an artwork' about anything and the object of that proposition 'does not require . . . the characteristics of art-ness'.[61] It is clear that such sentences could not have been written were it not for the existence of Duchamp's ready-mades.

But here is precisely where the misunderstanding begins. Kosuth dates the origin of conceptual art 'with the first unassisted ready-made',[62] but in fact *all* Duchamp's ready-mades are in some way 'assisted' — the object is always modified in some way by the artist's intervention and thus its original significance is in some special way shifted or cancelled out: the object is placed illogically, or is incomplete, or it bears an inscription. (There was even an inscription on the original *Sèche-bouteille*.) Of course Duchamp himself encouraged misinterpretation by his statement, for example, that he 'was interested in ideas — not merely in visual products',[63] and even that he considered the material product itself as unnecessary, that it was enough for him to live and breathe. But all these statements come from the time when he had abandoned work on the *Large Glass* and which, in truth, was a long period of creative crisis; and when later he worked secretly on his *Étant donnés*, he used these statements as a deliberate source of mystification. Moreover, it is from that later period of his work that we have the most important and clearly the most open declaration by Duchamp, the short text called *The Creative Act*, first delivered as a lecture in Houston in 1957 and printed many times since then. In this text, Duchamp lays to rest forever the legend that the mere transmission of the artist's ideas may be considered a work of art in itself. He says it clearly and simply at the outset:

An artist acts like a mediumistic being; all his decisions in

the artistic execution of the work rest with pure intuition and cannot be translated into self-analysis, spoken or written, or even thought out.

And what is more important, he defines 'art coefficient', or that evasive 'art-ness' of a work of art, as a 'missing link', that is, 'the difference between what [the artist] intended to realize and did realize.' What he creates is never any more than 'inert matter'. Everything depends on the viewer; he alone can supply the 'missing link', bridge the gap between the material form of the work and its immaterial and thus never expressed meaning.

Here Duchamp is apparently claiming two contradictory things. On the one hand, the material work of art is an absolute necessity for him. It is only through actually creating it that the artist attains that 'mediumistic state' that brings him genuine artistic experience. On the other hand, however, the work of art never contains this experience within itself: it can only be a mute appeal to the viewer to try, through the work, to come to the same experience. It is not surprising that this text of Duchamp's led Terry Atkinson to write a long polemic in *Art-Language* in which Duchamp appears as a hapless man, artistically, intellectually and morally inferior:

Many people believe him to be a great thinker and I believe him to be an iconoclast whose mania for iconoclasm and the individual position robbed him of any penetrative power of judgement he might have had.[64]

And Atkinson goes on to claim that Duchamp's statement on the creative act is mere theological diplomacy such as we (alas!) find in Leibniz.

Atkinson is the victim of his own theorizing and the meaning of Duchamp's text thus escaped him entirely. Art is not and cannot be spun out of theory. An artist does not create because he knows something, because he has ideas he would like to realize, express or communicate. He creates because he does *not* know something, and because he feels this lack of knowledge as a great personal lack, even a misfortune. He is seeking something he knows is escaping his intellect, something in terms of which his intellect is helpless. If he chooses the methods of artistic creation, it is because it is the only way that somehow conforms to what he is after, the only way he can expand his consciousness so that he can possess, reveal, or at least approach his goal. To put himself at the mercy of his work means, for the artist, to put himself at the mercy of experience where the category of mere reason is no longer enough, where he must go further to an area in which he will no longer be guided by logic, but only by inevitability, no longer by deliberation, but only by intuition.

It is in this sense that the artist is like a 'mediumistic being'. His new experience does not derive from reason. But it is not enough to call it irrational. If dreams, love and madness belong to the irrational, then artistic experience is something else. There can be no doubt that it takes place in the clearness of consciousness: thus Duchamp was always against painting being considered some manifestation of instinct and demanded that it be

located in the 'grey matter of the brain', that it be an 'idea'. The particular nature of artistic creation consists in the fact that it does take place in our material world and yet at the same time it somehow escapes it; it speaks to our life here and yet it seems not to be of it. There is always something in it that is incomprehensible, paradoxical, absurd, scandalous. Art theory may not be able to comprehend this, but every artist is more or less aware of it. Thus Duchamp spoke of that 'missing link' between the materiality of a work of art and its artistic significance. In that lies the essence of the creative process, the 'coefficient' that makes art art.

10.

Duchamp's relationship to Surrealism was never unambiguous. Though he took part in surrealistic exhibitions and even designed their installation, he never signed any of the numerous declarations issued by the Surrealist group. For the entire period when they were most active, he consistently maintained an inner distance from them. He never declared his affinity with Rimbaud, but rather with Laforgue, Mallarmé, Roussel and Redon. The surrealist conception of art never inspired Duchamp, and when Surrealism was at its height, he devoted his time to activities that were far removed from surrealist aesthetics: optical experiments, mathematical investigations of roulette, and chess. His kinship to Surrealism was above all a kinship to Breton, but it is significant that he defines his closeness to Breton in terms of the notion of an intelligence 'enlarged, stretched, extended'[65] — whereas Breton himself proclaimed the automatic releasing of subconscious activity. Nor was Duchamp's remark to Breton (in a letter in 1953) that 'my unconscious is *dumb*, just like any unconscious' without its point.[66] It was not until Breton's death that the reticent Duchamp revealed the essence of his relationship to him. As he told Parinaud.

> I have never known a man who had a greater capacity for love. He was the lover of love in a world that believes in prostitution.[67]

This, by the way, is an argument supremely significant for Duchamp, who always protected himself with a mask of intellectual irony, a man for whom life and art were supposed to be merely a 'distraction'.

Whenever Duchamp was required to characterize his art, he did so in different terms than the surrealists used of themselves. In 1963, William Seitz asked him what adjective he would use to describe his work. It is not political, he said; does it then have an aesthetic or philosophical significance? 'No, no,' replied Duchamp without hesitation, 'Metaphysical, if any'.[68] The word 'metaphysical' does not belong in Breton's vocabulary. Breton was a self-possessed and genuine materialist in the sense that, for him, the aim of art was to capture the fullness of life on earth such that it would embrace even that deep level of life that he called 'the miraculous' and later, 'love'. He was against rationalism because rationalism was capable of giving only an incomplete picture, a mere schema of reality. The life forces that bore reality

had to be sought elsewhere, beneath that superficial rationality. He wanted art to transform life, he wanted human life and human society to be organized to give those life forces every possible freedom. But did Duchamp want to transform life? Rather than wanting to make his art an agent for changing the world, it would be truer to say that he concealed it. He turned to art in solitude, in silence, so that with its help he could clarify, understand and know his own life. It was obvious to him that in this society, a product of European civilization, art cannot continue, but rather than protest he chose to maintain a consistent distance from it. He was a Dadaist among Surrealists, but his was not the stormy Dada of Hausmann or Tzara, it was not 'nihilism', as his work was later described,[69] but rather a 'metaphysical attitude'.[70] He was an ascetic, not a revolutionary. In his last statement of principles, made in 1961,[71] he made his position clear: 'The great artist of tomorrow will go underground,' he said.

Theories of art wander aimlessly in and out of insoluble contradictions because they continue to consider art merely as a way of representing the world or human experience. But art does not represent or describe. It is neither a report on the world nor a statement about it. It asserts nothing; it passes no judgement. It does not present us with some truth, it gives us no advice. It is not a way of knowing nor a means of enlightenment. It points in a direction opposite to logic and ethics: not to the world but away from it. In modern art, the experience of emptiness, silence, amorphism, nothingness, *acosmia*, continually recurs — in Mallarmé, Cage, Malevich, Picabia, Rilke. This experience probably has it own hieroglyph in the allegorical language of Duchamp's *Large Glass* as well. It is very likely that most mysterious part of the work, the amorphous cloud — which, by the way, is prefigured several times in earlier works. Three openings in it, the Draft Pistons, lead into emptiness. They are emblems of accident through which, into our completed and ordered world, the wind from outside blows — from the region of the unworldly, from eternity.

Recently, the idea of *acosmia* has been reappearing more and more urgently:

> No texture . . . No forms. No design. No colours. No light. No space. No time. No size or scale. No movement. No object, no subject, no matter. No symbols, images, visions or readymades. Neither pleasure nor pain. (Ad Reinhardt)[72]

Art returns man from the world to the primal act of consciousness, before the world that is given, before existence that is imposed on him, before entities, and before being himself. It returns that imperishable moment when human consciousness approaches the world from unworldliness, being from un-being. Art is 'fascination', as Blanchot says; through it, the world is revealed to us in the glare of consciousness. It is primal consciousness; it is at the same time a primal prayer.

11.

Various aesthetic systems point on the one hand to the rationality and logic of a work of art, and on the other hand to its irrationality and alogic; to its deliberately structured form on the one hand, and to its amorphousness on the other. They all reduce the work of art to its materiality. But a work of art is a symbolic work. It never contains its object, never depicts it, never signifies it: it points to it. Returning to the origin of consciousness, it leads us to the world as it is, to the world that comes into being, endures, and ceases to exist, that is chaos and order, accident and necessity, Mallarmé's *A Cast of Dice* and *Constellation*. It is both; not in a dialectic suspension of discursive reason, but in primal unity where distinctions first begin. Therefore the basic method in art is universal metonymy (and its derivative, metaphor). We might also say: endless melody. The miracle of the world and the miracle of consciousness come together. In this sense (and in this sense only) the origins of mind are the origins of the world.

The structures of art correspond to the structures of the established world, but through the interstices of these structures, or in their dissolution, shines the primal nature of the world. For this reason amorphousness, unstructuredness, unclearness, indistinguishability are so important in a work of art. Thus a work of art is always to some extent 'blurred', as Ehrenzweig has said. The language of art always contains silence; at the centre of a work of art there is always an obscure place that cannot be interpreted in any way if the work is not to lose its essential meaning. In the article 'What is Poetry' already quoted from, Roman Jakobson explains the parallel between Mácha's love poetry and the intimate passages in his diary as a double semantic plan of the same subject. But as in other cases the meaning of a poetic text lies in the interstices within it, may not the meaning here lie as well in the space between these two texts by Mácha, in the painful tension that in a sense cancels out the meaning of both the poetry and the diary? Do they not both exist so that together they may more closely embrace that obscure place from which they both arose and to which they both return, without being able to include it directly in themselves? Duchamp himself, by the way, as Katharine Kuh tells us,[73] originally wanted to create his *Mariée mise à nu* on something like a double semantic plan — or rather in two media: along with the *Large Glass* there was to have existed a verbal pendant that was to be 'quite as important as the visual material' and for which the notes he later collected in *La boîte verte* were only a kind of rough draft.

A particularly important parallel to Mácha's double texts, however, may be found in the symbol of the Bride and the Milky Way in the *Large Glass*. Willis Domingo[74] has correctly pointed to the key importance of the brief symbolist phase (1910–11) in Duchamp's work. Here, cloud-like formations similar to the Milky Way appear. These formations surround the hieratic female figures in the pictures *Le buisson* (1910–11) and *Le baptême* (1911), and they even recur in a late etching of *La mariée mise à nu . . .* from 1968. In the *Large Glass*, when the Bride became a mere mechanical-chemical apparatus, this vague form was separated from her, Duchamp now called it the Milky Way (or also Top Inscription) — but the only 'inscription' that the Milky Way bears are those three Draft Pistons, symbols of the breeze that wafts into our world from *elsewhere*. And that, in the end, is the real 'command' of the bride.

Art, to be at the beginning, must be as well *before* the beginning, where the world is not yet, and consciousness is still empty and void. This is true even for philosophy. The great works of philosophy can never be reduced to a system. They are disturbing because a dark place persists at their centre that seems to be the unique source of everything else in them and at the same time, continually seems to undermine them. Philosophy is not science. It is not a doctrine that explains, but rather it points beyond all explaining.

A computer cannot create a work of art, but merely a feeble imitation. A computer is always and only in the world.

Art is an indication away from the world and, at the same time, an indication into the world. Therefore there is always a tension in every work of art between form and formlessness, between *acosmia* and structuredness. This tension is not symmetrical. Speaking and silence do not form a binary system. They are asymmetrical, paradoxical. The disparity between them is absolute: the decisive link is missing and this gap is in fact the 'art coefficient' that points beyond the work and leaves it to the viewer, the reader or the listener to find the courage to go in the direction it suggests. If this gap disappears, the art-ness of the work disappears with it. There remains only a 'skeleton' in 'the graveyard of history', to use Jakobson's words — the skeleton of a form whose transcendental meaning we are no longer capable of reading, or the skeleton of an idea that no longer suggests anything to us. In other words, art cannot be considered to be contained either in a mere material work or in a mere immaterial idea. Both decorativism and conceptualism are nothing more than two sides of the same coin: they are aestheticism; that is, the cult of art that has lost its paradoxical nature and along with it, its mission.

Anton Ehrenzweig, who has dealt as no one else has with the relationship between the formless, 'oceanic' depth and breadth of artistic experience and the closed form of the work of art itself, made some very interesting remarks on Duchamp's *Large Glass* in his book *The Hidden Order of Art*. This work, he said, is not artistically independent: the viewer requires the accompanying texts in *The Green Box*.

The spectator should work his way through the artist's private reasoning . . . A new kind of cooperation between the artist and his public may spring up, which paradoxically rests on a diminution of the art's ambiguity and indeterminacy.

However intangible and abstract [Duchamp's concepts] were in the beginning, they became completely realized objects to him with little surrealistic and irrational qualities.[75]

It is a comment that Ehrenzweig repeated when talking about the second part of Goethe's *Faust*:

He rationalized his instinctive disregard for superficial logic as a conscious principle of poetic composition.[76]

Here is perhaps the answer to a question that is usually brushed aside: why did Duchamp leave this work, which he considered his chef-d'oeuvre, unfinished? Duchamp's own explanations are thin and inconclusive. But the reason seems clear. Duchamp found himself in a blind alley. He referred to his *Large Glass* as an 'allegory', an attempt to create a language that would have a rational meaning. And in fact, Breton and his followers were able to offer an interpretation of the *Large Glass*, as if it had been written in some hieroglyphics that could be entirely translated into language comprehensible to us. In a later conversation with Arturo Schwarz, Duchamp indirectly admitted the error of allegorization:

> You cannot express anything through words . . . Love does not express itself through words. It is just love . . . You will distrust completely the original message, whatever you say about it.

The approach he chose was wrong. For almost twenty-five years Duchamp devoted himself instead to roulette, chess, acting as an agent for his friends and organizing exhibitions for them; he referred to himself only as an 'anti-artist' and an 'engineer'. He almost ceased to believe in art. He felt closest to the surrealists but, as he said in his conversation with Parinaud in 1966, he saw in their art, nostalgically, merely 'the most beautiful, youthful dream'—his own lost dream. Anaïs Nin, in her *Diary*, wrote in August 1935 that Duchamp

> looks like a man who died long ago. He plays chess instead of painting because that is the nearest to complete immobility, the most natural pose to a man who died. His skin seems made of parchment and his eyes of glass.[78]

The same year, 1935, Duchamp began to put together his *Boîte-en-valise*; it was like a final restrospective.

It was not until 1946 that Duchamp began working on a new and definitive version of *La mariée*, work that would continue for another twenty years. His title for it was taken from the first words of his plan from 1912: *Etant donnés*: 1° *La chute d'eau*, 2° *Le gaz d'éclairage*.

There is a fundamental difference between the two versions. It could be said that Duchamp proved the truth of Ehrenzweig's comments (Ehrenzweig did not live to see this final *Mariée*). In the first place, the allegorical nature of the first version disappears entirely. Just as the first could be deciphered like a puzzle, the second cannot, in fact, be interpreted at all.

> The essential difference . . . lies in the fact that the Bride is presented in the former as appearance to be deciphered, while in the latter she is a presence offered to our contemplation

is how Octavio Paz puts it.[79] And just as there is nothing in its content to be revealed, there is nothing in its form to be analysed. It is a purely naturalistic presentation which is in itself meaningless; the artistic form of the work is lacking and its naturalism is in fact amorphism. When, in a conversation in 1963, Duchamp spoke of his ready-mades, he was probably thinking more of this

particular piece in progress: it is not, he said, 'the act of an artist, but of a non-artist, an artisan if you will.'[80] Technically, *Etant donnés* is a very difficult and elaborate work, but at the same time, what is visible in it is meaningless: the whole sense of the work is relegated to the realm of the invisible.

I have never had the good fortune to see the original *Etant donnés* and I probably never shall have. Nevertheless, it seems that Paz has penetrated its meaning more profoundly than anyone else:

> The silence is absolute. All is real and verges on banality; all is unreal and verges—on what?[81]

On a sacred silence: it urges one on to prayer.

> The sacred place *is* the goddess . . . The forces of Nature are concentrated in the divine presence, and this presence in its turn is diffused throughout the physical surroundings. Imperceptibly the sacred place moves from being merely a magnetic and generally secluded spot where ceremonies are held, to being the centre of the world. It then becomes detached from earthly space and is transported into an ideal place: Eden, Paradise.[82]

Some of my friends, who are very erudite in matters of art and who have seen the work, talked to me about it as though it were something nonsensical. What confused them was probably their very erudition. For this work manages to escape entirely from the context of art; even in the middle of modern art, which has so many aspects and facets, it remains entirely unique and alone. It has turned so far away from our civilization that it has turned away even from what that civilization calls art, or even anti-art.

12.

Ad Reinhardt was right when he wrote that 'Every revolution in art turns over Art from Art-as-something-else into Art-as-only-itself.'[83] The ultimate function of art is to remind us, within our world, of what the world is not, and to do this it must be 'Art-only-as-itself'. But for that very reason it is just as true that every artistic revolution returns art to our world in a new way, makes it a part of that world. Art is always, at the same time, 'Art-as-something-else'.

The origin of a work of art can never be anywhere else but in the world, inside human life, and it is the same with its meaning. The reason for its origin lies in an oppressive darkness and modern artists have shown again and again how the way from this darkness leads to the experience of emptiness, non-being, nothingness. But the work of art is born precisely from that experience. It is a new world, created with its own laws. Words themselves create the poem, forms themselves create the picture; the artist should only obey their inner tendencies and logic. Yet this autonomous order and this new creation are not limited to the autonomy and the newness of the work of art. If the origin of a work of art is in the darkness and the strangeness of the world, its meaning lies in the discovery of the world in its brightness

and nearness. The autonomy and newness of a work of art are themselves the symbol of this very world.

At the beginning of this study Edmund Leach is quoted as saying that present theories of anthropology, though they provide 'fairly comprehensive models' by which the internal and external organization of any society may be explained, prove inadequate in the study of concrete societies. The same holds true for present-day theories of art. We have a whole series of 'fairly comprehensive models' to choose from, some derived from psychoanalysis, some from propositional logic, some from linguistics, some from information theory or other disciplines that happen to be in vogue at the time. But such models always lack what makes art art: its specific nature, its aestheticity, its human significance.

The reason for this lack may be found in false generalization. These theories treat artistic knowledge as though it were scientific knowledge and therefore they subject it to scientific interpretations. Art, however, is an incomprehensible and irregular exception in our scientific world. Even the artist himself seems to defy adequate explanation. Marcel Duchamp was sometimes considered a clown, sometimes a magician, sometimes an alchemist, sometimes a linguist. Yet he never allowed himself to be pigeonholed. He was an artist.

Modern science deals with the world objectively and each human life, in its individuality and variety, is treated by science as a mere statistic. But the real essence of human life is its unique and unrepeatable subjectivity. Nor does art begin with lectures in art history, nor with experiments in the laboratories of aesthetic institutes. It begins in the subjectivity of a simple human life, in its individuality and privacy. It should also attain a generality, but of a different kind than the generalities of scientific theorems.

Modern society has given a kind of legal sanction to the notion that everything in the world is objective. The world, in its generality, is seen as a closed whole, governed by unalterable laws. It is a world that is thoroughly predetermined and forever finished. There is no place in it for what can only be called artistic creation, for the radical initiative of the work of art, for its genesis *ex nihilo*, for its unworldly dimension. The initiating quality of art in this world is *a priori* impossible, unthinkable, 'mere mysticism', as the technical term has it. For the generality of art is the generality of subjectivity: the generality of a world that is not self-sufficient because it is continually open to that otherness which is not the world.

Art, in so far as it cannot be reduced to something that belongs to the closed world of objectivity, appears in the modern world as something illegal. Whereas art has been a natural part of all other civilizations, in our age the artist is presented with the problem of defending himself before his own society and finding a place for his art in it and, moreover, if he is successful, he has to confront the further problem of guarding against deformations of its meaning that would convert its subjectivity into a new kind of objectivity.

The complex strategy with which Duchamp presented his work during his lifetime had no other purpose than to protect it from this false kind of publicity, to keep it from being transferred into the world of objectivity. In my article on Duchamp in *Opus International*,[84] I drew attention to the fact that Duchamp hesitated to exhibit his work, and if he showed it all, then in the most inconspicuous way possible and usually a long time after doing it. His first ready-made, *Roue de bicyclette*, was not exhibited until forty-one years after he first put it together. His first one-man show was held in Chicago the year he turned fifty: only nine works were exhibited and Duchamp himself did not attend the opening. When he had his first retrospective in his native land at the age of eighty, he held it initially outside the main art centre, in Rouen, the quiet town of his youth. In the end, he exhibited his *Etant donnés* so that it could only be looked at through peepholes in a firmly closed wooden gate by one person at a time, thus making an encounter with the work a private affair for each viewer. And at the opening exhibition in Peggy Guggenheim's gallery in New York during the war, reproductions of Duchamp's works could only be looked at through a peephole in the wall.[84a] His installation of the Surrealist exhibition in New York in 1942 was symbolic of Duchamp's attitude: instead of offering the works to the public for observation, he created a network of strings criss-crossing the room so that it was impossible or difficult to get near the exhibits.

On the other hand, from 1935 on, Duchamp carefully and painstakingly prepared his quite unusual monograph *Boîte-en-valise*. It is a collection of sixty-eight reproductions of his work packed in an attaché case. *Boîte-en-valise* cannot be exhibited either; the viewer himself must go through the collection, and thus the works that originated in the artist's privacy once more return to the privacy of the viewer.

Duchamp correctly surmised that there must be another road for art to take in modern society, a road different from the one created for it by the bourgeoisie of the nineteenth century with its salons, its museums and its commercial galleries. *Boîte-en-valise* was an attempt to create that approach.

13.

The rationalism of the nineteenth century made 'book learning' the only legitimate form of knowledge. Theories that continually convert artistic experience into conceptual structures are merely continuing in this tradition. The same could be said as well of the kind of journalism that tries to reduce art to forms that fit into a few general trends with names that are easy to remember and understand. But the popularization of modern art has produced results that could scarcely have been foreseen. Art is treated as a sensation: it is placed against the background of a rational conception of the world and points to it as a kind of irregularity. But this simply reinforces the suspicion that modern art, by virtue of its very exceptionality, embodies some important truth.

At the same time there has been an important change in the

structure of journalism itself. It was originally a form of literature: in the 'post-Gutenberg' age, with the rapid proliferation of illustrated magazines and books, film and television, journalism has had to adapt itself to these non-verbal forms of mass media. In the nineteenth century, a work of poetry or art was 'explained', its 'content' was verbally interpreted. Modern art began to arouse disfavour precisely because it could not be 'explained' in these terms, because it lacked 'meaning'. Lévi-Strauss still complains about this. But the new media techniques now give priority to immediate and largely visual presentation over verbal interpretation.

For modern art this is a revolutionary process. Its chief means of reaching the public is no longer the exhibition, nor even verbal descriptions, but rather very faithful reproductions. Moreover, looking at reproductions is not a public, social event, but rather the viewer's private affair. The work of art is not to be admired, but contemplated. This is the way in which Duchamp set out: he cared little for exhibiting his works and instead concerned himself with putting together his unusual publication, the *Boîte-en-valise*. René Berger, who devoted much attention to this penetration of modern art into the new forms of mass media in his book *Art et communication*, is right to draw attention especially to Duchamp:

> Can there be anything odder than the case of Marcel Duchamp, an artist so secret, known by only a few admirers mostly as fervent as they were reserved, whose very rare works have suddenly been published in the weekly series *Masterpieces of Painting* in Italian, French, and English, a publication which overnight is to be found at newsagents or in kiosks (at 5 francs) between *Playboy*, the Bible in instalments, and super-king-size cigarettes.[85]

In his collection of essays *Le livre à venir* (1959), Maurice Blanchot has a very beautiful passage about the 'small noise' that art makes in our deafening age:

> Nothing serious, nothing loud, scarcely a murmur that adds nothing to the great tumult of the cities that we believe we suffer from.[86]

Only a few decades ago it might have seemed that modern art would remain the affair of an insignificant group of outcasts from modern society, a ridiculous eccentricity. But the small noise of art, this muted 'murmur', is unceasing, Blanchot adds, and whoever hears it once will never stop hearing it. Today, the modern artist has become a mythical figure. His exceptional standing has been unconsciously accorded a redemptive significance.

'He suffered much for us,' Baudelaire wrote of Poe (and of himself).

It is very likely that in its enormous activity, our civilization is on the brink of a catastrophe. It is difficult to believe that it might yet be saved by some revision: there is a grave flaw in its very foundations. The rejection of art from its structure is an especially marked symptom of this.

Civilizations never die out completely. Through their crises, they discover within themselves a hidden potential to be re-born. It is highly likely that the new potentialities of our civilization are outlined precisely beneath the forms of modern art. Art is not on the fringe of its time; it is rather hidden at the very secret centre of its vitality.

The tragedy of the old civilizations lies in the fact that in trying to fend off their own death, they reject as well that which could save them. By amplifying the scarcely perceivable voice of art in the pandemonium of our world, our civilization falsifies it, tries to make it conform to the world's principles. It seems as if, in a panic, we have succumbed to an erroneous *manie de l'interprétation*. The fate of Marcel Duchamp's work is an outstanding example of this. While our world needs more than anything else to return to that life-giving subjectivity from which and for which a work of art is born, that very subjectivity is taken away from this work. If it cannot be ignored or ridiculed, then it is explained in terms of something other than art.

Marcel Duchamp's life and work have a single meaning. Like Baudelaire and Mallarmé, like Satie, like Chlebnikov, like Joyce, Duchamp, in this difficult time, sacrificed everything that he was to the hard task that was laid before him: he remained *nothing but an artist*. Perhaps in our time it is the most urgent task of all.

1. Conversation with Richard Hamilton on the BBC. Quoted by A. d'Harnoncourt and W. Hopps, *Etant donnés . . .*, Philadelphia Museum of Art, 1969, p. 40.
2. Edmund Leach, *Lévi-Strauss*, 1970, p. 19.
3. Lawrence Alloway, 'Network: The Art World Described as a System', *Artforum*, September 1972, pp. 28–32.
4. Grégoire Müller, *The New Avant-garde*, 1972, p. 14.
5. Jack Burnham, *The Structure of Art*, rev. ed., 1973, p. 14.
6. *Ibid.*, p. 164.
7. Ursula Meyer, 'The Eruption of Anti-Art', *Art Idea*, ed. Gregory Battcock, 1973, p. 118.
8. Gabrielle Buffet, *Aires abstraits*, 1957, p. 157 sequ.
9. *Ibid.*, p. 30.
10. Christa Baumgarth, *Geschichte des Futurismus*, 1966, p. 77.
11. Richard Weiner, 'Návštevou a nového Františka Kupky', *Samostatnost*, 8 August 1912.
12. *Kupka avant 1914*, catalogue of the exhibition in the Galerie Karl Flinker, Paris, 1966.
13. Michel Sanouillet, ed., *Marchand du sel, écrits de Marcel Duchamp*, 1958, p. 110.
14. 'Apropos of myself', 1964, quoted in *Marcel Duchamp*, catalogue of the exhibition in The Museum of Modern Art in New York and Philadelphia Museum of Art, 1973, p. 258. Further cited as *Marcel Duchamp*, catalogue 1973.
15. Arturo Schwarz, *New York Dada*, 1974, p. 185.
16. *Frantisek Kupka* 1871–1957, catalogue of the exhibition in the Národni Galerie in Prague, 1968.
17. *Du cubisme à l'art abstrait*, ed. by Pierre Francastel, 1957, p. 129.
18. Jindřich Chalupecký, 'Les symboles chez Marcel Duchamp', *Opus International*, 49, 1974, p. 41–48.
19. Marcelin Pleynet, 'Le fétiche Duchamp', *Art Press*, 1, 1973, p. 6.
20. Marcel Duchamp, *A l'infinitif*, 1966, p. 5.
21. *Art News*, 1963. Quoted by Richard Kostelanetz in 'John Cage', p. XVII.

21a. Octavio Paz, ' * Water writes always in * plural', *Apariencia desnuda*, 1973; quoted from the English translation in *Marcel Duchamp*, catalogue 1973, p. 150.
22. Paul Ricoeur, *Le conflit des interprétations*, 1969, p. 63.
23. Arturo Schwarz, '*L'alchimiste mis à nu chez le célibataire, même*', *Data*, 3 September. 1973, pp. 30–37.
24. C. G. Jung, *Psychologie und Religion*, 1942, p. 48.
25. Karl Jaspers, *Philosophie*, III, 1932, p. 146 n.
26. Stéphane Mallarmé, *Magic*, 1893; *Oeuvres complètes*, Pléiade, 1945, p. 400.
26a. Wallace Fowlie, *Mallarmé*, 1953, p. 188.
27. Sanouillet, *op. cit.*, p. 113.
28. *Ibid.*, p. 173.
29. Michel Sanouillet, 'Marcel Duchamp and the French Intellectual Tradition', in *Marcel Duchamp*, catalogue 1973, p. 52.
30. François Caradec, *Vie de Raymond Roussel*, 1972, p. 64.
31. Velemir Chlebnikov, *Sobranie Proizvednij*, V, 1933, p. 269.
32. Quoted in Henri Mondor, *Vie de Mallarmé*, 1941, p. 257.
33. Quoted in *Marcel Duchamp*, catalogue 1973, p. 276.
34. Sanouillet, *Marchand*, p. 167.
35. Pierre Cabanne, *Entretiens avec Marcel Duchamp*, 1967, p. 14.
36. Jack Burnham, 'Unveiling the Consort II', *Artforum*, 9 August, 1971, p. 59.
37. Jack Burnham, '*Marcel Duchamp, la signification de Grand Verre*', *VH 101*, 6, 1971, p. 65.
38. Jack Burnham, *The Structure of Art*, 1971, p. 162.
39. Quoted by Patrick Waldberg in '*L'Unique et ses propriétés*', *Critique*, 194, 1959, p. 865. Also by Arturo Schwarz in *Marcel Duchamp*, catalogue 1973, p. 81.
40. Roman Jakobson, '*Co je poesie*', *Volné směry*, 30 July 1934, pp. 229–39.
41. Karel Hynek Mácha, 'Máj' (May), lines 5–10. Unpublished translation by W. E. Harkins.
41a. Because of censorship, Jakobson quoted only some relatively harmless fragments from the diary. The passage quoted here is typical. The unexpurgated text of Mácha's diary has not yet been published.
42. Claude Lévi-Strauss, *La pensée sauvage*, 1962, p. 290.
43. Georges Charbonnier, *Entretiens avec Lévi-Strauss*, 1961, p. 115.
44. Ibid., p. 94; also in Lévi-Strauss, *Le cru et le cuit*, 1964, p. 29.
45. *Le cru et le cuit*, p. 31.
46. Charbonnier, *op. cit.*, p. 114.
47. *Le cru et le cuit*, p. 18.
48. Claude Lévi-Strauss: *L'homme nu*, 1971, p. 614.
49. *La pensée sauvage*, p. 206.
50. *L'homme nu*, p. 582.
51. *Le cru et le cuit*, p. 26.
52. *Ibid.*, p. 24.
53. *L'homme nu*, p. 579.
54. Jean Piaget, *Le structuralisme*, 1968, p. 7.
55. Burnham, *The Structure of Art*, p. 3.
56. Joseph Kosuth, 'Art After Philosophy I', *Studio International*, 915, 1969, p. 135.
56a. Victor Burgin, 'Situational Aesthetics', *ibid.*
57. Ian Burn and Mel Ramsden, 'Stating and Nominating', *VH*, 101, 5, 1971.
58. Victor Burgin, *Architectural Design*, August, 1970, quoted by Terry Smith, 'Art and Art and Language', *Artforum*, 12 June 1974, p. 50.
59. *Art-Language*, 1, 1969, p. 1.
60. Unsigned commentary (Atkinson's?) on an article by Lynda Morris in *Art Press*, 10, 1974, p. 19.
61. Burn and Ramsden, *loc. cit.*
62. Kosuth, *op. cit.*, p. 35.
63. Recorded by J. J. Sweeney, Sanouillet, *Marchand*, p. 109.
64. Terry Atkinson, *Art-Language*, 2, 1970, p. 59.
65. Cabanne, *op. cit.*, p. 19.
66. Sanouillet, *Marchand*, p. 163.
67. *Art-Loisirs*, 54, 1966. Quoted by Robert Lebel in 'Marcel Duchamp and André Breton' in *Marcel Duchamp*, catalogue 1973, p. 140.
68. *Vogue*, 141, New York, 1963. Quoted by Kynaston McShine, *ibid.*, p. 134.
69. Katharine Kuh, *The Artist's Voice*, 1962, p. 89.
70. Duchamp said this to Sweeney. Sanouillet, *Marchand*, p. 114.
71. 'Where Do We Go From Here', manuscript, 1961.
72. Ad Reinhardt, 'Twelve Rules for a New Academy', in *The New Art*, ed. Gregory Battcock, 1966, p. 200.
73. Katharine Kuh, *op. cit.*, pp. 81, 83.
74. Willis Domingo, 'Meaning in the Art of Duchamp I', *Artforum* 10 April, 1971, p. 74.
75. Anton Ehrenzweig, *The Hidden Order of Art*, 1969, pp. 97, 99.
76. *Ibid.*, p. 203.
77. Arturo Schwarz, 'The Complete Works of Marcel Duchamp', 2nd ed., 1970, p. 195.
78. Anaïs Nin, *Diary*, II, 1967, p. 56.
79. Paz, *op. cit.*, p. 157.
80. Quoted by Richard Kostelanetz, *loc. cit.*
81. Paz, *op. cit.*, p. 145.
82. *Ibid.*, p. 156.
83. Reinhardt, *op. cit.*, p. 203.
84. See note 18.
84a. Dore Ashton, *The New York School*, 1973, p. 121.
85. René Berger, *Art et communication*, 1972, p. 116.
86. Maurice Blanchot, *Le livre à venir*, 1959, p. 265.

Marcel Duchamp
Nude Descending a Staircase No. 2 1912
Louise and Walter Arensberg Collection,
Philadelphia Museum of Art

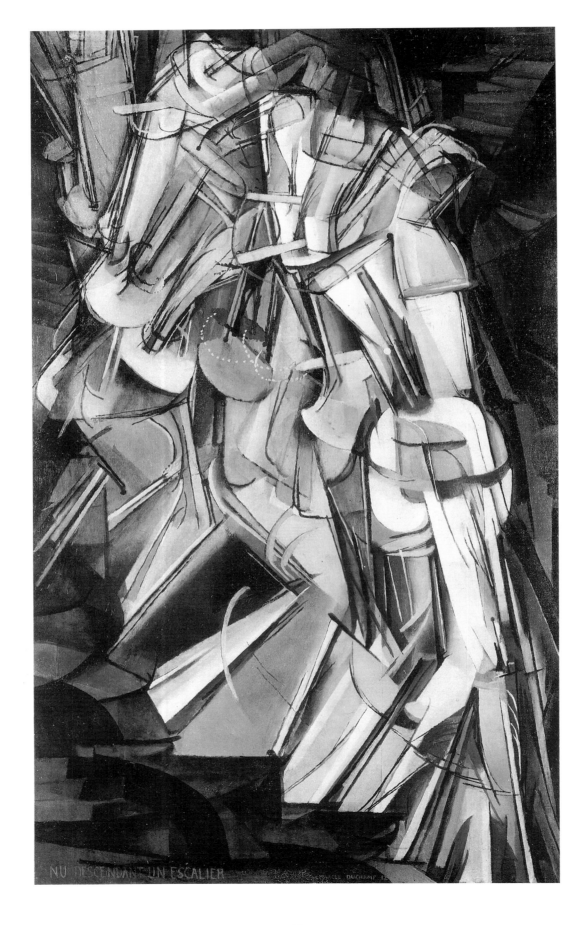

Margit Rowell

Kupka, Duchamp and Marey

From Duchamp issue of *Studio International*, January–February 1975

When Marcel Duchamp had his first direct experience of futurist painting, he was twenty-five years old and fresh from the completion of the final version of *Nude Descending a Staircase*. His own ideas about the representation of movement in painting were already highly developed by February 1912, the date of the first futurist exhibition in Paris, and they are reflected in the way he chose to see the work of the Italians:

> The futurists also were interested in movement at that time and when they exhibited for the first time in Paris in January (*sic*) 1912, it was quite exciting for me to see the painting *Dog on a Leash* by Balla, showing also the successive static positions of the dog's legs and leash.[1]

Although he was surely cognizant of futurist ideas, both from Severini who lived in Paris from 1906 and from the first futurist manifesto published in Paris in 1909, Duchamp's description of Balla's painting indicates an entirely different and in fact opposed conception of the subject of motion, based on analytical discontinuity rather than the synthetic continuity to which the futurists aspired. This concept developed in relation to sources within Duchamp's Parisian context, particularly the work of François Kupka, and implies an attitude to the relationship of matter to space and time that is incompatible with the futurist experience.

Duchamp's sole explanation is the following:

> This final version of the *Nude Descending a Staircase* . . . was the convergence in my mind of various interests, among them the cinema, still in its infancy, and the separation of static positions in the photochronographs of Marey in France, Eakins and Muybridge in America.[2]

Duchamp's knowledge of Marey and Muybridge was no accident. These were interests that François Kupka and Raymond Duchamp-Villon shared, and which they applied to their art as early as 1908–09. The Kupka/Duchamp-Villon family friendship dated from at least 1900, the year Kupka moved in next to Jacques Villon on the rue de Caulaincourt in Montmartre. Kupka followed Villon to 7 rue Lemaître in Puteaux in 1906 where they were joined in 1907 by Raymond Duchamp-Villon. In this small community of men, Kupka seems to have played a crucial role. He had arrived in Paris from Vienna in 1896 at the age of twenty-four. Shortly after, he discovered the first cinema or 'moving picture' in the form of the 'praxinoscope' perfected by Emile Reynaud.[3] This rather primitive apparatus consisted of two nested cylinders: the outer one was lined with panels on its inner face, each one depicting a different and consecutive phase of a figure in motion; the centre drum was sheathed with mirrors. As the outer cylinder revolved around the stationary inner drum, the mirrors registered the turning images, reconstituting them into one consecutive movement.

Already by c.1900–02, Kupka had executed a drawing inspired by his experience of the 'praxinoscope'.[4] In this drawing, *The Horsemen*, the representation of movement is primitive. The vertical seams which scan the drawing's surface reproduce the effect of the praxinoscope's juxtaposed mirrors which ripple at

each juncture. Moreover, at the extreme right of the image is a horseman turning toward the rear, indicating that Kupka was inspired by a convex image, or more exactly, an image on a circular drum. He drew *The Horsemen* in his studio on the rue de Caulaincourt. It is here that he met Marcel Duchamp for the first time.[5] The meeting was not particularly memorable, at least from Kupka's point of view; he was close to thirty, and Duchamp was in his teens. However Duchamp's life-long admiration for the older artist probably dates from this time.

The Horsemen is a precocious but isolated experiment with motion in Kupka's career. Although the technique for recording movement seems based essentially on Reynaud's invention, the subject probably has other sources. During the last three decades of the nineteenth century, Eadweard Muybridge and Etienne-Jules Marey had revolutionized the understanding of motion through their photographic studies of a horse's various gaits. The Paris art scene was particularly affected by these experiments.[6] From the mid-1870s on, illustrated books and magazines appeared, lectures and demonstrations were given, and documentation and instruments were displayed at the Paris Musée des Arts et Métiers as early as 1883 and 1887. In view of the impact of these discoveries and their large audience among artists, Kupka could not have remained ignorant of them.

Furthermore, in 1900, Dr Marey organized an exhibit of 'instruments and images relative to the history of chronophotography' at the Paris World's Fair.[7] The stand included the following items: photographs showing the analysis of animal locomotion according to the method of Muybridge; figures in relief obtained by chronophotography; multiple-lens camera developed by Albert Londe; multiplication of images—(1) partial photographs (2) dissociation of images (3) photographs of a band of film in movement; photographs of points and lines on the body of a figure in motion; double action chronophotograph;

François Kupka
The Horsemen 1900–02
Musée National d'Art Moderne, Paris

Etienne-Jules Marey
Jump
Photograph Cinémathèque Française,
Paris

Etienne-Jules Marey
Sword Thrust
Photograph Cinémathèque National,
Paris

chronophotographic projectors; Edison's kinetoscope of 1894; the Lumière brothers' cinematograph.

Kupka exhibited at least one work at the Fair for which he won a gold medal.[8] In keeping with his customary behaviour, he certainly visited the fair-grounds to inspect his own exhibit. His interest in photography and the moving picture surely led him to visit Marey's pavilion. During the early years of the twentieth century, he did little painting. He depended on book and newspaper illustrations for his livelihood. Around 1908, when he resumed painting, the subject of figures in motion reappeared in his work. Simultaneously, an interest in high-speed photography emerged in the work of Raymond Duchamp-Villon, who, until 1898, was a medical student at the Salpétrière, where he was in contact with Dr Albert Londe, Director of the Photographic and Radiographic Division.[9] A physiologist like Marey, Londe developed a multiple-lens camera for taking high-speed photographs of nine or twelve successive poses. Thus Duchamp-Villon encountered the physiological analysis of movement before leaving the medical profession to become a sculptor. His small sculpture *Song* of 1908 shows the artist's first explicit reference to high-speed photography. William Agee has indicated that a series of Muybridge photographs of a 'seated figure slightly turning with arm raised' was the source of inspiration for this sculpture.[10] Agee notes that Duchamp-Villon turned to Muybridge 'to confirm his own observation'. The truth of the matter was that a real understanding of muscular activity depended on these recent developments in photography.

That same year Kupka's interest in movement showed itself again, but in a quite different way. In 1908 Kupka painted his wife's daughter Andrée holding a ball. Frustrated by the realization that he could not depict the ball in rotational movement, he began to do diagrams of the child with the ball. These studies of the gesture of throwing and the elliptical trajectories of the ball in the air, combined with scientific studies of colour as the ball rotated through the spectrum, led to the series of 1911–12, *Newton's Discs*, and finally to the *Fugue for Two Colours* of 1912. However, simultaneously, studies of the child's silhouette

as it turned upon itself established the basis for another series of works of 1909–11 which depict consecutive phases of movement in space and time. These works, less abstract, and therefore less spectacular than the studies leading to the *Fugue*, are close in form and particularly in concept to Marcel Duchamp's paintings of 1911.

Between 1908 and 1911, Kupka worked on two series which explicitly render consecutive phases of movement in space. The first theme, that of a woman picking flowers, culminates in 1909 in a series of large vibrant pastels. Within this group, the earlier studies show a compacted image of stiff, discrete silhouettes shuffling one into another at regular intervals. A pronounced blur of horizontal strokes suggests the trajectory from one position to another. In the final versions, this evenly cadenced pattern of motion is loosened and dissolved into a more ambiguous image. The movements are slower and less discretely defined. What becomes important is a rhythmic articulation of motion fanning out from a central rotating axis contained in the upright central figure.

Kupka's second series, executed between 1909 and 1911, depicts a woman with one arm raised, the other on her hip. Whereas the final oil version *Planes by Colours* appears as a static composition laid out across a flat vertical grid, a study of two preparatory pastels reveals an implicit kinetic dimension. These working studies show the head and arms in several positions simultaneously. And as the upper limbs shift positions, the torso, hips and thighs rotate rhythmically from a three-quarter to a frontal position. The inevitable effect produced by this illusion of movement is a second illusion of virtual volume or a three-dimensional activity in space. Although the painting implies the same motion, it is not immediately legible. Attempting to suppress not only the baroque rhythms and chromatics but the third dimension, Kupka took each fluid silhouette and translated it into a flat rectilinear plane; the arbitrary colours were similarly transformed into an even progression of hues inspired by the spectrum.

Etienne-Jules Marey's chronophotographs are the obvious

47

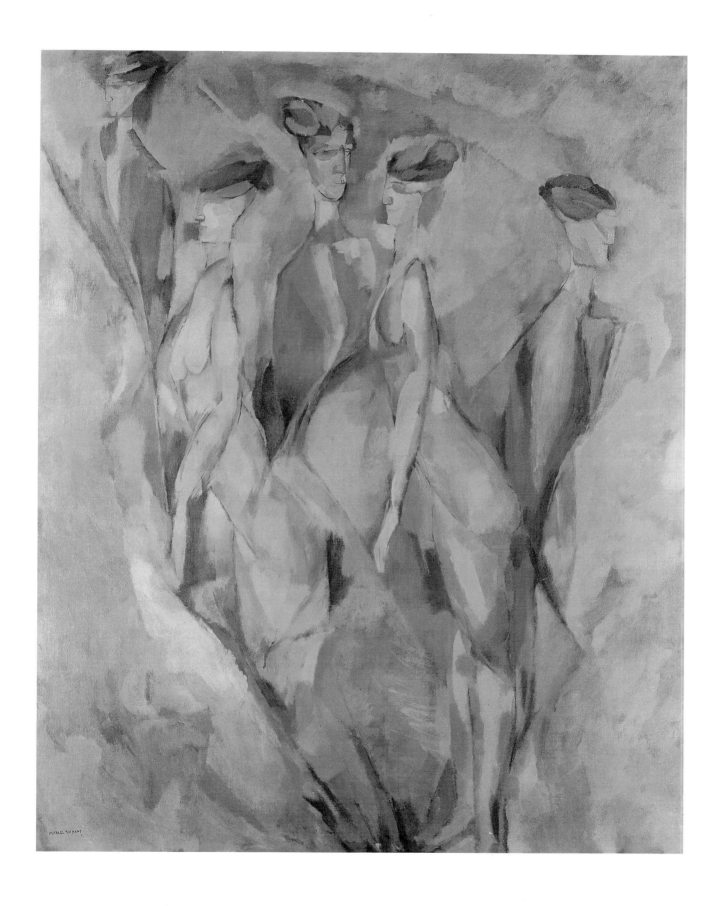

Marcel Duchamp
Nude Descending a Staircase No. 1 1911
Louise and Walter Arensberg Collection,
Philadelphia Museum of Art

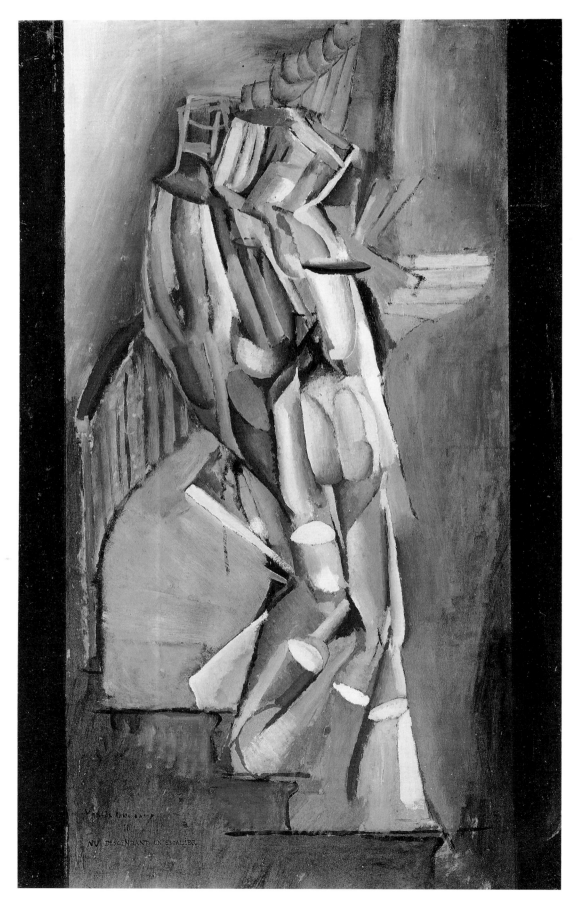

François Kupka
Woman Picking Flowers
(Earlier version) 1909
Musée National d'Art Moderne,
Paris

François Kupka
Woman Picking Flowers
(Later version) 1909–11
Musée National d'Art Moderne,
Paris

inspiration for these works. In contrast to Muybridge's single image studies taken from several points of view, Marey's chrono-photographs, such as *Sword Thrust*, show a compound image of separate but interpenetrating movements, all taken from the same viewpoint. Muybridge moved around his subjects. Marey had is subjects revolve before his retina or lens. As the chrono-photographs show, the trace images between positions assume as much presence and substance as the figure itself, which conversely is dematerialized in its kinetic progression. Thus Marey's invention levelled all aspects of his subject to the status of virtual volumes.

Marey defined the objectives of chronophotography as follows: 'to analyse movements by means of a series of instantaneous photographic images taken at very short and equidistant intervals. In thus representing the successive attitudes and positions of an animal for example, chronophotography allows one to follow all the phases of its gaits and even to translate these into true geometric diagrams . . . By passing a series of analytical images before the spectator's eyes, one reconstitutes the appearance of movement itself.'[11]

Kupka spoke of movement in identical terms:[12] 'Movement is no more than a series of different positions in space . . . If we capture these positions rhythmically, they may become a kind of dance.' The underlying idea found consistently in Kupka's works of this period and in his writings is a definition of movement as a pattern of consecutive points in space, or moments in time. The concept of discontinuity emphasized by Marey is inherent to Kupka's interpretation. Duchamp's understanding of Balla's painting, which he describes in terms of 'successive static positions', evolves from an identical interpretation. No painting illustrates this more explicitly than the artist's *Dulcinea* of 1911. This 'portrait' depicts five separate positions in space and moments in time of the same woman. Rather than overlapping them, as Kupka had done, Duchamp isolated each position along an arabesque-like path, meandering from left to right to left again. Visibly this is a sequential arrangement of static images.

Somewhat later the same year, Duchamp painted the *Chess Players* in which for the first time he used a system of multiplied contours. However, the impression of motion is minimal. It was not until December 1911, with the *Sad Young Man in a Train* and *Nude Descending a Staircase*, *No. 1*, that Duchamp introduced overlapping silhouettes to project a kinetic dimension. Duchamp's analysis of motion is more linear than Kupka's; his figures proceed through space from one point to another, albeit along a serpentine path. Kupka's studies tend to rotate around a fixed central axis. The two orientations are not contradictory; Marey investigated both types of mobility.[13] Finally in January 1912, Duchamp arrived at his final version of the *Nude Descending a Staircase*. After noting that he was interested in 'the separation of static positions in the photochronographs of Marey . . . Eakins and Muybridge', Duchamp continued in his

notes: 'I discarded completely the naturalistic appearance of a nude, keeping only the abstract lines of some twenty different static positions in the successive action of descending.'[14]

The important pictures for both Kupka and Duchamp were executed prior to the futurist exhibition at Bernheim-Jeune. They are fully developed in their conception. Although the initial impetus may have been encouraged by futurist ideas which were in the air, the concept of motion was totally different. The futurists looked toward movement to transcend the object. More ideologically inclined, they spoke of it in terms of a 'fourth dimension', which one cannot see, but which exists: the intuition, the sensation, the atmosphere and essence of movement. Probably influenced by Bergson,[15] their concept of movement denied space and time in an attempt to express the vital continuum. They openly denied any interest in Marey, a denial which is unconvincing. However, the following quote from Bergson expresses their attitude, an attitude which is antithetical to Marey's: 'Consider a movement in space . . . Along the whole of this movement we may imagine possible stoppages . . . but with these positions, even with an infinite number of them, we shall never make movement.'[16] At least Kupka seemed aware of both alternatives. On a small drawing[17] of 1909 he wrote: 'Three-dimensional movement is performed in space, whereas four-dimensional movement is produced through exchanges between atoms. In order to set down a gesture a movement on the space of a canvas . . . set down several consecutive move-

François Kupka
Fugue for Two Colours 1912
Musée National d'Art Moderne,
Paris

ments.' The 'exchanges between atoms' may refer to a passage from *Matière et mémoire*: 'Imagine the universe composed simply of atoms; in every one of them there will be felt . . . to a degree varying with distance, the activity of every other atom in the universe.'[18]

Kupka was drawn toward movement through his interest in science which had taught him that nothing in life is still. He found Cubism colourless, lifeless, static. Duchamp, a much younger man, was intrigued by Cubism but sought to develop his own interpretation of it. Like Muybridge, the cubist painter moved around his subject. Whereas Duchamp and Kupka induced the subject to move before their eyes. Their studies of figures in motion reintroduced an illusion of depth or a third dimension to their art. The virtual volumes thus produced, particularly visible in Kupka's case, led them away from the restrictive staticity and flatness of Cubism and into new interpretations of the function of the picture plane. Their culminations were Duchamp's *Large Glass*, started in 1913 and Kupka's *Fugue for Two Colours* of 1912.

1. Quoted from notes by Marcel Duchamp in d'Harnoncourt and McShine (eds), *Marcel Duchamp*, The Museum of Modern Art, New York 1973, p. 258.
2. *Ibid.*, p. 256.
3. Madame Denise Fédit of Paris, in preparing the Kupka inventory catalogue for the Musée National d'Art Moderne (1966), found a prospectus for Reynaud's séances of 1896 or 1897 among Kupka's personal papers. I am indebted to Madame Fédit for her invaluable assistance and information (both published and unpublished material) concerning this particular aspect of Kupka's development.
4. Fédit dates *The Horsemen* 1900–02, based on conversations with Madame Kupka who maintained that the drawing was done prior to her meeting Kupka in 1903. Fédit alludes to the praxinoscope in her catalogue discussion of this drawing.
5. In view of close family ties, Duchamp surely visited his brother Villon prior to 1904 when he actually moved in with him.
6. See Aaron Scharf's extensive discussion of events, publications and impact in *Art and Photography*, London 1968, pp. 162–208.
7. Accompanied by a catalogue: *Musée Centennal de la classe 12 (Photographie) à l'Exposition universelle internationale de 1900 à Paris*, Bibliothèque Nationale, Paris.
8. There is some confusion about exactly what Kupka exhibited and for what he won a medal. However it is certain that he did exhibit in 1900.
9. I am indebted to Monsieur Michel Frizot of Dijon for bringing this contact to my attention.
10. G.H. Hamilton and W.C. Agee, *Raymond Duchamp-Villon*, Knoedler and Co., New York 1967, p. 41.
11. E.J. Marey, preface to the catalogue mentioned in note 7 above.
12. In unpublished manuscripts written for the most part between 1910 and 1914. These are mostly rough drafts written in French of Kupka's book, published in Czech in Prague in 1923: 'Creation in the Plastic Arts'. All these drafts are in private hands.
13. The photographs reproduced here were chosen particularly for their relation to Kupka and therefore do not show a linear progression, which was extremely common in Marey's experiments.
14. Duchamp, *loc. cit.*
15. See Brian Petrie, 'Boccioni and Bergson', in *The Burlington Magazine*, vol. CXVI, no. 852, March 1974, pp. 140–47.
16. Quoted in Petrie, *op. cit.*, p. 143.
17. Karl Flinker Collection, Paris.
18. Quoted in B. Petrie, *op. cit.*, p. 145.

Contre-Dossier

From *Opus International*,
'*Duchamp et après*', no. 49, March 1974
Edition Georges Fall, Paris

52

CONTRE DOSSIER

Un tableau qui ne choque pas n'en vaut pas la peine
Marcel Duchamp

F-X. Redo
Multiple Portraits 1991

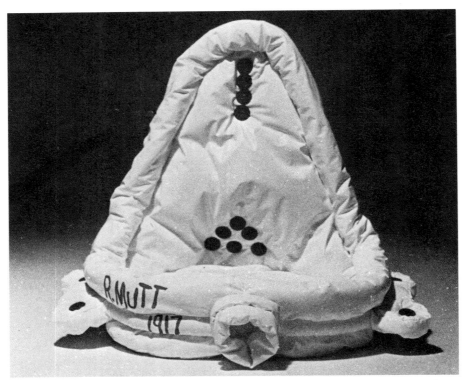

R. Doxfud/N. Fouts, *Soft Fountain* 1973

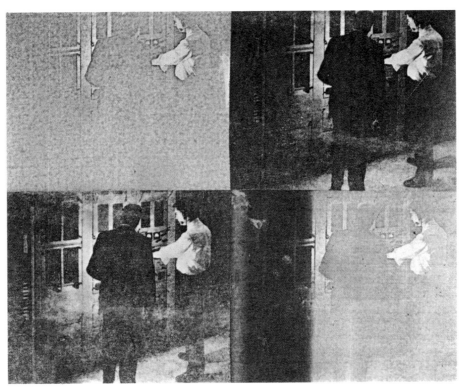

Rem Doxfud.
Two bachelors regarding a fresh widow in the style of Andy Warhol (1973)

From catalogue
*The International Exhibition of Modern Art:
Collection of the Société Anonyme*,
Brooklyn Museum, 1926–7
Pages arranged by
Katherine S. Dreier and Constantin Aladjalov

MARCEL DUCHAMP

BORN in the late 80's, like Arp he is one of the few real Dadaists, but instead of joining groups and creating movements as Arp does, he has always remained a free lance, throwing his weight into the balance for greater freedom of thought and expression. He belongs to the few favored artists whose works have always a market. No collection seems complete without a Duchamp and yet there are so few to be had.

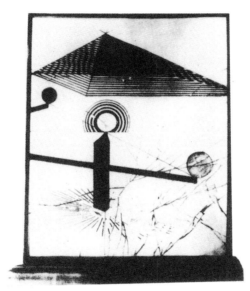

23

F-X. Redo
Marcel Duchamp smoking, Milan 1964 1990
Collage
Photographs: Joseph Rykwert

PAINTING

(continued)

DADAISM: PURISM: SURREALISM

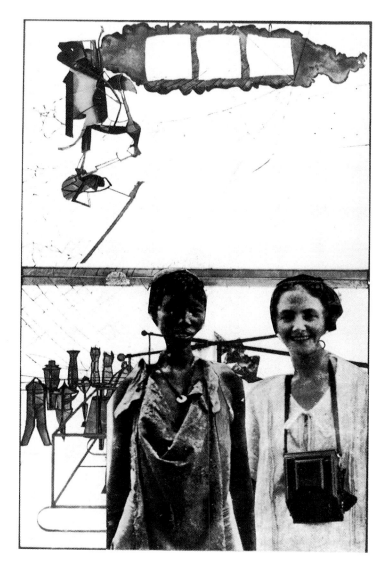

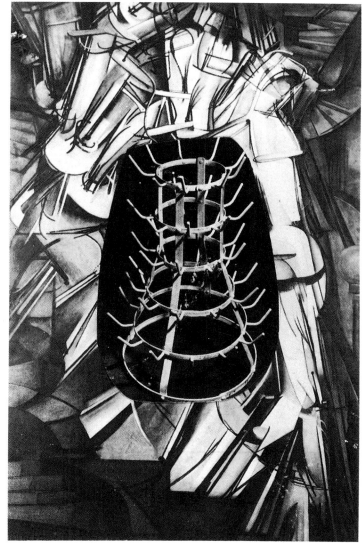

F.-X. Redo
Visiting the Large Tumbler 1990
Collage

F.-X. Redo
Hook Jacket 1990
Collage

Victor Horta (1861–1947)
Water closet in bedroom
Maison Horta 1899–1900

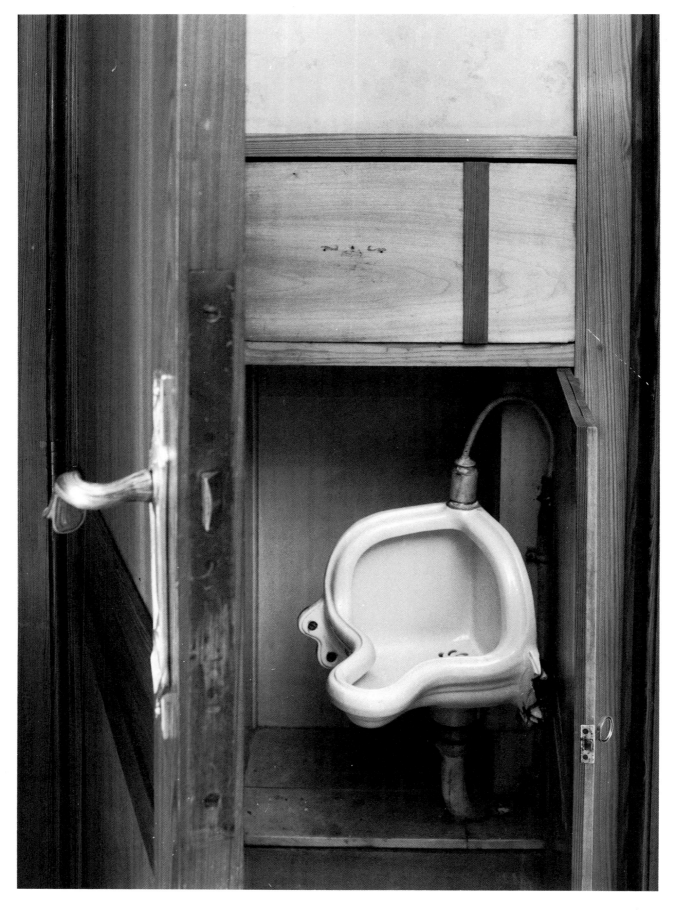

F.-X. Redo
A Shorter Large Glass 1986
Collage

Otto Hahn
Collages from a letter to Anthony Hill
20 January 1983

Hans Haacke
Baudrichard's Ecstasy 1988
Mixed media
Photograph courtesy John Weber Gallery,
New York

Hans Haacke
Broken R.M. . . . 1986–87
Enamel sign, broken gilded snow shovel

Mark Thomson
Vue Générale de Rouen, 1988
Photographs, perspex, frame

Duchamp Lui-Même

Jacques Villon
Portrait of Marcel Duchamp 1951
Henie Onstad Kunstsenter

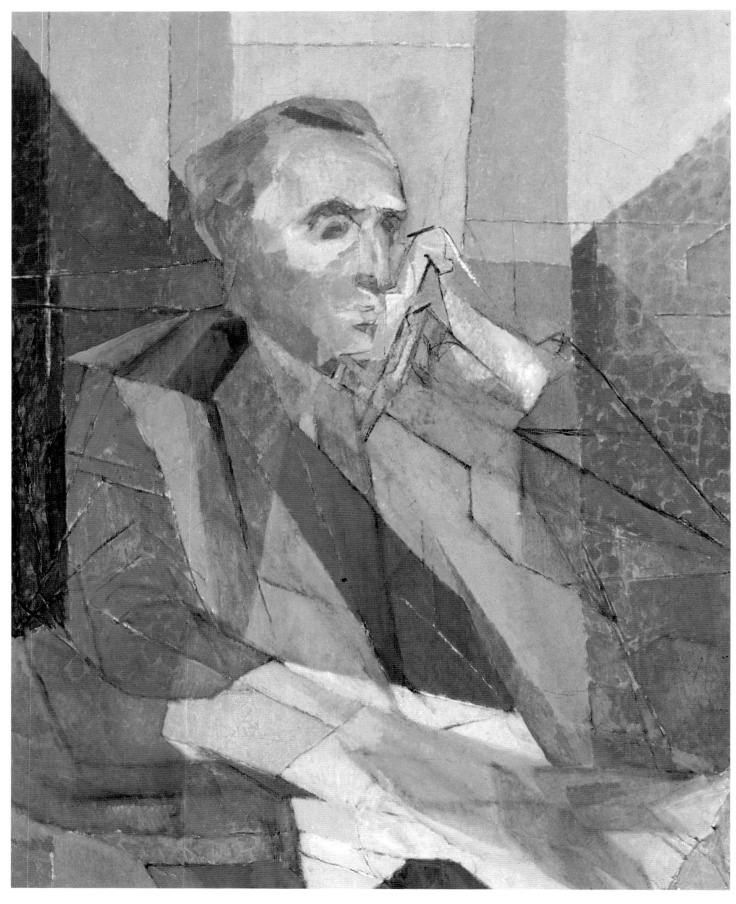

Otto Hahn

Marcel Duchamp Interviewed

First published in *L'Express*, Paris, no. 684, July 1964, pp. 22–3
Also in *Art and Artists*, vol. 1, no. 4, July 1966

MARCEL DUCHAMP: I live like a provincial, out of touch with everything. In New York one gets 300 private view cards a month . . . And as I don't go to exhibitions, I'm out of touch. Of course I know the Morrises, Bob and Yvonne Rainer, charming people, whom I like a lot. Cage: very important. Oldenburg: has a thing going for him. Very fine, his last exhibition. I also like Segal, . . . that much I can tell you . . .

I also go and see a happening from time to time: it's not a bad thing to do. At the 40th Street Theatre I saw a happening by Wesselmann. There was another by Oldenburg. Recently I met Andy Warhol, at Cordier-Ekstrom, during the American Chess Foundation sale. It was at the end of the exhibition: Dali had just finished his piece, and they had laid on a little ceremony. Warhol had brought his camera and he asked me to pose, on the single condition that I keep my mouth shut for twenty minutes.

OTTO HAHN: *In some of Warhol's films, where one sees the face only, weird things go on off-camera, calculated to disturb the subject . . .*

It's very odd: in my case I had a girl on my knees, at least, nearly: a very cuddly little actress came and sat by me practically lying on top of me, rubbing herself up against me. I like Warhol's spirit. He's not just some painter or movie-maker. He's a *filmeur*, and I like that very much. Does he dye his hair? He looks like a Merino, a white rabbit with pink eyes . . . it's very strange, that grey-white hair which doesn't manage to be blond, or the other way round.

Did the American Chess Foundation sale go off alright?

We're up to $32,000 and we haven't sold everything. If chess is going to continue to absorb people, it's good that artists should be partly responsible. These kinds of sales are all the rage in New York. John Cage often uses them for his Performing Society.

Your name is often associated with John Cage, isn't it?

We're great buddies. He comes and plays chess every week. I met him in 1941, in New York, at Max Ernst's and Peggy Guggenheim's. He must have been about 25. If people choose to associate us it's because we have a spiritual empathy, and a similar way of looking at things. An extraordinary thing about him is his ability to remain constant. He thinks in a light-hearted way, without elaborating; things based in humour. He never stops inventing language, and he doesn't explain; he's not a schoolmaster, nor a schoolmarm, he's got away from the boring side of music; it didn't stop him playing Satie's *Sonate de huit heures*, which I don't believe has ever been performed in France.

What was your relationship with Satie?

We collaborated a bit for *Entr'acte*. He was on the roof of the (Théâtre des) Champs Elysées, with an umbrella and a bowler hat. We didn't continue the relationship: we met by chance. He led a rather active social life; to survive, he was obliged to eat with duchesses and baronesses; even if he later returned to Arceuil, in the suburbs, on foot. He used to joke about it himself. The

Groupe des Six took up some of his ideas, but never the spirit. Auric brought it off very well—he is the director of the Théâtre National de l'Opéra. Georges Auric and Darius Milhaud are serious people; the musical Reformers! I know Sauguet and Poulenc less well. But what about Honegger? A sort of high priest! Is he dead?

Yes, his death was rather curious. A blood clot got stuck in his heart. He knew he could die at any time, that the clot had only to move slightly to block the aorta. So, he lived with his death; advertised it so no one could forget it. He derived a morbid self-satisfaction from terrorising people into becoming obsessed by his death. When he got the Légion d'honneur, or at least, one of its grades, some friends gave a small party. After the investiture, he got up to make his speech of acceptance: 'This is a dead man talking, I might die before your very eyes . . .' Then he sat down, still as a corpse, to stare at the guests. The party broke up, and none of the guests dared say a word.

Most amusing. It's very funny to be able to play with death like that. I wouldn't like to at all. I'm not very brave, and I don't want to think about death.

Since we're talking about musicians, what was your relationship with Varèse?

Forty years ago, he was a pain in the ass. Completely 'dedicated' to his music. Not at all amusing, no sense of humour. He could just about understand second-hand student jokes. I remember a supper with Ionesco—what a joker—where Varèse didn't understand a thing. There was no understanding. The thing which distinguishes Varèse's music is violence; and I'm sure Cage doesn't like that at all. It's again a question of forms. To make a noise like Mozart or to make a noise like Varèse is the same thing. Varèse is louder. Stockhausen and Boulez are on the same lines, only slightly less loud. I should think Cage is opposed to that: with him, it's Satie. And Satie, even if he could, would not have made electronic music.

What do you mean by 'Varèse was a pain in the ass'?

You couldn't meet him without his buttonholing you: 'I've got a thing going at the moment, old boy, wait till you see it; and I'm starting on something else, fantastic . . .' It was a colic of 'Me', always explaining ideas, which were no more than the outline of ambitions, verbally described . . . When he was better known, and more accepted, Varèse didn't need to explain himself so much. It was better. More bearable. There's no lack of pains in the ass among artists though; Metzinger for example. And Delaunay . . . You couldn't meet him for more than five minutes without wanting to run away. Egomaniacs.

Don't you like music?

I'm not anti-music. But I don't get on with the 'cat gut' side of it. You see, music is gut against gut: the intestines respond to the cat gut of the violin. There's a sort of intense sensory lament, of sadness and joy, which corresponds to retinal painting, which I can't stand. For me music isn't a superior expression of the individual. I prefer poetry. And even painting, although that's not very interesting either.

Not interesting because it has to be sanctioned by a public. Instead of forcing the public to come up to the work, one goes out and begs for its sanction. The bore with art, as it is now, is this necessity for having the public on its side. Under the kings, it was at least a little better: the sanction of a single person, or of a small clique was sufficient. Just as dumb, but in smaller numbers.

It's not very democratic.

I know; I'll be thought a reactionary and a fascist . . . but I don't give a damn: the public makes anything look indifferent. Art has nothing to do with democracy.

It's true. In the Musée d'Art Moderne in Paris, they put up lots of paintings, to please everybody. If they take away a picture, only two or three people need complain for them to put it back. Everyone has to be able to find something he likes—even imbeciles.

Museums are full of mediocrities. In Russia it's worse; real bedlam. Anything to please the public.

Have there been any fake Duchamps?

Not in the serious sense. One day, Walter Pach 'phoned me, because he'd found a framed drawing in a filthy little sale room, with 'Duchamp' on the frame. I went to have a look. It was a series of academic drawings representing a nude descending a stair. I didn't say anything, and I didn't make a scene. Another time Saindenberg bought a signed drawing for which he paid $60. It was a fake. He wrote off the $60 and gave the drawing to the museum of Fakes at the Fogg Museum, Cambridge. By giving it to a museum, he got back $30, tax deductible. I've been back to see the drawing at Boston, where they have a room full of fakes. Fake Utrillo, fake Cézanne, fake Renoir. A secret fund of fakes, only shown to very good pupils. I am quite closely in touch with this business of fakes, because I am now a frequenter of examining magistrates: they call me in regularly because of my brother, Jacques Villon, who gets literally robbed. I'm called in as professional witness. I have to sign declarations saying that it's not his work.

Would you make a fuss about, or prosecute forgers who thought to copy your work?

I wouldn't do anything. I don't give a damn. A forgery is a type of publicity, unless it's tendentious. It would even be amusing to go and see it. Perhaps not, it wouldn't amuse me all that much. If I want to see some fakes I go to the Metropolitan Museum in New York with my friend Robert Lebel, who points them out to me. They ought to give them marks, and put stickers on them: 'Fake', 'Near fake', 'Not a complete fake' . . . and with the marks: 10/20 faked, 4/20 faked, 15/20 . . . make a show of it, enter into the faking game.

Have you always been interested in Surrealism?

It's the only movement of the century. The only one which lent a technical aspect to painting, which wanted to get away from the visual aspect—I won't say retinal. I talk too much about that; in each interview I mention my rejection of retinal painting, which is concerned with the eye's reaction only . . . The Surrealists tried to break away from the sensual and superficial aspect, but in the end they came back to it. André Breton is, after all, a man of the 'Twenties, not completely rid of notions of quality, composition, and the beauty of materials.

Didn't you participate in several Surrealist exhibitions, as technical advisor?

I did the decor: the strings, or the sacks of coal hung from the ceiling . . . to try and get a bit of gaiety into it. The danger is of being academic; and one cannot put up a successful show without a bit of gaiety. I tried to lend some, although the Surrealists were not lacking in it themselves. They had managed, despite everything, to hang on to a gay side, which came from Dada. One cannot easily gloss over Dada.

How do you explain the sudden return to Dada, after Surrealism has held the stage for 30 or 35 years?

Because Dada never received its due. It was just a brush fire, soon forgotten. Surrealism appeared and threw water on the fire. But a characteristic of the century now coming to a close is the 'double-barrelled gun effect': Kandinsky, Picabia and Kupka invented abstraction. Then abstraction was finished. No one talked about it anymore. It came back 35 years later with the American Abstract Expressionists. One can say that Cubism came back in an impoverished form with the post-war Ecole de Paris. Dada has also come back. Double-barrelled, second shot. It's a phenomenon peculiar to this century. It didn't exist in the 18th or 19th century. After Romanticism came Courbet. And Romanticism has never come back. Even the Pre-Raphaelites were not born out of the Romantics.

When one talks of Dada, one always mentions Duchamp-Picabia. Why is this?

Another characteristic of this century is that artists come in pairs: Picasso-Braque, Delaunay-Léger, although Picabia-Duchamp is a strange match. A sort of artistic pederasty. Between two people one arrives at a very stimulating exchange of ideas. Picabia was amusing. He was an iconoclast on principle. He accepted something for ten days, or a month, then he would destroy it all with some new exaggeration. He always ended up not giving a damn . . . that was the reason for his lack of success. Painters should always be serious people!

There was never any Dada in England, how do you explain that?

The English woke up to modern art very late. Forty years ago the idea of art did not interest them very much. 'Art' with a capital A couldn't even have been in the dictionary! It could be only conceived of in terms of the portrait, or the 18th-century Englishman. Doubtless, this was because of the monarchy. In a monarchy, painters paint portraits and exhibit at *salons*. In terms of poetry, this gave rise to a very esoteric poetry: Henry James and Eliot, who came to London with new ideas, introverted themselves. The English did not react strongly to them, which gave rise to this tendency for the esoteric: as long as there was no reaction, time wasted was best wasted in the esoteric.

For Christmas I sent you an anagram on your name: instead

*of Marchand du Sel, which is the title of one of your books,
I proposed Marchand de Cul.*

MAR cel du CHAMP

MARCHAND du cel (sel)

MARCHAND de cul

Very good. I kept the anagram, I have it here. Put it in your article. Since the interview will appear in London, the English won't get it, ha ha!

Why did you go to Buenos Aires early in 1918?

I didn't know anyone there, except the parents of a friend in Paris. Very nice people: they ran a brothel. But that wasn't the reason for the trip. I was obliged to go to Buenos Aires: I had already left France because of the war. And when America came in, in turn, I had to leave again . . . But perhaps I shouldn't say that? I'll be taken for a pacifist, a dreadful revolutionary. And it's not true: I really couldn't give a damn.

Your life seems to have followed a very pure trajectory. Isn't that a retrospective illusion; or is it true?

It's an illusion. Nothing was intentional. The most I had decided was not to make a living by painting. It's neither a trajectory, nor a virtue, nor a work of art in itself. If you like you could say painting has never been 'my cup of tea' (sic). It's all different today: painters make a lot of money. They really rake it in . . . and I don't blame them. They're quite right, but I can't help bracketing them with good business men.

Production foremost, and they produce as much as they can. That's what worried me. If I ought to worry, that is. It didn't exist before. Nobody bothered with the artists, the papers didn't talk about them. One just went on working because one wanted to. At the moment the artist gets put on a pedestal, he sits at the hostess's right hand. He's a superior being, possessed of intangible faculties. It's OK for me to have a good laugh, isn't it?

Does this social elevation of the artist dissatisfy you?

Painters think everything's fine, because they've got a 'one man show'. They can't see the trap that's been laid for them. As I told you once before, there are heaps of geniuses. There are 50 or 100 around at the moment. The difficulty lies in hanging on to it. Refusing to become a 'fashion'. The public ruins everything. It kids the artist that he's made it then gets bored and drops him. The game is never over for the artist. Despite the scandal and the publicity which surrounded *Nude Descending a Staircase*, had I died in 1912, no one would talk about me any more. But I replenished the *Nude* with the Readymade, then the readymade with the *Large Glass*. Success is just a brush fire, and one has to find wood to feed it.

How was the Large Glass *made; with set-square and compass?*

I found a trick; instead of drawing a line. I took a plumb line and plucked it. It made a line. I also had a trick for the circles. Always in order to discredit the idea of the hand-made.

To wipe out the idea of the original, which exists neither in music, nor in poetry: plenty of manuscripts are sold, but they are unimportant. Even in sculpture, the artist only contributes the final millimetre; the casts and the rest of the work are done by his assistants. In painting, we still have the cult of the original. It's the acceptance of the idea of distance within time: for example, stamps which are valuable only because they were printed in 1860, and we look at them in 1966. That's what makes them valuable. There is a hypocrisy in the possession of a work of art. Take the man who buys a Van Gogh so he can say, 'I've got a Van Gogh'; the value is in its possession, and not in its deeper value. Similarly, the man who buys a Holbein for it's true value, pays a lot of money for the frame and the canvas or wood, because they are 500 years old.

To get back to your Readymades; I thought that R.MUTT, *the signature on* Fountain, *was the name of the maker, but in an article by Rosalind Krauss, I read:* R.MUTT, *a pun on the German,* armut *or* poverty. *Poverty would completely change the meaning of* Fountain.

Rosalind Krauss? The redhead? That's not it at all. You can contradict it. Mutt comes from Mott Works, the name of a large sanitary equipment manufacturer. But Mott was too close so I altered it to Mutt, after the daily strip cartoon ' 'Mutt and Jeff' which appeared at the time, and with which everyone was familiar. Thus, from the start there was an interplay of Mutt: a fat little funny man, and Jeff: a tall, thin man . . . I wanted any old name. And I added Richard [French slang for money-bags]. That's not a bad name for a *pissotière*.

Get it? The opposite of poverty. But not even that much, just R. MUTT.

What is the interpretation of the Bicycle Wheel? *Does it represent movement in a work of art? Or a fundamental point of departure, like the Chinese inventing the wheel?*

The wheel serves no purpose, unless it's to rid myself of the conventional appearance of a work of art. It was a fantasy. I didn't call it a work of art. Actually, I didn't call it anything. I wanted to finish with the idea of creating works of art. Why should they be static? The object—the bicycle wheel—came before the idea. I had no intention of making a meal of it, it has nothing to do with being able to say 'I made this object, myself, and no one has done it before me'! By the way, the originals have never been sold.

And the geometry book left out in bad weather? Could one say that that is the idea of integrating time in space?

No. No more than the idea of integrating movement in sculpture. It was only humour. Nothing but humour, humour. To disparage the seriousness of a book full of principles.

From the considerable documentation on the Large Glass, *one is led to think that all your works, even the Readymades, are the fruit of lengthy development.*

The Readymades are completely different from the *Large Glass*. I made them without any object in view, with no intention other than unloading ideas. Each Readymade is different, there is no common denominator between the ten or twelve readymades, other than that they are all manufactured goods. As for recognising a motivating idea: no. Indifference. Indifference to taste,

Jean-Jacques Lequeu
He is Free 1798–99
From Philippe Duboy:
Lequeu: An Architectural Engima,
Thames and Hudson, London 1986

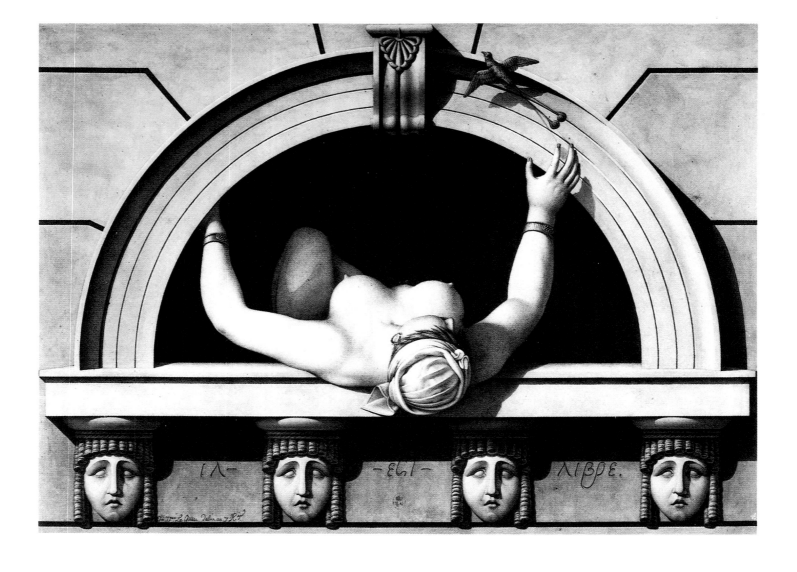

taste in the sense of photographic reproduction, or taste in the sense of well made materials. The common factor is indifference. I could have chosen twenty things an hour, but they would have ended up looking the same. I wanted to avoid that at all costs. Of course people ended up seeing similarities. That's the price of time.

Some people consider that in authorising reproduction of your Readymades, you have betrayed your heroic standpoint, the disdain of commerce, to which you were committed for 40 years. In other words, you have destroyed the myth.

Ah. Complaining and whining, are they? They ought to be saying 'Its atrocious, it's an outrage, a disgrace . . .' It would have suited them nicely to have me shut up in some category or formula. But that's not my style. If they're dissatisfied, *je m' en fous.* One mustn't give a F---. . . . *et merde, ha ha . . .*

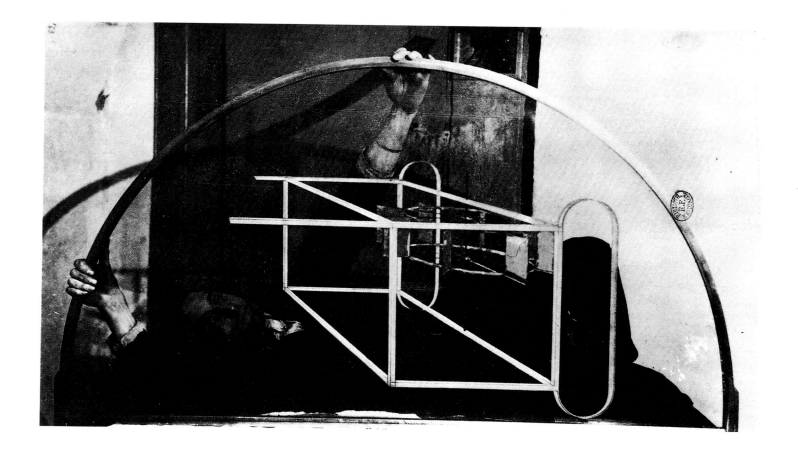

Man Ray
Marcel Duchamp
Photograph reproduced in *The Green Box*
1934

Marcel Duchamp
With my Tongue in my Cheek 1959
Sculpture and drawing

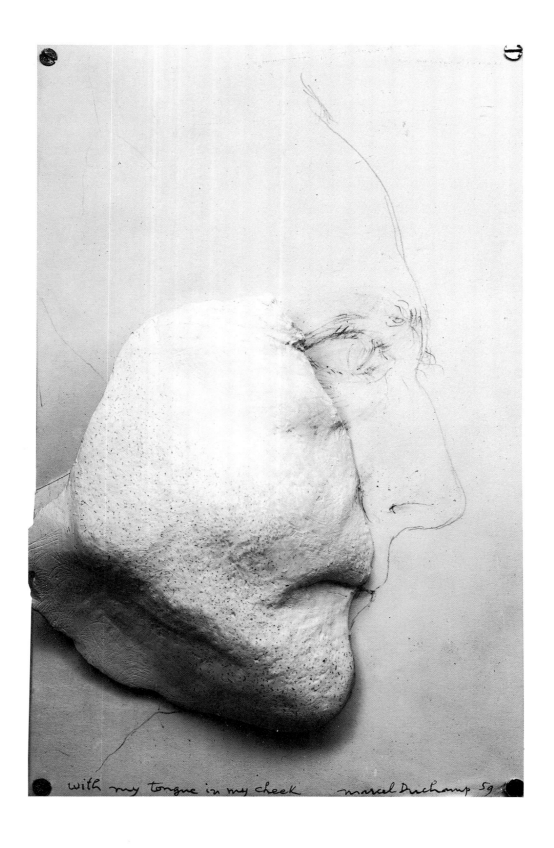

with my tongue in my cheek marcel Duchamp 59

Dore Ashton

An Interview with Marcel Duchamp

First published in *Studio International*, vol. 171, no. 878, June 1966

I have never had much faith in the interview as a means of acquiring significant information about an artist. The journalist, as Proust pointed out in his well-wrought attack on Sainte-Beuve, is always working with the unwitting collaboration of other people. Therefore both the questions he poses and the answers he solicits are slightly vulgar. The 'mob' is looking on.

This interview with Marcel Duchamp is no exception, as I think he would be the first to acknowledge. The questions are necessarily limited and so are the replies.

The interview took place in Duchamp's 10th Street apartment in one of the spacious old brownstones still graced with floor-to-ceiling windows. (Duchamp lives on a block which has a house bearing a bronze plaque advertising the former residence of Mark Twain.) His own apartment is comfortably furnished with old but not ostentatious furniture, and an impressive collection of works of art. I noticed Miró, Matisse, Tanguy, Brancusi, Giacometti, Rauschenberg, and works of African and pre-Columbian art. There is also a chess set, of course.

Duchamp, wearing grey whalebone corduroys and a checked shirt, settled himself, cigar in hand, in a deep comfortable chair, smiling amiably as always. I posed my first question:

'You have called yourself a Cartesian, yet you say the role of the artist is mediumistic. Is this a contradiction?'

'Oh, no,' he answered without hesitation. 'I've never read Descartes to speak of. I was thinking of the logical meaning, the reasoning Cartesianism implies. Nothing is left to the vapours of the imagination. It implies an acceptance of all doubts, it's an opposition to unclear thinking.'

But what about the artist's mediumistic role in that case?

'You must understand that I am not a Cartesian by pleasure. I happen to have been *born* a Cartesian. The French education is based on a sequence of strict logic. You carry it with you. I had to reject Cartesianism in a way. I don't say that you can't be both. Perhaps I am.'

At this point, Duchamp asked where this interview would appear. When I told him, he said he used to buy *Studio* in 1900 or 1903, a 'very good magazine at the time.'

I then asked him what he meant when he said that painting had become too 'retinal'.

'Well, ever since the nineteenth century, painting has been retinal. Of course the pre-Raphaelites were not, they went further than the retina. Maybe they weren't better, but at least they weren't retinal. The whole of modern art—the Impressionists, the Fauves, the Cubists—the whole, except maybe the Surrealists, were retinal. Abstract Expressionism was very retinal, and of course, Op art is very retinal. A little too retinal for one's taste.'

I interrupted to point out that the Op artists sometimes claim him as a father. He laughed.

'It was only an episode in my life. Who has not made a spiral in his life? Everybody has. But you can't keep on doing it. The Pops maybe were not retinal. Lichtenstein is not retinal. They have some extra content. Mondrian was not retinal, Seurat was

not, but Cézanne and Monet were. The whole century since 1880 works in retinal terms. Only sensuous feeling. It's like a bath. I got out of the bath. The roto-reliefs were only a moment's visit for me. There never was a programme with me, though. I never decided *not* to be retinal so clearly. I don't say my way is the *only* way of doing things. Art is a condition, a Heraclitan condition of always changing isn't it?'

What about his interest in mathematics?

'Oh, I'm not much of a mathematician. In those days 1910, 1911, 1912, there was a lot of talk about the fourth dimension and I was tempted. Non-Euclidian geometry had been invented in the 1840s but we were just hearing about Riemann in 1910. It was very interesting because there were no straight lines left. Everything was curved. I'd say I liked the fourth dimension as one more dimension in our lives. We knew an amateur mathematician, Princet, and we used to talk with him. Now, you know, I live only in three dimensions. It was mostly talk with us, but it did add an extra-pictorial attraction.'

I next asked Duchamp how he felt about all the elaborate, often arcane interpretations of his work.

'I learned a lot from them,' he laughed. Then, more seriously. 'You see, I *do* believe in the mediumistic role of the artist. What's written about him gives him a way of learning about himself. The artist's accomplishment is never the same as the viewer's interpretation. When they explain all those documents in the *Green Box*, they are right to decide what they want to do with it. A work of art is dependent on the explosion made by the onlooker. It goes to the Louvre because of the onlookers.'

You have often remarked on your delight in a *succès de scandale*. Why?

'Because a *succès de scandale* has a chance to survive. In 1870 a painter called Regnault painted a *Salomé* which was a great *succès de scandale*. Regnault died in the war. But people kept talking about that picture and still do. *Guernica* may not have been exactly a *succès de scandale*, but it was at least shocking. Unfortunately, you cannot have a *succès de scandale* every year.'

Is it still possible to shock the public as Regnault did?

'Today there is no shocking. The only thing shocking is "no shocking". Shocking has been one of the main themes of modern art, its baggage. Something that would shock me? Well, Russian painting. Those young girls at the window like in 1880, or Hitler in his bunker. It's a diminished shock, but still a shock. Pop artists are not shocking because the public is always expecting another movement. They see it and they say: 'What's next?' A movement should really last at least twenty years. The only movement that seems to last for any time is Surrealism, but that's because it is not essentially a painters' movement.

'Movement; modern—they're new words. Rather silly. Think of Art Nouveau, how old it seems. The word "artist", for instance. Until the French Revolution it hardly existed from a social point of view. There were artisans. Now the artists are integrated. They are commercialized. Too commercialized. It wasn't

that way in the days of the kings. (Don't make me into a monarchist!) Such a levelling as we have now may not engender many geniuses.'

But, I interrupted, I've always thought you more or less believed in genius, in which case all this brouhaha would not inhibit the engendering of genius.

'No, no. Top minds can't come up in such circumstances. A genius is not made by mind itself. It is made by the onlooker. The public *needs* a top mind and makes it. Anything can be on top. Genius is an invention of man, just like God.'

You've said that success is demoralizing. Do you feel demoralized?

'Oh, I've never had success. Not normal success. My first one-man show was two years ago in Pasadena when I was 75 years old. Even then, it wasn't very important. But then, what's important to the onlooker now is always changed by the second onlooker twenty-five or seventy-five years from now. Look at Gautier for instance. Everybody read him, and he was very important, but who reads him now? Every few years there's a revision. We make El Greco what we want him to be. An *oeuvre* by itself doesn't exist, it's an optical illusion. It's only made to be seen by the people who look at it. The poor medium is only gratuitous. You could invent a false artist. Whatever happens could have been completely different. Look at those poor things from Africa (pointing to the African and pre-Columbian sculptures), so important in our lives. We've made modern art of them.'

What, I asked, does he mean when he sometimes refers to 'bad art' and 'good art'?

'There *is* bad art, only people forget it if they can. It's art anyway. The St Sulpice images, for instance. Or Tanagras: the Tanagras were bad Greek art that are now worth a lot. Generally it's bad art that becomes good. The simplest thing is to take a thing disliked and re-habilitate it. A group of four or five men can do this very easily. Part of the shock of a new movement is just that.'

You've suggested, I continued, that artists today are corruptible and too much involved in commercialization to amount to much. In that case, why do you continue to say you are interested in artists, not art?

'Because artists are the only people who have a chance to become citizens of the world, to make a good world to live in. They are disengaged and ready for freedom.'

Who is an artist? Anyone who says he is? Duchamp laughed good-naturedly: 'Nowadays I suppose the answer would have to be, Yes. It is hard to define, but we know what we mean. In a way the artist is no longer an artist. He is some sort of missionary. Art has replaced religion and people have the same sort of respectful attitude to art that they once had for religion. Art is the only thing left for people who don't give science the last word. Let's say I have a professional sympathy for the artist.'

To change the subject, I continued: You have authorized the manufacture of replicas of your original ready-mades. Is that a contradiction of your original premise?

'I like the idea. I've never had a special respect for enshrined art. The minute people say "It's an outrage", I'm ready to do it. It tempts me. Here, I'm an anti-Cartesian. It's an amusing form of giving light meaning instead of heavy serious meaning. I have to defend myself. Seriousness and importance are my main enemies.'

What, I asked, does he think of Richard Hamilton's professorial analysis of the *Bottle Dryer*; his discussion of the 'symmetry', etc.?

'Symmetry was only a point in my life. Since asymmetry dominated from 1870, I reintroduced symmetry in order to use something not accepted at the time. If you think of the kind of distorting for distorting's sake indulged in by Matisse. . . . He did it for pleasure, for the fun of it. He was right to do it, but I have to laugh at the great theories around it. Yes, he was retinal all right. But the retina is only a door that you open to go further.'

I asked Duchamp whether he had anything to say about the extensive linking of art with technology, and the attempts to make him a progenitor of the tendency.

'They have to get somebody as a progenitor so as not to look as though they invent it all by themselves. Makes a better package. But technology: art will be sunk or drowned by technology. Look, I'll show you an example.'

Duchamp then plugged in a framed box in which electric heat acts on the liquid and crystals within, making them surge up in a sea-green orgy of movement.

'This is a work by Paul Matisse, Matisse's grandson, who does not regard himself as an artist. In fact, he intends to manufacture this, and you'll probably see it in every motel in the country. It could be seen as an artistic conception I suppose.'

'Technology will surely drown us. The individual is disappearing rapidly. We'll eventually be nothing but numbered ants. The group thing grows. You can already feel the tendency in the arts today. Speed, money, interest. A hundred years ago there were few artists, few dealers and few collectors. Art was a world by itself. Now it is completely exoteric — not my cup of tea. There is something wonderful about the secret society that is lost.

'To get back to what you asked me about the ready-mades. You can't choose with your taste. Taste is the great enemy. The difficulty I had was to choose. Now my *Bottle Dryer* is in the books and some regard it as a beautiful sculpture, but not all ready-mades were the same. Once, many years ago, I was dining with some artists at the old Hôtel des Artistes here in New York and there was a huge old-fashioned painting behind us—a battle scene, I think. So I jumped up and signed it. You see, that was a ready-made which had everything except taste. And no system. I didn't want to be called an artist, you know. I wanted to use my possibility to be an individual, and I suppose I have, no?'

We then spoke a little while about Duchamp's renown, and he pointed out that he had never been particularly cherished by the French.

'You can't be a prophet in your own country. I certainly am not.'

Are you better appreciated here, and why did you settle here?

'The melting pot idea, you know. And the lack of difference between classes. It interested me then. The French Revolution was more evident here in those days. It was good for an artist. Of course, it's a little messy now. Such business affairs, papers, taxes! Do you know there was hardly any tax to pay here until after the crash?'

Duchamp spoke then about how lazy he is, how much he enjoys a placid life, and how, although he is no beatnik, he is 'very like'. Then he abruptly shifted back to the problem of art in America.

'We don't speak about science because we don't know the language, but everyone speaks about art. Art is going down to the people who talk about it. You know, about that question of success: you have to decide whether you'll be Pepsi-Cola, Chocolat Menier, Gertrude Stein, James Joyce . . . or James Joyce is maybe Pepsi-Cola. You can't name him without everybody knowing what you're talking about. What happened to me is worse, though. That painting [meaning *Nude Descending a Staircase*, which he referred to only as "that painting" throughout the interview] was known but I was not. I was obliterated by the painting and only lately have I stepped on it. I spent my life hidden behind it. . . . You know, an artist only does one or two or three things in his whole life. The rest is merely filling up the hole. It is not desirable to be Pepsi-Cola. It is dangerous.'

George Heard Hamilton

A Radio Interview

Conducted in New York on 19 January 1959
for broadcast on BBC Radio
Third Programme on 13 November of that year
and repeated on 12 August 1960

GEORGE HEARD HAMILTON: *Mr Duchamp, so many people want to know about the readymades these days. I was wondering if you could tell us a little about them: for instance, how many of them have there been?*

MARCEL DUCHAMP: Well, I can count a small dozen of them. I can even list some of them here. The first one was in 1913. It was a bicycle wheel.

Just an ordinary wheel?

An ordinary wheel, a bicycle wheel on a stand. The mobility, the movement of it, would be like a fire in a fireplace; you know — it has the attraction of something moving in the room while you think about something else. Then the second one was a bottle dryer, a French model, of the kind they have in cellars. In French cellars, they put the bottles up.

The wine bottles?

You put them on it when they are empty.

And then the third one was a snow shovel, which I did here in New York when I first came in 1915. It was just a plain snow shovel.

Just an ordinary commercial shovel?

I bought it in a hardware shop. And it's new — a replica of it is in Yale. And then another one was called *Why Not Sneeze?* Of course the title is not a descriptive title, because that readymade was a birdcage, a small birdcage, in which instead of a bird there was a square cube which looked like sugar — sugar cubes.

Cubes of white marble?

Yes, because I intentionally made it of marble, although for the onlooker it looks like sugar.

When one picked it up, it was extraordinarily heavy.

That was the pun, the visual pun — that when you picked it up, you understood it was marble rather than sugar. I also added a thermometer to it. Well, this has nothing to do with sneezing, you may say, but the fact that it has nothing to do with the title was also intentional and to bring more of the readymade effect, you see.

Then there came another one that was what you call 'readymade aided' — assisted, you know. In other words, I added a few details to a completely ready-made thing. For example, in this one I aided by adding plaques of brass screwed together and holding in between the two of them a ball of twine.

Why the title then 'With hidden noise'?

Because there was a noise in it. I gave this to my friend Arensberg and he put in the ball of twine, without my knowing it, some metallic thing. I'm sure it was metal because when we screwed the thing up and he shook it, there was a noise. There was something inside which I never knew. Arensberg is dead now. I'll never know unless I undo the thing, and I will not undo the thing.

Another one was the vial. I was in Paris in, I think, 1919 or somewhere around then, and I was thinking of bringing back a present for Arensberg in California, so I went to a drugstore, and said, 'Will you give me a vial, but you'll empty it of whatever

serum is in it, and seal it again, and what will be in it will be Paris air, air of Paris.' Of course, it had to be. So the druggist did it and I brought my present to Arensberg in California and it was called 'Vial with fifty cubic centimetres of air of Paris'.

Was that the last of the actual readymades to be manufactured?

Yes. Maybe there are one or two that I don't remember now, but in my notes in the *Green Box* there are mentioned some that could be made or done. I call them the 'reciprocal readymades'. You take a painting by Rembrandt and instead of looking at it, you use it plainly as an ironing board. You iron your clothes on it, it becomes a readymade — a reciprocal.

It's rather hard on the Rembrandt.

It is, but we have to be iconoclastic.

Mr Duchamp, there are two kinds of readymades: those which existed, so to speak, already before you came upon them, and those which you have assisted. Do you put any priority on one kind rather than the other?

No. I just sort of add a little diversity to the idea. As I said, it was not a very active part of my life. When you make one or two readymades a year, you have plenty of time for something else.

Do you think anybody else could make one?

Yes, everybody can, but as I don't attach any value, commercial or even artistic, to it, hardly anybody would do it for the sake of doing it. But some people have done it, in fact, like Joseph Cornell in America, who has used the idea indirectly.

But his are much more elaborately constructed?

Yes, of course. They come out of the idea of the readymade but with an elaboration of his own. I mean, his own invention.

Is there any way in which we can think of a readymade as a work of art?

That is the very difficult point, because art first has to be defined. All right, can we try to define art? We have tried, everybody has tried, and every century there is a new definition of art. I mean that there is no one essential that is good for all centuries. So if we accept the idea that trying not to define art is a legitimate conception, then the readymade can be seen as a sort of irony, or an attempt at showing the futility of trying to define art, because here it is, a thing that I call art. I didn't even make it myself, as we know art means to make, hand make, to make by hand. It's a hand-made product of man, and there instead of making, I take it ready-made, even though it was made in a factory. But it is not made by hand, so it is a form of denying the possibility of defining art.

You don't define electricity; you see see electricity as a result, but you can't define it. I remember that a professor of physics always said that you cannot define electricity. You can't say what it is but you know what it does. You see, that is the same thing with art: you know what art does but you don't know what it is. It is a sort of inner current in man, or something which you don't have to define. The first definition is not necessary.

But with the readymades it seems to me that they carry out of the world of everyday life — out of the hardware shop, as in the

case of the snow shovel — something of your own sense of irony and wit, and therefore can we believe that they have some sort of message? Not message but value, which is artistic even though you haven't made them. The actual intention in choosing and selecting, in setting them aside from everything else in the world, does that not give them some kind of possibly intellectual value?

It has a conceptual value if you want but, it takes away all the technical jargon. I don't know whether it means exactly what we want to say. Painting should be made with colours; painting should be made with pencil, with brushes, and when you take something that is not made by those technical instruments, then you feel you don't know where you are. You don't know whether you should take it as a work of art, and that is where the irony comes in and yet, as you say, it is the artist's choice to make that decision, to sign it as a work of his own.

The irony, of course, is very much part of the world of the First War.

Yes. It was a very important form of introducing humour in a very serious world at that time.

You said once to me, some years ago, that the Dada spirit had been operating in New York — with you, for instance, and with Man Ray — before Dada was named as a movement?

Oh yes. It was in the air, as many of these things are, and we certainly had the same spirit as that in Zurich, and started under the same name. They invented a name and of course the name was a good sort of flag around which all these ideas crystallized. But even before the war there was a Dada spirit. It has always existed. Rabelais is in essence a Dada.

Would you consider that Dada is more than just a criticism of art?

It is — much more. It has many more intentions. It is the non-conformist spirit which has existed in every century, every period since man was man. It is just that this time round they found a name for it.

Could we turn for a moment to another work, which is the Large Glass *now in the Philadelphia Museum. Is the* Large Glass *a Dada work, would you say?*

I wouldn't say that — no, no. It was started long before the word Dada was invented in 1912-14, before the war, and even though I tried in that big glass to find a completely, personally new, expression, the final product was to be a welding of mental and visual reactions. In other words, the ideas in the *Large Glass* are more important than the actual visual realization.

But this sounds almost contradictory because a work of art is primarily a visual experience.

Yes. But this welding of two different sources of inspiration gave me a satisfactory answer in my research for something that had not been previously attempted.

You see, I was the young man who wanted to do something by himself and not copy the others; not use too much of the tradition. In that quest my research was to find some way of expressing myself without being a painter, without being a writer; without taking one of these labels, and yet producing something that would be a produce of myself. As I said, this mixture of idea and visual representation attracted me as a technique, if it has to be a technique at all.

You had to invent everything for the first time?

Yes, because Courbet's revolution was mainly visual. He insisted, without even mentioning it, that a painting is to be looked at, and only looked at, and the reactions should be visual or retinal, not much to do with the brain. A plain physical reaction in front of a painting. This is still in vogue today, if I might say so. Expressionism is the line, the form, the play of colours together and the more abstract the better.

And all that has nothing to do with your plan?

I thought it was a reaction against the retinal conception of painting, and I think it still is. Literary painting has been done before, but my art is not literary. It is much deeper than that. It uses words, but using words is not necessarily literary.

But it also means that we could never reduce the visual elements in the Large Glass *to verbal?*

Exactly, because the other side, which is important, is description — the literary part, if you prefer it. The description of the visual part is the literary part. That is why I say welding; the welding of the two sources is very important.

Are there any ready made elements in the Large Glass?

Hardly no. There was hardly any ready made activity at that time.

Perhaps this is too difficult a question, but does the Large Glass *now mean things different to you from what it meant when you were working on it?*

No. You know it never was finished. I worked on it until 1923. It got broken and then I repaired it to have it in good shape, but I couldn't work on it any longer because it was split into two. So it never was finished and really, it does not matter, because the notes help to understand what it could have been. As I said, it is hardly to be looked at, so whether it is there or not, is not important. Some of the notes, the written notes, explain what could have been done on it, drawn on it.

Do you think people understand it the way you would like them to, or is it subject to interpretations, like so many works of modern art?

I don't think people take time to understand it; it is not an attractive subject for the public today. Collectors take a different attitude today: they regard art as a commodity, a thing that they put on their walls, a conversation at table. Painting, art in general, has become such a conversation piece. But in the *Large Glass* there is nothing to converse about, unless you make an effort to read the notes in the green box, but who cares? I mean, it is not interesting for the public today; it has no public appeal.

But every time I have seen it in Philadelphia, there have been one or two people . . .

Well, art students might be interested in it. In fact it has no

appeal for the public at large. I notice it very much.

Is it fair to think of the Large Glass *in terms of works of the same time which have mechanical elements in them, such as the paintings of Picabia?*

Oh yes, we were very great friends, Picabia and I. We were together all the time in Paris. Picabia's mechanical drawings of 1914–15, his absolute copies, were actually in the same spirit. They were more aesthetic since he wanted to make a drawing a work of art, while I tried to avoid that kind of artistic effect. That was the difference between the two of us. There was an American boy whose name was Schamberg, who died very young. You know, he disappeared. He even made some readymades. One of them is in my room in the Arensberg Collection in Philadelphia.

Picabia would have seen the Large Glass *when he was in New York during the war, wouldn't he?*

Yes. He saw it when he came in 1916. I was here, we were together all the time.

Mr Duchamp, if your works are ironic reflections upon the difficulties of defining art as a function, a process, is it wrong to exhibit them in art museums?

No, it is not wrong because, after all, even if they are supposedly ironical, they still belong to the same form of human activity. Whether you object to their conception, they are still in the same medium. They are not scientific, they are artistic, even if they are against art in this way.

Marcel Jean
Marcel Duchamp 1975–85
Medal, diameter 24.8 cm
From an edition by
La Monnaie de Paris

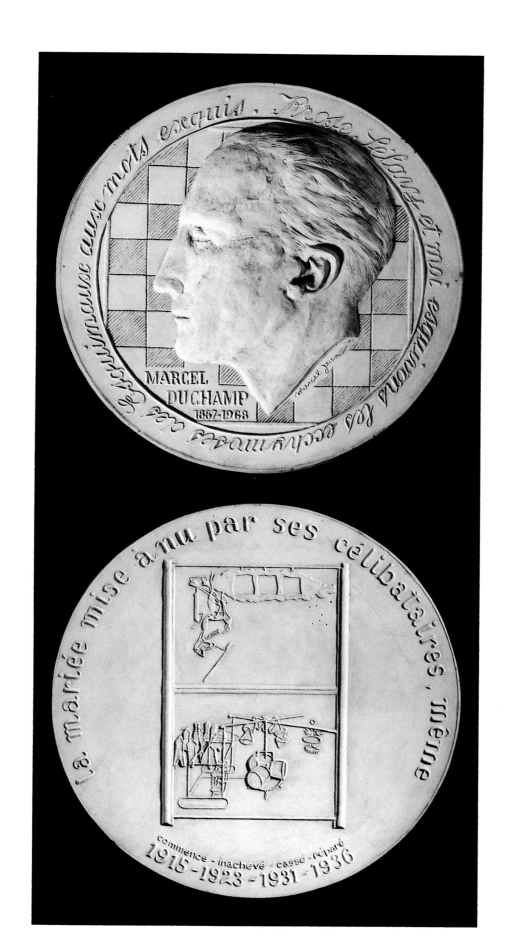

Marcel Duchamp

A Complete Reversal of Art Opinions

First published in *Arts and Decoration*, New York, vol. 5, no. 2,
September 1915, pp. 427–8, 442
as 'by Marcel Duchamp, Iconoclast'
Reprinted in the Duchamp issue of *Studio International*, 1975

'It is just because Rembrandt is none of the things that posterity has given him that he remains.'

Monsieur Duchamp explodes figurative bombs like this one in a tone that is matter of fact but not arrogant. He is neither modest nor vain. He has red hair, blue eyes, freckles, a face, except for a certain sensitiveness, and a figure that would seem American even among Americans. He is young and strangely unaffected by the vast amount of argument created by his work. He is away from the French front on a furlough. He neither talks, nor looks, nor acts like an artist. It may be that in the accepted sense of the word he is not an artist. In any case he has nothing but antipathy for the accepted sense of any of the terms of art. He talked in a studio almost bare of adornment, and containing, here and there, leant against a wall, a chair and a table, pieces of a picture painted on glass that eventually will be put together on a single canvas.

'Rembrandt could never have expressed all the thoughts found in his work. In the religious age he was the great religious painter, another epoch discovered in him a profound psychologist, another a poet, still another, the last one, a master craftsman. This may prove that people give more to pictures than they take from them. Certainly no man can be a profound psychologist and a great religious preacher at once. Rembrandt dipped his pictures in a solution of sentiment. If they are good, they are good despite that.

'There may be an association between Cézanne and Rembrandt. I do not know. The greatest scientific spirit of the nineteenth century, greater in that sense than Cézanne, is Seurat, who died at the age of thirty-two. The twentieth century is to be still more abstract, more cold, more scientific. The American character contains the elements of an extraordinary art. Your life is cold and scientific. Perhaps you are too young in art. The traditions weigh too heavily upon you, turn you into a sort of religious fanatics as little yourselves as possible.

'In architecture the Florentine palaces here have disappeared with the advent of the skyscraper, with the call of utility, that means. Assuredly the Plaza Hotel with its innumerable windows, voraciously taking in light, is more beautiful than the Gothic Woolworth Building, but I like the immensity of the latter.

'New York itself is a work of art, a complete work of art. Its growth is harmonious, like the growth of ripples that come on the water when a stone has been thrown into it. And I believe that your idea of demolishing old buildings, old souvenirs, is fine. It is in line with that so much misunderstood manifesto issued by the Italian Futurists which demanded, in symbol only however, though it was taken literally, the destruction of the museums and libraries. The dead should not be permitted to be so much stronger than the living. We must learn to forget the past, to live our own lives in our own time.'

Monsieur Duchamp was asked for opinions upon the work of men whose names are written large in the list of art.

'Velasquez, like Constantin Meunier, is the type of great man. You feel that he asks you to stand by and admire his greatness, his dexterity, his grandeur and he is terrifically suave. That is not so true of Rodin who is more subtle and thus better able to fool us. His drawings may last for twenty years but next to those of Cézanne they are impossible. Rodin is always sensuous, a materialistic animal, if you will. Cézanne reaches much higher.

'Greco is the root of Picasso. They call Picasso the leader of the cubists but he is not a cubist strictly speaking. He is a cubist today—something else tomorrow. The only real cubists today are Gleizes and Metzinger.

'But that word cubism means nothing at all, it might just as well, for the sense it contains, have been policarpist. An ironical remark of Matisse's gave birth to it. Now we have a lot of little cubists, monkeys following the motion of the leader without comprehension of their significance. Their favourite word is discipline. It means everything to them and nothing.

'Daumier was good in a caricatural way, selected by himself to be sure, but his irony was not so profound as Goya's. The spirit of Daumier is revived in the Greek cartoonist Gallinis who has lately done some very interesting themes in the manner of the cubists.

'Gauguin is an impressionist and a romanticist—a great force—Baudelairian, exotic, a traveller gathering romances out of vague or rare or uncivilized or little known countries.

'Sargent, Simon, Blanche, Cottet, Bernard are impossible. They trade upon antiquity. The prolific Bernard is an especially disgusting parasite. Maurice Denis is a little better. But he goes to mass and going feels that he must reflect the fact in his work. And so in the twentieth century we have what may be called neo-catholicism in art. I do not believe that art should have anything in common with definite theories that are apart from it. That is too much like propaganda. I like Bouguereau better than any of these men, he is so much more honestly an Academician. The others pose as revolutionary and their puny little souls cannot know what revolution means. They must have taken their definition out of the dictionary.

'Whistler has a living personality that he could not fully conserve in his pictures. Remove all the evidence of the influence of traditions upon the work of Gustave Moreau and you will find that he is the most isolated figure of his epoch. There is a great sympathy between the work of Redon and Moreau in refinement of colour and sensitiveness.

'Redon is one of the sources to which Matisse has gone consciously or not. Matisse's colour has not the solidity of Cézanne's, but it cannot be viewed from the same angle. There is nothing that you can take hold of in Matisse's colour, not in the old sense of quality in colour. It is transparent, thin, perhaps, but when you have left his pictures, you will see that they have taken hold of you.'

RAYMOND DUCHAMP-VILLON

SCULPTEUR

(1876 - 1918)

EX LIBRIS

PARIS

—

MCMXXIV

JUSTIFICATION DU TIRAGE

———

Il a été de tiré de cet ouvrage 20 exemplaires sur Vélin d'Arches Impérial

Numérotés de 1 à 20

et 280 exemplaires sur Vélin mat, numérotés de 21 à 300

Achevés d'imprimer par les soins de Jacques POVOLOZKY, Éditeur
sur les Presses de l'Imprimerie Crozatier, à Paris
le 20 Mars 1924.

N° 162

Title page of monograph
by Walter Pach, 1924

Marcel Duchamp

Jugements et Critiques

Jean Metzinger

From catalogue, Société Anonyme, 1943

In 1911 two distinct groups of painters were giving form to the new theory of Cubism which was then brooding in an incubating period. Picasso and Braque on one side; Metzinger, Gleizes and Léger on the other. Metzinger was then the most imaginative theoretician of Cubism and must be held responsible in a large measure for the critical and ever-increasing interest which the general public took in this new form of expression. Through his articles and his book, *Du Cubisme*, written in collaboration with Gleizes, he managed to give a substantial *exposé* of the main intentions of the new painters and helped to clarify the really obscure results thus far achieved. His paintings of the first period were marked by a rich technical discipline, coupled with a very deep insight, leaning towards the intellectual. Such activities made Metzinger one of the outstanding pioneers of Cubism. Later his vigor lessened and he did not repeat his early achievements.

Antoine Pevsner

From catalogue, Société Anonyme, 1949

Pevsner started as a painter in Russia long before the Revolution; his wax paintings of 1913 show his awakening interest in the technique of transparency and already announce his later experiments with translucent materials. But *trompe l'oeil* painting was too limited a medium for Pevsner who, quite naturally, turned to sculpture.

Sculpture of construction, or Constructivism, is an aesthetic attitude toward life which the two brothers, Gabo and Pevsner, conceived and expressed in their 1920 manifesto.

Pevsner's demands on art could not be satisfied by volume sculpture, but led him to create a new 'setting', a sort of 'chamber architecture' to express his space-time reality. In his recent works on the analysis of the 'surface', Pevsner uses bronze instead of transparent materials. The surface, expressed only by its generating elements, fine lines close together, becomes a 'denatured' surface, another important discovery of Constructivism. The surface is suggested by the lines but not actually seen or visible as real surface.

Jacques Villon

From catalogue, Société Anonyme, 1949

Four of the seven children in the Duchamp family became artists; Jacques Villon, the oldest; Raymond Duchamp-Villon, the sculptor and architect; Marcel Duchamp; and Suzanne Duchamp. Jacques Villon first made a name for himself as a cartoonist around 1900, but his real vocation was etching and oil painting. His early etchings show the technical perfection and traditional respect for that medium. He expressed still more personality in his oil paintings; after joining the Cubist Movement among the first he never lost his lyrical qualities and kept true to himself even during his most severe Cubist period. After passing through the various experiments of his long career, Villon has now reached an incisive formula, where the relationship of color is supported by an architectural drawing; an affirmation, a conclusion, which brings added joy to those who have witnessed his constant growth and great achievement.

Raymond Duchamp-Villon

From catalogue, Société Anonyme, 1943

Raymond Duchamp-Villon had already received recognition as a sculptor when the new art theories tempted him and made him the first exponent of Cubist sculpture. His well known *Horse* will always be remembered as one of the landmarks of the Cubist Movement. His premature death makes one feel, very acutely, the significance of the far too few pieces he left behind. His *Baudelaire* and *Seated Woman* are two fine examples of his simplification which at the time the work was done, about 1908, even exceeded Rodin's synthesis of the *Walking Man*, and are still in advance of much of the sculpture of today.

Albert Gleizes

From catalogue, Société Anonyme, 1943

On the strength of the first tangible results which Cubism had already obtained, in 1912 Gleizes and Metzinger wrote a book, *Du Cubisme*, in which they clarified the mental chemistry of Cubism. Through the analysis and conclusion Gleizes showed the connection between the theoretical mind and the brush, winning the reading public to the new cause. In his personal approach to Cubism, he dissected several large compositions of a descriptive character. This was in opposition to the almost microscopic research of Braque. Gleizes was among the first to see the application of the new methods to the 'Unamist', scenes. The 'Unammists' were members of a literary group in Paris, about 1905, who concerned themselves with the conflict between organized bodies of society one against another, or organized bodies of society one against the individual. Gleizes showed great personality in his form of painting, and later on when the technique of Cubism became more a dogma than a necessity Gleizes turned to his writings again, this time with a humanitarian touch. It was natural, therefore, that in later years, he should have left the Cubist world, as all Cubists have done, and have continued to develop his own ideas of visualization. Albert Gleizes is deeply concerned with the social problems of our day especially those affecting the workman. His recent paintings serve a definite religious purpose and have become the stained-glass windows of his new creed.

Kupka

From *Kupka*, exhibition catalogue, Louis Carré Gallery, New York, 1951

Almost fifty years ago Kupka gave a memorable New Year's party at his studio at the Rue Caulaincourt and shortly thereafter he began to see 'abstract', as one calls it nowadays. For the word was not yet in the dictionary of that happy time. Apollinaire used the word 'Orphism' when he spoke about those things . . .

And now the search for the father is conducted by the father-candidates themselves, who do not, (however) believe in any poly-paternity of this gigantic child.

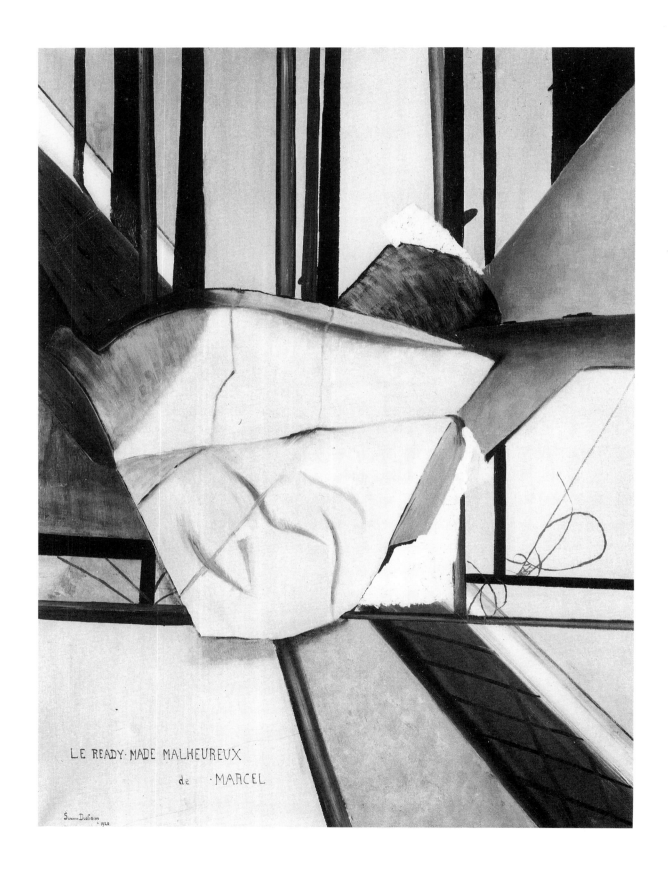

Marcel Duchamp

Apropos of 'Readymades'

Address given at the Museum of Modern Art, New York, 19 October 1961
Translated by Marcel Duchamp and Simon Watson Taylor
First published in *Art & Artists*, vol. 1, no. 4, July 1966, p. 47

IN 1913 I HAD THE HAPPY IDEA TO FASTEN A BICYCLE WHEEL TO A KITCHEN STOOL AND WATCH IT TURN.

A FEW MONTHS LATER I BOUGHT A CHEAP REPRODUCTION OF A WINTER EVENING LANDSCAPE, WHICH I CALLED 'PHARMACY' AFTER ADDING TWO SMALL DOTS, ONE RED AND ONE YELLOW, IN THE HORIZON.

IN NEW YORK IN 1915 I BOUGHT AT A HARDWARE STORE A SNOW SHOVEL ON WHICH I WROTE 'IN ADVANCE OF THE BROKEN ARM'.

IT WAS AROUND THAT TIME THAT THE WORD 'READYMADE' CAME TO MIND TO DESIGNATE THIS FORM OF MANIFESTATION.

A POINT WHICH I WANT VERY MUCH TO ESTABLISH IS THAT THE CHOICE OF THESE 'READYMADES' WAS NEVER DICTATED BY AN AESTHETIC DELECTATION.

THIS CHOICE WAS BASED ON A REACTION OF *VISUAL* INDIFFERENCE WITH AT THE SAME TIME A TOTAL ABSENCE OF GOOD OR BAD TASTE . . . IN FACT A COMPLETE ANAESTHESIA.

ONE IMPORTANT CHARACTERISTIC WAS THE SHORT SENTENCE WHICH I OCCASIONALLY INSCRIBED ON THE 'READYMADE'.

THAT SENTENCE INSTEAD OF DESCRIBING THE OBJECT LIKE A TITLE WAS MEANT TO CARRY THE MIND OF THE SPECTATOR TOWARDS OTHER REGIONS MORE VERBAL.

SOMETIMES I WOULD ADD A GRAPHIC DETAIL OF PRESENTATION WHICH IN ORDER TO SATISFY MY CRAVING FOR ALLITERATIONS, WOULD BE CALLED 'READYMADE AIDED'.

AT ANOTHER TIME WANTING TO EXPOSE THE BASIC ANTINOMY BETWEEN ART AND READYMADES I IMAGINED A 'RECIPROCAL READYMADE': USE A REMBRANDT AS AN IRONING BOARD!

I REALIZED VERY SOON THE DANGER OF REPEATING INDISCRIMINATELY THIS FORM OF EXPRESSION AND DECIDED TO LIMIT THE PRODUCTION OF 'READYMADES' TO A SMALL NUMBER YEARLY. I WAS AWARE, AT THAT TIME, THAT FOR THE SPECTATOR EVEN MORE THAN FOR THE ARTIST, *ART IS A HABIT FORMING DRUG* AND I WANTED TO PROTECT MY 'READYMADES' AGAINST SUCH CONTAMINATION.

ANOTHER ASPECT OF THE 'READYMADE' IS ITS LACK OF UNIQUENESS . . . THE REPLICA OF A 'READYMADE' DELIVERING THE SAME MESSAGE; IN FACT NEARLY EVERY ONE OF THE 'READYMADES' EXISTING TODAY IS NOT AN ORIGINAL IN THE CONVENTIONAL SENSE.

A FINAL REMARK TO THIS EGOMANIAC'S DISCOURSE: SINCE THE TUBES OF PAINT USED BY THE ARTIST ARE MANUFACTURED AND READY-MADE PRODUCTS WE MUST CONCLUDE THAT ALL THE PAINTINGS IN THE WORLD ARE 'READYMADES AIDED' AND ALSO WORKS OF ASSEMBLAGE.

From *Antoine Pevsner*,
exhibition catalogue
Edited and published by René Drouin, Paris 1947

Signification des principales indications éventuelles
pouvant figurer en tête de l'adresse

D.... = Urgent.
AR. = Remettre contre reçu.
PC. = Accusé de réception.
RP. = Réponse payée.
TC. = Télégramme collationné.
MP. = Remettre en main propre.

XPx = Exprès payé.
NUT..... = Remettre même pendant la nuit.
JOUR ... = Remettre seulement pendant le jour.
OUVERT = Remettre ouvert.

Via WESTERN UNION

PST1 65/2 NJA NEWYORK 23 2

= JE SOUSSIGNE DECLARE CONNAITRE ANTOINE PEVSNER DEPVIS
1923 ET LUI ETRE REDEVABLE DE MAINT ETONNEMENT=
= MARCEL DUCHAMP.

Telegram

From Marcel Duchamp (New York)
to Katherine Dreier (Connecticut),
16 January 1948

ALREADY 1920 NEED FOR SHOWING
MODERN ART STILL IN CHAOTIC STATE
OF DADA IN NON COMMERCIAL
SETTING TO HELP PEOPLE GRASP
INTRINSIC SIGNIFICANCE STOP AIM OF
SA TO SHOW INTERNATIONAL ASPECT
BY CHOOSING IMPORTANT MEN FROM
EVERY COUNTRY UNKNOWN HERE
SCHWITTERS MONDRIAN KANDINSKY
VILLON MIRO DUCHAMP 1920 DADA SA.

Marcel Duchamp

The Creative Act

First published in *Art News*, New York, vol. 56, no. 4,
Summer 1957, pp. 28–9

Let us consider two important factors, the two poles of the creation of art: the artist on one hand, and on the other the spectator who later becomes the posterity.

To all appearances, the artist acts like a mediumistic being who, from the labyrinth beyond time and space, seeks his way out to a clearing.

If we give the attributes of a medium to the artist, we must then deny him the state of consciousness on the esthetic plane about what he is doing or why he is doing it. All his decisions in the artistic execution of the work rest with pure intuition and cannot be translated into a self-analysis, spoken or written, or even thought out.

T. S. Eliot, in his essay on 'Tradition and the Individual Talent', writes: 'The more perfect the artist, the more completely separate in him will be the man who suffers and the mind which creates; the more perfectly will the mind digest and transmute the passions which are its materials.'

Millions of artists create; only a few thousands are discussed or accepted by the spectator and many less again are consecrated by posterity.

In the last analysis, the artist may shout from all the rooftops that he is a genius; he will have to wait for the verdict of the spectator in order that his declarations take a social value and that, finally, posterity includes him in the primers of Art History.

I know that this statement will not meet with the approval of many artists who refuse this mediumistic role and insist on the validity of their awareness in the creative act—yet, art history has consistently decided upon the virtues of a work of art through considerations completely divorced from the rationalized explanations of the artist.

If the artist, as a human being, full of best intentions toward himself and the whole world, plays no role at all in the judgement of his own work, how can one describe the phenomenon which prompts the spectator to react critically to the work of art? In other words how does this reaction come about?

This phenomenon is comparable to a transference from the artist to the spectator in the form of an esthetic osmosis taking place through the inert matter, such as pigment, piano or marble.

But before we go further, I want to clarify our understanding of the word 'art'—to be sure, without an attempt to a definition.

What I have in mind is that art may be bad, good or indifferent, but, whatever adjective is used, we must call it art, and bad art is still art in the same way as a bad emotion is still an emotion.

Therefore, when I refer to 'art coefficient,' it will be understood that I refer not only to great art, but I am trying to describe the subjective mechanism which produces art in a raw state—*à l'état brut*—bad, good or indifferent.

In the creative act, the artist goes from intention to realization through a chain of totally subjective reactions. His struggle toward the realization is a series of efforts, pains, satisfactions, refusals, decisions, which also cannot and must not be fully self-conscious, at least on the esthetic plane.

The result of this struggle is a difference between the intention and its realization, a difference which the artist is not aware of.

Consequently, in the chain of reactions accompanying the creative act, a link is missing. This gap which represents the inability of the artist to express fully his intention; this difference between what he intended to realize and did realize, is the personal 'art coefficient' contained in the work.

In other words, the personal 'art coefficient' is like an arithmetical relation between the unexpressed but intended and the unintentionally expressed.

To avoid a misunderstanding, we must remember that this 'art coefficient' is a personal expression of art 'à l'état brut,' that is, still in a raw state, which must be 'refined' as pure sugar from molasses, by the spectator; the digit of this coefficient has no bearing whatsover on his verdict. The creative act takes another aspect when the spectator experiences the phenomenon of transmutation; through the change from inert matter into a work of art, an actual transubstantiation has taken place, and the role of the spectator is to determine the weight of the work on the esthetic scale.

All in all, the creative act is not performed by the artist alone: the spectator brings the work in contact with the external world by deciphering and interpreting its inner qualifications and thus adds his contribution to the creative act. This becomes even more obvious when posterity gives its final verdict and sometimes rehabilitates forgotten artists.

Philadelphia, 1960

WHERE DO WE GO FROM HERE?

Pour inventer l'avenir il faut peut-être partir d'un passé plus ou moins récent qui pour nous aujourd'hui semble commencer avec le réalisme de Courbet et de Manet. Il semble bien en effet que le réalisme ait été à la base de la libération de l'artiste en tant qu'individu dont l'oeuvre existe par elle-même et à laquelle le spectateur ou le collectionneur s'adapte, quelquefois avec effort.

Cette période de libération donne bien vite naissance à tous les ismes qui se sont succédés pendant les 100 dernières années, à la vitesse d'un nouvel isme tous les 15 ans environ.

Il faut, je crois, au lieu de différencier ces ismes, les grouper dans une directive commune pour essayer de deviner ce qui se passe demain.

Considérées dans le cadre d'un siècle d'art moderne, les productions très récentes d'abstract-expressionism rentrent bien l'apogée de l'approche rétinienne commencée par l'impressionisme. Par rétinien j'entends que la délectation esthétique dépend presque exclusivement de l'impression sur la rétine sans faire appel à aucune interprétation auxiliaire.

Il y a 70 ans à peine le public demandait encore à l'oeuvre d'art quelque détail représentatif pour justifier son intérêt ou admiration.

Aujourd'hui le contraire est presque vrai...le grand public connaît l'existence de l'abstraction, la comprend et l'exige même des artistes.

Je ne parle pas des collectionneurs qui ont soutenu depuis 50 ans cette progression vers un complet abandon de la représentation dans les arts visuels, ils ont été, comme les artistes, entrainés par le courant. Le fait que le problème des cent dernières années se réduise presque au seul dilemme du "représentatif et du non représentatif" me semble corroborer l'importance que je donne, si j'ose un instant à l'aspect complètement rétinien de toute la production des différents ismes.

Therefore après cet examen du passé je suis enclin à croire que le jeune artiste de demain refusera de baser son oeuvre sur une philosophie aussi simpliste que celle du dilemme "représentatif ou non représentatif."

Il sera amené, j'en suis convaincu, à traverser le miroir de la rétine comme Alice in Wonderland pour atteindre à une expression plus profonde.

Je sais trop bien que parmi les ismes dont je viens de parler, le surréalisme a introduit l'exploration du subconscient et réduit le rôle de la rétine à celui de fenêtre ouverte sur des phénomènes matière grise.

Le jeune artiste de demain devra je crois aller plus loin encore dans cette même direction pour mettre à jour de nouvelles valeurs de choc qui sont et seront toujours la base des révolutions artistiques.

Si maintenant nous envisageons le côté plus technique d'un avenir possible il est très probable que, las du culte de l'huile dans la peinture, l'artiste se trouve amené à abandonner complètement ce procédé vieux de 5 siècles et dont le joug académique, genère en liberté d'expression.

3

D'autres techniques se sont déjà fait jour récemment et on peut prévoir que de même que l'invention de nouveaux instruments en musique change toute la sensibilité d'une époque, les phénomènes lumineux dus aux progrès scientifiques actuels peuvent entre autres moyens, devenir l'outil nouveau pour l'artiste nouveau.

Dans l'état actuel des rapports entre artistes et public nous sommes témoins d'une production gigantesque que le public d'aille rencontre et encourage. Les arts visuels par leur étroite connexion avec la loi de l'offre et de la demande sont devenus une "commodity", l'oeuvre d'art est maintenant un produit courant comme le savon et les "securities."

On peut donc parfaitement imaginer la création d'un syndicat qui règlerait toutes les questions économiques concernant l'artiste... on peut imaginer ce syndicat décidant du prix de vente des oeuvres d'art comme le syndicat des plombiers réglemente les salaires de chaque ouvrier...on peut encore imaginer ce syndicat forçant l'artiste à abdiquer sa personnalité au point de ne pas même avoir le droit de signer ses oeuvres. L'ensemble de la production artistique dirigée par un syndicat de ce genre formerait-il une sorte de monument de l'époque comparable aux cathédrales anonymes??

Ces divers aspects de l'art d'aujourd'hui nous amènent à l'envisager globalement sous la forme d'un esotérisme hypertrophié. J'entends par là que le grand public accepte et demande beaucoup d'art, beaucoup trop d'art; que le grand public recherche aujourd'hui des satisfactions esthétiques enveloppées dans un jeu de valeurs matérielles et spéculatives, et entraine la production artistique vers une dilution massive.

4

Cette dilution massive perdant en qualité ce qu'elle gagne en quantité s'accompagne d'un nivellement par le bas du goût présent et aura pour conséquence immédiate un brouillard de médiocrité dans un avenir prochain.

Pour conclure j'espère que cette médiocrité conditionnée par trop de facteurs étrangers à l'art par se amènera une révolution d'ordre ascétique cette fois dont le grand public ne sera même pas conscient et que seuls quelques initiés développeront en marge d'un monde aveuglé par le feu d'artifice économique.

The great artist of tomorrow will go underground.

Marcel Duchamp

Marcel Duchamp

Where Do We Go From Here?

Symposium at Philadelphia Museum College of Art, March 1961
Address to a symposium at the Philadelphia Museum College of Art,
March 1961
Translated by Helen Meakins
First published in the Duchamp issue of *Studio International*, 1975

To imagine the future, we should perhaps start from the more or less recent past, which seems to us today to begin with the realism of Courbet and Manet. It does not seem in fact that realism is at the heart of the liberation of the artist as an individual, whose work, to which the viewer or collector adapt himself, sometimes with difficulty, has an independent existence.

This period of liberation rapidly gave birth to all the 'isms' which have followed one another during the last century, at the rate of one new 'ism' about every fifteen years.

I believe that to try and guess what will happen tomorrow, we must group the 'isms' together through their common factor, instead of differentiating them.

Considered in the framework of a century of modern art, the very recent examples of Abstract Expressionism clearly show the ultimate in the retinal approach begun by Impressionism. By 'retinal' I mean that the aesthetic pleasure depends almost entirely on the impression on the retina, without appealing to any auxiliary interpretation.

Scarcely twenty years ago the public still demanded of the work of art some representative detail to justify its interest and admiration.

Today, the opposite is almost true . . . the general public is aware the existence of abstraction, understands it and even demands it of the artists.

I am not talking about the collectors who for fifty years have supported this progression towards a total abandon of representation in the visual arts; like the artists, they have been swept along by the current. The fact that the problem of the last hundred years boils down almost entirely to the single dilemma of the 'representative and the non-representative' seems to me to reinforce the importance I gave a moment ago to the entirely retinal aspect of the total output of the different 'isms'.

Therefore I am inclined, after this examination of the past, to believe that the young artist of tomorrow will refuse to base his work on a philosophy as over-simplified as that of the 'representative or non-representative' dilemma.

I am convinced that, like Alice in Wonderland, he will be led to pass through the looking-glass of the retina, to reach a more profound expression.

I am only too well aware that among the 'isms' which I have mentioned, Surrealism introduced the exploration of the subconscious and reduced the role of the retina to that of an open window on the phenomena of the brain.

The young artist of tomorrow will, I believe, have to go still further in this same direction, to bring to light startling new values which are and will always be the basis of artistic revolutions.

If we now envisage the more technical side of a possible future, it is very likely that the artist, tired of the cult for oils in painting, will find himself completely abandoning this five-hundred-year-old process, which restricts his freedom of expression by its academic ties.

Other techniques have already appeared recently and we can foresee that just as the invention of new musical instruments changes the whole sensibility of an era, the phenomenon of light can, due to current scientific progress, among other things, become the new tool for the new artist.

In the present state of relations between artists and the public, we can see an enormous output which the public moreover supports and encourages. Through their close connection with the law of supply and demand the visual arts have become a 'commodity'; the work of art is now a commonplace product like soap and securities.

So we can perfectly well imagine the creation of a union which would deal with all the economic questions concerning the artist . . . we can imagine this union deciding on the selling price of works of art, just as the plumbers' union determines the salary of each worker . . . we can even imagine this union forcing the artist to abandon his identity, even to the point of no longer having the right to sign his works. Would the total artistic output controlled by a union of this kind form a sort of monument to a given era comparable to the anonymous cathedrals?

These various aspects of art today bring us to look at it as a whole, in terms of an over-developed exoteric. By that I mean that the general public accepts and demands a lot from art, far too much from art; that the general public today seeks aesthetic satisfaction wrapped up in a set of material and speculative values and is drawing artistic output towards an enormous dilution.

This enormous dilution, losing in quality what it gains in quantity, is accompanied by a levelling down of present taste and its immediate result will be to shroud the near future in mediocrity.

In conclusion, I hope that this mediocrity, conditioned by too many factors foreign to art *per se*, will this time bring a revolution on the ascetic level, of which the general public will not even be aware and which only a few initiates will develop on the fringe of a world blinded by economic fireworks.

The great artist of tomorrow will go underground.

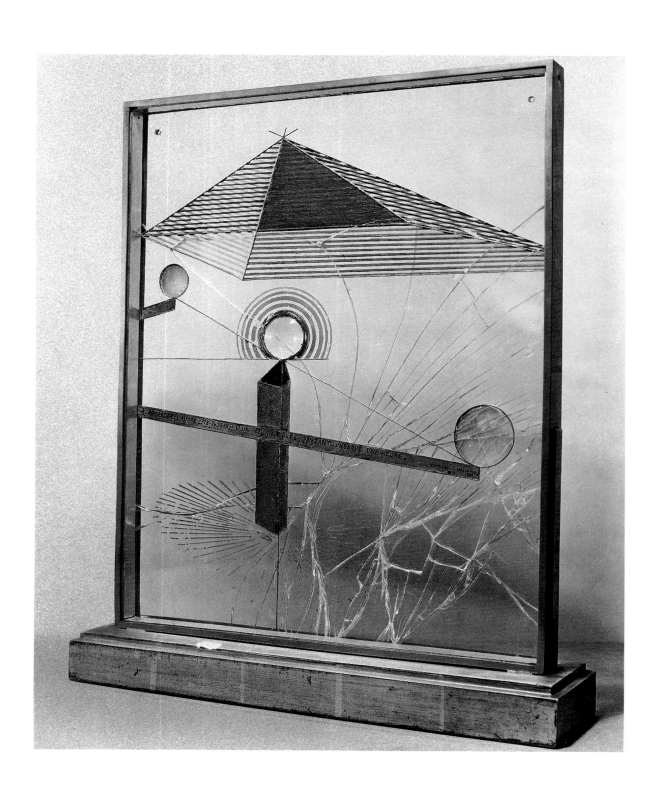

Le Grand Verre

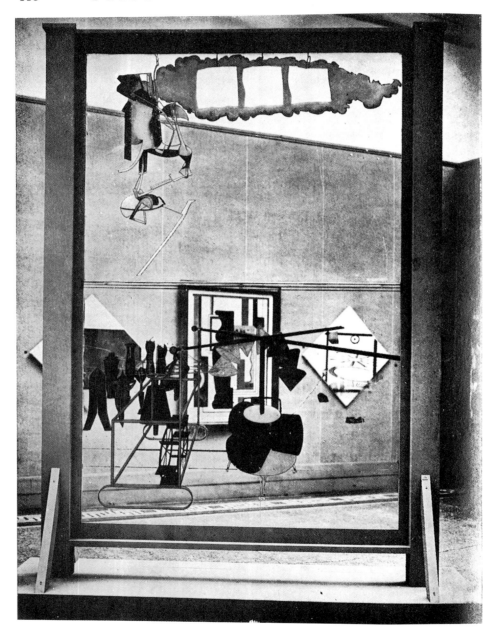

118 FOUNDATIONS OF MODERN ART

Object painted on transparent glass. Through it can be seen pictures by
Léger and Mondrian.

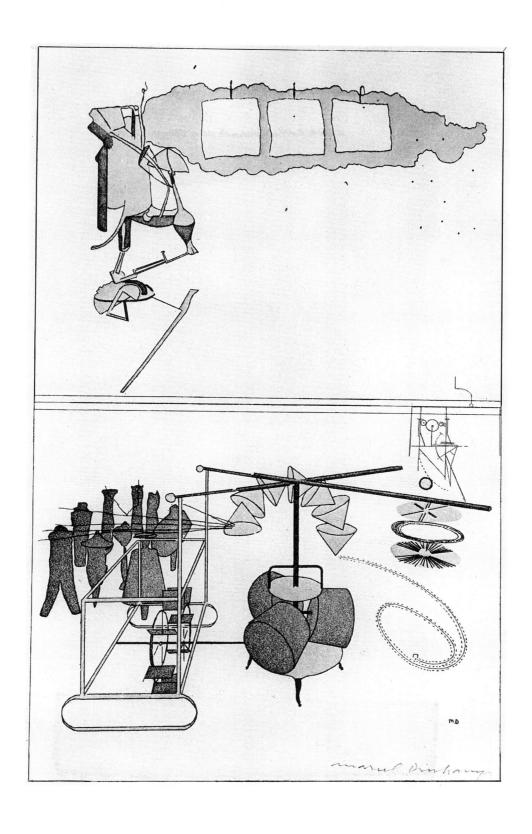

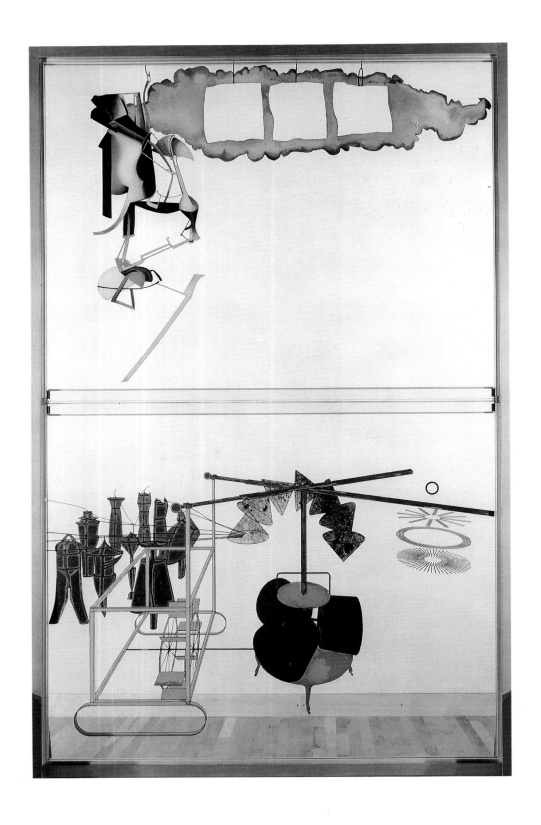

94

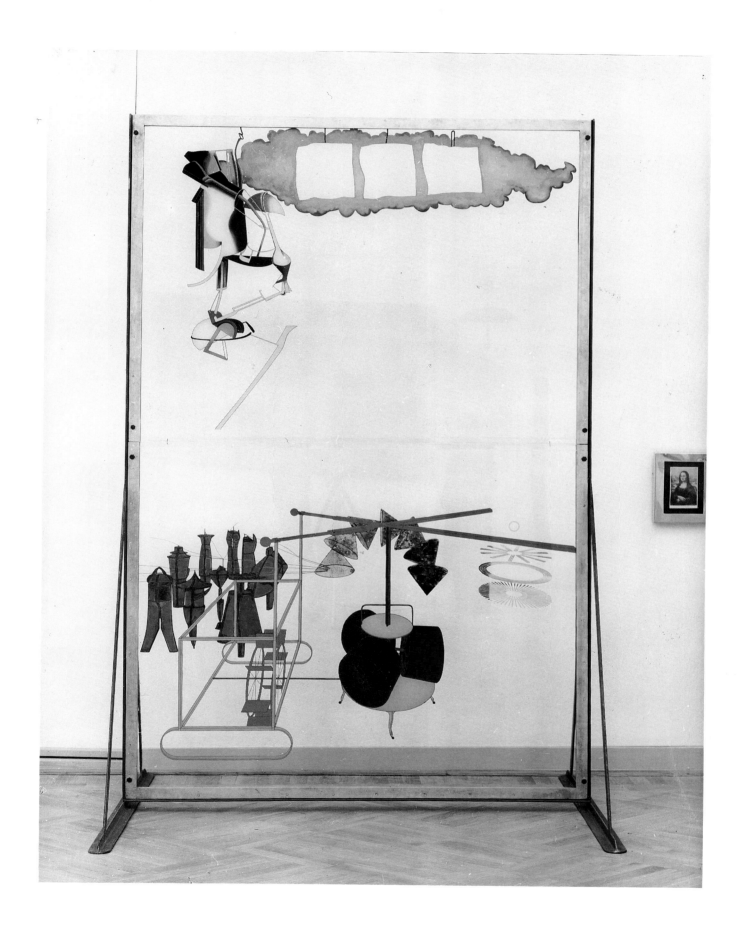

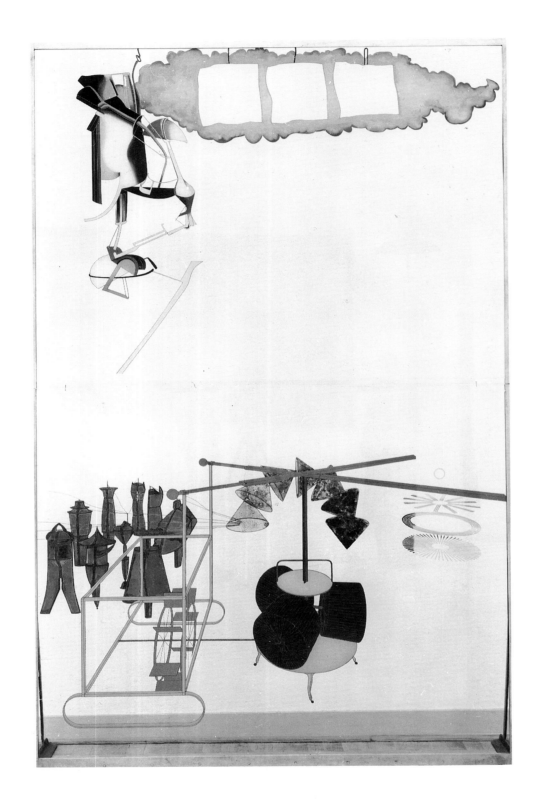

Yoshiaki Tono
Replica of the Large Glass 1981
First exhibited Seibu Museum, Karuizawa and Tokyo,
1981

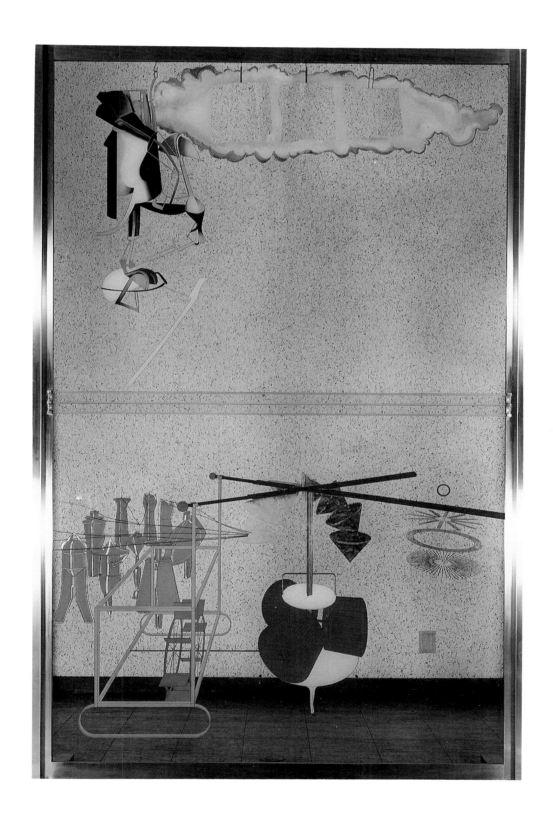

Marcel Duchamp
Water Mill with Glider 1913–15
Glass
Louise and Walter Arensberg Collection,
Philadelphia Museum of Art

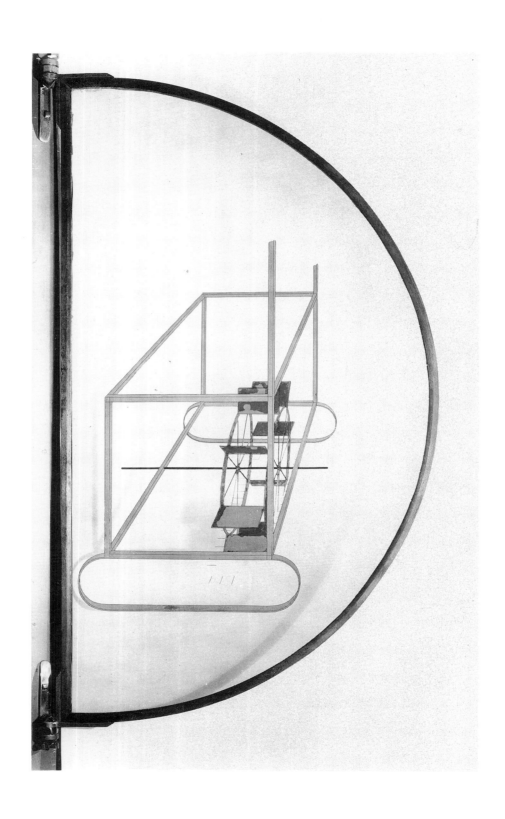

Jennifer Gough-Cooper and Jacques Caumont

Frederick Kiesler
and *The Bride Stripped Bare . . .*

First published in Dieter Bogner, ed., *Frederick Kiesler*,
Locker Verlag, Vienna, 1988

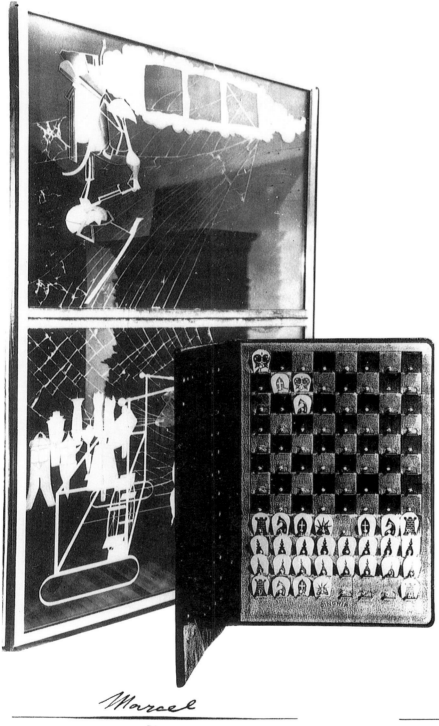

Three events in the Thirties triggered an awakening of interest in *The Bride stripped bare by her Bachelors, even*[1] by Marcel Duchamp. In 1931 the *Large Glass*, as it is commonly referred to, was shattered in transit by truck between New York and West Redding, Connecticut;[2] in September 1934, Rrose Sélavy published the manuscript of *The Bride stripped bare . . .* known as *The Green Box*;[3] in the summer of 1936, Duchamp spent more than two months painstakingly repairing the Glass for its owner Miss Katherine S. Dreier.

The announcement to the artistic world that an unpublished manuscript for the Glass existed, was made by André Breton in 1932 when he was guest editor of *This Quarter*.[4] Three years later Breton, who still had not seen the Glass, used *The Green Box* as the basis for the first published account of the *Large Glass*: 'Le phare de la mariée' in which he firmly situated Duchamp on the crest of 'the tidal wave . . . upsetting from base to summit, far and wide, the artistic and moral landscape.'[5] Kiesler, who did not possess a copy of *The Green Box* but had been impassioned by the Glass after Duchamp had repaired it, wrote and designed eight pages for the May number of *The Architectural Record* in 1937. It was the first study of *The Bride stripped bare . . .* to appear in America.

The Bride stripped bare by her Bachelors, even photographed by Berenice Abbott and *Pocket Chess Set* (photo Daniel Pype) showing an example of a final position using the Raymond Roussel Formula, montage J & J.

Duchamp's reaction to Kiesler's article was one of evident pleasure and at the same time astonishment:

Quelle surprise vous m'avez faite! J'ai eu très grand plaisir à lire votre article . . . d'abord l'esprit de l'article, puis votre interprétation et la présentation de vos idées! Je vous remercie d'avoir bien voulu regarder le verre avec une telle attention et d'avoir fixé les points que peu de gens connaissent.[6]

The Bride stripped bare . . . which had been lying neglected in America for many years was gradually becoming the subject of attention.

Duchamp and Kiesler first became acquainted in Paris at the time of the *Exposition internationale des arts décoratifs et industriels modernes* in 1925.[7] Afterwards, while Duchamp remained in Paris and Kiesler lived in New York the opportunities to meet were rare. However, Duchamp crossed the Atlantic docking on 20 October 1926 with the contents of a massive Brancusi exhibition which, after the well-publicized battle with customs as to whether the sculptures were Art or not, opened on 17 November at the Brummer Gallery in New York. Two days later the International Exhibition of Modern Art organized by the Société Anonyme opened at the Brooklyn

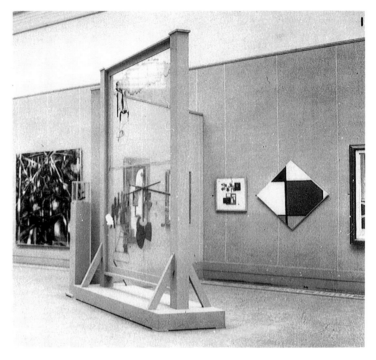

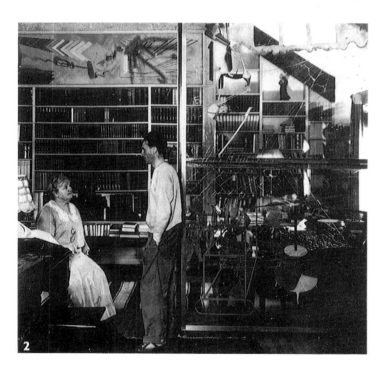

Museum. This remarkable updated sequel to the Armory Show consisted of more than 300 works by 106 artists from 23 countries. The greater part of the exhibits had been collected by the perceptive Miss Dreier (co-founder and driving force of the Société Anonyme) assisted by Duchamp (in his capacity as Secretary to the association) on her recent whistle-stop tour of studios in Europe. In the exhibition, *The Bride stripped bare . . .* made its first and only public appearance before it was broken. (Fig. 1) Duchamp himself advised on the framing and its installation.[8]

At the time of Duchamp's arrival in New York, Kiesler, who had met Miss Dreier earlier in the year, was working on the design of a 'modern room' for the Société Anonyme exhibition.[9] A model of the 'television room', as Miss Dreier later called it,[10] where visitors at the simple touch of a button could see masterpieces from museums all over the world, was incorporated in the reduced version of the exhibition at the Anderson Galleries in New York. Duchamp, who had been in Chicago for three weeks with the Brancusi exhibition, was back in New York just in time to attend the opening on 25 January 1927.[11]

Duchamp returned to New York with another Brancusi exhibi-

1. *The Bride stripped bare by her Bachelors, even,* exhibited in the International Exhibition of Modern Art organized by the Société Anonyme at the Brooklyn Museum, 1926.
 Société Anonyme Archive, the Collection of American Literature, Beinecke Rare Book and Manuscript Library, Yale University

2. MD and KSD at The Haven, West Redding on 30 August 1936 after The Large Glass had been repaired and installed in her studio.
 Société Anonyme Archive

tion in the fall of 1933 and during his stay he dined one evening with the Kieslers.[12] He visited the United States again in 1936 in order to repair the *Large Glass*. On this occasion, Duchamp spent most of June and July staying with Miss Dreier at West Redding, working relentlessly on the restoration. During one of his short breaks in New York, on 25 June, he joined the Kieslers, Sidney and Harriet Janis for dinner.[13]

The task of finding and fitting together thousands of slivers of shattered glass was a heroic act in itself, for a re-birth of *The Bride stripped bare . . .* to be the outcome was miraculous. (Fig. 2) Kiesler, who after all had seen the *Large Glass* at the Brooklyn Museum, considered that 'not until the breakage had actually occurred was the cycle of perfect fusion of the sub-conscious image with its realization completed, and the time ripe to give its message to the public.'[14]

In preparation for his article, Kiesler invited Berenice Abbott to photograph the Glass. One very cold day at the end of January 1937[15] they motored to West Redding with Miss Dreier who later wrote that Berenice Abbott, taking 'tremendous pains', photographed the Glass with a black cloth behind it and with 'a lens which cut out all reflections.'[16] The result was a

series of dramatic photographs in which the glinting, uncannily symmetrical cracks marry with the luminous painted areas and the meticulously laid lead strips of the original drawing. One illustration used in the article is a detail of the Glass which Kiesler with uninhibited poetic licence turned sideways creating a curiously darkened landscape over which streaks a slipstream of cracks and the Oculist Witnesses hover mysteriously in the illuminated sky. (Fig. 3)

'Architecture is control of space. An easel painting is illusion of Space-Reality. Duchamp's Glass is the first x-ray-painting of space' Kiesler wrote as the epigraph for his article. 'It is architecture, sculpture and painting in ONE' and to create such a *gesamtkunstwerk* he maintained 'one needs as a lens (a) oneself, well focused and dusted off, (b) the subconscious as camera obscura, (c) a super-consciousness as sensitizer and (d) the clash of this trinity to illuminate the scene.' Kiesler refused to attempt any interpretations, preferring to concentrate on 'the teaching of its techniques' and predicted that 'such physic and psychoanalysis will be readily found here and there, now and later . . .'

Kiesler observed that glass is the only building material which expresses 'surface-and-space' at the same time and that

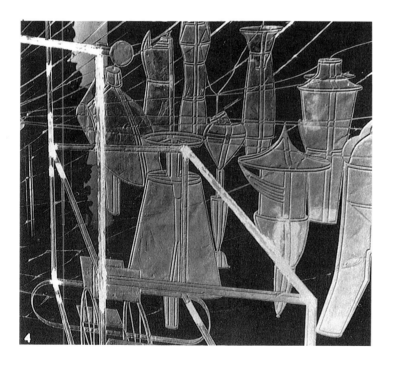

3. Detail of the *Large Glass* photographed by Berenice Abbott.

4. Detail of the *Large Glass* photographed by Berenice Abbott.

Duchamp, in painting part of the transparent surface, 'accentuated the space division optically' and created a spacial balance between stability and mobility: 'the painting seems suspended in midair . . . It floats. It is in a state of eternal readiness for action, motion and radiation.' Using a photograph of a magnified winged insect juxtaposed with the front and back views of the Malic Moulds in close up (Fig.4), Kiesler stressed the importance of precise joints and contours in design to make form.

> The ligaments of steel-or-what-not, single or double spaced, wires that are used, instead of paint strokes, for contourings make wider and narrower outer and inner-contours to create precise form articulation. Those heavier and lighter lines thus divide all shapes and at the same time link them!

A fully illustrated description of the ancient way to build stained glass windows was included but the author claimed that Duchamp 'simplified such antiquated techniques, and outmoded them with his new method of "structural painting".' Although Kiesler terminated his article with general information about the properties of modern glass and plastic sheet and examples of their use in contemporary building, the piece cost him his job on the magazine.[17]

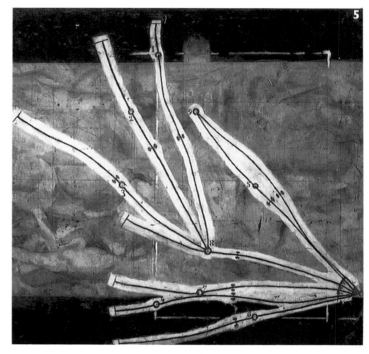

Kiesler's fascination with the *Large Glass* did not end there. As well as acquiring Duchamp's canvas *Network of Stoppages*, 1914 from Joseph Stella in May 1937[18] (Fig.5), Kiesler received a complimentary copy of *The Green Box* a few weeks later from Duchamp who wrote saying he hoped that in reading through the notes he would see how right he, Kiesler, had been in his approach to the Glass.[19] Spurred by this encouragement and primed with the notes, Kiesler prepared a lecture on the *Large Glass*. The plan of his discourse was ingenious. First he read a sentence from the Box and then he showed each detail of the Glass in turn, drawing on material from his article, and only at the end of his lecture revealed the whole composition of *The Bride stripped bare . . .*[20] Miss Dreier highly approved and much enjoyed the evening when Kiesler repeated the lecture at the Art Students' League on 26 January 1938.[21]

*

In January 1941 Duchamp completed the first copy of his own museum in miniature, *The Box in a Valise*,[22] and he forecast that he could assemble them at the rate of one every three

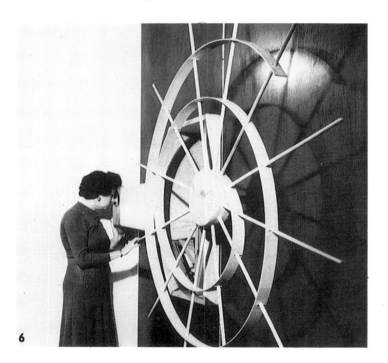

5. *Network of Stoppages*, 1914.
Collection, Museum of Modern Art, New York

6. Peggy Guggenheim looking at the *Box in a Valise* as it was installed by Frederick Kiesler in her gallery Art of this Century, New York.

weeks. In spite of extreme difficulties of communication, Peggy Guggenheim took delivery of one of the first in April 1941[23] before her departure from Marseilles. After gradually ferrying to freedom the contents of the Valise from Paris to the unoccupied zone, Duchamp finally arrived in New York on 26 June 1942. He stayed a few weeks with Robert Parker, then with Max Ernst and Peggy Guggenheim before moving in October[24] to a room offered to him by the Kieslers in their penthouse at 56 Seventh Avenue where he lived for a year. When Duchamp moved to their apartment, Kiesler was fully occupied with the decoration of Peggy Guggenheim's gallery-cum-museum, Art of this Century, which opened on 20 October 1942. As an integral part of his design, Kiesler installed Duchamp's *Box in a Valise* in a corridor opposite a group of Paul Klees. The conception of the installation recalled Kiesler's idea for the 'television room' of 1927. Simone de Beauvoir described the mechanism as *'une grande roue de bateau dont le mouvement tournant déclenche l'apparition d'une série de reproductions . . .'*[25] The Valise itself was exhibited with part of its contents in a glass case set into the wall with, on the left, the peephole revealing one by one fourteen images from the Valise, and on the right, the huge spoked wheel

incorporating a recurring motif in Duchamp's work, the spiral, which the visitor was invited to rotate. (Fig. 6)

During the war years the European exiles lent a febrile air to the artistic scene in New York. Groups of them met frequently to share their sorrows and boost each other's morale. (Fig. 7) In one or two of their numerous exhibitions and publications Duchamp and Kiesler found themselves side by side. They both contributed to the magazine *VVV* founded by André Breton: Duchamp's idea for the back cover of the Almanac for 1943 was fashioned with Kiesler's collaboration. A woman's trunk in profile, drawn by Duchamp, was cut out in the cover and wire netting substituted in the opening. Opposite the inside back cover an illustration of Pegeen Guggenheim showed how to perform the 'Twin-Touch-Test': 'Put the magazine flat on the table, lift back cover into vertical position, join hands on both sides of wire screen, fingertips touching each other and slide gently along screen towards you.' (Fig. 8) On another occasion, one day in August the same year, the Kieslers accompanied Duchamp to the Brevoort to shoot a scene for a film, another sequence of which was made on the terrace of their penthouse.[26]

At the beginning of October, Duchamp moved just round the

7. Marcel Duchamp and Frederick Kiesler (in foreground) with, from left to right, Yves Tanguy, Kay Sage, Maria Martins and Enrico Donati.

8. The 'Twin-Touch-Test' by Marcel Duchamp and Frederick Kiesler for *VVV*, nos. 2–3 (Almanac for 1943), New York, 1943.
Documentation du MNAM Centre Georges Pompidou, Paris Photo: Daniel Pype

corner from 56 Seventh Avenue to a studio at 210 West 14th Street which he was to occupy for twenty-two years. Duchamp and the Kieslers continued to meet from time to time according to their corresponding interests and projects. Chess, one of Duchamp's passions and a pastime which Kiesler enjoyed too,[27] was a strong thread in the intricately woven pattern of friendships during the war in New York. During the summer of 1944, Julien Levy invited his friends to design and make sets of chessmen for an exhibition, *The Imagery of Chess*, which opened at his gallery on 12 December 1944. At a special evening performance, Duchamp refereed the simultaneous games which Alfred Barr Jr., Max Ernst, Kiesler, Levy, Dorothea Tanning and Dr Zilboorg played against the grand master George Koltanowski, who was blindfolded for the occasion.

By this date the editors of *View* already had plans to publish a special Duchamp number to appear in March 1945. Kiesler was to contribute to it and went with Duchamp to a meeting at *View* on 22 December.[28] On 1 January 1945 and again ten days later,[29] Kiesler and Percy Rainford photographed the studio at 210 West 14th Street. (Fig. 9–13) They posed Duchamp sitting at his cluttered table, his head turned in profile before a chess

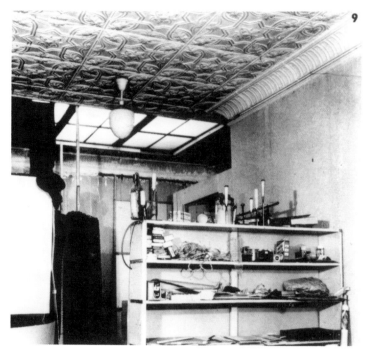

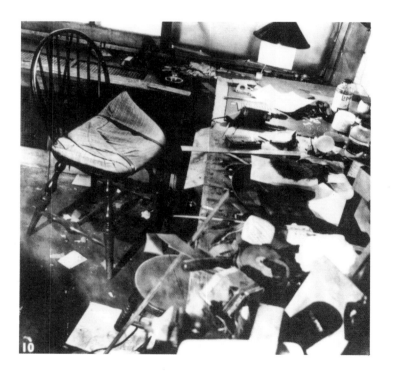

board propped up against the wall pinned with notes, letters and telegrams. They took shots of the opposite side of the room where a tier of shelves was strewn with papers and various odds and ends including, on the summit, part of Duchamp's bizarre invention for the cover of *View*: a bottle of Bordeaux labelled with his *livret militaire* and a tube curling from its neck, a device to simulate a puff of smoke—a more futuristic vessel than the Rochambeau to blast Duchamp from the Old World across the Milky Way to the New! They also photographed the side of the room where a press was lying on the sill of the ceiling-high windows with an overflowing wastepaper basket of crumpled newspaper, empty cartons and torn card on the floor.

These photographs served as the basis for a complicated six-page spread: a 'Triptych (which] when unfolded represents three walls of Duchamp's studio . . .' as Kiesler described it[30]. Finding that 'there seems to be a definite although unintentional correlation between the daily utilities of the artist's environment and the inner structure common to all his work'[31], Kiesler set out to illustrate his idea in these pages which he entitled *Poème espace* dedicated to 'H(ieronymous) Duchamp'. He cut out a flap

9. Marcel Duchamp's studio, 210 West 14th Street, New York, photo-graphed by Percy Rainford, January 1945.

10. 11 & 12. Ibid.

in each of the two outer panels of the triptych, which assume the shape of one of the Malic Moulds when interlocked, but when folded across the centre panel, conjure a mirage of *The Bride stripped bare . . .* Various objects around Duchamp's table were transformed by Kiesler's magic wand into elements of the *Large Glass*: two saws, a lamp and cords hanging from the ceiling become the *Pendu-femelle* (Fig. 14): film spools change to the Water Mill Wheel, and the ribbons of film to the Glider; a chair leg turns miraculously into the Louis XV chassis of the Chocolate Grinder, etc. The left panel includes an apparition of *The Brawl at Austerlitz*, and in the right panel the windows are partly transformed by the ghost of *Fresh Widow*.

On the back of the Triptych, a large imprint of Duchamp's right hand[32], with an inset of the Malic Moulds, almost covers the left panel; on the centre panel a photograph of the *Mile of String* (a tangled web Duchamp wove randomly across the rooms of the exhibition 'First Papers of Surrealism')[33] is juxtaposed with a reproduction of *Network of Stoppages*;[34] the right panel is composed of a close up of the back of the Chocolate Grinder where Duchamp wrote the title, dated and signed *The Bride stripped bare . . .* and a detail of the Scissors.

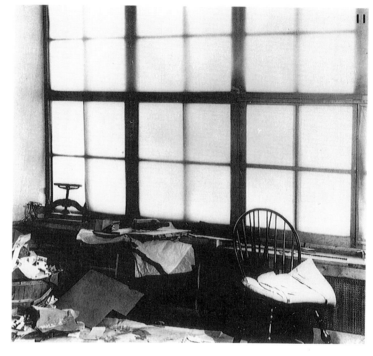

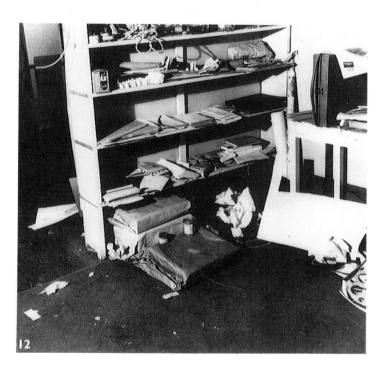

The text linking these panels reads: '*Du mirage, des réseaux circonflexes en peinture/du mirage de la cédille aux échecs — Fous, Cavaliers et Rois — Marcel D. né 1887 artiste-inventeur — R. Roussel né 1757 artiste-inventeur.*' The prominence which Kiesler gave to Raymond Roussel in his homage to Duchamp and *The Bride stripped bare . . .* is significant and represents a scoop. Kiesler made several pages of undated notes relating to the *Large Glass*, but he also scribbled some interesting biographical jottings, information which he undoubtedly gleaned from Duchamp during the period prior to the publication of *View*. On the subject of Roussel, Kiesler wrote the following notes: 'Raymond Russell [sic] 1912/1860 Café de la/Régence, playing chess,/Russell [sic] wrote on chess/design for winning/ — an arabesque for/the King, the bishop & Knight/ against King alone./*Impressions d'Afrique*/a play where Marcel/went with Apollinaire/and Picabia. (1912 or 1913)' Duchamp, therefore, told Kiesler of his debt to Roussel, how he had attended a performance of *Impressions d'Afrique* at the Théâtre Antoine in 1912, and how at the Café de la Régence twenty years later he recognized the relative newcomer to chess,[35] '*auteur de plusieurs oeuvres étranges dont la puissante fantaisie est surtout basée sur*

une nouvelle conception du mouvement . . .'[36]

Kiesler chose to use the *'Formule Raymond-Roussel'*,[37] that of bringing about checkmate with the Bishop and the Knight under the sign of the cedilla, as an affinity between his two artists, both 'inventors' of end games.[38] The work of the three white chessmen, King, Bishop and Knight, Roussel discovered, was *'profondément coordonné'* in their movement towards checkmate of the Black King. And this concise formula stated that the role of the Knight is confined to the position of cedilla or future cedilla to the Bishop. But many years before the publication of this magic formula, Duchamp had fallen under the spell of Roussel.

'It was fundamentally Roussel who was responsible for my Glass . . .' Duchamp disclosed to James Johnson Sweeney.[39] 'From his *Impressions d'Afrique*[40] I got the general approach. This play of his which I saw with Apollinaire helped me greatly on one side of my expression. I saw at once I could use Roussel as an influence. I felt that as a painter it was better to be influenced by a writer than by another painter. And Roussel showed me the way.' By applying Roussel's literary method to painting and sculpture, Duchamp established an entirely new process for

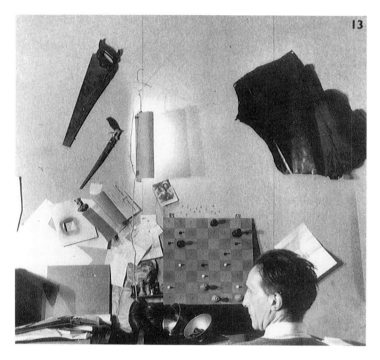

his creative act. The conciseness of style, which it was remarked was distinctive of a chess player,[41] coupled with an extraordinary linguistic source — the intriguing network of words that sound the same but have different meanings — when translated visually gave Duchamp the basic framework for his oeuvre dating from the first studies for *The Bride stripped bare by her Bachelors, even*, made in Munich in 1912.

*

In May 1946 Duchamp returned to a severely rationed Europe for eight months.[42] While he was in France, Breton asked Duchamp to help organize another major international Surrealist exhibition in Paris which Aimé Maeght had offered to hold at his gallery in July 1947. The gallery was to be transformed into a Surrealist environment as had the Galerie Wildenstein in 1938. The concept and structure of the exhibition was discussed in detail: Duchamp envisaged the Room of Superstition as a white grotto[43] and he was to draw the plans for the Labyrinth and the

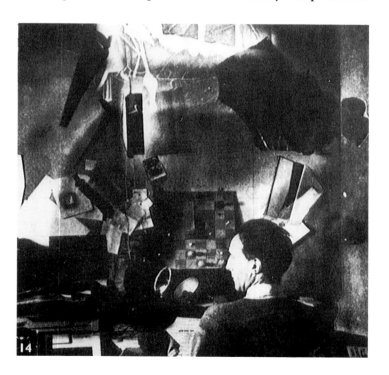

13. Marcel Duchamp at 210 West 14th Street, New York, photographed by Percy Rainford, January 1945.

14. Centre panel of Frederick Kiesler's *Triptych* in *View*, series V, no. 1, New York, March 1945.
 Photo: Daniel Pype

Rain Room in which, he suggested, a billiards table be installed. In a long letter to the participants, dated 12 January 1947, the eve of Duchamp's departure for New York, Breton meticulously described the whole project.[44]

On his return to New York, Duchamp had the onerous task of collecting works from the artists for the exhibition. Kiesler took charge and drew the plan[45] for the Room of Superstition: *Le lac noir*, *La cascade figée*, *Le Whist*, *Le rayon vert*, *Le totem des religions*, *L'homme-angoissé*, *Le vampire*, *Le mauvais oeil*, *La figure anti-tabou*, and *L'échelle qui annonce la mort* which he saw as an *'oeuvre collective'* and *'un premier effort vers une continuité Architecture-Peinture-Sculpture'*.[46]

For *Le rayon vert*, the subject allocated to Duchamp, Kiesler made a detailed drawing of the object: a box drawn from different angles, lit from above; a sheet of gelatine held between two pieces of glass; a gelatine labelled A and a photo B, representing between sea and sky a horizon, which on the gelatine is a band of blue and on the photo a strip of yellow. Kiesler wrote on the plan: *'Fusion de jaune et bleu par fixation/Hommage à Marcel'*. (Fig. 15) Duchamp did not make the voyage across the Atlantic for the exhibition, but amicably went to see his friend

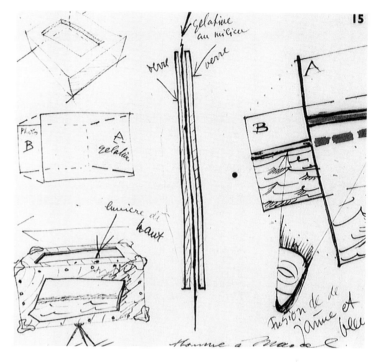

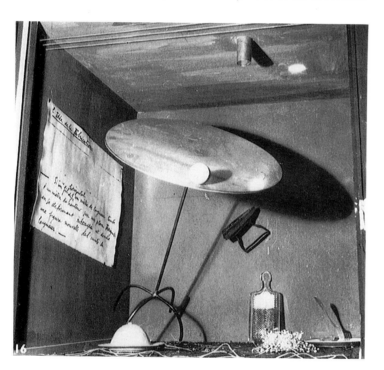

off when he flew from La Guardia to Paris on 27 May[47] to supervise the installation at rue de Téhéran. Undoubtedly Kiesler had received instructions for *Le rayon vert* and its construction in much the same way that Matta had been entrusted to make the shrine for *Le soigneur de gravité*.

Le soigneur de gravité was one of the 'beings' in the Labyrinth, a long rectangular room which had been divided into twelve octagons comprising each an altar dedicated to *'un être, une catégorie d'êtres ou un objet susceptible d'être doué de vie mythique'*.[48] The seventh altar, under the sign of Libra was dedicated to the mysterious element of *The Bride stripped bare. . . . intended but never realized on the Glass*.[49] Marcel Jean recalled the raking pedestal table with a ball on it *'qui aurait dû rouler, mais qui, bien sûr, ne roulait pas . . .'*[50] There was also a flatiron with 'A REFAIRE LE PASSÉ' inscribed on its base—an echo of Duchamp's reciprocal readymade: *'se servir d'un Rembrandt comme planche à repasser'*?[51] When Matta came to reconstruct *3 Stoppages Étalon*, he attached three parallel strings across the front of the 'altar', between the two sides, just below the 'ceiling', and he enlisted Kiesler's help when, using three more lengths of string; he one by one, an

15. *Le rayon vert*, 1947. Drawing by Frederick Kiesler, collection Mrs L. Kiesler.

16. The seventh altar by Matta, dedicated to *Le Soigneur de Gravité*, in the Labyrinth at the exhibition *Le Surréalisme en 1947*, Paris 1947.
Photo: Denise Bellon

end in each hand, pulled them taut horizontally and from the position of the first three, let them drop to the surface one metre below. (Fig. 16)

*

Many months before the irrevocable estrangement, Kiesler made his own, very personal impression of Marcel Duchamp. At 56 Seventh Avenue on 8 November 1947, from 2.30 to 6 in the afternoon,[52] Duchamp obligingly stripped to the waist and stood, his hands in his pockets, in his characteristically relaxed pose while Kiesler drew his full-length portrait, a galaxy of eight equal rectangles, which now belongs to the Museum of Modern Art, New York.

1. 1915–1923, coll. Philadelphia Museum of Art.
2. Letter dated 8 June 1936, from K.S. Dreier (KSD) to Frank Merchant.
3. *La mariée mise à nu par ses célibataires, même*, ed. Rrose Sélavy, 18 rue de la Paix, Paris 1934.
4. Foreword by Breton to 'Marcel Duchamp, The Bride stripped bare by her own Batchelors' in *This Quarter*, Vol. V, No. 1, September 1932, pp. 189–192 in which a number of notes from the Box are translated into English. Julien Levy in *Surrealism*, Black Sun Press, New York 1936, published his translation of a note relating to the Bride, p. 126.
5. In *Minotaure*, Paris, Vol. II, no. 6, Hiver 1935, pp. 45–49. The cover of this issue was designed by Marcel Duchamp (MD).
6. Letter dated 25 June 1937 from MD to Kiesler (FK).
7. Letter dated 29 August 1935 from FK to Mrs Reed.
8. Letter dated 23 October 1926 from KSD to H.B. Tschudy.
9. Letter dated 2 November 1926 from FK to KSD. KSD herself designed four rooms to show modern art in a domestic setting at the exhibition.
10. Acknowledgment by KSD, Collection of the Société Anonyme, Yale University Art Gallery, New Haven 1950, p. xvii.
11. Letter dated 13 January 1927 from MD to KSD.
12. 25 November 1933, Stefi Kiesler's diary (SKd).
13. SKd.
14. 'Design-Correlation' in *The Architectural Record*, May 1937, p. 54.
15. 28 January 1937, SKd.
16. Letter dated 23 February 1937 from KSD to MD.
17. Letter dated 6 July 1937 from KSD to MD. However articles by FK appeared in the following June, July and August.
18. Stella came to dinner on 14 May 1937 and brought the painting with him, SKd.
19. Letter dated 25 June 1937 from MD to FK.
20. Letter dated 13 January 1938 from KSD to MD.
21. Letter dated 28 January 1938 from KSD to FK.
22. Letter dated 7 January 1941 from MD to H.-P. Roché (HPR).
23. Letter dated 25 April 1941 from MD to HPR.
24. On 2 October 1942, SK cleared Marcel's room, SKd.
25. Simone de Beauvoir, ed. Paul Morihien, *L'Amèrique au jour le jour* Paris 1948, p. 37.
26. 15 August 1943, SKd. *The Witch's Cradle* by Maya Deren?
27. MD gave FK a copy of his *Pocket Chess Set* (v. title page).
28. SKd.
29. Ibid.
30. 'Les larves d'imagie d'Henri Robert Marcel Duchamp' in *View*, series V, no. 1, New York 1945, p. 24.
31. Ibid.
32. Originally published in *Minotaure*, op. cit.
33. FK's name appears in the catalogue of this exhibition held at 451 Madison Avenue, New York, 14 October–7 November 1942.
34. Julien Levy confirmed his undertaking to sell the painting for FK in a letter dated 30 January 1940 and it was later sold to Pierre Matisse.
35. Roussel started playing in 1932. *Vie de Raymond Roussel* by François Caradec, ed. Pauvert, Paris 1972, p. 354.
36. 'Raymond Roussel et les Echecs dans la Littérature' by S. Tartakower in *Les cahiers de l'echiquier français*, 33ème cahier, January–February 1933.
37. In *L'Echiquier, revue internationale d'échecs*, November 1932.
38. MD and V. Halberstadt published a book devoted to the end game: *L'opposition et les cases conjuguées sont reconciliées*, ed. L'Echiquier, Paris-Brussels 1932.
39. In *The Bulletin* of the Museum of Modern Art, New York Vol. XIII, no. 4–5, 1946, pp. 19–21.
40. Novel by Roussel, ed. Lemerre, Paris 1910 (from which the play of 1911–12 was adapted) first published in *Le Gaulois du Dimanche*, Paris 10 July–20 November 1909.
41. 'Le mat du fou et du cavalier' by S. Tartakower, *L'Echiquier*, December 1932.
42. MD spent a month in Switzerland and was staying, in early August, next to the waterfall at Puidoux, the photograph of which he used as the backcloth for his posthumous work *Etant donnés . . .*, 1946–1966.
43. Later this idea was abandoned and FK shrouded the room with green cloth.
44. 'Projet initial' by A. Breton in *Le surréalisme en 1947*, ed. Pierre à Feu, Paris 1947, p. 135.
45. *Hommage à Tanguy*, 2 April 1947, in *Le surréalisme en 1947*, op. cit.
46. 'L'architecture magique de la salle de superstition' in *Le Surréalisme en 1947*, op. cit., p. 131.
47. SKd.
48. 'Projet initial', op. cit.
49. The realm of *Le soigneur de gravité* is indicated in a reproduction of the Glass in *View*, op. cit., p. 7; MD etched *The Large Glass Completed* in 1965.
50. *Le Miroir de la Mariée* by Jean Suquet, Flammarion, Paris 1974, pp. 199–200.
51. *The Green Box*, op. cit.
52. SKd.

Frederick Kiesler

Design — Correlation:
Marcel Duchamp's *Large Glass*

As published in *The Architectural Record*,
May 1937, vol. 81, no. 5

DESIGN — CORRELATION

FREDERICK J. KIESLER

Architecture is control of space.
An Easel-painting is illusion of Space-Reality.
Duchamp's Glass is the first x-ray-painting of space.

From brush-painted glass pictures of the middle ages

to 1920's

Treasured by Miss Katherine S. Dreier in the living room of a colonial house in the U.S.A.

Structural Painting on plate glass of this Superior-Sane Iconoclast Marcel Duchamp, born 1887 at Blainville, Seine Inférieure, France.

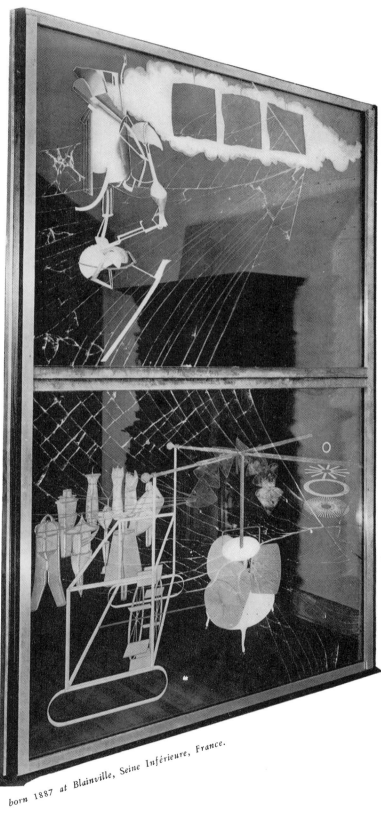

Its title is "La Mariée mis à nu par ses célibataires, même" 1915-1923 inachevé—cassé 1931—réparé 1936

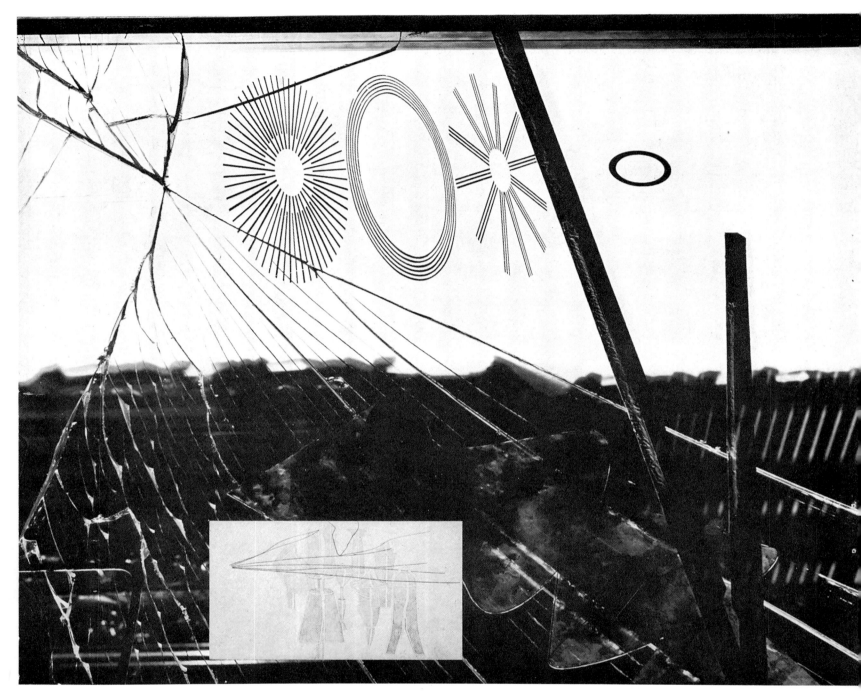

This detail and all following photographs of the "Big Verre" have been taken this winter by Berenice Abbott for the Architectural Record, on a special trip arranged by the writer.

Duchamp's "Big Glass" created 1912-1923 in New York City's Fourteenth Street, known at that time only to a small group, is in 1937 acclaimed by the progressive professionals throughout the world. It surpasses in creative ingenuity any painting since the great Illusion-Builder SEURAT, anticipating as well as continuing the line of development Picasso—Miro—Dali, X., Y., Z. It will fit any description such as: abstract, constructivistic, real, super-and-surrealist without being affected. It lives on its own eugenics. It is nothing short of being the masterpiece of the first quarter of twentieth-century painting. It is architecture, sculpture, and painting in ONE. To create such an X-ray painting of space, materiae and psychic, one needs as a lens (a) oneself, well focused and dusted off, (b) the subconscious as camera obscura, (c) a super-consciousness as sensitizer, and (d) the clash of this trinity to illuminate the scene. The glass plate cracked 1931, cutting strokes across the pane that would have broken any other composition, but not this singular masterpiece of tectonic integration. Strange for the factualist is the magic of subconscious creation with which the outburst of broken glass-streaks which now veins the whole picture was anticipated by Marcel Duchamp. A preparatory drawing of 1914 (insert above) already showed radiating lines abstractly superimposed upon the reality of the main theme of the design. But it seems to me that not until the breakage had actually occurred was the cycle of perfect fusion of the subconscious image with its realization completed, and the time ripe to give its message to the public.

We look at it not to interpret its bio-plastic exposition of the upper half of the picture or of the mechanomanic lower part; such physio and psycho-

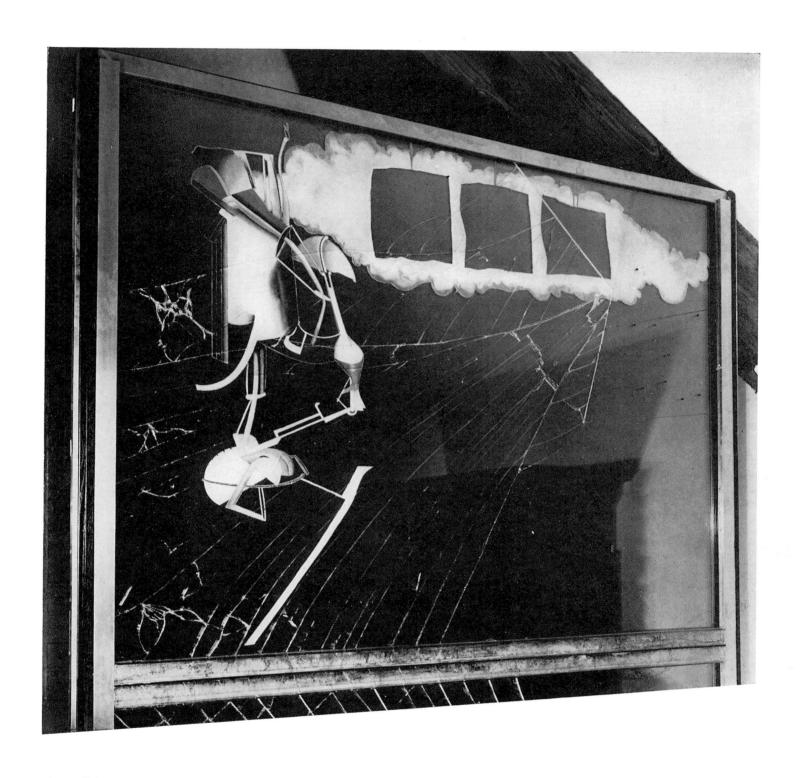

analysis will be readily found here and there, now and later—but I bring to the technicians of design-realization the teaching of its techniques.

Translucent material such as glass being used more and more in contemporary building finds its manufacturing not for commercial but constructive reasons. [Those who think only in "practical" meanings: dollars and cents, brick and mortar, jobs and publicity—would do well to turn to the very last page of this section. The best way to understand such painting is to look at it with closed eyes and an open mind; or with eyes wide open and the mind alive like darkness.] Glass is the only material in the building industry which expresses surface-and-space at the same time. Neither brick nor stone, nor steel, nor wood can convey both simultaneously. It satisfies what we need as contemporary designers and builders: an inclosure that is space in itself, an inclosure that divides and at the same time links.

Normally one looks through a translucent plate glass from one area into another, but in painting an opaque picture (like this) one also accentuates the space division optically. The painting then seems suspended in midair negating the actual transparency of the glass. It floats. It is in a state of eternal readiness for action, motion and radiation. While dividing the plate glass into areas of transparency and non-transparency, a spatial balance is created between stability and mobility. By way of such apparent contradiction the designer has based his conception on nature's law of simultaneous gravitation and flight.

Nature distinguishes between framework and tensional fillings, both elastic and interdependent, while we build rigidly, inflexibly, lifelessly. The manner of joining parts of similar or different densities in this interdependence is tantamount to nature and to artificiae. Contour design is nothing else but joint. A contour is the illusion of a spatial joint of forms. Joints are dangerous links; they tend to dis-joint (everything in nature is joined and a group of joints is form). Hence, all design and construction in the arts and architecture are specific calculation for re-joining into unity, artificially assembled materiae, and the control of its decay.

Duchamp's painting's outstanding (tectonic) achievement is its new joint-design. The ligaments of steel-or-what-not, single or double spaced, wires that are used, instead of paint strokes, for contourings make wider and narrower outer and inner contours to create precise form articulation. Those

Eastman Kodak

heavier and lighter lines thus divide all shapes and at the same time link them! Technically they are held fast to the glass-back-surface by mastics or cooled-off white lead. That is unimportant, because you may and will invent your own mastics and the Marcel-imprint should not be imitated; but important is its spirit, guiding lost guides and collective herd back to juicy roots embedded in nature's creative subconscious instead of encouraging them to take refuge in re-search and statistitching.

The structural way of painting is Duchamp's invention. Anybody who designs space (forms) knows the pre-conscious command for sharp contour, exact contour, unmistakable accentuation of shape horizons. Areas between the boundaries are here, not brush-stroked, but once and a million times tamponed to give a vibrant mass of luminous densities, transparent, lucidly shivering with its tender layers of color-coverings.

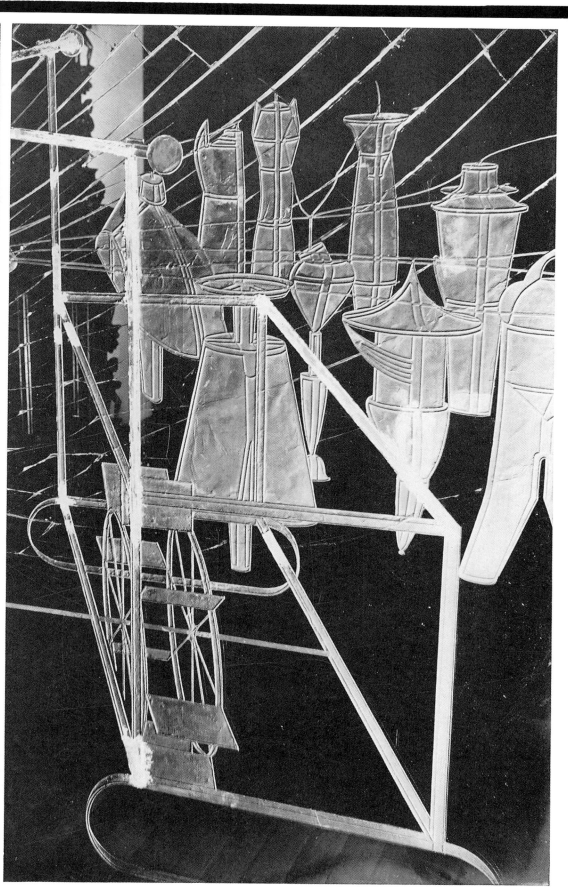

(left) *Front view of details. Back view of details* (right).

Marcel Duchamp's plate glass picture carries its structural paint technique only on one side (back) of the glass pane. The plate glass as a whole is intact. In the stained glass windows of the middle ages the large windows were composed of small pieces of colored glass held together by small structural members of lead, soldered together with an approximate composition of forty per cent lead and sixty per cent tin. The artist's design is reproduced in flux (crown glass) which is mixed with colored powder and applied only on the (front) glass surface. It melts in the heat of the kiln (about 900 degrees) and is bound insolubly to the glass. First, the whole design is cut into a pattern of paper templates. Later, they are replaced by glass pieces of precisely the same shape, spaced by an outline that has the exact thickness of the center wall of the I-shaped frame-bar. The outer face of the bar which is visible to the eye has the width of the standard flange of the same frame-bar. Marcel Duchamp has simplified such antiquated techniques, and outmoded them with his new method of "structural painting."

As may be seen in this x-ray-graph of a leaf, heavier structural members cover the whole area to give additional strength to the small network of

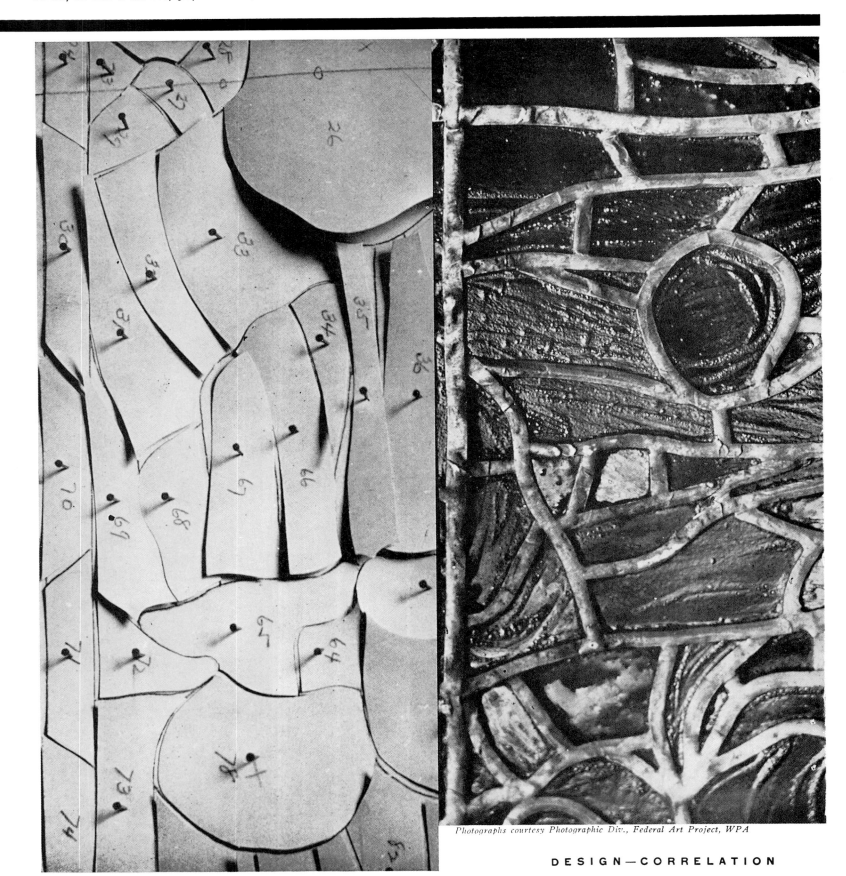

Photographs courtesy Photographic Div., Federal Art Project, WPA

DESIGN—CORRELATION

vascular veins and to the chlorophyll-bearing cells that carry on the work of photo-synthesis. The veins are merely the extensions into the leaf of the chief elements of the stem. They form the framework of the leaf, as well as the complex network of highways for the transportation of materials between the blade as a whole and the stem. They help to create TUR-GOR, the resistance—rigidity of plant—structures.

Mildred Davis

Stained glass window design showing width of contour equal to width of came-lead bar.

To cut templates a special scissors with double-edge blades is used. Distance of double edge equals thickness of the center wall of

the came-lead used for framing.

Glass pieces being put into the came-lead.

Detail of a completed stained glass window showing thickness of lead contour joints and bracing-bars.

117

Die Form

Big plate glass in metal frame used as room partition by
Mies van der Rohe (1931).

Model of the building of the Czechoslovakian pavilion for the
World's Fair in Paris (1937) showing interpretative design
applied to translucent outer wall material.

Bullet-proof glass of the Pittsburgh Plate Glass Co. The insert shows the girl looking through
nine and one-half inch thickness of Lucite, a new duPont plastic, which is clearer than optical
glass, only half as heavy and is non-shatterable. It resists 8,000 pounds pressure per square inch.

Insert photo by Dana B. Merrill

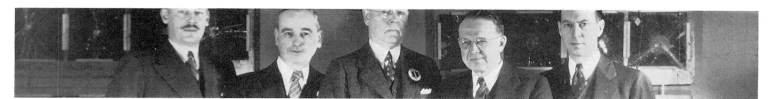

Five men standing on Herculite tempered plate glass specially processed by heat and
chilling, demonstrating the resistance to an impact seven to eight times greater than
ordinary plate glass.

Johnson & Johnson and Pittsburgh Plate Glass Co.

Échecs

Cover 1932
Book designed by Marcel Duchamp

Raymond Keene

Marcel Duchamp: The Chess Mind

Revised version of article first published in *Modern Painters*
vol. 2, no. 4, winter 1989–9.

The most highly esteemed artist to play chess at Master level.
OXFORD COMPANION TO CHESS

Two 'facts' are popularly 'known' about Marcel Duchamp and chess. One is that in 1923 he 'gave up art for chess,' and the other is that in 1927 his new bride glued his chess pieces to his board, in an act of desperation at the attention he was paying to them, rather than to her. This mythical aspect of Duchamp's relationship with chess has tended to obscure the reality. That reality was sufficiently impressive for him to be awarded the Master title by the French Chess Federation in 1925, and for Duchamp to represent France in no less than four Chess Olympics from 1928 to 1933.

Duchamp had been passionately attached to chess from his youth, as might be inferred from his paintings of 1910 and 1911, *The Chessplayers* and *The Portrait of Chessplayers*. The renowned chess critic Harry Golombek, in his *Encyclopaedia of Chess*, wrote of the latter work, that it gives a more complete picture of the process of chess-playing than many a stylised representational painting. Mark Kremer, writing in *New In Chess International Magazine*, added, that the emphasis in these pictures is not on the idyllic nature of a game of chess, as seen by a possible observer (compare Duchamp's own *The Chess Game*, of 1910, on which the two later works are a huge advance), but on its insular quality, its isolation vis-à-vis the outside world. In 1923 Duchamp declared the *Large Glass* permanently unfinished and returned to France to make his passion his second career. This was at the age of 36, a time when many contemporary chess Grandmasters are beginning to feel that they are gradually approaching near veteran status! Although he was a late starter, Duchamp, as noted above, not only achieved the Master title and played for France in the Olympics, but also wrote one chess book, translated another, covered chess for *Le Soir* newspaper, became an official of the French Chess Federation and finally was active in organisation of chess events and fund-raising for the game.

What sort of player was Duchamp? The *Bulletin of the French Chess Federation* of 1924 described him thus: '. . . *étant donné son jeu profond et solide . . . sa froideur imperturbable, son style ingenieux . . .* font de lui un adversaire redoutable.' It was bad luck for Duchamp that his best known game is a loss to Le Lionnais from Paris 1932. This game happened to be annotated by the celebrated Franco-Polish Grandmaster Xavielly Tartakower, in the prominent Austrian magazine, *Wiener Schachzeitung*. This brought the game a certain prominence, but Le Lionnais himself was also not slow to trot it out (eg, in his interview with *Studio International*, 1975) whenever he was asked about Duchamp and chess.

It should be added that Duchamp had drawn a game with Grandmaster Tartakower himself in 1928 and later, in the Chess Olympics at Hamburg 1930, he held the American World Championship contender, Frank Marshall, to a drawn result. In 1929 Duchamp beat Koltanowsky, several times Belgian

Champion and one time world record holder for the greatest number of opponents faced in a blindfold simultaneous display. The tactical tricks Duchamp produced in that game, his evident love of paradoxical solutions, bowled over his distinguished opponent with extreme speed. I now give the moves of this game with my comments. The notation used is the internationally accepted algebraic version, which can be understood by anyone who can follow an A–Z street map. I have given four diagrams to assist readers in following the moves.

Let us conclude our introduction with the game played by Duchamp at Paris in 1929 against George Koltanowski (1903), the Belgian Champion. Koltanowski went on to emigrate to the United States, he is still alive, still playing chess and he holds, I believe, one of the world records for playing a vast number of players at one and the same time in blindfold chess. I think he's played 30 or 40, maybe even more people at once without being able to see the board. So this is an amazing achievement and this is the man that Marcel Duchamp is facing in this game at Paris in 1929.

Before discussing this game we should mention something about Nimzowitsch's book *Chess Praxis*. When I (RDK) saw the game Koltanowski–Duchamp, I thought this is pure Nimzowitsch, this has to be Nimzowitsch and when I went to visit Teeny Duchamp (Marcel Duchamp's widow) in Paris in 1990 I asked if I could rummage around in the back cupboards to see if any Marcel Duchamp chess memorabilia might tumble out of a drawer. Sure enough I discovered page after page, both written up in Marcel Duchamp's own hand and occasionally typed with his own comments, of this book. Marcel Duchamp had been through this book, *Chess Praxis*, and written out the whole thing in his own handwriting or typed it up. Now if that does not show dedication to principles of a chess grandmaster and a teacher, I don't know what does. He could have bought it, I suppose. Perhaps he couldn't have bought it, but by copying it out and, back in the old days when there were no photocopiers and people had to really struggle to win knowledge, this was the time honoured way of doing it and believe me you learn what's going on that way. I hope now that when I show you the game Koltanowski–Duchamp you will see what I mean by these hypermodern principles being translated to this game.

White: Koltanowski — Black: Duchamp
Paris 1929
Queen's Indian Defence

1. d4 Nf6
2. c4 e6
3. Nc3 d6

To modern eyes this looks eccentric, since Black renounces any immediate attempt to fight for the centre. Nevertheless, as we have noted, Duchamp was imbued with the spirit of hypermodernism, the fashionable theory of the day, which held, amongst other things, that the battle for domination of the centre need not involve the intervention of the pawns.

4. e4 b6

This fianchetto development of the queen's bishop was, of course, closely associated with Grandmaster Aron Nimzowitsch, the celebrated iconoclast, chess teacher and leader of the hypermodern school of thought. Indeed, the entire strategy of restraining the Black central pawns was enthusiastically advocated by Nimzowitsch in his influential books *My System* and *Chess Praxis*.

5. f4

In contrast to Black's diffident stance with his small pawn centre, Koltanowski unrestrainedly fills the centre with his own pawns. There are two sides to this. These pawns may represent a source of weakness, ultimately being exposed as targets by Black's subtle flank operations. Alternatively, White's infantry may act as a bludgeon which sweeps Black from the board. In the further course of this game, both aspects come to the fore.

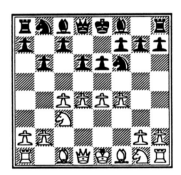

5. . . . Bb7 6. Bd3 Nbd7 7. Nf3

White has built up about as large a center as can be imagined, but this is also a target for Black, who strikes at it quickly.

7. . . . e5 8. d5

After this move, the Nd7 has access to c5.

8. . . . g6 9. 0–0 exf4 10. Bxf4 Bg7

Now Black has e5 available as well, and the bishop is well placed at g7. White therefore decides to advance the e-pawn, hoping to reduce Black's options.

11. e5

11. . . . dxe5 12. Nxe5 0–0 13. Qd2

White's center has lost much of its support, and this creates tactical possibilities for Black.

13. . . . Nxd5 14. Nxd7

14. Nxf7 Nxf4 15. Nxd8 Bd4+ 16. Kh1 Bxg2+
17. Qxg2 Nxg2 and now:
a) 18. Ne6! Nxc3 (18 . . . Rxf1+ 19. Bxf1 Bxc3
20. Bxg2) 19. Rxf8+;
b) 18. Rxf8+ Nxf8 19. Kxg2 Bxc3 20. bxc3
Rxd8.

14. . . . Nxf4 15. Nxf8 Bd4+

and here White resigned because of 16. Kh1 (*16. Rf2 Nxd3 17. Qxd3 Bxf2+*) Bxg2+ 0–1

This type of development of the Queen's Bishop was closely associated with Aron Nimzowitsch, the celebrated iconoclast, chess teacher and Grandmaster of the 1920s. Indeed, the whole strategy of holding back the Black centre pawns was enthusiastically advocated by Nimzowitsch in his books and articles.

A complex tactical blow which reveals Duchamp's talent for paradoxical, hidden points. White now has to lose at least a pawn and in trying to avoid this, worse befalls.

There is an important variation here which Duchamp had to calculate before he could launch out on his bold 13th move. It goes like this: 14.Nxf7 (instead of Nxd7) 14 . . . Nxf4 15.Nxd8 Bd4 + 16.Kh1 Bxg2 + 17. Qxg2 Nxg2 18.Rxf8 + Nxf8. 19.Kxg2 Bxc3 20 dxc3 Rxd8 when Black has a much superior position and should win. Duchamp had to see all of these possibilities in his mind's eye before he could play 13 . . . Nxd5. Quite a colossal feat of the imagination for most people. Chessplayers amongst the readers of this article should try it for themselves, aiming to visualise this entire sequence in their mind from the second diagram, before making the moves on a chess board!

Had White decided to play on he would either have to play 16.Kh1 when 16 . . . Bxg2 + wins White's Queen, or . . .16 Rf2 when 16 . . . Nx3 17.Qxd3 Bxf2 + , also wins White's Queen.

Much of the accepted wisdom about Duchamp as a chessplayer stems from the 1975 interview with Le Lionnais in *Studio International*. Le Lionnais stated: 'In Duchamp's style of play I saw no trace of a Dada or Anarchist style, though this is perfectly possible. To bring Dada ideas to chess one would have to be a chess genius rather than a Dada genius. In my opinion Nimzowitsch, a great chess player, was a dadaist before Dada. But he knew nothing of Dada. He introduced an anticonformism of apparently stupid ideas which won. For me that's real Dada. I don't see this Dada aspect in Duchamp's style . . . Duchamp applied absolutely classic principles, he was strong on theory he'd studied chess theory in books. He was very conformist which is an excellent way of playing. In chess conformism is much better than anarchy unless you are Nimzowitsch, a genius. If one is Einstein, one says the opposite to Newton, of course, if one is Galileo, one contradicts everyone, but otherwise it's safer to be a conformist.'

I suggest, however, that Le Lionnais was simply unaware of the degree to which Nimzowitsch, author of the incredibly influential book, *My System* and a virtual candidate for the World Championship by 1927, had shaped Duchamp's style. Even the opening of the oft-quoted game Duchamp lost with the white pieces to Le Lionnais (1c4c5 2Nc3 Nc6 3g3 g6 4Bg2 Bg7 5d3 d6 6e4) had been introduced by Nimzowitsch at Dresden 1926. Similar instances of Duchamp borrowing Nimzowitsch's open-

ings ideas proliferate throughout his games. See, for example, my notes to the win against Koltanowsky.

One also detects philosophical resonances between Duchamp and Nimzowitsch in their attitudes to chess (in Nimzowitsch's case) and to chess and art with Duchamp. Take, for example, the following statement by Duchamp: 'Chess is a sport — a violent sport. This detracts from its most artistic connexions . . . If anything it is like a struggle.' And Nimzowitsch, apropos the international tournament at San Remo 1930: 'In its fascination and its rich variety chess is a mirror of the life struggle itself, but to a similar degree it is exhausting and full of pain.'

Further points of contact emerge from an examination of the reasons that may have attracted Duchamp to chess. Some writers have maintained that the symbol of the opposition of two hostile 'sides' runs through Duchamp's work, for example, the Bride's domain and the Bachelors' territory in the *Large Glass*. The *Times* of June 14, 1966 speculated that Duchamp's lifelong passion for chess might be thought an expression of his dislike for the trappings that cover purity of thought. Man Ray, Duchamp's friend and designer of a chess set which Duchamp owned, said that chess is a game where the most intense activity leaves no trace. In essence, Duchamp and Nimzowitsch were both seeking criteria to determine the aesthetic, and they arrived at identical conclusions.

Kremer, writing in *New In Chess*, has this to say of Duchamp's attraction to the game:

In chess, beauty is not so much visually observable but, selon Duchamp, is, 'completely in one's grey matter.' Duchamp is interested in, 'cerebral art, in which there is an appeal to the viewer's intelligence and imagination, more so than in the average sensuous offerings.'

To support this I now cite George Heard Hamilton — *Inside the 'Green Box'*:

. . . for Duchamp art is a mental act, a fact of consciousness. His life, a long one, and his career as a professional artist, so disconcertingly short, have been dedicated to the deliberate annihilation of what he calls 'retinal painting' that sort of art which appeals principally or only to the eye, which he believes began with Courbet and reached its greatest splendors and deceptions in our times with Picasso and Matisse. What he wanted, we might say, was not a painting of something, but painting as something, painting which should not only represent an object but be in itself an idea, even as the object represented might not be actual in the phenomenal sense, but rather a mental image. As he said in 1945 — I wanted to get away from the physical aspects of painting, I was interested in ideas — not merely in visual products. I wanted to put painting once again at the service of the mind.

Chess is a marvellous field for this kind of operation, for the beauty of a move in chess lies in the thought behind it, not in the move itself. Nimzowitsch wrote in *Chess Praxis*

Das Aesthetische Empfinden im Schach muss eben im

Gedanklichen verankert sein, das ist die Pointe. Wer nur nach ausserem Schein geht, kann leicht dazu kommen, Zuge als hässlich zu empfinden, die es durchaus nicht sind. Schon im Schach ist eben letzten Endes doch nur das Gedankliche. (The aesthetic feeling in chess must be firmly anchored in appreciating the thought behind the moves, that is the point.

Those deluded by outward appearances only may mistakenly condemn moves as ugly, when they are not so at all. Beauty in chess is, in the final analysis, conditioned solely by the quality of thought.)

With this thought, that Duchamp, Nimzowitsch and Dada were not so far apart after all, I conclude.

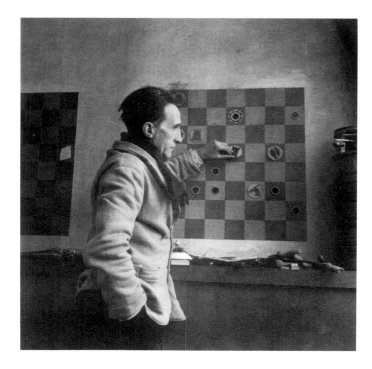

Marcel Duchamp
Photograph by Denise Bellon 1938

Raymond Keene

Principal Chess Happenings in the Life of Marcel Duchamp

1910 Paints *The Chess Game*

1911 Paints *The Chessplayers* and *The Portrait of Chessplayers*

1918 Duchamp in Buenos Aires studies Capablanca's games (Capablanca was to become World Champion in 1921) and designs his own chess set. The King had no cross on the crown

1920 Becomes member of the Marshall Chess Club, New York

1923 Competes in first serious Chess Tournament in Brussels

1924 Plays chess against Man Ray in René Clair's film *Entr'acte*

1924 Wins Chess Championship of Haute Normandie

1924 Competes in Chess Championship of France (he plays a further three times up to 1928)

1924 Competes in World Amateur Championship, Paris. Duchamp shares 21st place in B Group

1925 Duchamp declared a Chess Master by the French Chess Federation. He designs the poster for the French Championship held in Nice

1927 Marries Lydie Sarazin-Levassor on June 7. Daughter of a wealthy car manufacturer, Lydie, 15 years Duchamp's junior, left him after approximately one week, after she had glued his chess pieces to his board

1928 Shares First Prize at the Hyères International Tournament with O'Hanlon and Halberstadt

1928 Represents France in Chess Olympics at The Hague

1930 André Breton criticises Duchamp for abandoning art for chess in 'The Second Manifesto of Surrealism'

1930 Represents France in Hamburg Chess Olympics, playing on second board behind the World Champion, Dr Alexander Alekhine

1930 Duchamp exhibits *L'Echiquier mural* at Paris

1931 Becomes Member of Committee of French Chess Federation and French Delegate to the World Chess Federation, a post he holds for six years

1931 Represents France in Prague Chess Olympics

1932 Publishes chess book *L'opposition et les cases conjugées sont reconciliées* with Halberstadt in a limited edition of 1,000 copies

1932 Wins chess tournament in Paris. Plays against Buenos Aires club by radio

1933 Translates classic book by Zsnosko Borovsky into French (*Comment il faut commencer une partie d'échecs*)

1933 Represents France in Folkestone Chess Olympics (Duchamp's last Olympiad)

1935 Captain of French team in First Correspondence Olympics

1937 Writes chess column for *Le Soir*

1939 Duchamp makes top score (9 points out of 11) in Correspondence Chess Olympics

1944 'Pocket Chess Set with Rubber Glove' is Duchamp's contribution to the exhibition, 'The Imagery of Chess' in the Julien Levy Gallery in New York (other contributors are: André Breton, John Cage, Max Ernst and Man Ray)

1946 Commences work on *Etant donnés*, concealing chess board under twigs beneath nude figure

1952 Collaborates with Hans Richter in the film *8 × 8*, based on chess

1954 Oil sketch of *The Chessplayers* (1911) is acquired by the Musee National d'Art Moderne in Paris, Duchamp's first work in a French public collection!

1963 On the occasion of his first retrospective exhibition at the Pasadena Museum of Art, Duchamp plays chess in front of the *Large Glass* against a naked female opponent. Game result unknown

1964 'Game of Chess with Marcel Duchamp', a filmed interview for French television by Jean–Marie Drot, wins first prize at the Bergamo International Film Festival, Italy

1965 Exhibits, in New York, his work *Chess Score*, a record of a game he drew in 1928 with Grandmaster Tartakower

1966 Duchamp organises chess exhibition, *Hommage à Caissa* at the Cordier & Ekstrom Gallery, New York, to benefit the Marcel Duchamp Fund of the American Chess Foundation

1967 Attends Monte Carlo Grandmaster Tournament, won by Bobby Fischer

1968 In Toronto takes part in *Reunion*, a musical performance staged by John Cage, in the course of which Duchamp, Teeny Duchamp and Cage play chess, the moves played electronically triggering musical notes

Literature

Pierre Cabanne, *Dialogues with Marcel Duchamp*, London 1971

Yves Arman, *Marcel Duchamp Joue et Gagne*, Paris 1984

Moure Gloria, *Marcel Duchamp*, London 1988

Richard Hamilton, *The Bride Stripped Bare by Her Bachelors, Even: A Typographic Version*, London 1960

Jacques Caumont and Jennifer Gough-Cooper, *Ephemerides on and about Marcel Duchamp*, Port Cros 1987

Mark Kremer, 'The Chess Career of Marcel Duchamp', *New in Chess*, 2/89, Alkmaar, Holland

François Le Lionnais, 'Interview by Ralph Rumney', *Studio International*, 1975

Raymond Keene, 'Champing', *The Spectator*, London, 1 April 1989

Raymond Keene, *Aron Nimzowitsch: A Reappraisal*, London 1974

P. Feenstra Kuiper, *Hundert Jahre Schachturniere*, Amsterdam 1964

David Hooper and Kenneth Whyld, *The Oxford Companion to Chess*, Oxford/New York 1984

Marcel Duchamp and Vitaly Halberstadt, *L'opposition et les cases conjugées sont reconciliées*, Brussels/Paris 1932

Harry Golombek, *The Encyclopaedia of Chess* London 1977

Aron Nimzowitsch, *Mein System*, Berlin 1925

Aron Nimzowitsch, *Die Praxis meines Systems*, Berlin 1929.

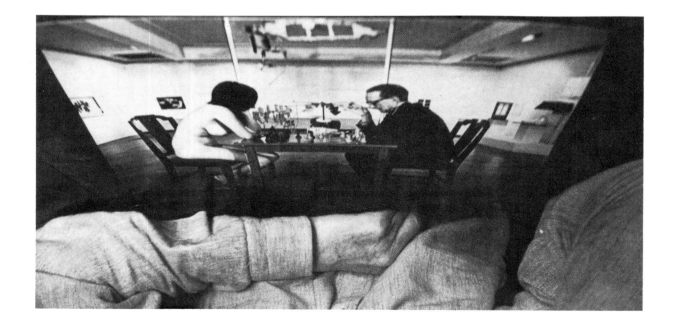

François Le Lionnais interviewed by Ralph Rumney

Marcel Duchamp as a Chess Player
and One or Two Related Matters

My interest in discussing Duchamp as a chess player with François Le Lionnais was prompted by the fact that a game he played, and won, against Duchamp in 1932 was published in the *Neue Wiener Schach-Zeitung* with comments by Tartakower and has been frequently reprinted, most recently in *Florilège des echecs en France* (Tristan Roux-Payot 1974).

The introduction to this game in this work describes Le Lionnais as a founder of Dada, an accusation which he indignantly denies, but as he says:

I was a witness of its beginning. I knew Tzara, Picabia and Duchamp for different reasons. When I began studying mathematics in the science faculty in Strasbourg, Dada already existed a bit—in Berlin, and to some extent in Paris and New York. But Strasbourg is a train stop between Paris and Zurich. And Maxime Alexandre, Marcel Noll and I were three very enthusiastic Dadaists. But I am a very marginal person—a sort of 'anarchist who refuses to join an anarchist organisation'—and while I felt that Dada was for me I did not wish to be part of a Dadaist organization.

I got to know Duchamp when he came over from the States and became involved in European Dada and we met from time to time . . . For me the essence of Dada is Picabia, Tzara and Duchamp. Anyway I broke away when Surrealism appeared. In some way I didn't want to get involved. Because it seemed to me that Surrealism was an *embourgeoisement* and recuperation of Dada.

Well, at the time, I'm not quite sure how, I learned that Marcel Duchamp was a chess player. So we used to meet in a club—the Caissa club (Caissa is the goddess of chess) which shifted from one café to another every ten years or so . . . This gave a new substance to our friendship. We would meet to play chess and talk chess and then very quickly the discussion turned, I wouldn't say to Dada, but to our ideas . . . For instance *La mariée mise à nu*.

He talked to me about that long before it was made, about his preparations . . .

I think we met in 1921 or '22. Then we lost touch in '24 or '25 until '27 or '28 and since then we've never really been out of contact. And of course once he settled in Neuilly we saw a lot of each other, almost entirely in connection with chess.

When I founded OuLiPo, Marcel was made an associate member, and though he did not take part in our work he was interested in it. So we met from time to time when there were chess tournaments . . . for instance we were together at the Monaco international tournament in, I think, 1966. A chess tournament always begins at three in the afternoon and ends at eight. At five past three Marcel and I would be seated in a quiet corner about three yards from the boards and at eight we would leave. In the meantime we might get up three or four times to have a coffee or pee, but otherwise we stayed glued to the board and of course exchanged our ideas and opinions about what was going on. I noticed that he had perhaps a certain American patriotism . . . He would say 'I think Larsen is being too

optimistic' or 'Ah! at last Fischer's won his game'. It would have been interesting to collect his comments but they're lost forever.

RALPH RUMNEY *Could you describe Duchamp's qualities as a player?*

FRANÇOIS LE LIONNAIS I don't know how well I can do that . . . in his style of play I saw no trace of . . . a Dada or anarchist style though this is perfectly possible. To bring Dada ideas to chess one would have to be a chess genius rather than a Dada genius. In my opinion, Nimzovitch, a great chess player, was a dadaist before Dada. But he knew nothing of Dada. He introduced an anticonformism of apparently stupid ideas which won. For me that's real Dada. I don't see this Dada aspect in Duchamp's style. What I did find was considerable honesty; he was very serious and very applied. This is also exemplified by the way he set about *La mariée mise à nu*. This may have been a fundamental trait of his character, which was in fact very serious.

It must be stressed that he represented France in the chess Olympiads, and consequently he was always up against stronger players than himself. He was often matched against international class players. And this prevented him from playing brilliant games. It's easier to play brilliantly against a weaker player than a stronger. Being himself the weaker he had to play very carefully and this was a handicap. He played a very fine game in which he forced a draw against Marshall, who was champion of the United States from 1909 to 1936 and a world championship candidate.

You say he was not a Dadaist as a chess player . . . but was he an innovator?

Absolutely not. He applied absolutely classic principles, he was strong on theory—he'd studied chess theory in books. He was very conformist which is an excellent way of playing. In chess conformism is much better than anarchy unless you are Nimzovitch, a genius. If one is Einstein one says the opposite to Newton of course, if one is Galileo one contradicts everyone. But otherwise it's safer to be a conformist.

What exactly was Marcel Duchamp's attitude to mathematics and science?

Well, he showed interest in our conversation. He liked talking to people with scientific backgrounds, and he asked them questions; he talked about mathematics. But until the end of his life he was stuck at Henri Poincaré—I managed to change his ideas quite a lot towards the end of his life. He had read a lot of books—not mathematical texts which he would have been unable to understand, but . . . philosophical works . . .

Popular science . . . ?

That's it, for instance *Science and Theory*. That is the philosophical musings of a great mathematician, which combine philosophical and mathematical qualities. This influenced him a lot. And then when we ran into each other I surprised him by saying (and I have no idea what influence this may have had)

'Poincaré—he's completely out of date'. That surprised him, shocked him. And I talked to him about Bourbaki[1], who was very modern at the time. Because I was involved with the Bourbaki movement from it's origins just like Dada . . . In my own work Dada was at the origin of things like *Le 3ème Secteur* and Bourbaki gave rise to OuLiPo[2]—with a lot of free interpretation of course. And when I spoke of Bourbaki to him he was very interested, and then I remember saying, towards the end of his life, 'Bourbaki's finished, it's out of date', and he seemed to be pleased that things had moved on. Then I would talk to him about Claude Berge, set theory and so on.

Would you agree that in much of Duchamp's work . . . the collections of documents, les moules maliques *and so on, there is a quasi or pseudo scientific approach?*

Yes, even pseudo and quasi . . . that is there is always the margin of error which an artist can't avoid because his culture is inadequate, and at the same time a quality of vision which gets him through somehow. It's probably something like love where one finds something by other methods than pure reason.

It seems to me that the extremely conformist style of Duchamp's chess which you describe has parallels in everything he did, and that perhaps instead of looking for evidence of Dada in the way he played chess we should be looking for aspects of this conformism in his most anti-conformist actions?

I quite agree. In fact I have said so. This serious *appliqué* side of Duchamp shows up everywhere. I regard it as characteristic of Duchamp and I liked it better than Picabia and Tzara, though I admire them both much more than Breton who seems to me to be lost in the mists of the bourgeoisie. Duchamp seems to me to represent a tendency to combine what I might call a simulation made with scientific methods but applied to an area which is not science. The same thing might be said to some extent of Raymond Roussel.

Did Duchamp show any interest in recent forms like kinetic art which seem to start from a scientific approach?

Well we hardly mentioned them; of course there were his rotodiscs which were a step towards kinetic art. But more and more when we met, in his last years especially, it was not to talk about art, but about chess. He was much more interested in chess. I greatly admired the book he wrote with Halberstadt, *Les cases conjuguées et l'opposition reconciliées*. That is really in the scientific spirit, not at an extremely high level but authen-tically scientific. And in it he takes chess a step forward . . . a very clear step forward in a limited domain, but definitely a step forward.

Could you amplify that?

A game of chess is normally considered as being in three parts. The opening, the middle-game and the endgame. The opening involves a kind of thought process which no longer occurs as the game proceeds . . . the pawns can advance one or two squares at the beginning but cannot retreat. And that is what is behind opening theory. In endgame theory, because many pieces have disappeared, often one can only hope to win by transforming a pawn into a Queen. The theory of the middle-game is another kettle of fish. Well, his contribution occurs within a particular area of general endgame theory. It sometimes happens that there are no 'pieces' (Queen, Rook, Bishop, Knight) left on the board except the two Kings and a certain number of pawns. If one of the pawns can get through to the other side and become a Queen that's the end of the game. But pawns block one another, and sometimes when there are a lot of pawns on the board the whole position is frozen. In that case the only possibility is for the King to manoeuvre round the pawns, and take his opponent's pawns so as to get one of his pawns through. The theory is very difficult. We had a sixteenth- or seventeenth-century theory called the theory of opposition but nothing else. Now since the two Kings can move on to a number of squares without any apparent danger, why is it that in the solution to a problem Reichelm was able to show that if the White King moved to a certain square at one end of the board he obliged the Black King to make a certain move? It's as though there were a sort of telepathy between the squares! And what Halberstadt and Duchamp perfected was the theory of this relationship between squares which have no apparent connection, *les cases conjuguées*, which was a sort of theory of structures of the board. That is to say because the pawns are in a certain relationship one can perceive invisible connections between empty squares on the board which are apparently unrelated.

1. *Bourbaki* is a collective pseudonym or *nom de plume* for a *société anonyme* of famous French mathematicians formed before the Second World War.
2. *OuLiPo* stands for *Ouvroir de la Littérature Potentielle*, a group which included Le Lionnais, Georges Perec and Raymond Queneau, the aim of which was to explore techniques and methods of creating literature.

Opposition et Cases Conjuguées
Opposition und Schwesterfelder
Opposition and Sister Squares

sont réconciliées par

sind durch versöhnt

are reconciled by

DUCHAMP ET HALBERSTADT

PARIS - BRUXELLES
L'ÉCHIQUIER

Edm. LANCEL
274, Avenue Molière, 274
BRUXELLES
(Belgique)

Gaston LEGRAIN
9, Rue des Ecuyers, 9
St-GERMAIN-EN-LAYE
(France)

Opening Theory Attacks

Game No. 11, English
Parisian Masters' Tournament 1932

M. Duchamp	Le Lionnais
1. c4	c5

The symmetrical treatment. Against 1. . . .e5 (which results in a Sicilian opening game), 2. a3 is perhaps most effective.

2. Nc3	Nc6
3. g3	. . .

Instead of this complex Bremen system, the lively opening up of the centre by 3. Nf3, followed by 4. d4, is also readily used.

3. . . .	g6
4. Bg2	Bg7
5. d3	d6
6. e4	. . .

An important decision. 6. Nf3 Nf6, 7.0–0 0–0, etc, is more usual (and safer) but White wants to branch off into the so-called Dresden system (characterized by the pawn formation c4, d3, e4, and possibly f4 as well). 6. f4, should be considered here.

6. . . .	f5

A considerable innovation that should give Black counterplay on the f–file, whereas with the usual reply 6. . . . Nf6, 7. Nge2 0–0, 8. 0–0 Rb8 (a counter-demonstration), 9. f4 a6, 10. h3 etc. White immediately obtains an important advantage over the rook.

At this point we should also mention that Black, in Sicilian double fianchetto: 1. e4 e5, 2. Nc3 Nc6, 3. g3 (the so-called closed treatment!) 3. . . . g6, 4. Bg2 Bg7, 5. d3 d6, 6. Nge2, could try the sharp counter-thrust 6. . . . f5, instead of the more common moves 6. . . . Bd7, 6. . . . Nf6, or 6. . . .e6 (followed by Nge7).

7. Nge2	Nf6
8. 0–0	0–0
9. Rb1	

Having achieved the development of his pieces, White now wants to ensure the protection of the b2 pawn, but also, incidentally, to prepare the familiar wing attack b2–b4 etc.

9. . . .	Bd7
10. Bg5	

To accomplish the familiar change of position manoeuvre: Qd2 (or Qc1), followed by Bh6.

A stronger preparation of this plan, however, consisted of 10. h3, for Black now succeeds in avoiding the exchange of both of his important defensive pieces (Nf6 and Bg7).

10. . . .	Ng4!
11. h3	Nge5

From this new position, the Black knight pressures the isolated pawn d3.

12. f4	

This chases the knight, but cuts off the retreat of his own bishop. Therefore, the prior retreat 12. Be3 should have been considered, leading to the complicated variant: 12. . . . fxe4 13. Nxe4 Nf3 + 14. Bxf3 Rxf3, 15. Nf4 Ne5, 16. d4 etc. A material gain for White would be ensured.

12. . . .	Nf7
13. exf5	

This exchange (which White has been trying to avoid since his seventh move, to prevent the attack by Black's queen's bishop on the isolated pawn d3) has become necessary to ward off the threat of 13. . . . h6, 14. Bh4 g5, etc. and Black's subsequent capture of a piece.

The preventative move 13. Bh4 would, on the other hand, not solve the problem, because of: 13. . . . h6, 14. g4 fg, 15. hxg4 Bxg4 etc. with the easy gain of a pawn for Black.

13. . . .	Nxg5	. . .

If now 13. . . . h6, then 14. fxg6 would be interposed (instead of 14. Bh4 g5).

14. fxg5	Bf5
15. g4	. . .

Once again (as with White's twelfth move) an attacking measure with a psychological grounding, but which is nevertheless rash, for it exposes White's own rook. Better then to omit it, and immediately to play 15. Ne4, and if 15. . . . Qc8 (or Qd7), then 16. Kh2.

15. . . .	Bd7
16. Ne4	Rb8

After this successful interlude (in which White made a vain attempt to transfer the force of the attack to the king's side), Black now takes up the position characteristic of this opening, which not only screens the queen's rook from the opposing bishop en fianchetto, but also prepares the way for a lateral offensive (b7–b5 etc.).

17. Qd2	Nd4
18. Nf4	Bc6
19. Nd5	

As White no longer has at his disposal a pair of bishops with long-range usefulness, the opening up of the lines by 19. b4 cxb4 etc., would have very double-edged results. He prefers to manoeuvre the short-range pieces, rather than undertake a carefree pawn offensive.

19. . . . a5!

19. . . . Bxd5 20. cxd5 etc. is not a trouble-free acquisition, as the battle would heat up, for, example as follows: 20. . . . b5, 21. Rxf8 + Qxf8 22. Rf1 Qe8 23. Nc3 b4, 24. Ne2 etc.

Alternatively, 19. . . . b5 would be premature because of the counter-move 20. b4. But the textbook move threatens to be followed by 20. . . . b5, and the prospect, in certain circumstances, of sacrificing the pawn a5.

20. Rxf8 +

Not 20. a3, because of 20. . . . Nb3, followed by 21. . . . a4.

20. . . . Qxf8!
21. Rf1

It would be a mistake to accept this poisoned gift: 21. Q × a5 etc. The consequence: 21. . . . Bxd5 22. cxd5 Nf3 + 23. Kh1 Qf4, 24. Bxf3 Qxf3 + etc.

21. . . . Qd8
22. Kh1 Be5
23. Qe3

It would be futile to play 23. Qf2, because there would follow 23. . . . Bxd5, 24. cxd5 Qe8 etc. The textbook move offers the opponent a double trap:
(1) 24. Nxc5 dxc5 25. Qxe5, with the gain of a pawn as well as an exchange of bishops.
(2) 23. . . . Nc2? 24. Qf2, and an immediate breakthrough on f7.

23. . . . b5!

A liberal reply, which seems to ignore the opponent's threat of winning a pawn. In reality Black achieves his own strategic aim, the possession of the b–file, thus establishing a close rivalry between the two files open to the rooks: b (for Black) and f (for White).

24. Nxc5 bxc4
25. dxc4 Rxb2

The breakthrough takes place with a simultaneous threat on two fronts:
(1) The gain of a knight by 26. . . . Re2, followed by 27. . . . dxc5.
(2) The gain of a pawn without compensation by 26. . . . Rxa2.

26. Ne4 Bxd5
27. cxd5 Rxa2

A small but significant material gain has been made. In the following phase of the game, White, understandably, tries a whole variety of tactical tricks.

28. Nd2 a4
29. Nc4 Re2
30. Qd3 Bg7
31. h4! Qc8!

Attack and defence are balanced.

32. Rf4 Rel +.
33. Kh2 Nb3
34. h5! Qc5!
35. Bf1 gxh5

After a precise calculation, Black is not afraid to abandon the f5 square, for he could have chosen the more cautious moves 35. . . . Be5, 36. Nxe5 dxe5 etc. or 35. . . . Re5 36. hxg6 Rxg5 etc.

36. gxh5

The last tactical opportunity lay with 36. Qf5 (threatening 37. Qf7 + Kh8 38. Qe8 + etc.). Nevertheless, Black could still have overcome this attack with 36. . . . Kh8! 37. Qf7 Qc8, 38. gxh5 Qg8, 39. h6 Be5, 40. Nxe5, Rxe5 etc.

36. . . . Re5
37. Rf5 Rxf5
38. Qxf5

The endgame, now being reached, is still tactically very interesting. The preceding development was fascinating from a strategic standpoint, but now some brilliant sacrifices are made.

38. . . . Nd4
39. Qe4 a3!
40. Bd3

This threatens 41. Qxh7 + and prevents 40. . . . a2, because of 41. Qxe7!

40. . . . Nf3 +!

A diversionary tactic that gains valuable time. 40. . . . a2, would be wrong because of 41. Q × e7!

41. Qxf3

Forced.
41. . . . a2
42. g6

Or 42 Qe4 Qf2 +. 43. Kh3 a1Q 44. Qxh7 + Kf8, and Black wins.

42. . . . hxg6
43. Bxg6 Bf6!
44. Qg2

The final attempt.

44. . . .	a1Q
45. Bh7+	Kxh7
46. Qg6+	Kh8

| 47. Qe8+ | Kg7 |
| 48. Qg6+ | Kf8 |

White resigns.

Gaston Legrain

Paris International Tournament of 1928

Zuckertorte Opening

White: Tartakower *Black*: Duchamp

| 1. Nf3 | Nf6 |
| 2. b3 | d6 |

This unusual move is made to provoke P-Q$_4$.

| 3. d4 | d5 |

Black has lost a tempo in order to obstruct the long black diagonal.

| 4. e3 | Bf5 |
| 5. Bd3 | Bxd3 |

Against someone of Tartakower's stature it is not disadvantageous to clear the chess-board through exchanges.

6. Oxd3	c6
7. Nbd2	e6
8. 0–0	Nbd7

White has made seven developing moves as opposed to Black's four. This difference will result in prolonged difficulties for Black.

9. e4	dxe4
10. Nxe4	Nxe4
11. Qxe4	Be7
12. c4	0–0
13. Bb2	Bf6
14. Rad1	Re8
15. Ne5	Qc7
16. f4	Rad8
17. Rfe1	Nf8
18. Ng4	

Hitherto, White has played mechanically. This last move made some careful consideration necessary.

18. . . .	Bh4	P(i)
19. g3	f5	
20. Qe5	Qxe5	
21. Nxe5	Be7	

22. Kg2	Bb4
23. Re2	Nd7
24. a3	Bf8

It would clearly cost a P to return to e7.

25. Nxd7	Rxd7
26. Rde1	Kf7
27. Kf3	

To attack Black's backward e-pawn, White has only the K left.

27. . . .	g6
28. g4	fxg4+
29. Kxg4	Bg7
30. d5	cxd5

If 30 . . . Bxb2 White wins the exchange.

31. Bxg7	Kxg7
32. cxd5	Rxd5
33. Rxe6	Rxe6
34. Rxe6	

A fresh liquidation leading quite clearly to a draw. Our friend Duchamp has been most successful in annihilating his redoubtable adversary's endeavours.

34. . . .	Kf7
35. Re3	Kf6
36. h4	h5+
37. Kf3	Kf5
38. b4	a5
39. bxa5	Rxa5
40. Rb3	Ra4
41. Rb5+	Kf6
42. Rb6+	Kf5
43. Rb5+	Kf6
44. Rb6+	Kf5
Draw	

Second Round of the Philidor Cup
Hyères, January 1928

Queen's Pawn

White: M. Duchamp[1] *Black*: E. H. Smith

1. d4	d5
2. Nf3	Nf6
3. e4	e6
4. Nc3	b6

At this stage of the game, the development of the QB en fianchetto is certainly unwise, and the usual moves 5 . . . Be7, Nbd7, c6 are surely preferable.

5. cxd5	

A classic move in positions of this kind. Black is forced to retake with the P and, consequently, to close the diagonal in which he wishes to instal the B.

5. . . .	Nxd5

The capture by the Kt in fact gives White the chance of gaining time by 6. P-K$_4$. But he prefers here to develop his QB.

6. Bd2	Ba6

This odd move has the object of preventing e4, which would be followed by Bxf1. White quickly refutes it.

7. Ne5	Nxc3
8. Bxc3	f6?

One fault generally leads to another. This move is a grave error, resulting from Black's incorrect development with b6.

9. e3!	

One cannot overemphasize the fact that the combination inaugurated by this move is not the creation of White but that of Black who, playing badly, has placed himself in a bad position. The role of White, in such an occurrence, is to exploit his good position, and to consolidate the potential advantage by discovering the winning combination.

9. . . .	fxe5

The other alternative was prettier than the actual text. He could in fact have played: 9. . . . Bxf1; 10. Qh5 + Ke7 (if 10 . . . g6 11. Nxg6 etc. . . with catastrophic results for Black); 11. Qf7 + Kd6 12. Bb4 + c5 13. dxc5 + Kxe5 14. Bc3 + Kf5 15. Qh5 + g5 16. e4 + Kxe4 17. Qf3 mate!

10. Bxab	Nxa6
11. Qa4 +	Qd7
12. Qxa6	Be7
13. dxe5	0-0
14.	0-0 c5
15. Rad1	Qc7
16. Qc4	

Putting pressure on the isolated weak P on e6.

16. . . .	Qc6
17. P24	a4 Rad8
18. f4	

Threatening Rxd8 followed by f5.

18. . . .	Rxd1
19. Rxd1	g6

To oppose the advance of f5. But the occupation of the advanced square, with the sacrifice of the exchange, opening a diagonal towards the castled position of the Black K and creating an advanced pawn as powerful as a piece, is now decisive.

20. Rd6!	Bxd6

The withdrawal 20. . . . Qc8 would have been no better. The game is lost.

21. Qxe6	Rf7
22. exd6	Qd7
23. Qe5	Resigns

The position is hopeless. If, for example, 23 . . . Rf8 24. Qh8 + Kf7 25 Qh7 + and the passed pawns are irresistible.

1. Duchamp translated the moves of this and the next game into English notation for the American edition of Marcel Jean's *Histoire de la peinture surréaliste*.

Cinéma

Marcel Duchamp in
Maya Deren's film
The Witch's Cradle 1943

Marcel Duchamp
in René Clair's *Entr'acte*
1924

From *Film as Film*
exhibition catalogue
Arts Council of Great Britain
1979

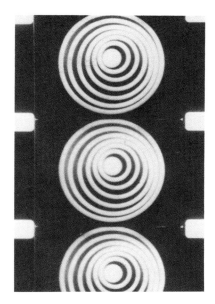

Marcel Duchamp

1887 Born in Blainville, France
1906-1913 Begins career as a painter in Paris
1915-18 In New York, abandons painting, begins optical experiments
 with Man Ray
1919 Returned to Paris, participated in Dada and Surrealist activities,
 eventually 'ceasing to produce art'.
1968 Died in Neuilly

1920 *Moustiques Domestiques Demi-Stock* (stereoscopic experiments
 with Man Ray, never completed as a film) 1925 *Anemic
 Cinema* 7 mins

It is through his research into three-dimensionality that Marcel
Duchamp, with the help of Man Ray, become interested in the
cinema. A first attempt in 1920 in New York, made with two
synchronised cameras (a transposition of stereo-photographic
techniques known and used widely since the beginning of the century),
was ruined in the developing process except for a few images.

But another solution, using circles de-centred from their axis of
rotation, had been envisaged since 1920 and was successfully realised
with the 'rotary demi-sphere' constructed for Jacques Doucet in 1925.
This film, whose anagrammatic title immediately evokes an illusory
'profoundness', was very strictly composed of 10 optical discs between
which alternated nine discs carrying the following inscriptions:
— Bains de gros thé pour grains de beauté sans trop de Bengué.
— L'enfant qui tête est un souffleur de chair chaude qui n'aime pas le
chou-fleur de serre chaude.
— Si je te donne un sou, me donneras-tu une paire de ciseaux
— On demande des moustiques domestiques demi-stock pour la cure
d'azote sur la Côte d'Azur.
— Inceste ou passion de famille à coups trop tirés.
— Esquivons les ecchymoses des Esquimaux aux mots exquis.
— Avez-vous déjà mis la moelle de l'épée dans le poéle de l'aimée?
— Parmi nos articles de quincaillerie paresseuse, nous recommandons
le robinet qui s'arréte de couler quand on ne l'écoute pas.
— L'aspirant habite Javel et moi j'avais la bite en spirale.
It is not known exactly when, nor by whom, several very short shots
were introduced in the middle of the film (the face of a girl, a tank
clearing an obstacle, a statue of Napoleon which crumbles), shots
perhaps indebted to Eisenstein (according to G. Sadoul, who describes
the film in this form in his *Souvenirs d'un témoin*). But it was probably
done very early, as attested by the early copy conserved by the Danish
film archive.

Duchamp however has explicitly and entirely denounced this in an
unpublished correspondence with Serge Stauffer. In a first letter dated
10 May 1961, Stauffer asked him if he remembered the 'realistic
section which lasts a little more than a minute' in *Anemic Cinema*.
Duchamp responded from New York on 28 May that he had 'no
memory of the interpolations (Napoleon, etc) of which you speak,
certainly done without my consent'. Not completely satisfied with this
response, Stauffer returned to this point in another letter dated 20
June and he included stills from the film. The reply from Duchamp
(date 26 June) was emphatic: 'I am sending you the stills of *Anemic
Cinema*, and all those marked "do not recognise" have been added by
"anonymous". It is essential that they not be published or thus create
a general delusion about a version for which I am in no way
responsible.'

from *Cinéma Dadiste et Surréalist,* Centre Georges Pompidou, Paris,
1979, p. 32.

Marcel Duchamp
in a scene from Hans Richter's film
Dreams that Money Can Buy
1944–47

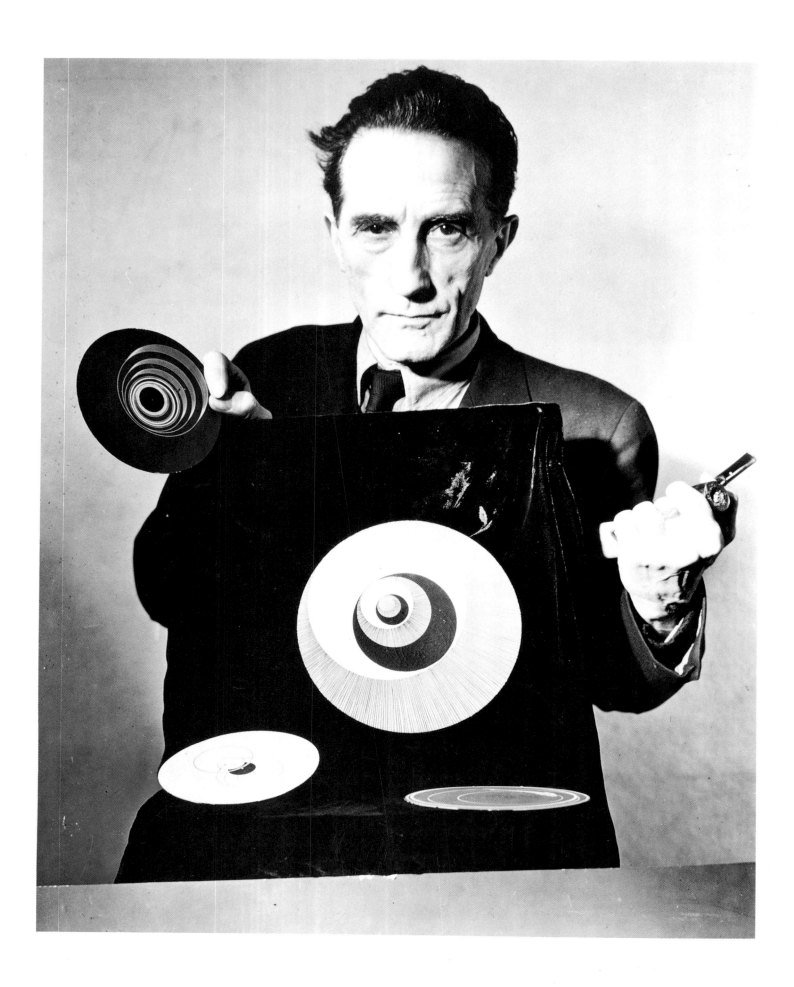

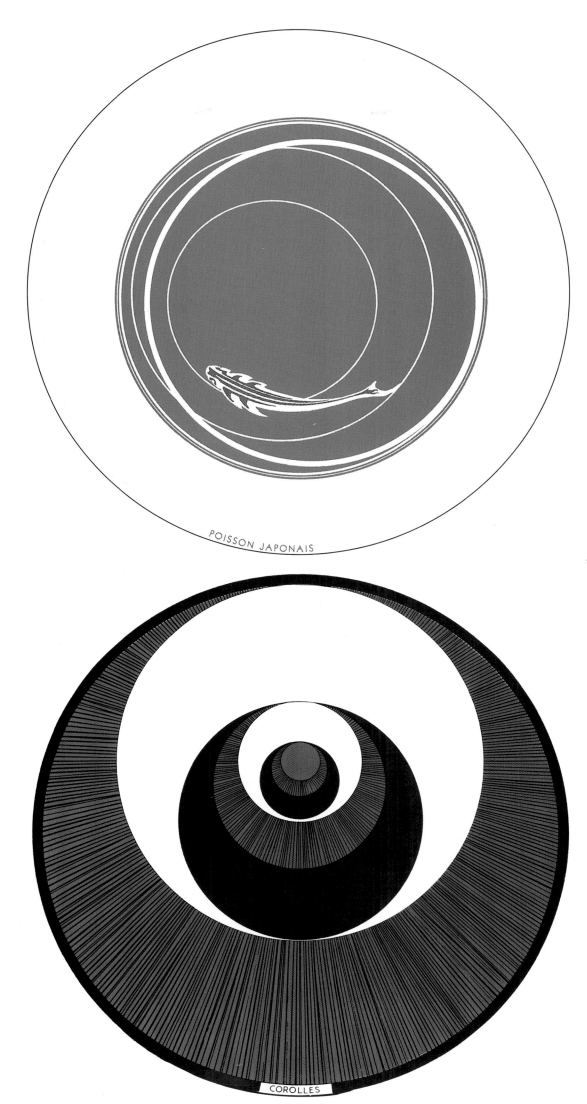

POISSON JAPONAIS

COROLLES

139

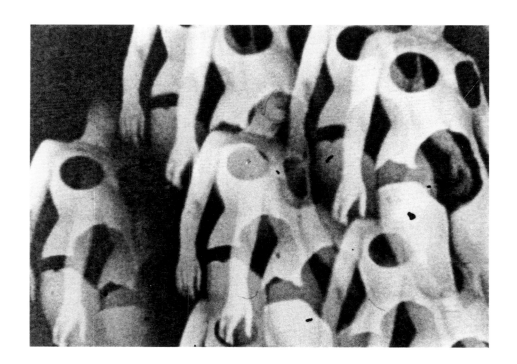

Marcel Duchamp
Frames from *Anémic-cinéma*
1924–26

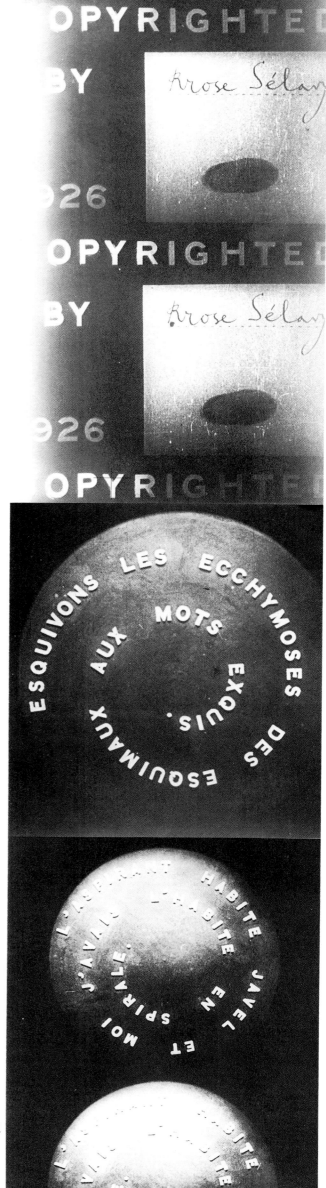

141

Musique

Marcel Duchamp
Erratum musical
(*La mariée mise à nue par ses célibataires, même*)
c. 1913

Marcel Duchamp
Avoir l'apprenti dans le soleil
January 1914
from *The Box* 1914

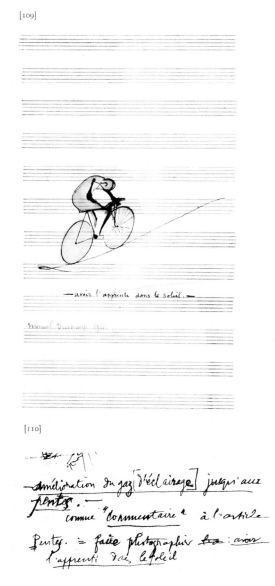

Gavin Bryars

Notes on Marcel Duchamp's Music

First published in *Studio International*, vol. 192, no. 984, November 1976

Although I've always felt that John Cage's text, *26 Statements re Duchamp*,[1] is one of the weakest ones that he wrote, it has for me one memorable line: 'One way to write music: study Duchamp.' The story of Cage's friendship with Duchamp towards the end of his life is a very moving one, interestingly outlined in the interview with Moira and William Roth, an interview in which he also talks about his response to Duchamp's work as a whole.[2] There are at least three major pieces in Cage's work that are directly linked with Duchamp: the prepared piano piece *Music for Marcel Duchamp*, 1947, written for the Duchamp sequence of Hans Richter's film *Dreams that Money Can Buy*, 1948; *Reunion*, 1968, in which Cage and Duchamp (then Cage and Teeny Duchamp) played chess on a board specially constructed by Lowell Cross, which contained circuits to allow the various moves to modify, transmit or interrupt the sounds made by musicians David Tudor, Gordon Mumma and David Behrman;[3] and *Not Wanting to Say Anything About Marcel*, 1969, a piece of visual work made in collaboration with Calvin Sumsion, printed on layers of plexiglass mounted in a frame, on which texts are fragmented through chance operations, these being described in an accompanying booklet.[4]

In many ways, these three works shows the ambivalence of any attempts at drawing up relationships between Cage and Duchamp, although both are cited as being in part responsible, for example, for a shift away from an emphasis on the finished art-object/piece of music in performance and so on. Cage himself points to this difficulty in the interview with the Roths, and again in a recent interview with Michael Nyman. To the Roths, Cage said: 'A contradiction between Marcel and myself is that he spoke continuously against the retinal aspects of art, whereas I have insisted upon the physicality of sound and the activity of listening. You could say I was saying the opposite of what he was saying.' But Cage is well aware that the position is more complicated than this, as his observations on *Etant donnés* (1946–66) make clear. Cage had always enjoyed what he felt were the 'freedoms' offered by the *Large Glass* in, for instance, the way the environment was allowed to interact with it through the use of a transparent material and points to the 'uncomfortable' nature of *Etant donnés*: 'the imprisoning us at a particular distance and removing the freedom we had so enjoyed in the *Large Glass.*' However, it is plain from Richard Hamilton's work, and from that of Reg Woolmer, that the *Large Glass* imprisons the viewer in precisely the same way and that there is a uniquely 'right' view for that work too, even if Duchamp does not prescribe what it is. Cage hoped that the contrary aspects of his work and Duchamp's are resolved by this last work: 'with *Etant donnés* we feel his work very physically . . .' In the interview with Nyman, Cage points out how 'Feldman has complained that my friendship with Duchamp was false because of this contrary . . . but I think the contrary was the same. It was just that the arts changed. In other words that being physical in music was the same as having ideas in painting . . .'[5]

I can understand the historical point that Cage is making, that

introducing ideas into art stops the retinal rot—according to Duchamp dating from Courbet—and that the emphasis on the physical nature of sound and the musical experience of the listener shifts focus away from the presence of ideas in music (from allegories, from programmes, from systems etc). But I cannot imagine that Duchamp would have concurred with it. The parallel seems to be more that the physical emphasis, the tympanic I suppose, mirrors the Courbet/Impressionism heresy of retinal painting, and that the reintroduction of ideas into music by younger composers today represents the Duchampian alignment. Certainly both retinal art and tympanic music are necessary in a sense which Cage might appreciate, in that they fulfil the function of 'studying Zen' in the story that Christopher Hobbs once quoted to the effect that studying Zen may involve many deprivations, ascetic diet and so on, but after having achieved enlightenment, the monk may well feel free to eat anything, including lamb chops.[6] The 'physicality' of sound, about which Feldman especially talks, the retinal art that Duchamp deprecates, may all constitute this temporary and necessary asceticism so that one may go back to descriptive music, to figurative painting, with one's feet 'a little off the ground'— Duchamp's ironic distance.

Among all the various Duchampian hermeneutics, the least known, and the most attractive, is that put forward by Gary Glenn, an interpretation only casually hinted at in the letter columns of *Artforum*.[7] His thesis is that 'Duchamp was merely aping the thoughts and gestures of the greatest artist of all times, Sherlock Holmes'; and substantiates this in outline by pointing to the Queen Bee/Bride relationship and the frequent appearances of waterfalls and gaslamps at key points in their respective work. Later he developed this further in correspondence with me and, resting as it does on the complete absence of direct reference to Holmes in all Duchamp's known utterances, it is a good deal more plausible than the alchemic version which originates in a tentative negation on Duchamp's part.[8] A further piece of armour for Gary's arsenal can be found in the importance of musical and sounding experimentation in their work: and—although Duchamp never attempted a monograph on the scale of Holmes' treatise on the Polyphonic Motets of Lassus—notes on sound-making, musical references in notes, musical notations, the occasional presence of manuscript paper and the one or two intrusions of sounds into his iconography, are sufficiently considerable to form a body of perhaps peripheral but, in sum, significant probings into musical realms.

As an outline, let me list these as a kind of catalogue of Duchamp's music:

(Box of 1914)

1. 'One can look at seeing; one cannot hear hearing.'
2. 'Make a painting of frequency.'
3. *Avoir l'apprenti dans le soleil* (To have the apprentice in the sun). Executed in ink and pencil on music paper, this is the only drawing Duchamp included in the *Box of 1914* and considered

of sufficient importance to think about including in the bottom panel of the *Large Glass* (see 7) as a photographed 'commentary'. The idea of photographing this work does not necessarily mean that he would have printed the photograph on the Glass in the area of the Slopes. It is more likely to mean that having a photograph made of *Avoir l'apprenti* . . . would in itself be a 'commentary' on this section, an unusual and interesting move that may have been executed. The continuous line, moving up across music paper, may equally comment on the note on precision musical instruments (see 14), the notation for a continuous tone, unrealizable by the mechanical means he suggests in the note itself.

(The Green Box, 1934)

4. 'The number 3 taken as a refrain in duration—(number is mathematic duration)'. The occurrence of the number three in the scheme of the *Large Glass* has been commented on many times, most notably by Richard Hamilton,[9] and its use is so frequent as to constitute an almost invariable echo rather than the more optional refrain.

5. '*Musical Sculpture*. Sounds lasting and leaving from different places and forming a sounding sculpture which lasts.' This idea anticipates the much later three-dimensional musical pieces using continuous tones by Alvin Lucier.

6. 'To lose the possibility of recognising 2 similar objects—2 colours, 2 laces, 2 hats, 2 forms whatsoever to reach the impossibility of sufficient visual memory, to transfer from one like object to another the memory imprint.
—Same possibility with sounds; with brain facts.'

This note is one of the three 'academic ideas' which Jasper Johns says he has found particularly useful.[10]

7. 'As a "commentary" on the section Slopes. = have a photograph made of:
to have the apprentice in the sun' (see 3)

8. 'Exposé of the Chariot (in the text = litanies of the chariot).
—Slow life—Vicious circle—Onanism—Horizontal—Buffer of life—Bachelor life regarded as an alternating rebounding on this buffer—Rebounding—Junk of life—Cheap constructions—Tin—Cords—Iron Wires—Crude wooden pulleys—Eccentrics—Monotonous flywheel.'

9. 'By eros' matrix, we understand the group of 8 uniforms or hollow liveries destined to receive the illuminating gas which takes 8 malic forms (gendarme, cuirassier, etc). The gas castings so obtained, would hear the litanies sung by the chariot, refrain of the whole celibate machine.' These two notes (8 and 9) taken in conjunction, give a sort of soundtrack to the workings of the Glass and amplify what Duchamp meant when he told Pierre Cabanne that calculations and dimensions were the important elements of the work and that he was 'mixing story, anecdote (in the good sense of the word), with visual representation, while giving less importance to visuality, to the visual element, than one generally gives in painting . . .'[11]

10. '*Song*; of the revolution of the bottle of Benedictine.

—After having pulled the chariot by its fall, the bottle of Benedictine lets itself be raised by the hook . . . it falls asleep as it goes up; the dead point wakes it up suddenly and with its head down. It pirouettes and falls vertically according to the laws of geometry.'

11. '*Rattle*. With a kind of comb, by using the space between 2 teeth as a unit, determine the relations between the 2 ends of the comb and some intermediary points (by the broken teeth).'

12. '*Erratum musical*. Yvonne/Magdeleine/Marcel: 'To make an imprint mark with lines a figure on a surface impress a seal in wax.' It is worth noting that, although the musical score is composed by chance—picking the notes out of a hat—Duchamp evidently knew enough about music to pitch the voices within their respective ranges: his own tenor voice from C below middle C to B above it, and his two sisters having alto voices from F below middle C to E at the top of the treble stave. The changes of clef within each part are a little odd: he allows his own voice to go only to G in the bass clef before changing to treble clef (A flat), and his sisters' voices come down to G in the treble before changing to the bass clef for F sharp; all of which, while being internally consistent, is not conventional. The text itself is a dictionary definition of the verb 'to print' and the title of *Erratum*, having the sense of 'misprint' (Musical Misprint) gives it an odd flavour, the more so when the whole range of meanings for 'print' are looked at, many of which have a more than casual significance for the procedures involved in the Glass.

13. '*Piggy Bank (canned goods)*. Make a readymade with a box containing something unrecognisable by its sound and solder the box—already done in the semi readymade of copper plates and a ball of twine.'[12] The realisation of this note, *With Hidden Noise*, 1916, was co-authored by Walter Arensberg in that it was he who chose the object for inclusion inside the ball of twine, and the secrecy element may reflect his interest in the cryptic. The phrase 'make a Readymade' has a curious flavour, and it seems likely that the childishly simple cipher that Duchamp wrote on the two metal plates is only the first stage of a more extended one. (To be developed, as Duchamp would say.)

(A l'infinitif, 1966)

14. 'Construct one and several musical precision instruments which produce mechanically the continuous passage of one tone to another in order to be able to record without hearing them sculptured sound forms (against 'virtuosism' and the physical division of sound which reminds one of the uselessness of the physical colour theories)' (see 3).

15. 'A thing to be looked at with one eye
 ″ ″ ″ ″ ″ ″ ″ the left eye
 ″ ″ ″ ″ ″ ″ ″ ″ right ″
What one must hear with one ear
 ″ ″ ″ ″ ″ ″ ″ ″ the right ear
 ″ ″ ″ ″ ″ ″ ″ ″ ″ left ″
to put in the Crash-splash.

One could base a whole series of things to be looked at with a single eye (left or right). One could find a whole series of things to be heard (or listened to) with a single ear.'

While *To be looked at (from the other side of the glass) with one eye, close to, for almost an hour*, 1918, probably Duchamp's most underrated work, was a realisation of this note as a self-contained piece, serving in part as a study for the right hand side of the lower panel of the *Large Glass*, the notes relating to listening were not realised. The concern for determining what, exactly, should be the point and manner of perception of a piece related both to the *Large Glass* and to *Etant donnés*, as well as to many other manifestations of this, such as the exhibition installation of the *Exposition internationale du surréalisme*, Paris 1938; *First Papers of Surrealism*, New York 1942; *Anémic-cinéma*, 1926; *Hand Stereoscopy*, 1918–19; *Tu m'*, 1918; the unfinished *Cheminée anaglyphe*, 1968; and the lost films in anaglyphe and stereoscopy. It is also worth recalling the installation by Frederick Kiesler of the *Boîte-en-Valise* in the Peggy Guggenheim gallery, New York, 1942, in which the Box was observed through a fixed viewer.

(Miscellaneous Works)

16. *Erratum musical* (*La mariée mise à nu par ses célibataires, même*), a musical composition not included in the collections of notes. (See below for discussions of this piece.)

17. *Flirt*, 1907. An inscribed early drawing with the following caption written below, of a woman sitting at a grand piano talking to a man: 'She: "Would you like me to play 'On the Blue Waters'? You'll see how well this piano renders the impression suggested by the title." He (wittily): "There's nothing strange about that, it's a watery piano."' (*Piano aqueux* = watery piano, *piano à queue* = grand piano).

18. *Musique de chambre*, 1909–10. Another captioned picture of a woman at a piano, this time being given a music lesson. The woman says 'Button your jacket, here's the maid . . .'

19. *Sonata*, 1911. Duchamp said of this painting that it was his 'first attempt to exteriorize (his) conception of cubism at that time.' And the painting shows that, just as chess had been a constant activity in his family circle at home and became the subject for a series of exploratory drawings leading to *The Chess Players*, 1911 and *Portrait of Chess Players*, 1911 (painted by gaslight), so too music played a similar role both as a family pastime and as the subject for this important painting. It's worth noting that his choice of Magdeleine and Yvonne as the other two participants in the *Erratum musical* (see 12) originates in their already existing musical abilities, Yvonne as a pianist and Magdeleine as violinist, and the humour of *Flirt* and *Musique de Chambre* could well stem indirectly from observation.

20. *With Hidden Noise*, 1916. The realisation of the note in the *Green Box*, there called *Piggy Bank* (see 13).

(Texts with musical sense)

21. '*Parmi nos articles de quincailleries paresseuses, nous recommandons un robinet qui s'arrête de couler quand on ne l'écoute pas.*' (Amongst our articles of lazy hardware, we recommend a faucet which stops dripping when no one is listening to it).

22. *Caleçons de musique (abréviation pour: leçons de musique de chambre)*' (Musical shorts (abbreviation for: chamber music lessons)).

23. *Il faut dire: La crasse du tympan, et non le 'Sacre du Printemps'* (One should say: Eardrum grease, and not *The Rite of Spring*).

24. *Une boîte de Suédoises pleine est plus légère qu'une boîte entamée parce qu'elle ne fait pas de bruit.* (A full box of matches is lighter than an opened box because it does not make any noise).

25. *Mi Sol Fa Do Re* (phonetic equivalent for Michel Cadoret)

26. 'après: '*Musique d'ameublement*' d'erik SATIE
 voici: '*Peinture d'ameublement*' de YO Savy (alias Yo Sermayer).
 Rrose Sélavy (alias Marcel Duchamp).'
 (after 'Furniture Music' by erik SATIE here is: 'Furniture Painting' by YO Savy (alias Yo Sermayer)
 Rrose Sélavy (alias Marcel Duchamp).

27. 'A transformer designed to utilize the slight, wasted energies such as: . . . laughter . . . sneezing . . . the sound of nose-blowing, snoring . . . whistling, singing, sighs etc . . .'

28. 'The sound or the music that corduroy trousers, like these, make when one moves, is pertinent to infra-slim . . .'

The various texts not linked directly to elements in the *Large Glass* itself, but nevertheless included in the collections of notes associated with it, are largely researches of a speculative nature — not unlike the kind of researches undertaken by Leonardo into musical areas, such as the invention of possible musical instruments (often of a mechanical nature), especially in two pages of the Madrid notebooks that appeared in 1967. The comments that Winternitz makes about those drawings and notes seem, in part, to be appropriate to the musical ideas in Duchamp's collections of notes:

> they add considerably to our comprehension of (Leonardo's) restless, indefatigable mind, so overwhelmed by new ideas, associations, and technological imagination that he could cope with this onslaught only by jotting down passing thoughts, often so sketchily that important details which he evidently took for granted are neither delineated nor explained in his comments.[13]

In the Madrid notebooks we find designs for a bell using a damper mechanism to produce four distinct tones, a system of bellows for 'continuous wind' with a three-piped instrument, string instruments played by elbow action, a keyed string instrument, and so on. The mechanical nature of Leonardo's speculations compares very well with that of much of Duchamp's musical writing, for example the 'musical precision instruments' (see 14) that 'produce mechanically the continuous passage of one tone to another' and which have the effect of supressing the virtuosic role of the performer.[14] This effect is equivalent to his concern for eliminating the manipulation of paint which, as Hamilton says,

Marcel Duchamp
Erratum musical 1913
from *The Green Box* 1934

had 'become repugnant'[15] to him but which he was obliged to overcome in painting the 'blossoming' in the top panel of the *Large Glass*.

It was from Brisset that Duchamp found that a concern for the sounding aspect of language, what might seem superficially to be its retinal aspect, could lead to a new dimension of meaning. Brisset's system of finding new relations of meaning through a network of alliteration and pun corresponded to his own developing sense of *'infra-mince'*,[16] through which minute shifts produce large-scale change. The pun itself is an example of this concept, in that it is the shift of focus by the *hearer* which induces new meanings. Clearly, sound is necessary for the pun (and for its extension, the strict rebus) and several of the puns themselves (see 21–28) deal with sounding elements as though to emphasise this fact. One of them, 'Lazy Hardware' (see 21), occurs so often that it must have had additional significance for Duchamp. It is one of the discs in *Anémic-cinéma*, 1926; it is included in the André Breton *Anthologie de l'humour noir*, 1940; it is reprinted in the *Boîte-en-valise*, 1941; it is written on a photograph of Duchamp working on the window display at the Gotham Book Mart, New York 1945, where he fixes a tap to the mannequin's thigh: and it also appears on a 1965 etching of the *Fountain* entitled 'An Original Revolutionary Faucet: Mirrorical Return?' Again this text throws the onus of artistic activity onto the spectator (listener), in a sense closely related to Berkeley's idealist philosophy in which existence is conditional on being perceived. Duchamp emphasises this in his conversation with Cabanne, when he maintains that, even if some 'genius were living in the heart of Africa and doing extraordinary paintings every day, without anyone's seeing them, he wouldn't exist.' On the other hand he felt, mistakenly I think, that Walter Arensberg's Baconian studies were only 'the conviction of a man at play', whereas Arensberg is really a very good example of the creative spectator (here decoder) completing the artwork.

It is in the musical works themselves, the two sets of *Erratum musical*, that the difference between Cage's and Duchamp's attitudes to chance are most apparent. In the vocal *Erratum musical*, Duchamp wrote the notes on pieces of paper, put them in a hat, and then pulled them out again. Cage says: 'I wouldn't be satisfied with that kind of chance operation in my work . . . there are too many things that could happen that don't interest me, such as pieces of paper sticking together and the act of shaking the hat.' On the other hand, it is very clear that this very feeble (a frequent term in Duchamp's work) use of chance is very appealing to Duchamp. The *Large Glass* is full of similar pieces of puniness: the 'feeble-cylinders' and the 'timid-power' of the *Bride*,[17] the falling metre of thread for the *Standard Stoppages*, the air-currents used to form the *Draft Pistons*, the toy cannon shooting painted matchsticks for the *Nine Shots* and so on.

The other *Erratum musical*, the manuscript of which was given to Cage by Teeny after Marcel's death, is another example of a use of chance which would be quite alien to Cage. For this, a vase containing 89 numbered balls, each one indicating a note, has an opening at the base which allows the balls to drop into a series of small wagons, like a miniature goods train, which travel at a variable speed so that each wagon received a number of these balls. When the vase is empty, the notes are recorded and this indicated one period of the composition. It is odd that Duchamp says 89 notes since in all the transcriptions of the numbers he only ever uses 85, and, in fact, 85 is the number of notes on a 7-octave piano from A to A, and even a piano having the extra high C would only have 88. (Although he notes the possibility of there being more notes — using quarter tones he does not mention using less.) Given what Richard Hamilton feels is the improvisatory nature of the original composition of the *Large Glass* in plan view, working outwards from the stem of the *Chocolate Grinder*,[18] it seems feasible that the measurements in that plan, especially the overall width of 170 centimetres, gave Duchamp the idea of the piano's width (2×85). The coincidence of the one generates the parenthetical research of the other and, given also that at this time the ninth *Malic Mould* had not been added to the scheme, the limitation of the number of periods in Duchamp's transcription to eight may not be arbitrary. As in the note 'precision musical instruments' (see 14), he again indicates his preference for 'a designated musical instrument (player piano, mechanical organ or other new instruments for which the virtuoso intermediary is suppressed).'[19]

It is when examples like this come to light that Duchamp's debt to the stage performance of Roussel's *Impressions d'Afrique* becomes even more apparent. The third of the 'tableaux vivants' announced by Carmichael in *Impressions d'Afrique* is the one where the actor Soreau plays the part of Handel as an old blind man 'composing the theme of his oratorio, *Vesper*, by a mechanical process.' Granted that Roussel's wonderful conception of Handel composing the work by selecting one from the seven sprigs of holly in his left hand, each indicating a note on the diatonic scale, and noting it on the balustrade of a winding staircase, is far in excess of Duchamp's piece of mechanical music, it is sufficiently striking in the context of all other half-remembered elements from *Impressions d'Afrique* that filter through into his work. (Only the consummate skill of the ageing composer prevents chance selection of notes from the diatonic scale from becoming tedious, a fear that Duchamp feels for his own piece when he adds that it would be 'a very useless performance in any case').[20] Of the five possible Rousselian examples that leave traces in the *Large Glass*, three deal directly with music of a mechanical nature and of these three, two involve performance within glass containers.[21]

Apart from his friendship with John Cage in the last years of his life, we know that Duchamp previously had other connections with the world of musicians, though of a more tangential kind. He knew Varèse, having met him at the Arensberg's and he took part in a performance of Satie and Picabia's *Relâche* in 1924, appearing as Adam, wearing a false beard and a fig leaf, with Brogna Perlmutter as Eve (and made an etching, one of the

Lovers series of 1967–8, based on the photograph of this tableau, *Selected details after Cranach and Relâche*', 1967), as well as appearing in the film *Entr'acte* with Satie, Picabia and Man Ray. Duchamp lived in the Hotel Istria in Paris from 1923–26, during which time Satie moved there during his last illness before being finally moved to hospital. And, though even more fleeting than this previous example and absolutely of no use for any historical connection to be made, he was a regular visitor to Katherine Dreier's home in the 1930s where he reassembled the broken *Large Glass*, in West Redding, Connecticut, the place where Charles Ives had retired to live. Such remote and passing-in-the-street acquaintances apart, it is worth noting the curiosity that *To have the apprentice in the sun*, 1914, the two examples of *Erratum musical* and the set of puns *Poils et coups de pied en tous genres* included in the *Boîte-en-valise*, were all done on music paper. Given Duchamp's extraordinary care about the choice of the different papers in the edition of the *Green Box*, what was he doing with all that music paper?

1. John Cage, '26 Statements re Duchamp', 1963, first published in *Mizue*, Sept, 1963, reprinted in *A Year from Monday*, Calder and Boyars, London 1968, pp. 70–72.
2. Moira Roth and William Roth, 'John Cage on Marcel Duchamp: An interview', *Art in America*, November–December 1973, pp. 72–79.
3. See also, Shigeko Kubuta, *Marcel Duchamp and John Cage*, Tokyo 1968, a limited edition of 500 copies, being a photo-essay of *Reunion*, including *36 acrostics re and not re Duchamp* by John Cage, and a recording of the piece by David Behram.
4. John Cage, *To Describe the Process of Composition Used in Not Wanting To Say Anything About Marcel*, Cincinnati, 1969. The booklet itself, which details the compositional method, is a much more impressive work than the eight plexiglass constructions and it is ridiculous to maintain, as Barbara Rose does in her oft-reprinted but uncritical essay on the work, that they represent 'another extension of a multi-dimensional personality defying the limitations of a one-dimensional world.' In fact this imbalance between the realisation of the work and the composition is something that characterises Cage's music of the last 20 years. For Barbara Rose, the 'feeling of 3-dimensional forms floating in free space' inevitably recalls Duchamp, although I fail to find that fragments of words in superimposition give any feeling of three-dimensionality. But certainly Cage's choice of a transparent material is odd if, as he says, he wanted to 'not say anything about Marcel', for few things are more likely to bring Duchamp to mind.
5. Michael Nyman, 'Interview with John Cage,' August 1976 (not yet published).
6. In Christopher Hobbs, *English Music*, programme for John Tilbury's series of concerts, *Volo Solo*, Macnaghten Concerts, October–December 1970.
7. *Artforum*, November 1972, pp. 6–7.
8. 'If I have ever practised alchemy, it was in the only way it can be done now, that is to say, without knowing it.' (Marcel Duchamp, quoted by Robert Lebel in *L'art magique*, ed. André Breton and Gerard Legrand (Paris: Club Français de l'Art, 1957, p. 98).
9. Richard Hamilton, '*The Large Glass*', in *Marcel Duchamp*, Museum of Modern Art and Philadelphia Museum of Art, 1973.
10. Quoted in John Cage 'Jasper Johns: Stories and Ideas,' first published in catalogue of Jasper Johns exhibition at the Jewish Museum, New York 1964, reprinted in *A Year from Monday*, pp. 73–84. The other own 'academic ideas' Johns refers to are 'what a

teacher of mine (speaking of Cézanne and cubism) called "the rotating point of view" . . . and Leonardo's idea . . . that the boundary of a body is neither a part of the enclosed body nor a part of the surrounding atmosphere.'
11. Pierre Cabanne (trans. Ron Padgett), *Dialogues with Marcel Duchamp*, Thames and Hudson, London 1971, pp. 38–9.
12. The linguistic twist involved in using 'twine' would have appealed to Arensberg: *ficelle* (twine) in French is also a colloquialism for 'pal' or 'chum'.
13. See Emanuel Winternitz, 'Strange Musical Instruments in the Madrid Notebooks of Leonardo da Vinci', *Metropolitan Museum Journal*, vol. 2, 1969.
14. Erik Satie in '*Propos à propos de Igor Stravinski*,' published in *Les Feuilles libres*. October–November 1922, wrote in support of Stravinsky's then-current interest in theories of mechanical interpretation. Although Satie did not favour them himself, he pointed out that while the virtuosity of the mechanism could never be equalled by the performer, it did not take his place. He added that the player piano differs from the piano not so much as a photograph from a drawing: 'the lithographer as it were plays the pianola, while the draughtsman plays the piano'.
15. Richard Hamilton, *op cit.*, p. 63.
16. The term *infra-mince*, often translated as 'infra-slim', first appears on the back cover of *View* magazine, March 1945, an issue devoted to Duchamp who designed the cover. The text, in translation, means 'when the tobacco smoke also smells of the mouth which inhales it, the two odours are married by 'infra-slim', '*mince*' means either 'slender' or 'slim'. What Duchamp called 'human or affective connotations', and it also has the sense of insignificance when used, for example, with a word such as 'argument'. The alliance of this imprecise term with 'infra', a precise preposition with scientific overtones (as in 'infra-red', 'infra-mammary', etc), mirrors the conjunction of precision and inexactitude found in the various examples of it. Duchamp said to Denis de Rougemont, in 1968, that the concept of *infra-mince* was 'a category which has occupied me a great deal over the last 10 years.'
17. Ironically, these so-called 'feeble' elements are the most efficacious sources of power and energy in the *Large Glass*'s mechanics.
18. Richard Hamilton and Reg Woolmer, in redrawing the plan and elevation of the *Large Glass* to scale with absolute precision — that is, not allowing any gaps in the procedure to be filled in by information only knowable after the existence of such a drawing, not copying the existing one, and not making any guesses, however intelligent — both found it very striking that the only point from which it is possible to begin, clearly the starting-point for Duchamp too, is the central stem of the Chocolate Grinder, and that there is a definite and fixed sequence of moves from this outwards. Richard Hamilton said, in conversation, that he sensed a kind of freedom in the drawing process that may not be apparent from the finished result, but which is found in re-drawing it.
19. Recently a number of realisations of this piece have been made, taking it as an indeterminate piece of music, by Petr Kotik of the SEM Ensemble, Buffalo. A recording of this has been made for West German Radio in Cologne, and for the Gallery Multipla, Milan. A percussionist, Donald Knaack, also of the State University of New York at Buffalo, is making a realisation, which he has recorded on Finnadar Records, New York. He plans to perform it in London in May 1977.
These 'realisations' of Duchamp's work seem to me to be as awkward an enterprise as the vogue, early in the days of graphic notation, for taking extant paintings, especially systemic ones, and treating them as musical scores — the obverse of transcribing Bach fugues into multi-coloured grids, or making hazy impressions of Sibelius' *Swan of Tuonela*. If, as a cursory glance would seem to confirm, the second *Erratum musical* is directly concerned with the *Large Glass*, then it is an important element in the body of notes that accompany it and is an integral part of that work; and it makes

no more sense to make 'realisations' of this piece than to do the same for the *Large Glass* itself. Clearly anything can be used as a notation — at one time it was said of David Tudor that he could play the cross-section of a currant bun — and, as an exercise, it is harmless enough. But it does seem odd that Cage, who rightly tries to ensure that his own music is played within the spirit of its composition, should be much less careful with the work of others whom he respects. His argument that a response to other people's work should take the form of creation rather than criticism begs the question, especially when he finds the highly creative Duchampian criticism of no interest — he says that although he has the books, he never reads them.

The problem seems to be that, for someone with a powerfully defined position of their own, like Cage, it is difficult to see someone else's work without it being subsumed within that philosophy. And Cage's thought inevitably colours his view of Duchamp, so that he sees the *Large Glass*, for example, as allowing the environment to interpenetrate the art work just as, in Christian Wolff's early music, performed sounds have no greater value than incidental ones and, in *4'33"*, our attention is drawn to these incidental sounds alone, but this has little or no place in Duchamp's thought. On the other hand, although Cage's text is weak on the Readymades (and even to use a single unqualified term blurs their complexity) he reveals, in the Roth interview, a sensitivity to the fundamental difference between himself and Duchamp, pointing out that: 'When we think of the Readymades we think of something other than what Duchamp did.' And Cage's 'blurring of the distinction between art and life' is, as he indicates, only remotely related to Duchamp.

20. The other examples which appeared in the play and that relate strongly to the *Large Glass* are: 1. The performance on the zither by the miraculous worm held in a glass (mica) casing filled with a liquid as heavy as mercury: 2. The statue made from corset whalebones resting on a chariot which moved from side to side on rails of calf's lights: 3. The painting machine of Louise Montalescot: and 4. The thermodynamic orchestra of Bex, which was housed in a glass case.

21. It is clear from the interview with Cabanne that, although the initial impact was the play's presentation, he did follow this up by reading the book soon afterwards. Hence, it is worth conjecturing a further, possibly remote, connection much later in Duchamp's oeuvre when he specifies that one of the rotoreliefs is of 'a soft-boiled egg', recalling a striking image in the story when Balbet, the crack marksman, shot away the outside of a soft-boiled egg to reveal the yellow, but without disturbing the inner content. Although this was not portrayed in the stage version, Duchamp had by then, in 1935, read the novel. And the specification 'soft-boiled' is so peculiar, in view of the fact that the spectator sees the exterior form of the egg, that it draws attention to its Rousselian parallel and, further, reinforces the connections that can be drawn earlier.

Donald Knaack

The Musical Works of Marcel Duchamp

The musical works of Marcel Duchamp number three. Two of the three works are listed in the Duchamp catalogue of the Museum of Modern Art, Philadelphia Museum of Art edited by Anne d'Harnoncourt and Kynaston McShine.

The *Erratum musical* (1913) is a short composition for three voices composed by Duchamp for himself and his sisters Yvonne and Magdeleine. The score was derived from chance procedures in which music staff paper was cut into small pieces—a single musical note was copied on to each piece—the papers were placed in a hat and shuffled. The papers were then removed and recorded on the actual score in sequence of removal. The text was derived from the definition of 'to print', *Faire une empreinte marquer des traits une figure sur une surface imprimer un sceau sur cire* (To make an imprint—mark with lines a figure on a surface—impress a seal on wax).

The Bride stripped bare by her Bachelors, even. Erratum musical (1913) bears the same title as the *Large Glass*. It proposed an elaborate compositional process utilizing chance operations to create a new musical alphabet. The score consists of a manuscript that describes the compositional process and how to realize it.

The composition may be performed on a player piano, mechanical organ or any other new instruments for which the virtuoso intermediary is suppressed. Once an instrument has been chosen, the compositional process may begin. The process requires the following: a large funnel, five open-connected wagons and numbered balls. There must be one numbered ball for each sound (timbre and/or pitch) the chosen instrument(s) is capable of producing.

Each one of the five wagons represents a predetermined time period. The balls are all placed into the funnel and fall at random into the wagons which are pulled under the funnel. Once the funnel is empty and all the wagons have passed under—the balls are removed from each wagon and notated in sequence of removal. The duration of each note is determined by the number of balls in a given wagon in relation to the assigned time period of that wagon (e.g., numerous balls in a wagon = less proportioned space between notes: fewer balls = more proportioned space between notes). Dynamics are left to chance in each performance. The completion of the process yields one period with five sections. The process may be repeated if additional periods are desired.

This work has been recorded by the author for Finnadar Records (Atlantic Recording Co.) and will be released in February 1977. For my realization I chose to make new percussion instruments from glass that suppress the virtuoso intermediary. Glass was chosen because of Duchamp's interest and work with glass and transparency. The instruments include twelve types of wind chimes, a xylophone made of glass rods, xylophones made of bottles, wine glasses, tube chimes and glass maracas. There are twenty-four instruments and ninety-five timbres. Live performances are accompanied by visual slides dealing with Duchamp's work and transparency.

153

Donald Knaack
Realization of Marcel Duchamp's
The Bride stripped bare by her Bachelors, even
Erratum musical

Témoignages

Art News and Review, vol. XI, no. 20,
October 1959, p. 6

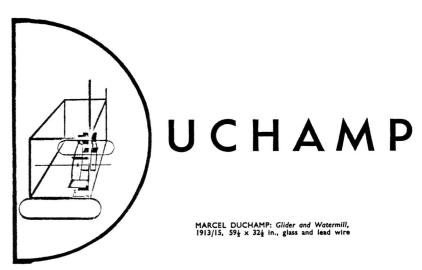

DUCHAMP

MARCEL DUCHAMP: *Glider and Watermill,*
1913/15, 59¼ x 32¼ in., glass and lead wire

ANTHONY HILL

'Homage to Marcel Duchamp' is the title of an exhibition arranged by Richard Hamilton at the I.C.A. The exhibition is held in connection with the book Trianon Press is publishing: *Marcel Duchamp* by Robert Lebel. In the members' room one can see an aquatint by Jacques Villon of Duchamp's painting, *The Bride* (1912), two drawings of 1911, and *Pharmacie* (1914). In the cabinet is the cover of *Surrealism en 1947* and a small piece called *Figleaf* of 1951. In the library there is a 'disc', a cover for *Minotaur* (1934) and photographs of paintings. In the cabinet, *The Valise* (1941), *The Boite* (1934) and various documents. A display has been made of illustrations from the book; there is also a splendid brochure made available to visitors and one can purchase in the main gallery for 6d. a little memento which serves in place of a catalogue. The cover of the memento is from *Fresh Widow* No. 1 (1920) and there is inside his notice, 'Wanted $2,000 Reward . . .' which shows Duchamp's face as it would appear in a police poster, the date 1923. From all this a visitor will see that the occasion has been well marked. The free brochure contains a colour reproduction of Duchamp's *Coffee Mill* (1911) which is the same dimensions as the original (a photographic enlargement in black and white in the library serves no useful purpose).

'Petrol is scarce' as one says in the desert or during a war, and in the same sense, 'Duchamp is rare'. Four-fifths of his work is in the United States, Duchamp's works have nearly all been acquired by close personal friends and from thence to museums so that it is no use asking a dealer to find you a Duchamp. Moreover he has never had a 'one man show' in a commercial gallery. In all this of course he is unique. For those interested there have been opportunities to purchase 'Duchamp' in an equally unique manner, namely the *Boite* and the *Valise*, and the discs* each produced in a limited edition.

Last year a translation by George Heard Hamilton, of texts from the *Boite* was published, this year the definitive catalogue raisonné appears—that is the book by Lebel already mentioned—and forthcoming books include a study of the 'large glass' as it is known, with accompanying studies from the *Boite*, this is by Richard Hamilton with Marcel Duchamp's co-operation; also there is to be a definitive collection of Duchamp's texts in the original. These will complete what exists in the way of studies and documentage—which already amounts to a highly selective, concentrated but in no way small output. So that what has sometimes been described as a gap will have been well and truly bridged. With over three-quarters of his works available to the public in Museums in America and the above mentioned literature, the legend and the work now enter into the phase of complete accessibility and it is debatable whether under these circumstances and Marcel Duchamp's continued co-operation one cannot safely predict that in his remaining lifetime he will see himself elevated to an embarrassing height of fame. This would seem an inevitability and as such will subject the Duchamp legend—the Duchamp ascendancy to much inquiry. Now that we have all the facts we can make our evaluations.

Duchamp has said, "Il n'y a pas de solution parce qu'il n'y a pas de probleme", and one cannot help noticing a possible similarity in this to the well known final oracular statements in the Tractatus of Wittgenstein, (for others it might suggest Zen).

One facet of Duchamp's mind exhibits a recognisable syndrome: Enquiry, doubt, questioning, analysis, which mixes reticence to be absorbed with an ability for intense concentration as witness his publication with Halberstadt in 1932, 'Opposition et cases Conjugées sont Réconciliées'.*

As many people have observed, the addiction to chess is an important clue to Duchamp's mental make-up, as the biographers sometimes put it, the year 1925 sees Duchamp 'give up painting and take up chess'. Recently I read a biographical note by a well known philosopher in which he stated that he gave up playing chess for the reasons that Leibniz is said to have given—that it is too serious to be a game but not a serious enough thing to devote time to.

Amongst Englishmen it is of Lewis Carroll—with all his essential traits—that we nevertheless start to think when we come across the mathematical/phantasy trait as being the best 'in a word' clue to Duchamp. A comparison survives when all is weighed, but as such the comparison itself is not offered as an easy key to a man who has been likened to Leonardo da Vinci, on account of this sort of claim he is much more difficult to feel one has pinned down than Lewis Carroll.

My own summing up prior to giving my own personal judgment as to the role and subsequent importance of Duchamp would have to be preceded by a longish account of his career as I see it to have been, and some explanation of how it came about that the impact of it all at one time stopped me in my tracks. All this would be of small passing interest to those of his audience whom one presumes to be addressing, however, there is much one can say in a less personal frame of mind about the contributions of Duchamp to Modern Art in general—in particular today's abstract art.

Duchamp joined the Cubists in 1911 and painted in that year, *Nude descending a staircase*, for which he is justly famous. From 1912-1923 the best known works can all be regarded as studies culminating in the *large glass, the Bride stripped bare by her own bachelors* which he left uncompleted. There are no works by Duchamp after 1914 employing the conventional oil on canvas recipe, he had already commenced working on a glass in 1913 and it was in 1914 that he presented his first 'ready mades' such as the famous bottlerack (you can still obtain them in Paris today).

The remainder of his work includes the *bicycle wheel* of 1916—precursor of all mobiles and numerous more elaborate explorations with motion and light.

Duchamp has written of Picasso: "Thousands today in quest of supernatural aesthetic emotion turn to Picasso who never lets them down."

Concerning Duchamp, Jacques Maritain has written of his work that it, " . . has captured the imagination of high brow gapers fond of hermetic marvels." Over the last thirty years or so, Duchamp has engaged in producing footnotes and editions of his oeuvre rather than making any substantial additions. The circle of his admirers has had to be content with increasingly less—book jackets, waistcoats, window dressings and 'ready made' type objects—these tokens of his continued participation must nevertheless be judged as something between freshly minted souvenirs for the cult and purely personal playthings, and which ever way one sees them it would be misleading to claim they had anything of the qualities associated with his pre-war days. It is in the role of technique that Duchamp can be said to have opened up possibilities for other artists. Mechanical anonymity, the object quality, motion and chance these are some of the things to which abstract art must acknowledge Duchamp's contribution first and foremost.

I think it can be said that Duchamp the inventor/experimenter (the glasses, the Rotoreliefs, etc.) and Duchamp the speculative aesthetic philosopher (the concept of the 'ready made' and many pertinent re-evaluations in the 'role of the artist' situation) are happily linked and can bear some degree of separation from Duchamp the fantasist (with his literary-poetic imagination) the esotericist, erotic humorist. The diverting tricks, games, puns, etc., have not succeeded in insulating his talents from having served a more positive role. There is no cheer in this for Duchamp and it is certainly true that he is more a mentor for the surrealists than he is for abstract art. With a mind more accessible to science than most 'realist abstract artists', in art he would seem to prefer the hermetic and always with the accent on phantasy. One can go further and say that one can be sure that for Duchamp the very idea of a work of art is a complex proposition which will have to contain a number of different and even conflicting components, the whole situation more refined, subtler and finally more personal (while being depersonalised) than anything that artists of today can be shown to be engaged in.

In 1946 Duchamp wrote, "This is the direction in which art should turn: to an intellectual art rather than to an animal expression." And as quoted by *Time* magazine (March, 1957) "Painting today is a Wall Street affair. When someone makes a business out of being a revolutionary, what are you? A crook. As Brancusi used to say, 'Art is a swindle'."

Remarkable tributes have been paid to Duchamp, the leitmotive of them all seems to be the idea that the value of his work lies in its essential characteristic of being a private game, a game which never sought to go beyond its bounds, but whose bounds know no limits, thus finally resulting in a transcendental, critical and speculative act of creation. The indifference, anonymity, irony, etc., that is associated with Marcel Duchamp cannot mask a degree of objectivity and more serious impartiality which is finally—quite naturally—found to surround an essential temperament. This essential temperament I believe to be far from disengaged; speculation, strength of purpose, candour, the particular form of integrity of which these are the ingredients force Duchamp to take a stand. That the stand is negative does not mean to all that it is therefore valueless, destructive and totally devoid of positive possibilities. What we understand by the tag 'passionate sceptic' as Bertrand Russell has been called, suggests the existence of an equally pertinent one for Duchamp though I confess I haven't yet found one.

* *Life* magazine once printed minitones, in colour—a sort of do it yourself give away, to be cut out, mounted and rotated on a gramophone turntable.

* An analysis of K. Ebersz's end game, a chess problem of an entirely mathematical character, published by Lancet & Legrand, Paris and Brussels.

Anthony Hill

The Spectacle of Duchamp

First published as the editor's introduction
to the Duchamp issue of *Studio International*,
vol. 187, no. 963, January–February 1975

In 1966 Richard Hamilton wrote in the first paragraph of the Tate exhibition catalogue: 'No living artist commands a higher regard among the younger generation than Marcel Duchamp.'[1]

Writing of the *Large Glass* John Golding says that it is a work 'that still holds a substantial claim to be the most complex and elaborately posed art object that the twentieth century has yet produced' (1973).[2] Last year, in an interview, Motherwell said: 'I would say that one of the most astonishing things in my lifetime as an artist is his (Duchamp's) prominence. Thirty years ago, if someone had said to me "He may become the major influence in the art scene" I would have said "You're out of your mind". And most of my judgements were quite accurate at that time.'[3]

These judgements are of course significantly those of artists and while there may be artists who take a different stand towards Duchamp's 'prominence' it is notable that the chief spokesman for a critical-to-hostile attitude is to be found expressed most forcefully by critics (Alloway, Greenberg, Hess and others). I think John Golding put his finger on an important point when he spoke of Duchamp as being 'arguably the most aristocratic artist of his generation'; he adds to this that Duchamp is also 'unquestionably the twentieth-century symbolist *par excellence*'.

If we describe Duchamp as being both superstar and *éminence grise* (two clichés that come to mind) this at least serves to keep in mind his essential dualism which could be confused with the idea of fulfilling a double role. But perhaps it is more the case that as a 'public' figure he appeared as an *éminence grise*, and as a private artist as a superstar?

One of his greatest admirers, the Mexican poet Octavio Paz, has described Duchamp's art as '*public* because he set out to renew the tradition of an art "at the service of the mind" and *hermetic* because it is critical'. In attempting to locate the key to Duchamp's hermeticism Paz claims that '*The Bride* is the (involuntary) representation of the only idea-myth of the Western world in the modern era: criticism.'[4] This is a formidable assessment. Duchamp has stated 'I have forced myself to contradict myself in order to avoid conforming to my own taste': and this certainly confirms the idea that Duchamp operated a complex personal dialectic. Perhaps Duchamp's 'strategy' is reflected in the conflicting interpretations and evaluations which have been forthcoming and will continue? On balance one sees that the sum of the problems posed has become the most important of Duchamp's legacies. Almost all his works are in museums at his own bidding—the bequests were taken care of in his lifetime. No artist has given more and demanded less, and done so in a way consistent with the outstanding traits of his personality. Duchamp combined modesty with audaciousness, profundity with lightheartedness and commitment with indifference.

Everyone who has come under the spell of Duchamp will have reacted to that part of him which pleases them most and this will show up in the 'account'—an unwitting falsification of the books!

In speaking of him one should match candour with candour; for this reason I find it difficult to know what to speak of at a personal level, and it would be an indulgence to say any more than seems essential in introducing a *Studio International* supplement devoted to Marcel Duchamp. Suffice to say that at an early and impressionable age I elected Duchamp, in secret, to be a kind of artistic step-father; I can think of no better terms to describe my *attachment*. The bare outward facts can be summarized briefly enough. Duchamp certainly exercised a fascination for me on the basis of the image I had built up of him and my belief that he had achieved something altogether different from the 'archetypal' modern artist. However, while I had no ambition to directly emulate his standpoint I nevertheless believed that much of what he had done was of more than indirect relevance to abstract art, fully knowing that abstract art was not of direct interest to Duchamp. His stand against painting, his innovations and particularly the notion of the ready-made had a profound influence on me. Above all was the idea of putting 'mind' back into art, although for Duchamp this was clearly not the same as having 'rational' content.

The strategy of being 'influenced' by literature was a very shrewd one, an effective outer coating as it were, but it seemed to me to rely in Duchamp's case too much on the indulgence of elaborate personal fantasies. This appealed to me but principally as something to resist at all cost. In this I was reacting to Duchamp's dialectic of contradiction, already mentioned, which I chose to take 'literally'—if one can put it that way. My reasons for writing to Duchamp (I did so first in 1951) were two-fold: first, I was interested in the climate of events developing out of Cubism and wanted to ask a number of questions and his permission to quote his notes in the Dreier Collection catalogue; later I obtained a copy of the *Green Box* and this stimulated more personal questions. I first met Duchamp in 1959. Richard Hamilton had emerged as one of the leading authorities on Duchamp by then and had arranged a small exhibition to celebrate the publication of the Lebel monograph. On the basis of our conversation I was stimulated to try and write something specifically on Duchamp, and using the event of the small ICA show in London wrote a piece for *Art News & Review*.[5] I sent this article to Duchamp and as on previous occasions received a most charming and courteous reply: '. . . very much enjoyed your article which brings out many points never noticed before, it was great fun to meet you especially after imagining a "you" from our correspondence.'

The next and last time I met Duchamp was at the dinner arranged for him on the occasion of his exhibition at the Tate Gallery in 1966. In Schwarz's book[6] amongst the 'statements' of Duchamp listed is: *302 (An Address)* delivered by Duchamp at the Tate Gallery . . . What Duchamp said is not recorded, neither was it 'recorded' in any sense by the Tate. But if my memory is correct, when asked to speak in reply to the official toast he restricted himself almost wholly to the 'warning': '*Prenez garde de la peinture fraîche*'.

Years later when I saw a photo of the casing Duchamp devised for the collection of notes *A l'infinitif* (1967) I could not suppress the thought that Duchamp had perhaps also liked the typographical motif I had devised for the *Art News* article. One of my favourite Duchamp works is the one I always think of as the D-shaped glass *Glider Containing a Water Mill* (1913–15) and so I used this as the capital D in Duchamp. In his casing he simply reproduced the D-shaped glass on the front.

In the piece I wrote on Duchamp, I ventured the following: 'Duchamp has said "*Il n'y a pas de solution parce qu'il n'y a pas de problème*", and one cannot help noticing a possible similarity in this to the well-known final oracular statement in the *Tractatus* of Wittgenstein (for others it might suggest Zen). I had recently talked with Duchamp and was able to verify that at that time he had never heard of Wittgenstein; however, he did admit to having tried to read Ogden and Richards' *The Meaning of Meaning* . . . (where incidentally Wittgenstein is almost certainly referred to). The idea of a comparison with Zen was not my own. I had learned in the early Fifties from Gabrielle Buffet-Picabia that at least one American student was then developing this notion (in a thesis).

In 1969 Arturo Schwarz's *The Complete Works of Marcel Duchamp* was published and I was to discover that these ideas were appearing ten years later, almost word for word. However, it was not till I read John Golding's monograph[7] that I became aware of the exact context of this oft-quoted phrase, 'There is no problem . . .'; it seems Duchamp was questioned about the *Large Glass* and the statement turns out to be his answer.[8] So both Schwarz and I were under the illusion that Duchamp had made this statement about art/life when in fact it was about one of his works.

By chance at about that time I read that Duchamp had indeed made a 'note' which really did reflect the kind of 'aphorism' associated with the later Wittgenstein. It is stated that in a note — dated on the back 1913 — Duchamp had posed himself the question: 'Can one make works which are not works of Art?'[9] It is then the *latter* note which we should ponder, with its Cartesian feeling, and not the response elicited by someone asking what the *Large Glass* was all about . . . as if Duchamp had not given sufficient evidence already, or at least in due course.

In the publication *Art of This Century* (a catalogue of the Peggy Guggenheim collection) there appears a compelling quotation from Duchamp's sculptor brother Raymond Duchamp-Villon. It is undated and runs: 'The work of art to be accomplished should be a bond between the external and the ego and a natural penetration of the one by the other (it can no longer be the object itself, nor can it be the ego exclusively, it must be a creation)'.

Since he died in 1918 it seems possible that Duchamp-Villon could well have written this before 1914 and in doing so was responding to Duchamp's question, although not a direct answer. It can be argued that Duchamp in fact set about testing his notion, notably with the penetration of 'ready-mades', the earliest of which was the *Bicycle Wheel* dating from 1913.

I cannot count myself amongst the truly faithful admirers of Duchamp. I am something of a heretic; my response to the works I admire is almost wholly 'formalistic' and this could be compared to enjoying religious art for its aesthetic values while totally rejecting the religious imperatives.

A crucial issue is that of *Etant donnés*: I do not take this work seriously as do his most ardent admirers, who in consequence greatly value all the preparatory 'studies' that lead up to this work. For me, and perhaps many others, the Second World War is the 'break' after which I sense a complete change and a great deterioration . . . a genuine tiredness. *Etant donnés* is the kind of thing Duchamp can be excused for choosing as a means of passing the time. I admire a number of the contingent features of the work, the 'legislative' aspects (the restriction against reproduction), the idea of keeping it a secret and best of all — if it is fair to mention it — the judicious timing of his retirement from *life* in connection with its premiere. But it remains in conception a banal affair, a peep-hole tableau; Ralph Rumney has remarked that it would be a great commercial success if marketed (by Schwarz) in a handy-sized multiple version. It must have come as quite a surprise to Segal when he discovered what was to be seen through the peep-holes in the colossal Spanish door! *Etant donnés* has no residue of the earlier Duchamp, the eroticism is so unbelievably blatant. There is a character in one of Céline's novels who declares that the only things of importance in life are the penis and mathematics — everything else counts for nothing. It is a strange and no doubt comical utterance and yet it echoes Nietzsche when he wrote: 'All human knowledge is either experience or mathematics.'

Duchamp certainly followed the same route as Picasso in old age, succumbing to eroticism. I personally find this sad. *Etant donnés* seems also to lack the quality of 'Norman' humour (Satie and Alphonse Allais were also fellow Normans). However, I know of life-long intimate friends of Duchamp who nevertheless regard *Etant donnés* as primarily an elaborate hoax on the art-loving public!

Duchamp was much preoccupied by the fear of artistic sterility and repetition. He accused Picasso of being an onanistic painter, and of course Dr Schwarz has said as much of Duchamp himself. One might suppose that in his book *Erotic Art of the West* Robert Melville would have written enthusiastically upon *Etant donnés* but he doesn't even mention it. The short description of the *Large Glass* reads '. . . was devoted to the emblematical representation of nine masturbators aiming their ejaculations in the general direction of a woman and deliberately missing'.[10]

My point is that Duchamp had a touching narcissistic attitude to his creations — his 'children' — and this is manifest in so many features of his artistic output. It must have indeed flattered him that independently two artists set out on the task of 're-creating' the *Large Glass*, first the Swede Ulf Linde and then our own Richard Hamilton.

It is no surprise or paradox to see how Duchamp was attracted

overleaf:
Duchamp newsletter
produced by the Division of Education,
Philadelphia Museum of Art
to accompany the exhibition *Marcel Duchamp*
organized by the Philadelphia Museum of Art and
Museum of Modern Art, New York, 1973

in equal measure to the banal and to the 'hermetic'. In feudal times the use of the Lord of the Manor's mill was compulsory for all tenants—it was known as the *banal mill* and the phrase has given us *banal* and *run of the mill*. The *Coffee Grinder* and *Chocolate Mills* are amongst the most attractive of all Duchamp's canvases; indeed the *Study for Chocolate Grinder No. 2* of 1914 (Kunststammlung Nordrhein-Westfalen, Düsseldorf), recently exhibited at the Tate Gallery, is such a sensuous painting that many people were stopped in their tracks on seeing it. Never again was Duchamp to exhibit this non-erotic sensuality in a work. So it is no paradox either to find the 'retinal' in this anti-retinal artist, rationality in this champion of the irrational, and that Duchamp the iconoclast was a Duchampian icon maker, *Etant donnés* being by far the most generous offering in that direction, although in no sense a real rival to the 'stained glasses' that really are his masterpieces.

I have expressed my own view that after the Second World War Duchamp could well have retired, in the sense that he was always supposed to have done, and that *Etant donnés* is for me a disappointment. However, as against this I believe that Duchamp's activities in the field of 'artistic philosopher'—if that is the best term—make up for any disappointment, Duchamp emerged as one of the most challenging minds of his time. I would like to conclude these lines with a quotation from Sartre which I discovered in 1950 and copied out:

> The Surrealists took a hearty dislike to that humble certainty on which the stoic based his ethics . . . Any means were good for escaping consciousness of self and consequently of one's situation in the world.

. . . Automatic writing was, above all, destruction of subjectivity . . . But the Surrealists' second step was to destroy objectivity in turn . . . We are given a first draft of this procedure in the false pieces of sugar which Duchamp actually made in marble and which suddenly revealed themselves as having an unexpected weight. The visitor weighed them in his hand, was supposed to feel, in a blazing and instantaneous illumination, the self-destruction of the objective essence of sugar.

. . . What appears to me essential in Surrealist activity is the descent of the negative spirit *into work*; sceptical negativity *becomes concrete*, Duchamp's pieces of sugar as well as the fox table are *works*, that is concrete and painstaking destruction of what scepticism destroys only in words.[11]

1. Richard Hamilton, introduction to the Tate Gallery exhibition, *The Almost Complete Works of Marcel Duchamp*, London 1966.
2. John Golding, *Duchamp: The Bride Stripped Bare by her Bachelors, Even*, Art in Context, Allen Lane, The Penguin Press 1973.
3. *Art News*, April 1974.
4. * Water writes always in * plural', *Marcel Duchamp*, MOMA/Philadelphia Museum of Art, Ed. d'Harnoncourt & McShine, 1973.
5. *Art News & Review*, October 1959.
6. Arturo Schwarz, *The Complete Works of Marcel Duchamp*, Thames & Hudson 1969.
7. Golding, ibid.
8. Golding, ibid.
9. *A l'infinitif* 1967.
10. Robert Melville: *Erotic Art of the West*, Weidenfeld & Nicolson 1973.
11. *What is Literature: The situation of the writer in 1947*, Gallimard 1948, English translation by Bernard Frechtman, Methuen, London 1950.

Marcel Duchamp
Why not Sneeze Rose Sélavy? 1921

Marcel Duchamp

July 28, 1887 – October 2, 1968

Marcel Duchamp: Where Art Has Lost, Chess Is the Winner

By RITA REIF

SINCE Marcel Duchamp gave up art in 1923 to play chess, he has won for the world an abundance of artist-designed chess sets. The 80-year-old master strategist of the chessboard has, consciously or unconsciously, moved other artists, wood-pushers all, to design sets.

But the daddy of dada and grandpa of pop art has himself designed only portable chess sets, which he dismisses as of no importance.

"We use this set in traveling or in bed or any time we need it," the artist said of a billfold-size set in a leather case. "I did the first one of these portable sets in the nineteen-thirties. This one is printed on plastic and these pins on the chessboard catch and hold the pieces in place."

When he and his wife are at home in their Greenwich Village apartment, they play on an outsize board with two inlaid chess clocks that was a gift from the widow of Francis Picabia, the artist.

"I have never collected chess sets," Duchamp said, watching his wife set up sets made by Man Ray, Max Ernst, Alexander Calder and John Cage, the composer. "We have them because we have received them from friends.

The gifts—arranged on a refectory table, an antique chessboard and a Brancusi bench—differ as much as the artists' personal styles.

The Ernst set is certainly the most imposing. The pieces are boldly carved, miniature surrealistic sculptures. A cubist set by Man Ray is a study of cylinders, cones and spheres.

"Duchamp and Man Ray were always playing chess together," said Jacques Kaplan, the furrier, who has kibitzed games between the artists. "Man Ray designed his first chess set to play with Duchamp in the late nineteen-twenties or early thirties. Later he gave the set to Duchamp."

On other occasions Man Ray whipped up sets according to "the necessity of the moment," Mr. Kaplan reported.

More recently, Duchamp nudged Salvador Dali to design a set for the American Chess Foundation. The set, now in prototype, has all the chessmen, save the rooks, modeled on the fingers and parts of hands of Dali and his wife. The rooks are pepper and salt shakers.

When the set is produced, money gained will be used to send American chess players to foreign tournaments and to advance the cause of chess generally, according to Sidney Wallach, the foundation's executive director.

A Promise

Once, while Duchamp was playing chess with Arman Fernandez, the French artist, he brought up the subject between decisive moves. Arman recalled recently. Before the game was over, Arman, who will represent his country next month at the Biennale in Venice, had promised to execute his idea for a set that he had been considering for some time.

Arman's set, now in prototype, is of hexagonal-shaped nutlike pieces that will be cast in brass or bronze.

There are other modern chess designers who may not have come into direct contact with Duchamp but whose work still reflects his spirit.

John Harbeson, a Philadelphia architect, has made chessmen that are assemblages of buttons and toothpaste caps, hardware and cigar wrappings. His extraordinary designs are among the 450 other sets and parts of sets he has collected in 40 years. His collection was larger before he gave part of it to the Philadelphia Museum of Art.

— (excerpt)

Marcel Duchamp, master mover of chess and men, was given this Max Ernst set by artist.

THE NEW YORK TIMES, APRIL 12, 1963.

Creator of 'Nude Descending' Reflects After Half a Century

Marcel Duchamp, at 76, Recalls Days of Original Armory Show Between Moves of a Chess Game

By HAROLD C. SCHONBERG

Marcel Duchamp, the hero (or villain) of the 1913 Armory Show, looked over the chessboard at his opponent and played pawn to queen four. The 76-year-old artist, with his spare figure and ascetic face, looked like what St. Thomas must have looked like.

"It is not true that I retired from painting to concentrate on chess," he said. "I have been interested in chess since I was 13 years old. My brothers showed me the moves. But I am not of master caliber. For that, eight hours a day, nine hours a day, are necessary. One must devote one's life to chess to be a good player."

He set up a queen's gambit.

"I went down to see the show a few days ago," he said. "In 1913, when the show was held, I was in Paris. I heard about the scandal about my 'Nude Descending the Staircase.' This I found very pleasant."

He swung his queen to rook four, attacking his opponent's bishop's pawn.

Planned the Scandal

"I found it very pleasant," Mr. Duchamp said, "because, after all, my aim was not to please the general public. The scandal was exactly in my program, you might say. Also my picture was sold for $240. At least, I received $240. That also was pleasant."

Or was it? The painting today is valued at around $200,-000.

Mr. Duchamp picked off the bishop's pawn, breaking up his opponent's queen's side.

"There is a great correlation between chess and art," he said. "They say chess is a science, but it is played man against man, and that is where art comes in. Check."

His opponent respected the check and gazed ruefully at a ruined position.

"Both chess and music," said Mr. Duchamp, "are visual arts coupled to mechanics. Both are arts of movement. The beauty of a chess position is that it is not static. The beauty is in the arrangement and the inherent possibilities. I believe you have to lose a piece in this position, by the way."

Mr. Duchamp was right.

"Also," he said, "in art as in chess there must be new movements. I have been watching contemporary art. Take the New York School, or the advent of pop art. This is good. The important thing is that a group of young men do something different. The deadly part of art is when generation after generation copies one another."

Mr. Duchamp's opponent, staving off the end of his lost game, looked around the room —at the early Matisse, at the Miro, at the Tanguy.

"They were revolutionaries," said Mr. Duchamp. "Today things are different. The artist has been integrated into our society. I doubt very much if there could be ever again such a scandal as occurred with the 'Nude' in 1913. Today we see the complete democratization of art. Everything is accepted."

He made a move and leaned back. His opponent, looking at what remained of his position, resigned. Had he been a gentleman, the opponent would have resigned five moves earlier.

Composer Still Unintegrated

"There was more excitement in 1913," Mr. Duchamp said. "Do you know, I was present at the world première of Stravinsky's 'Le Sacre du Printemps'? I will never forget the yelling and the screaming. I must say that unlike the artist, the avant-garde composer has not been integrated into our society. Another game?"

Mr. Duchamp set up the pieces and went into a Nimzovitch Defense.

"I stopped painting in 1923 because there was too much commercialism," he said. "I did not like the mixture of money and art. I like a pure thing. I don't like-water in wine. And so I have made my life. I don't need much. Chess, a cup of coffee—24 hours are taken care of."

Los Angeles Times, Aug. 16, 1936

PAINTER HITS ART THEORY

French Artist Visits City

Marcel Duchamp Views His 'Nude Descending the Stair' in Hollywood Home

BY ARTHUR MILLIER

"Nude Descending the Stair," most publicized of all French modernist paintings, was not painted to demonstrate any deep art theory.

Marcel Duchamp, who painted it in Paris in 1912 and is now revisiting his masterpiece in Hollywood, thus blasts the reams of critical print which claimed the picture depicted motion.

"It is a piece of imaginative creation," Duchamp said yesterday. "If people see a nude in it, I don't object. Anyway, I long ago quit painting and took up chess.

DEATH OF ART

"I was becoming a professional painter," he said, "and professionalism is always the death of art.

"The old masters were professionals, which means they were one-man factories. Art isn't made in factories."

Duchamp smiled as he said that, with the reminder that he was one of the founders of the most gaily cynical art movement ever perpetrated, called Dadaism. The point of Dadaism, he explained, was that nobody believed the same thing from one day to the next. It expressed the post-war mood in France and disappeared as soon as people found new things to believe in.

QUITTING CHESS

Duchamp is quitting chess for the same reason he quit painting. As to what he will do next he hinted that he is working out a system to measure the imaginative power in works of art.

FIRST SHOWING

"Nude Descending the Stair" was first shown at the Salon des Independents in Paris in 1912 for one day. Duchamp personally removed it at the request of his friends. They feared it would ruin his reputation. The picture was bought from the Armory Exhibition in New York in 1913 by Mr. Torrey, a San Francisco art dealer, who sold it to Arthur Jerome Eddy of Chicago.

While in New York the picture was dubbed "Explosion in a Shingle Factory," which added to its notoriety.

The present owner, Walter C. Arensberg of Hollywood, bought it from Eddy to add to his collection of modern art. Duchamp says it is one of the most representative in the world. He is a guest at the Arensberg home. In about ten days he intends to return to Paris.

This is Duchamp's first visit to California, which he describes as a white spot in a gloomy world.

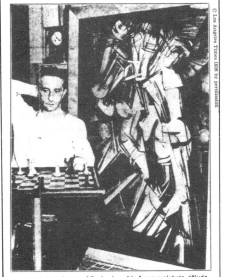

Marcel Duchamp of Paris views his famous picture, "Nude Descending the Stair." The French artist who quit painting for chess sees his masterpiece in Hollywood after a ten-year separation. It is in the collection of his host, Walter C. Arensberg.

Times photo

Artist Views Masterpiece

THE NEW YORK TIMES, MARCH 26, 1961.

WHITHER ART?

It Seems to Be On Its Way Somewhere But Everything Else Is a Puzzle

By JOHN CANADAY

"WELL-WELL-WELL," said Marcel Duchamp, sotto voce.

Then, recognizing the partnership of the microphone (a partnership that he rejected as the evening wore on) he gave the audience his ideas as to what is going to happen to art.

Mr. Duchamp's opponent, looking at what remained of his position, resigned had he been a gentleman, the opponent would have resigned some opinions of her own while throwing out baited lines.

The audience had expected the panel to answer the question "What Is Art Going to Look Like?" They were disappointed in that respect but they enjoyed some lively exchanges on related subjects during a typically loose-jointed panel discussion.

Preliminary

The remarks of Mr. Day and Mr. Stamos, for lack of space, must be summarized by stating their mutual conviction, which is that art is a matter of private experience and is going to go where the heart leads it. In her introduction, Mrs. Kuh spoke of the artists' compulsion to "smash everything up" in this century—"time, form, color, light"—and suggested that this was a reaction against the materialism of our age. In the future, "conquering space is bound to affect our vision, literally and psychologically," but Mrs. Kuh was too canny to hazard a guess as to just how.

A tour de force of the session was that Mr. Duchamp's "Nude Descending a Staircase" was referred to only by indirection. But since Mr. Duchamp both summarized and prophesied half a dozen modern movements in that extraordinary picture (which has its fiftieth birthday next year and is currently on loan from Philadelphia at the Guggenheim Museum), and since he stopped painting in 1923 to devote himself to thinking or chess, he would seem a good bet as a prophet. Actually, he was the only member of the panel who made a flat statement as to where art is going—a statement we will get around to shortly.

Duchamp

After his "Well-well-well," Mr. Duchamp said that "realism was a liberation" under Courbet and others, and he listed the proliferation of isms since that time, in abstract expressionism, he thinks, the isms have "reached the apex of a retinal approach" to art —

tions." (This might be translated into middlebrow as "good to look at, but doesn't say much," or into lowbrow as "beautiful but dumb.")

Like everyone else on the panel, Mr. Duchamp was weary of the division of painting into figurative - vs. - nonfigurative camps. Young artists should "resent" this division. "Young artists will uncover new shock values," and he looks forward to developments through the use of new materials involving new reactions to light "used like new instruments in music."

Art and Soap

But Mr. Duchamp saved his big guns for the deadly effects of commercialization on what the artist produces. "The dollar and art shouldn't mix, but they do, and since you can't destroy money, money is destroying art." And, "Art now is a commodity like soap or securities. How about a union deciding on prices as the plumbers' union decides on wages?"

The artist might also, under these union rules, be required to "abdicate the right to individuality, and not sign his works."

"Material speculation leads art to a massive dilution, a lowering of taste into the mist of mediocrity," and Mr. Duchamp hopes that this situation will lead to a revolt, "to an ascetic revolution." Thoroughly hypnotized by Mr. Duchamp's verbal means that the eye is offered "an esthetic delectation that depends entirely on the sensitivity of the retina with hardly any auxiliary associa-

which means that the eye is offered "an esthetic delectation that depends entirely on the sensitivity of the retina with hardly any auxiliary associa-

PESSIMIST—Not looking it, Marcel Duchamp thinks art is going underground.

concluded, "Where do we go from here? The great artist of tomorrow will go underground."

— (excerpt)

HERALD TRIBUNE, January 14, 1965

Pun and Games

By Emily Genauer
Art Critic

Marcel Duchamp, known to the world as a one-picture painter—the "Nude Descending a Staircase," of course, which literally started a riot when it was first shown in New York in 1913, and to many people remains both shocker and symbol—makes his public debut today as an artist with 50 years of continuous work behind him. The occasion is the opening of an exhibition at the Cordier & Eckstrom Gallery entitled "Not Seen and/or Less Seen of/by Marcel Duchamp/Rrose Selavy."

The time-span covered in the show is from 1904 to 1964. But "work"? Many, seeing the show, will question whether the last 40 years of that span were given to work or to play. Duchamp stopped painting around 1923, and thereafter concerned himself with visual fun-and-games, with experiments in optical illusion, with isolating what he himself calls "ready-made" objects from their everyday context to give them new meaning, and with playing chess.

"Selavy"? No mystery, there. It's a pun on "C'est la vie," and in line with the Duchamp general approach to art as well as to life.

The artist, now 78 and still a figure of intense vitality tempered by a gentle sense of humor, was at the gallery yesterday and perfectly willing to answer whatever questions the show itself did not.

The first was why a painter as exceptionally gifted as his early works prove him to be (there are drawings, done when he was 17 that ally him to Ingres, Daumier, Lautrec; watercolors, dated 1907, closely related to Cezanne's oils, from around 1910, as intimate and as luminous as anything being done at the time by Vuillard and Monet) should to stop painting after his brilliant cubist experiments. Duchamp's answer is that he stopped painting but not making art. Thereafter he concerned himself with "conceptions," he says, which he holds more important than mere technique, possessed by any artisan. The conceptions, one sees in the show, have to do with optical effects, with objects that move, with visual puns, with his investment of existing and familiar shapes with new significance. Many of the "works" of the succeeding decades are gimmicky, trivial, even sophomoric, notable less as idea than as precisely that tastefulness which Duchamp professes to deplore.

Are they art? Yes, if you count as art those allegedly avant-garde esthetic experiments of our own day termed pop, junk, kinetic and retinal. Which you should. Because the best of them will live, not just as examples of historicalisms but as fusions of idea and form that grew out of a uniquely 20th-Century situation.

The interesting and important thing is that Marcel Duchamp anticipated them all. There are dozens of items in the exhibition that were made 40 years ago, yet might readily be labeled as being by Warhol, Indiana, Oldenberg, countless other people much in the art news.

He anticipated even the ideas that the pop, junk and optical artists are rebelling against, those of the action painters. It is a basic tenet with Duchamp that accident should be understood and used as a fact of both art and life.

Duchamp's features, in the guise of his alter ego, Rrose Sélavy reproduced on a perfume bottle.

THE NEW YORK TIMES, JANUARY 17, 1965.

Leonardo Duchamp

By JOHN CANADAY

CHRONOLOGICALLY Marcel Duchamp, who was born in 1887, is just about even with Picasso (born in 1881) as the living godhead of modern art, but philosophically he is decades younger. Picasso, if you are a Duchamp man, is left behind in a cloud of intellectual dust as the last of the humanists, while Duchamp is the man who knows that nothing —at least of all—is important, but that all of it can be fun.

Duchamp has not painted seriously for some 40 years past, and few of his important works can be called "serious" except in relative contexts. Yet in his own off-beat way he is beginning to look like a kind of Leonardo da Vinci, a connection partially established by his well-known retouching of the Mona Lisa with a goatee and moustache, but exaggerated by the cultish dimensions of a regard that is, in any case, deserved.

Leonardo, a proficient painter, was less interested in painting than in recording, in his notebooks and in his own brilliant terms, ideas that were bred in the Renaissance air, including esthetic theories, scientific analyses and schemes for machines that would later, without reference to his plans, be invented, built and used.

Similarly, Duchamp discarded painting to entertain himself with intellectual exercises, with the difference that where he carried on in public by a man of the early 20th century whose participation in that century was channeled into a form of expression that he recognized as moribund — art. The comparison, let us admit, is wildly forced, yet persistently there is the fact that Duchamp was a genius of genius consists of an unexplained capacity to absorb and give appropriate innovational form to a dominant intellectual or emotional facet of an age.

The 20th-century artist who finds his archetype in Duchamp is engaged in finding such positive values as he can in a situation recognized in the first place as negative. This is not a condemnation, but a statement of a fact that is inescapable in the bulk of contemporary art. Pseudoscience, iconoclasm and mockery are better than boredom and suicide. They are at least a way of life, and while there's life—

— (excerpts)

Produced by The Division of Education, Philadelphia Museum of Art for the exhibition Marcel Duchamp organized by The Philadelphia Museum of Art and The Museum of Modern Art, New York. Made possible in part by a grant from the National Endowment for the Arts. Designer: William P. Miller, Jr.

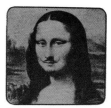

Marcel Duchamp
July 28, 1887 - October 2, 1968

Detail from Tu m'

Mona Lisa "assisted" by Duchamp

Marcel Duchamp Is Dead at 81; Enigmatic Giant of Modern Art

Special to The New York Times

PARIS, Oct. 2—Marcel Duchamp, one of the most influential artists of the century, died last night in his studio in the Paris suburb of Neuilly. He collapsed just after having had dinner with his wife and some friends.

Duchamp, who was 81 years old, was a naturalized American citizen. He maintained homes here and in New York. Funeral arrangements have not yet been announced.

The Grand Dada
By ALEXANDER KENEAS

Like the smile of the Mona Lisa, which he retouched with mustache and goatee, Marcel Duchamp remained an enigma.

Thrust into the international limelight by the 1913 Armory Show, he abandoned his career only a decade later, at the age of 36. Yet in half a century the enfant terrible who had thumbed his nose at the pantheon of art grew up to become the spiritual father of the pop generation — and Marcel Duchamp the artist had blossomed into Marcel Duchamp the idea.

The idea, however, posed more questions about the nature of art than it answered, for at its roots it was the idea of rejection.

"I'm afraid I'm an agnostic in art," Duchamp once said. "I just don't believe in it with all the mystical trimmings. As a drug, it's probably very useful for a number of people—very sedative — but as religion it's not even as good as God."

Duchamp was the quintessence of the Dada spirit. Unlike other figures in the movement who would go on after World War I to become serious painters, to assimilate subsequent artistic developments, he carried the vaudeville of esthetic nihilism to its logical conclusion. His exit was final, and the perfect complement to his output as an artist. Thus his life, as well as his much shorter career, was looked upon as esthetically significant (or its significant, for some critics regarded the withdrawal of the Grand Dada as an escape from his own inadequacies as an artist.

But for the most part Duchamp maintained an aristocratic detachment and reserve from such speculations, politely nodding in acquiescence to the legend that he gave up art to play chess; or, with a thin smile crossing his sharply featured, ascetically gaunt face, describing his occupation of later years as that of "respirateur." He was, in the words of Lawrence Alloway, former curator of the Guggenheim Museum, "the Duke of Windsor of modern art," and even in his abdication he commanded the esteem of the avant-garde.

'Posterity Has to Decide'

"It is disastrous for an artist to declare—to defend his art," he said to a reporter late last year. "Posterity has to decide —and even if it is wrong all over the place it has the advantage of coming into being. I wish I could live another hundred years." "But," he added with a pensive smile and a moment's pause, "perhaps it would be better to be dead. You see, I find it perfectly acceptable to contradict myself."

Contradiction formed an important part of the ideological and artistic universe that Duchamp had created for himself. Finding scientific laws to be too arbitrary, he formulated his own. "Why," he asked, "must we worship principles which in 50 or 100 years will no longer apply?"

He responded by devising a personal logic in which cause and effect became subject to chance, and reality shifted through visual and verbal puns. In his universe an apple might not choose to "condescend" to the laws of gravity; the act of love might—in mock deference to 20th-century science—exist as a fourth-dimensional ritual of machines.

It was all very seriously tongue in check, yet it was

ual malaise he at least offered wit, absurdity and the humor of paradox as anodyne.

Yet Duchamp's works also pointed to more positive concepts of art that would be articulated by generations to come: the illusionism of painting giving way to the reality of the three-dimensional object, the self-effacement of the artist, the object competing and merging with its environment.

Cubists or Octagonists

"There is no reason why people should not call themselves Cubists, or Octagonists, Parallelopipedonists, or Knights of the Isoceles Triangle, or Brothers of the Cosine, if they so desire; as expressing anything serious or permanent, one term is as fatuous as another."

With these words Theodore Roosevelt joined the rank of Americans who in a few short weeks were turned into art critics by the 1913 Armory Show. At the center of public ridicule, heaped primarily on the cubist section of the exhibition, Duchamp's "Nude Descending a Staircase" stood as the symbol of the insanity to which modern art had progressed.

The Association of American Painters and Sculptors, organizers of the show, not only anticipated the clamor that America's first exposure to Europe's new, nonrepresentational painting would generate; they also helped to create a circus atmosphere for its inspection. Press releases deluged the newspapers, which responded enthusiastically with satirical cartoons and literary commentary. The "Nude" became an "explosion in a single factory" and "a collection of saddlebags." Big crowds filed into the 69th Regiment Armory, at Lexington Avenue and 25th Street, and guards had to restrain outraged art lovers from damaging the painting.

It was neither the nude nor the staircase, apparently, that had provoked them, but the title, painted onto the canvas, which seemed to have little to do with either—and the idea of a nude descending instead of traditionally reclining or standing.

'Time and Space'

Duchamp carefully explained the painting:

"It is an organization of kinetic elements, an expression of time and space through the abstract presentation of motion."

In trying to consider the notion of form through space, in a given time, he said it was necessary "to enter the realm of geometry and mathematics."

"Now if I show the ascent of an airplane, I try to show what it does," he continued. "I do not make a still-life picture of it. When the vision of the 'Nude' flashed upon me, I knew that it would break forever the enslaving chains of naturalism."

Half a century after the Armory Show, Duchamp recalled the indignation that had made his name a household word: "I found it very pleasant because after all my aim was not to please the general public. The scandal was exactly in my program, you might say. Also I received $240. That also was very pleasant."

Marcel Duchamp was born in Blainville, near Rouen, on July 28, 1887, the third son of

champ-Villon), who was killed during World War I, had been one of the most gifted sculptors of his generation; a younger sister, Suzanne, would also become a painter.

With the blessings of his parents, Eugène Duchamp, a prosperous notary, and Lucie Nicolle Duchamp, Marcel left home at the age of 17 to pursue a career in art. He arrived in Paris at the twilight of an epoch. In just a few years, Braque and Picasso were to shatter the conventions of representational art with cubism; soon futurism would compete with cubism for the attentions of the avant-garde, and Dada would insist on sweeping away established values.

He enrolled at the Académie Julian in 1904 and took up quarters with his brother Jacques. But the Académie soon lost its glamour.

"I was already disgusted with the cuisine of painting," he said later. "I played mostly billiards at the time."

After a year of military service the young painter returned to Paris. He had already demonstrated an easy technical grasp of Cézanne and Matisse when he began to experiment

also especially appealing to more than a generation of intellectuals who felt that science had stripped them of traditional values and left them spiritually bankrupt. If Duchamp did not provide the cure for spirit-

a family remarkable for its contribution to art of this century. His eldest brother, Gaston (Jacques Villon), was to achieve international renown as a painter before his death in 1963. Another brother, Raymond (Du-

Magazine Section
Part Six

The New York Times.
SUNDAY, MARCH 16, 1913

Magazine Section
Part Six

"CUBISTS AND FUTURISTS ARE MAKING INSANITY PAY"

Cubist Art Explained!!!

Did the Armory Show Puzzle You? Just Read This, Which Tells All About It— Prize for a Translation.

By Francois Picabia.

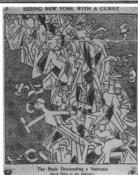

"Cubist Art Explained!!!"
Sunday New York World: March 16, 1913

SEEING NEW YORK WITH A CUBIST

cartoon from
The New York Sun: March 20, 1913

THE BLIND MAN
The Richard Mutt Case

BOSTON TRANSCRIPT,
APRIL 25, 1917

Mrs. Mutt Makes a Fuss

Here She Is: White Outline Shows "Nude Descending a Staircase."

"Here She Is . . ."
Chicago Tribune 1913

Continued from Column 4

wit and absurd humor, became close friends. Both had been familiar with earlier practitioners of the genre: Alfred Jarry, the playwright who, suffering from malnutrition, on his deathbed had asked for a toothpick, and Erik Satie, the composer who, criticized for writing shapeless music, offered a work entitled "Three Pieces in the Form of a Pear."

In this spirit, Duchamp developed a "playful physics." Dissatisfied with the meter as a fixed unit of measurement, he created his own, painstakingly scientific unit. He cut pieces of thread exactly one meter in length and dropped them on painted canvas from a height of exactly one meter. Then he varnished them in the chance positions they had assumed and had wooden rulers, cut from them. Later he used the rulers to trace lines in his big unfinished work on transparent glass, "The Bride Stripped Bare by Her Bachelors, Even."

Meanwhile he had begun to question the visual basis of art. "I wanted to get away from the physical aspects of painting," he once explained. "I was interested in ideas — not merely in visual products. I wanted to put painting again in the service of the mind."

In 1913 he produced the first of his "ready-mades" — the everyday objects he elevated by mere selection to the stature of art. These parodistic gestures against what he considered the inflated importance of "retinal" art were to become the alterpieces of pop artists and junk sculptors.

In 1917 Duchamp resigned from the Society of Independent Artists after it had reversed its policy of accepting for exhibition any work accompanied by a $6 entry fee. The object of the controversy was "Fountain," a porcelain urinal turned upside down and signed by a Philadelphia plumber, "R. Mutt."

"Fountain," of course, was Duchamp's own contribution to the exhibition.

In 1919 he visited a Paris in the full bloom of Dada as a hero of the movement. After contributing his "ready-made" Mona Lisa for the cover of Picabia's 391 magazine, he returned to New York without taking part in the organized Dada activities; it seemd to only enhance his prestige.

By this time he had abandoned painting on canvas and had begun piecing together, little by little, "The Bride Stripped Bare by Her Bachelors, Even," or, as it is sometimes called, "The Big Glass." He also decided to adopt a female alter ego, Rose Sélavy (a pun on c'est la vie), who signed such ready-mades as "Fresh Widow," a carpenter's model French window with black-leather-covered panes.

After working on it for eight years—never more than a few hours at a time—he stopped in 1923 because "the whole thing no longer interested me." That year also marked his departure from the formal practice of art. Commercialization and the acceptance of art by the middle class, he said la-

ter, had been factors in his withdrawal.

In the years that followed, he devoted a good deal of his time to playing chess, a game that he had enjoyed since his youth. Although not of master caliber, he was considered by experts a good match, who would rather risk loss by playing an unusual game than win conventionally.

During the nineteen-thirties and forties Duchamp's forays into public activity were infrequent. A shadowy presence on the international art scene, he advised dealers and collectors on purchases.

The rise of pop art in the early sixties stirred a renewal of interest in Duchamp's work. However, pop art's celebrations of the Coke bottle, the Campbell's Soup can and other mundane objects, unlike its ready-made predecessors, were to be accepted as genuine artistic statements. In 1962 he wrote a letter to Hans Richter, another founder of Dada:

"When I discovered readymades I thought to discourage esthetics. In Neo-Dada they have taken my readymades and found esthetic beauty in them. I threw the bottle-rack and the urinal into their faces as a challenge and now they admire them for their esthetic beauty."

Duchamp accepted his new acclaim, however. Museums — the august institutions he had long ago mocked — paid him tribute. In 1963 he was given his first big retrospective, at the Pasadena Art Museum. Another large Duchamp survey was mounted in 1966 by the Tate Gallery in London.

Duchamp, who became a United States citizen in 1955, lived comfortably in a brownstone on 10th Street off Fifth Avenue with his wife, the former Alexina (Teeny) Sattler, whom he married in 1954. On the walls of their living room, paintings by Matisse, Miró and other "retinals," as he called them, suggested that he would not have to issue a check on the "Teeth's Loan & Trust Co. Consolidated" to pay a $115 dental bill, as he did in 1919. His dentist, in true Dada spirit, accepted the check and later sold it back to him for more than the amount owed.

In recent years Duchamp was a familiar figure on Madison Avenue, visiting galleries and keeping up a lively commentary on the state of art.

He attributed his longevity to "not much liquor but all the women you want," and after smoking a pipe for many years, turned to inexpensive Philippine cigars. He also gave up chess.

"I don't play very much any more," he said last year. "I have a hard time winning, even from the wood pushers cs we call them. Once or twice a year I go to the Marshall Chess Club across the street, but that's all. You can forget about something you love very much. It's a Zen concept. When I put my 'Nude' under my arm and went home, it was my first Zen experience. Don't cry."

THE NEW YORK TIMES, MONDAY, JULY 7, 1969

Philadelphia Museum Shows Final Duchamp Work

By JOHN CANADAY

WELL, very well. What shall we say about the latest, . . without much question the final, work by the late Marcel Duchamp? Left to the Philadelphia Museum of Art with the stipulation that it not be photographed for 15 years, as so arranged that it can be seen by only one person at a time, it is posthumous verification of Duchamp's status as the trickiest, cleverest, and most seductive personality on the fringes of art that he established as part of true art.

Its provocative title, "Etant Donnés: 1. la chute d'eau; 2. le gaz d'éclairage," can be translated, in parody of a mathematical problem, "Given: a water fall and illuminating gas," with the possibility of some doors or close associations with the word 'donnés.' It was done between 1946 and 1966, when Duchamp was supposed to have abandoned creative endeavors in painting or sculpture (this is both (or neither) and goes on exhibition today as a permanent installation in Philadelphia's museum.

To describe it:

You enter a small room in which treadles in your path activate the lights and devices of the concoction. You go up to a couple of weathered barn (or shed) doors, which are enclosed in a brick arch ("Duchamp himself chose the bricks," we are proudly told) in the center of which (the center of the doors) are two peepholes at average eye level.

Just beyond the door your eyes encounter a brick wall in which a hole has been punched. Your pleasure as a voyeur is doubled by this peering through a double obstacle. Voyeurism is no fun unless it's secret.

Well, this business you are now looking at, is it a nature morte or a tableau vivant? Actually it is like a still life executed in three dimensions from a living picture that might have been included in "Oh! Calcutta!" There is no question as to exactly what

with the geometry and muted colors of cubism.

Unlike his brothers, however, who were to adapt their own sensibilities to cubism, Marcel again began to alter his style. Like the futurists he employed a succession of flat overlapping planes to depict spatial movement of machinelike forms. He also supplemented his work with verbal, extravisual ideas. His famous "Nude" had in fact started as a sketch for a poem.

In 1912, after making several preliminary studies of the "Nude," he submitted it to the Puteaux circle's exhibition at the Salon des Indépendents. The futuristic elements of the painting angered the members of the group, and at the request of his brothers he withdrew the work.

Duchamp recalled:

"I put the painting under my arm, got into a taxi and went home. After that groups meant very little to me."

'Playful Physics'

In the years preceding the war, he and the artist Francis Picabia, who shared each other's sense of iconoclastic

Continued in Column 1

the focal center of the composition is. You are confronted with a life-size female nude figure, apparently covered with skin or a skinlike substance tinted with what looks a lot like pancake makeup. She is lying spread-eagled, seen feet first, and holding in one hand an old-fashioned gas lamp with a six-inch cylindrical asbestos flame guard, glowing at the tip. Rather flabby as to physique, although young, the nude lies upon a bed, or sort of eagle's nest, of twigs and dead leaves, backed up by a painted scene of a lake and wooded hillside a tinted photograph actually, including a waterfall that has been animated with some kind of illuminated twisted glass device to look as if it is really water falling, like in

Through two peepholes in these doors, one person at a time can view Marcel Duchamp's "Etant Donnés: 1. la chute d'eau; 2. le gaz d'éclairage." The holes are in the center of the doors at average level of adult human eye.

A. L. Wyatt—The Philadelphia Museum of Art

an old-time Belasco backdrop.

This mixture of camp, high style, prophetically opportunistic sexual exhibitionism, surrealism, cynical wit and horseplay is pure Duchamp. She is lying spread-eagled, seen feet first, and she should never be taken with total seriousness except in the context of a concept of modern art that accepts effete exhaustion as a residual intellectual game.

But for the first time, this cleverest of 20th-century masters looks a bit retardataire. Edward Kienholz, as the major specific example, has gone so far beyond the spent and sterile sickness of this final Duchamp work that he makes Duchamp look like Bouguereau.

As for the restriction

against photography, it is explained by Duchamp's having tried, but failed, to photograph the work successfully. This is absurd. If the thing were an environment, then still photography might not cope with it. But you are held as rigidly to a single view (try as you may, you cannot twist your eyes to see beyond the peepholes in one direction or another) that your vision is as static as that of a camera's lens. This is the one completely photographable three-dimensional work that I can think of.

The Philadelphia Museum's current Bulletin is given over to a scholarly analysis of this latest acquisition by Anne d'Harnoncourt and Walter Hopps. I have not yet faced reading it, frankly. But the work belongs exactly where it is, with the bulk of Duchamp's work in the Arensberg collection. The new Duchamp is the unexpected addition to a legacy that everyone thought was final, the legacy of an entrancing personality who has been, along with Picasso and Matisse, one of the trio of most powerful influences on 20th-Century art but who, unlike his two peers, has exerted an influence primarily destructive—unless you want to say that the recognition of art as a parasitic appendage, an amusement, a vaudeville performance, is constructive in its flat admission that art has lost all connection with anything but the fluff of life.

This was Duchamp's own territory, and only by such recognition can he be thought of as a serious artist. The trouble is that he is too often thought of with the kind of exaggerated reverence that makes his art nonsensical. Philadelphia's new treasure is an entertaining invention that has arrived a bit too late to make a sensation. A swell Duchamp it is. But a major specific example, has a major addition to 20th-century art it is not. The impression is just a bit as if we had discovered the tomb of another Pharaoh. Very interesting, but nothing new.

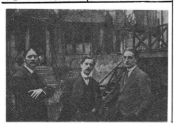

The Three Duchamp brothers in 1912, left to right, Jacques Villon, Raymond Duchamp-Villon, Marcel Duchamp.

Max Bill

On Duchamp

First published in *Wegleitung Nr. 234*, Kunstgewerbemuseum Zurich, 1960, on the occasion of the Duchamp exhibition
Translation first published in the Duchamp issue of *Studio International*, February 1975

Marcel Duchamp once wanted to become the anti-artist par excellence. He has become the prototype of the artist. His opposition to art, which he presented carefully wrapped in irony, has proved to be one of the most positive contributions to the intellectual history of the twentieth century. There are personal reasons why I suggested holding this exhibition and took charge of it, and I would like to give an account of them here. I met Marcel Duchamp in Paris in 1938. At that time I was working on a volume of the *Le Corbusier and Pierre Jeanneret* series and on producing my *15 Variations on a Theme* which was being prepared for printing in Paris. The Pevsners invited us for tea one afternoon, together with Marcel Duchamp and Piet Mondrian.

Tea consisted mainly of caviar (which I do not like) and 'rotoreliefs'. On a portable gramophone—which stood on the floor and was slowed down by hand to a very few revolutions per minute—Marcel Duchamp presented his rotoreliefs. As always when something did not quite suit him or seemed 'too naturalistic', Mondrian was wrapped in silence. The movements produced by the rotoreliefs, the partly naturalistic elements for a primitive movie, for example, *Lampe, Montgolfière, Poisson japonais*, did not meet with our unqualified approval, as optical phenomena, or as a trick seeming to produce space from flat forms by revolving them: neo-Renaissance! But as optical games they captivated us. Duchamp gave me the series of rotoreliefs and explained that he now had to go to Puteaux. I offered to drive him out there and bring him back. In Puteaux we stopped in front of a high garden wall with a narrow door. Duchamp went in, returned five minutes later, and we drove back. It was not until 1945 that I got to know this wall and what was behind it rather better; Duchamp's brother, Jacques Villon, still lives there today, and François Kupka used to live there.

The rotoreliefs had given me a slight shock, for these coloured discs, as long as they were not moving, seemed perfidiously similar to some of my *15 Variations* which were just going to press, and which I had been struggling with since 1935. Perhaps I owe it to this shock that Marcel Duchamp's work attracted me again and again, and that it still remains up-to-date for me today. That meeting is one of the reasons for this exhibition taking place: Duchamp's first big individual exhibition in a public museum and at the same time the only authentic French contribution to this year's Zurich June Festival, the theme of which is France. Of course, we must limit this statement a little: the exhibition begins at the end of the Festival and it contains a few of Duchamp's precious originals; most of them are in the Philadelphia Museum and, at the request of the donors Louise and Walter Arensberg, are not allowed to leave the United States. For the exhibition we are left with only the possibility of comprehensive documentation. On the basis of this documentation the following questions arise: on the one hand, what does Marcel Duchamp's work mean in the history of art, and, on the other, what does it mean for us today?

Marcel Duchamp's position in art history is determined, in that he took up the results of Cézanne's image-structure in his early years, and transferred them into Cubism, at the same time as others; also in that he finally took the elements of movement, which originated with the Italian Futurists, over into French painting. He brought these elements to a synthesis in his main works of around 1911, especially in *Nude Descending a Staircase*, which caused a scandal in the *Salon des Indépendants* and was withdrawn.

The involvement with presentation of movement led, by 1913, to the invention of a new kind of image-mechanics. This is burdened with thoughts of a literary symbolic kind, but also has a tendency to apply a kind of super-precision which thrusts across the geometric-mechanical reality into a meta-reality, where game and precision, idea and reality coincide.

About 1913, aged 26, Duchamp began his most fundamental work: *La mariée mise à nu par ses célibataires, même*. A long series of preliminary works of various kinds were combined in this so-called *Large Glass* between 1915 and 1923. Duchamp's fame today is founded not only on this work, which is documented comprehensively by the artist in the *Green Box*, and about which there is a study by Serge Stauffer in the catalogue of this exhibition, but also on a series of inventions which are still valuable today, especially the so-called 'Readymade', which means the selection and interpretation of all or any objects.

Finally I should mention Duchamp's experiments on 'precision-optics' which led to the 'rotoreliefs' after he had produced such effects with the help of a specially constructed device in the film *Anémic-cinéma* in 1926.

The *Great Glass* was exhibited in New York in 1926–27, finished after several interruptions, and labelled by Duchamp conclusively uncompleted. While being transported back from the exhibition the glasses broke. And so this masterpiece has not only remained 'incomplete', but has also become 'irreparable'.

In the meantime, however, Duchamp had shifted his talents to another field: chess. It was not inessential for his development that he should occupy himself early on with chess; he got on so well that he represented France in international matches and in 1932 published a book on finals together with Halberstadt. The boundary between meaning, logical consistency and play is the actual element that Duchamp adopted in art, and one can find here the point of connection between artistic personalities as different as Duchamp, Klee and Vantongerloo. This collapsing of the thought-game into artistic reality, this setting of rules of play, resulting in absence of play, this creation of open systems—as Klee so correctly said 'Art plays an unknowing or "ignorant" game with the highest things and yet achieves them'—characterizes their work, which becomes art even when the greatest risks are taken, justifies the well-known phrase of Schwitters: 'Everything an artist spits is art'.

Duchamp expressed himself again and again in writing. A selection of his statements is reprinted in the catalogue of this exhibition, selected and translated by Serge Stauffer, who has for years collected material for a book about Marcel Duchamp. In

preparing this exhibition I came across his work, and he put his careful text translations at our disposal saving us much effort and time; I would like to thank him for this, with the hope that his work will be brought to a successful conclusion. I also owe thanks to Arnold Fawcus, the publisher of the large Duchamp monograph, which appeared in his Trianon Press, written by Robert Lebel. Mr Fawcus took an active part in bringing this exhibition about — giving valuable help in acquiring the exhibits and the documentation.

And now back to the second question, why Duchamp is of particular significance for us today, since he himself did not seek the aesthetically valuable, but actually by uncompromising non-aestheticizing produced aesthetic inventions which manisfested a new — or perhaps the real, old — aesthetic through their newness. I mean the 'readymade', which is under discussion here. Imagine, as Duchamp himself explains, 'buying ice-tongs as "readymades" ', or a bottle-rack as he did with *Porte-bouteilles* in 1914, followed by a series of similar objects designated 'readymade' and exhibited in art exhibitions. The amazing fact is that things which are emphatically not generally seen from an aesthetic viewpoint, become aesthetic through the chooser, through the kind of choice, and gain new significance through time. Quite ordinary things are brought into an unexpectedly new context deliberately and provocatively, and are put into a museum apparently absurdly. What is the point of it? Has nothing like it ever happened before? Certainly, we must look at what is in the museums and test it: when object x is 1,000 years old it succeeds *a priori* as a work of art and thus gets into the museum. Older = more valuable = more art. Is therefore a revaluing of the objects of everyday life meant? Should the fatal gulf between art and everyday life be bridged? That was probably not Duchamp's intention. And yet it is no accident that, at the same time as his dadaistic demonstrations, the first traces of the creation of an improved environment appear, aimed at integrating art into everyday life and corresponding to civilization today. The complete environment — the whole of life — as art. I believe the essence of Duchamp's function as thinker and artist, critic and interpreter is seen here, and is *one* of the reasons for his relevance today.

A still further field should be mentioned here, in which Duchamp boasts achievements, the extent of which is not yet sufficiently recognized: language. Through a mixture of play and word combinations Duchamp has coined word-images, which unfortunately cannot be translated easily. Between speech and writing, he put the double-meanings of speech into writing, and transformed, for example, the 'objet d'art' into an 'objet-dard', or played a game with his pseudonym Rrose Sélavy, which he presented as the name of a wise lady: *'c'est la vie'* (such is life). But also in other respects: whoever reads his texts comes across countless creations, whose combinatory aesthetic, philosophical and critical worth has yet to be recognized.

Since the ruin of the *Large Glass*, Marcel Duchamp has very much restricted his creative work. The artist who began with delicate Cézanne-like works and finally wanted to destroy the aesthetic, who is indeed one of the most fruitful stimuli in the art of the twentieth century, has only occasionally added anything new to his old works. His activity has become more and more limited to the authentic interpretation and documentation of his own unchanged intentions, and to the presentation of his friends, especially Constantin Brancusi, whose first American exhibition he organized, and later the surrealists and dadaists.

Duchamp had always been wise in his choice of methods. He knew, when he made his own decisive contribution, how to keep himself from the danger of self-imitation. That cannot be too highly appreciated, and in this he is surely an example to be followed.

From *Form* (Cambridge, England)
No. 9, 1969

In Memory of Marcel Duchamp by Hans Richter

I see Marcel Duchamp—wherever he might be now—playing chess, playing the game with the intense passion of a lover, the way he played it when I first met him nearly fifty years ago—playing it with the delight for its beauty, with the desire to kill his opponent —to win, with the superiority of a master, with the enigmatic personality of a magician.

Nothing can describe him as clearly, as definitely as the infinite moves of the holy game. Wherever chess is played Marcel lives.

Marcel Duchamp invented Dada in the U S A in 1915, before it had been 'discovered'. His contribution to the philosophy of Dada is elementary, practical, and so obvious that it is regarded and accepted in the United States as the Only-True-Dadaistic-Doctrine. He invented what he found 'ready-made': bicycle wheels, bottle racks, pissoirs —the ready-made as the latest cry of Art. These objects proclaimed a new reality. With brutal Cartesian logic, these ready-mades were set up against the Laocoon and the Venus de Milo as a purgative for thoroughly hypocritical times and a society which had led to them.

Marcel Duchamp did not hail 'Anti-Art' like the Berlin Dadaists, but rather 'Non-Art'. And he has lived his creed with a consistency that has made him a mythological figure even in his lifetime. Through him Dada became an intellectual extension of nihilism, an idea of nothingness which could by no stretch of the imagination be brought to suggest meaning.

'Death? There is no such thing as death. When we no longer have consciousness then the world simply stops.' Such an acknowledgement of *cogito ergo sum* shattered me. But rendered with the earnestness of Marcel Duchamp, it seemed to solve all the problems of this world. In a mirror which thus no longer reflected anything, only existentialism found, once again, the vague outlines of a human silhouette ... while Marcel played chess ...

Since 1921 no-one has been able to bring him to produce any so-called 'art work', or to submit to the 'shabby processes' that underlie the art business in order to dispose of them. Walter Arensberg his collector and Dada friend tried it earnestly during the 2nd World War, when Marcel was seriously in need of means of existence, but he failed, as did his friend Roché and all of us who loved Marcel as an artist. .

He has remained faithful to his Dada protest, and instead of making art he has decisively submerged himself in the ephemeral, unnegotiable but spiritually as well as aesthetically satisfying world of chess. More than his work, his life sets up an amazing paradigm of morality. The quality of his paintings would be meaningful even without the scandal that *Nu Descendant l'Escalier* called forth in New York in 1912. Here is a man who has allowed his thinking to become such contempt for the so-called material and worldly advantages that both, perforce, have fallen into his lap.

Over his long lifetime, this muscular independence from a world of compromises in the midst of a conformist civilisation has exerted an enormous influence. Those who lack the strength to draw their own conclusions and act upon them have found a special attraction in identifying themselves with the ideas of Marcel Duchamp, who has all the strength they miss.

The temper of the present gives courage to these 'Nothing-People'. 'Nothingness', alas, becomes the insignia of a new snobbism. Is the Romanticism of 'Nothingness', which is so welcomed by a disappointed new generation, in danger of turning into a comfortable ideology?

I find the secret of Duchamp's magical force of attraction in the vacuum he created to replace 'rejected' moral and artistic attitudes. The reason for its attractiveness lies less in the artistic or in the shock value of the ready-made. It is rather that 'Nothingness' provides a home and an affirmation for the suicidal instincts of a generation which has been weakened by our cultural chaos. There are of course others for whom the 'belief-in-Nothing' becomes fashionable self-deception. They find a sly security in their self-created spiritual superiority, without which their self-confidence would collapse.

Duchamp's detachment, the first step of his wisdom, permeates his personality and works like a vacuum on fate, pulling things and people toward it. They approach him open-minded and open-hearted, offer him tributes and sacrifices, and he responds with equal generosity. He who seems to want nothing can freely offer advice to others and find fitting words for the petty inevitabilities of everyday life. They are words, though born out of indifference, which express sympathy and oblige gratitude in return.

His studio is a workroom where chess tables are watched over by automatic chess clocks. Every day they fulfill their duties for two hours. Duchamp has added to the already colossal fund of chess literature with his treatise on certain problems of the end game. As vice-president of the Marshall Chess Club—a leading chess club of New York—he won its championship.

I myself was finally sucked into his chess kingdom despite my less than amateur status. For four years I worked on the filming of a chess fantasy *8 x 8*, and on a story about the history of chess, *Chesscetera*. I had landed in his vacuum and was able to observe his passion without sharing it. His thoughts, his charm, his words in his impeccable French—are preserved in my film *Dadascope*.

The Dutch philosopher Huizinga traces the development of *homo sapiens* not à la Darwin to 'necessity' (in the struggle for survival), but rather to his instinct for play, unpurposeful and not directed toward any kind of practical use. Thus play becomes the most serious of activities, and Duchamp took Dada as a form of play. He takes chess quite as seriously as Dada. *Homo sapiens* never acquired wisdom; why not give *homo ludens* a chance?

Watching, a few days after his death, a film on T V, made several years ago by French T V, a film in which we, his friends, all paid tribute to this rare man, I was stunned and deeply moved by a sentence with which Marcel Duchamp ends the film. It still moves me ... a kind of 'last word', a kind of enigmatic 'solution' of the enigma of his life and personality. Smiling like the Mona Lisa which he once had decorated with a moustache, he seemed to summon up his philosophy and life endeavour: 'We are always alone: everybody by himself, like in a shipwreck'.

He prevails upon us to insist, 'like in a shipwreck', upon our own uniqueness, upon the originality of man as an individual, at every moment, all the time. That's the way the game should be played. And as we feel, more every day, that the ship is wrecked. Marcel has become the mythological figure of a prophet, whose word counts more than a thousand (painted) images.

Karl Gerstner

Souvenirs of Duchamp

Letter to Anthony Hill, 1976

Forgive me, M. Duchamp, and rest in peace. Souvenirs on Marcel Duchamp? With pleasure! But I didn't know him as well as I would have liked.

Georges Staempfli organized an exhibition on the three Duchamps in Houston, when only a few people in Europe were aware that Duchamp was still around. He introduced us. Later we visited Marcel and Teeny at 10th Street in Greenwich Village, and I took along my *carro 64*, an interchangeable picture that Staempfli had just edited. It consisted of 64 squares, like a chessboard. Duchamp was amused. He liked the idea of making art as if one were playing chess. After playing for a while, he turned some of the carros upside down, making a wholly new type of constellation. Typically Marcel: he didn't seek solutions within rules; he invented rules.

We next met in Cadaqués and went by boat to a silent beach. Teeny was swimming and diving. Suddenly she came back with a bottle containing a message: 'He who finds this bottle, contact Mister Duchamps somewhere in the Auvergne.' Typically Marcel: he couldn't escape changes (though he was a little unsatisfied: the other Mr. Duchamps wrote his name with an 's').

There was a time when I liked to ask people: 'What is art?' I always got the same answers: 'You know, it's difficult', 'It depends', and 'Actually each time has a different kind of art . . . even each person . . . today art means something else to me than yesterday'. Duchamp answered without hesitation: *'l'art est une artificialitée. Comme la réligion ou la philosophie. Une tautologie. Une escroquerie.'* Typically Marcel: during his life he proved the impossibility of defining art. Yet he alone had an answer.

Playing chess, he added, is different. In art, you never know what you're doing. Nobody can tell you what's wrong, what's right. But playing chess — c'est la bataille with three solutions: win, lose, remis.

When I observed Duchamp's attitude toward contemporary art, I had the impression he was interested in everything brought to his attention, though he could be very acid in judgement.

If you don't know what's wrong, what's right, it makes no difference: you can find everything wrong and everything right without any consequence. What counts isn't intellectual *judgement* of a work of art, but the *effect* of that work. Most of what you see you forget immediately: some you remember for a lifetime; and a very, very few works of art affect men at all times. I never spoke with Duchamp about this subject, but that is typically Marcel: he made me think about it through his behaviour.

Duchamp invited me to contribute to his *Homage to Caissa* exhibition. I constructed a money-making machine: drop in a quarter, and a king and queen turn like a roto-relief — the king toward heaven, the queen toward earth. The piece was entitled *'Marcel Duchamp et Rrose Sélavy mis à nu descendant un escalier, même'*. My mythical Machine never made a dollar, and finally rotted in the lobby of the Chelsea Hotel. But typically Marcel: he consoled me by explaining that effects are always different from goals.

Another year in Cadaqués I met Duchamp, together with Dali, at a paëlla party arranged by Georges Staempfli. A photographer was present. Every time Dali thought he was on camera, he posed. He turned his head toward the lens, positioned his crosier, adjusted his moustache upward, and stared goggle-eyed. Dali became what he beheld, but Duchamp was more interested in the dinner than in the photographer. Typically Marcel: he remained the man people greeted with 'Buenas dias, Señor Marcel'.

Several weeks after Duchamp's death, Dali told me Duchamp was a romantic, whereas he, Dali, was the classic artist of our time. Dali had proof: an unfinished drawing he had made of Gala — which looked like an Ingres. He let me see a photocopy of the last drawing Duchamp had made: for the mayor of Cadaqués, when he delivered bricks for his last piece, left in the Philadelphia Art Museum. Indeed, it looked like a drawing by Courbet. Typically Marcel: classified as romantic, after everything he did for changing art. The last surprise I would have expected from him.

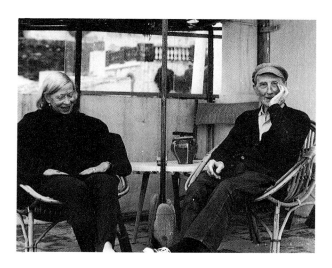

Marcel and Teeny Duchamp
Cadaqués 1964

David Myers

The Mystic

Extract from *The Thursday Evening Art World:*
The Alfred Weary Lectures, McCall, New York, 1970

Two days ago Marcel Duchamp, apostle of artistic silence, passed on.

When an important artist dies, our feelings are inevitably freighted with the simple heavy fact that we shall have no new works from him. Upon the death of Duchamp this simple heavy fact did not enter our feelings and sink them, for the fact has long been one we were accustomed to, and one which indeed over the last two decades has assumed the status of a relevant myth.

I am told by an intimate of Duchamp that he thought very little of that myth and continued until two days ago not to live up to it by producing, whenever he felt like it, works of art — usually small smooth polished sculptures — and selling them, too. He was apparently rather more indifferent about his theoretical abandonment of art than were his simpler-minded admirers, who often saw it as a grand, pure, heroic gesture, or than were his detractors, who usually attributed it solely to a collapse of creative powers.

When I used the word *indifferent* just now, I didn't mean to suggest that Duchamp didn't care about his public myth — he was far too conscious a creature not to care about everything. What I had in mind, rather, was the sort of absolute indifference that mystics attain or seek to attain — those mystics who tell us that to God there is no distinction in the beauty of things, and that it is only our human prejudice that makes us prefer for beauty the peacock to the wart hog, the Goya to the Rockwell.

Now I gather that Duchamp paid little or no mind to the idea of God, but he did, it would seem, have the godlike indeterminate view of things. His view — for we think of him as an artist — focused upon that area where determinations are traditionally made by the faculty named taste, and the point of his view was — wasn't it? — to abolish taste — or, if you prefer, to enlarge it so that it would include no less than everything. Is a Rembrandt of a higher order of art than an ironing board? A ridiculous question unless we can, first, accept Duchamp's definition of art — the only one he would accept as being true for all times and places: namely, that all man-made objects are works of art; and unless we can, second, accept his effort to abolish standard hierarchies. 'Use a Rembrandt as an ironing board,' he wrote in a note to himself, subsequently published in the *The Green Box*. And is it so silly after all? Only, I suspect, to one who has a Rembrandt and also does his own ironing — in other words, to no one. Surely the interchangeability of a Rembrandt and an ironing board is now acceptable to all of us. Who in this audience would be terribly shocked to see on a museum wall, where once a Rembrandt hung, an ironing board — especially if the ironing board was nicely framed and signed by, let us say, Jim Dine?

Duchamp's speculations, and his readymades, surely paved the way for all sorts of interchangeabilities — and also, I might say, for all sorts of misunderstandings, including, no doubt, my own.

But let me not talk about myself. Even that most intelligent of persons, Robert Motherwell, has apparently misunderstood: Motherwell has declared that Duchamp's *Bottle Dryer* (a simple kitchen utensil purchased, I suppose, from a hardware store) has 'a more beautiful form than almost any thing made in 1914 as sculpture.' And in so declaring he has missed the whole point — at least Duchamp's point, which I take to be that the *Bottle Dryer* is no more nor less beautiful in form than anything else. It is the way it is, and there is no need to desperately twist one's aesthetic taste to accommodate the *Bottle Dryer* to it. Such aesthetic taste was precisely what Duchamp was going beyond.

George Heard Hamilton says of Duchamp's Readymades that wrenched from their mundane environments they were 'obliged to live henceforth in the realm of mental facts' — a mystical realm where such physical matters as proportion and form are beside the point. For Motherwell's generation, Duchamp had to be accepted as a maker of beautiful forms, but for the generation that came after he was accepted, indeed honoured, as *paterfamilias* for his explorations of a non-formal, non-aesthetic realm of mental facts.

Mr Alan Solomon is of the critical wing of this new generation, and he tells us that Duchamp 'started' what clearly seems to be the 'mystical tendency in contemporary art' where 'the real object has become merely a clue, a clue to certain secrets of inner life, to certain mysteries of feeling and thought beyond the world, in the reality of the mind'. In other words, Mr Warhol's soup cartons or pictures of Marilyn are not simply public icons — they are mystical clues to certain secrets of Warhol's inner life. I — perhaps to your great surprise — agree.

I asked Jasper Johns what he thought about all this mystical business and he told me (and that is all he told me) a story about Duchamp and a young architect. It seems that there was a large downward dip in the ceiling over Duchamp's bed, which became progressively worse over the years, so that one day, when it looked as though the ceiling might cave in at any moment, Duchamp took a broomstick and wedged it between the window sill and the centre of the bulge. And there this little makeshift arrangement remained for several years more, holding things up quite nicely. But one evening a young architect was visiting Duchamp, and naturally being shocked by the fragile buttress he decided to do Duchamp a great favour and fix it properly. To study the situation, he wedged out the broomstick, at which moment the plaster began cracking every which way, and before he knew what had happened the architect was knocked off his feet and covered with falling debris. 'You see, I told you it wasn't safe', he said at last, rising and dusting himself off with trembling hands.

I suppose that some of the most essential ideas are held in place by mere broomsticks, and the well-meaning fellow who attempts, as I have attempted today, to give them a more substantial support may simply succeed in covering himself with dust — and messing up someone else's apartment.

First published in *Marcel Duchamp*, edited by Anne
d'Harnoncourt and Kynaston McShine,
The Museum of Modern Art, New York, Philadelphia Museum of
Art and Thames and Hudson, London, 1973
As amended by the author, 1991

GEORGE BRECHT

NOTES ON THE INEVITABLE RELATIONSHIP
(IF THERE IS ONE)

At the end of the 50s I found I had breathed all of Duchamp's water and gas at every level period.

Nevertheless, in the middle 60s it occurred to me that "Marcel Duchamp plays chess, and I play pick-up-sticks."

A little later I found myself making a note on D's Brasserie de l'Opera note.

The closest I ever got to meeting Duchamp in the flesh as they say was one time when I was living in Rome. Arturo Schwarz told me there was to be an exhibition of D's things and MD was going to be there. Arturo gave me the address and details. The show was to be in some furniture store, if I remember rightly. I prepared the last copy I had at the time of Water Yam by inscribing a few notes on some of the cards (in India ink) and tying the top onto the box with linen cord joined with a sailor's knot. After walking for quite a while under the sun (high at the time in Italian air-space), the box under my arm, I found the street and the number, but nothing remotely resembling what Arturo had described as the site of the great occasion.

No regrets.

I read somewhere, quite a while ago, that an interviewer asked: "How does it feel now, Mr. Duchamp, that everyone knows your name?" And Duchamp answered, "My grocer doesn't."

Al Hansen and I once cooked up a "Blues for Marcel Duchamp." Some of the parts were: spraying a bit of the tree outside MD's door on W. 10th St. with blue paint; leaving (within an hour of its appearance) a blue-dyed copy of the *New York Times* (impeccably ironed and refolded) in an empty milk bottle on his doorstep; playing a few bars of "Sunflower Blues" outside the windows of the house, and so forth. I think we came up with about fifty or so things to do, and actually put a notice in the *Voice* for the occasion, but beyond that I don't recall the thing going much further than leaving a blue trace on that tree.—*Cologne, 1972*; revised 1987

François Morellet

Duchamp

Letter to Anthony Hill, 12 March 1974

I like the way Duchamp pointed out that any thing could indeed be anything. I like this distance that he put between himself and what he did, leaving the spectators free to come up with their own inspired picnics.

I hate the myth surrounding Duchamp and the explanations given by the psychoanalysts, Marxists and the Cabalists, for work whose prime quality was to say nothing at all.

Shuzo Takiguchi
Telegram to *Studio International* 1974

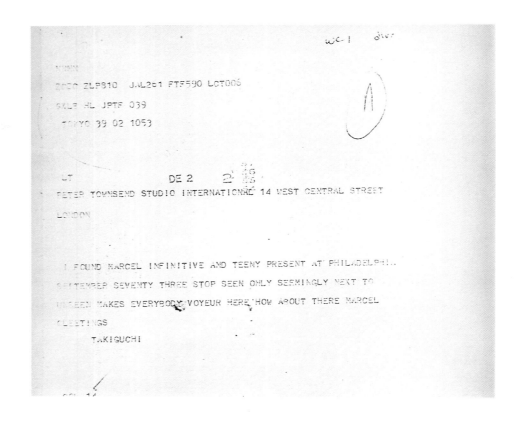

Mark Thomson

Interview with Hans Haacke

New York, April/November 1990

MARK THOMSON: *At the Beaubourg in 1989 you exhibited a pair of Duchampian works with elaborate punning titles,* Baudrichard's Ecstasy *and* Broken R.M. . . . *Also on show was your* MetroMobiltan, *a work whose title echoes its juxtapositions of material. There are some heavy ironies in these playful names for pieces, like extracting the letters of 'Mobil' from the word* Metropolitan, *or making a* richard *out of Baudrillard, or breaking the word 'arm' in* Broken R.M. . . .

This is a mysterious piece for me. It's not clear exactly how Duchamp's words (In advance of the broken arm) *and the snow shovel relate to each other — they are never completely distant, but neither is there an immediate ironical relationship as there is with the* Fountain, *it's more opaque.*

HANS HAACKE: I'm not quite sure what Duchamp was up to with the snow shovel. There is, of course, the psychoanalytic interpretation by Arturo Schwarz according to which the snow shovel represents Duchamp's phallus, with allusions to castration and incest, stories about Marcel Duchamp and his sister . . . I don't know whether it holds water. For me this first readymade Duchamp chose after his arrival in New York was a useful vehicle for doing a few other things. I have pulled together several Duchampian elements: the shovel itself, the readymade enamel plaque EAU ET GAZ A TOUS LES ETAGES, and in the title (*Broken R.M.*) references to *In advance of the broken arm* and his initials on the *Fountain*. 'R.M.' sounds like arm. In my version, the 'arm' is, in fact, broken; it's no longer a prediction of what will happen in the future. There are lots of interpretations for *R.Mutt* on the market. Pronounced in German it becomes *Armut* = poverty. Also the German word *Mutter* (mother) is hidden in it. For my purpose, in this case, the allusion to poverty is the more intriguing one.

Today Duchamp's readymade technique is no longer as viable as it used to be. It's 'broken' through overuse. It has lost its potency like a medicine that has been taken too routinely. You remember, Duchamp was quite determined to limit the number of his readymades. If the handle is broken, a shovel cannot be used to get rid of snow. We are then snowed under — we're getting a snow job. As you suggested, the handle could have broken under the weight of gold. When I designed the piece, I thought, among other things, of the unprecedented power money had gained in the art world during the eighties — not that there was none before (Duchamp complained in 1961: 'Art is now a commodity like soap or securities'). This takeover by a Wall Street mentality accompanied the boom in readymades. It sapped the bit of signifying power they may have had left — beyond their role as printing presses for junk bonds. The broken readymade is golden. A glossy dildo made in heaven has replaced the phallus. *Art et argent à tous les étages.*

And the other piece, Baudrichard's Ecstasy?

Obviously, I've turned Duchamp's *Fountain* into a reciprocal readymade. At some point Duchamp explained he chose the first name 'Richard' for 'R.Mutt' because in French 'richard' means moneybags, the opposite of *Armut*. There are also sexual

references: in my version the 'ejaculate' is recycled. It doesn't produce anything, it's infertile like simulated ecstasy. But it makes for b(e)au-tiful fireworks. The fire bucket as reservoir for the 'semen' assures us there won't be any real fire.

You're also using a Duchamp as an ironing-board!

Yes, that's the other reference. The Rembrandt!

The idea of the readymade is in many ways parallel to the idea of collage: both require the previous existence of things, and therefore a situation for those existences. Are you comfortable in the context of John Heartfield and Hannah Höch?

You're right, there is a connection between readymades and collage. The use of collage in visual communications probably predates Heartfield and his artist contemporaries; it was certainly well established in literature. Collage is a technique of combining materials from unrelated contexts which, due to their new constellation, produce a meaning they didn't have in the original setting. They also let their old context be seen from a new angle. It is an extremely useful device; I've used it often.

Your works have their own kind of precision, in the way that facts, usually words, are juxtaposed with an intricate and veiled visual semiotics. Let's take the Picasso and Braque pieces — superficially they are very familiar papiers collés. *But it doesn't end there, for each strip of newsprint has been scissored with evident care, and its texts are transcribed in the catalogue. In these fragments the transaction between Philip Morris and Jesse Helms is revealed in black and white.*

One normally assumes Picasso paid no attention to what was said in the newspapers he used in his collages, that they merely served as graphic material. This is wrong, at least in a good number of cases. Picasso's followers, for the most part, overlook this with deliberation, because it would undermine the strictly formalist interpretation of Cubism. There are numerous Picasso collages in which the contents of the clippings, drawn from several sources, refer to each other. For the life of me, I can't believe this was accidental. There is one glaring example, *The Suze Bottle*, from approximately 1912, which is now at the University Museum in St. Louis. No other *papier collé* in Picasso's oeuvre has more clippings. He added very little to them and was careful to fully preserve one long column, extending uninterruptedly from the top of the collage to the bottom. It is a report from a French newspaper about a Socialist rally on the outskirts of Paris, the songs they sang, the speeches that were held, etc. Among the speakers was a delegate from the German Social Democratic Party, who announced that workers don't shoot at each other — apparently in anticipation of possible international conflicts. There was roaring applause. If you take the trouble to turn your head upside down, you discover that all the other clippings are reports from the battlefield on the Balkans, some written from a technical military point of view, others describing in graphic detail the carnage. There are other *papiers collés*, perhaps less dramatic, where I sense attention to the text as a vehicle for information.

The frames are very carefully done, the impression is complete

169

apart from the fact that you have replaced pipes with cigarettes. You are making the language of art serve, or even serve again. To produce this kind of art is fundamentally more of an artistic act than a political one: it is to establish political criticism and analysis as an artistic programme, and it implies that not only itself, but all art can be looked at in this way. And what you have just said about the Picasso sums that up.

I am glad you seem to think the 'political' and the 'artistic' should be integrated to the point that the hackneyed talk about form and content becomes meaningless. Whether or not political references are intended, most human expressions, certainly those under the heading 'art' are 'tainted' by socio-political implications. It takes effort to decode them.

Autorisation / Authentique

Photo by Joe Costa of the New York World

Marcel Duchamp
The Non-Dada 1922
Pamphlet with collage
Religious pamphlet printed by
vocational students at the 'School of the Four Cs'
(Coney Creek Community Center) found by Duchamp
and sent to Man Ray with the remark
'The Non-Dada affectueusement Rrose'.
Exhibited in *Not Seen and/or less seen of/by
Marcel Duchamp/Rose Sélavy 1904–64*, Cordier and Ekstrom,
New York, 1965

Marcel Duchamp
Bouche-évier 1964
Lead sink-stopper made for shower
in Duchamp's apartment, Cadaqués

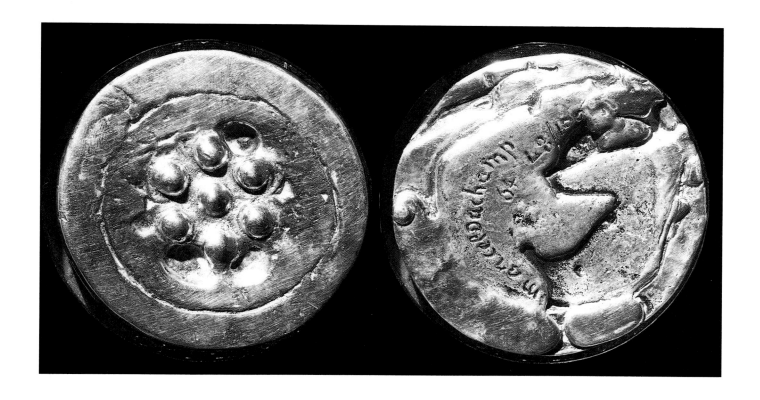

Edition A
1965 Cadaqués
Since this item proved too light for its function,
Duchamp had a second cast of exactly the same diameter
and twice the thickness

Edition B
1967, New York
The International Collectors Society, New York
issued an edition distributed in three series:
100 cast in bronze
100 in polished stainless steel
100 in sterling silver
plus 12 artist's proofs, six of which were reserved
for Duchamp.
Each piece is signed and dated
'Marcel Duchamp 64'.

From *Collected Words*:
The Complete Writings of Richard Hamilton
Thames and Hudson, London, 1984

236

Letter to Alison Knowles

Dear Alison

What a difficult question you ask – but I must try to answer. Not that I feel confident that my reply will be in any way definitive, even as far as I am concerned. I'm as open to argument as you are. However, this is the way I see it now.

If everything that Marcel signed is to be regarded as a Readymade by Duchamp, then we are in deep water. This is clearly not the criterion in this context. Two young men once went to see Marcel in Cadaques, they knocked at the door and pleaded a meeting. One of them, a big chap, became so excited in the presence of the great man that, when he was invited to sit down, he threw himself with such violence into the chair that it collapsed completely under him. This provoked more hysteria and he begged Marcel to sign the chair, which Marcel did with his usual kindness. Marcel and Teeny saw the chair being carried off triumphantly.

When Rita first met Marcel we were staying with Marcel and Teeny. One day Rita was sitting alone with Marcel at a cafe and she asked for Marcel's autograph (she didn't know that she would be seeing him again quite often in the future and she wanted a token of the occasion), so he wrote his name on the nearest piece of paper, Rita's cigarette packet. She still treasures it.

Another example relevant to this issue is a signature that Marcel sent to me in 1959. I needed a signature to reproduce in the Green Box book that I was just completing. He sent it to me on a piece of paper headed 'DONT FORGET'; you may have seen this as a postcard that Hansjorg Mayer and I made recently. We were careful not to say on the postcard that this was a work of art by Duchamp. Yet, although I asked Marcel for the signature, I am quite sure that his placing of it on the 'DONT FORGET' slip was a deliberate and beautiful thought. He could have used any scrap of paper and, no doubt, the pad was the handiest thing available but I see it as an entirely typical Duchamp image.

None of these cases, from an endless number, is similar to the one you describe. I understand that there was a quite voluntary signing of the object and that it was in no way prompted by a request. Marcel's answer to

Alison was making an edition of Duchamp's *Coeurs Volant*. The colour match is crucial, so she made up seven colour swatches so that Duchamp could choose the inks. Teeny Duchamp, seeing him with the definitive swatch, asked him when he had done the piece. 'He smiled and signed it.'

In December 1972 (after Duchamp's death) Alison wrote to ask if, in my opinion, this made the swatch a work of art by Duchamp.

Teeny's question is characteristically witty and the signing in these circumstances does sound like an aesthetic decision. However, I would be chary of saying 'this is a work of art by Duchamp' because Duchamp did not have the opportunity to confirm that statement by agreeing to its being exhibited or catalogued as just that.

The danger of adding to the catalogue, a game that Schwarz plays with great enthusiasm, is that the balance of the total oeuvre is changed. A criticism that I would have of the Schwarz book *The Complete Works* is the even weight placed upon things. The wide extension of the catalogue, at both ends, immature scraps in front and slight gestures filling the rear, devalues the great body of work. Or, at least, makes it more difficult to see it properly.

It is for this reason that I would suggest leaving well alone and not making the swatch a work of art. It was a theory of Marcel's that the more things he signed the more he devalued the unique object. Perhaps it would be a pity to give the swatch a unique value because he signed it.

DON'T FORGET

Marcel Duchamp

Reminder

A Marcel Duchamp Readymade

A number plate from his Volkswagen car
1962–63

He had done a play on words calling his Volkswagen: *'Faux Vagin'*.[1]

The number plate of the *'Faux Vagin'* was exhibited for the first time in Tokyo for the inauguration of the Seibu Museum of Modern Art, Karuizawa, in 1981 and was reproduced on a full page in the catalogue of this exhibition.

The Musée Beaubourg, which was very sorry not to have this piece for its inauguration with the Duchamp exhibition, informed the Seibu museum of the existence of this readymade.

There is a certificate of authenticity signed by Teeny Duchamp.

The piece is dedicated 'to Grati, affectionately', and signed.

Teeny Duchamp

Croyez-vous que	Do you believe that
Rrose Sélavy disait	Rrose Sélavy said
Volkswagen—faux vagin	Volkswagen—*faux vagin*[1]
Qui sais qui sais?	Who knows who knows?
C'est bien notre plaque	It's true it is our
d'immatriCULation	*plaque d'immatriCULation*.[2]

1. False vagina.
2. Number plate.

Marcel Duchamp
Faux vagin 1962–63
detail

Marcel Duchamp

Men before the Mirror

Ready-made text written by L. D., a German friend of Man Ray, in her mother tongue
English translation signed Rose Sélavy by Marcel Duchamp
Both versions published in *Man Ray: Photographies 1920–1934*, Cahiers d'Art, Paris, 1934

Many a time the mirror imprisons them and holds them firmly. Fascinated they stand in front. They are absorbed, separated from reality and alone with their dearest vice, vanity. However readily they spread out all other vices for all, they keep this one secret and disown it even before their most intimate friends.

There they stand and stare at the landscape which is themselves, the mountains of their noses, the defiles and folds of their shoulders, hands, and skin, to which the years have already so accustomed them that they no longer know how they evolved; and the multiple primeval forests of their hair. They meditate, they are content, they try to take themselves in as a whole. Women have taught them that power does not succeed. Women have told them what is attractive in them, they have forgotten; but now they put themselves together like a mosaic out of what pleased women in them. For they themselves do not know what is attractive about them. Only handsome men are sure of themselves but handsome men are not fitted for love: they wonder even at the last moment whether it suits them. Fitted for love and the great ugly things that carry their faces with pride before them like a mask. The great taciturns, who behind their silence hide much or nothing.

Slim hands with long fingers or short, that grasp forth. The nape of a neck that rises steeply to lose itself in the forest's edge of the hair, the tender curve of the skin behind an ear, the mysterious mussel of the naval, the flat pebbles of the knee-caps, the joints of their ankles, which a hand envelops to hold them back from a leap—and beyond the farther and still unknown regions of the body, much older than it, much more worn, open to all happenings: this face, always this face which they know so well. For they have a body only at night and most only in the arms of a woman. But with them goes always, ever present their face. The mirror looks at them. They collect themselves. Carefully, as if tying a cravat, they compose their features. Insolent, serious and conscious of their looks they turn around to face the world.

Ex Libris M.D.

Alphonse Allais

The Polymyth

Translated by Miles Kington
From *The World of Alphonse Allais*,
selected, translated and introduced by Miles Kington,
Chatto and Windus, London, 1977

I first set eyes on him in a cafe in the Latin Quarter when he came in and sat down at the table next to me. And ordered six cups of coffee.

'Aha,' I thought to myself. 'This gentleman is about to be joined by five friends, if I am not much mistaken.'

I was much mistaken. As soon as the six cups of steaming mocha had arrived he drank them all himself, one after the other. (Which is much the best way to do it, as you will know if you have ever tried to drink six cups of coffee simultaneously.) When he noticed my air of bafflement, he leant across to enlighten me.

'It's quite simple,' he said. (He spoke in a flat, down-at-heel sort of voice, as if he was talking with his shoe-laces undone.) 'The fact is, I am another Balzac. I, too, drink far too much coffee.'

Fascinated, I waited to see what he would do next. I didn't have to wait long. He called the waiter over and asked him to bring some writing paper. As soon as it came, he scribbled a few words on the first sheet, then crumpled it and threw it under the table. The same happened to the next. And the next. And the next and the next, until the floor was covered in screwed up pieces of paper.

'You see,' he told me in the same flat voice, 'you see, I am another Flaubert. I find it almost impossible to get a sentence right.'

Such a distinguished man was obviously worth cultivating and in order to find out more about him, I struck up a conversation. But when I happened to mention that I was a Norman from Honfleur, it brought a deep frown to his face.

'I am sorry to hear that. I am like Charlemagne; I despise the barbarians from the north.'

'I hastily explained that we Normans had ceased being Norsemen many years ago, and he looked relieved at the news.

'Ah, I didn't know that. I know nothing about the north — as a matter of fact, I am another Puvis de Chavannes. I too grew up in Lyons.'

Where, it turned out, all his family had been in the meat trade. In fact, his father had insisted on his going into the business for a while.

'I am another Shakespeare. I too started out as a butcher's boy.'

Then he had moved to Paris, fallen in love and got married. He didn't tell me very much about his wife.

'Let's just say that I have much in common with the Emperor Napoleon I. We both married a woman called Josephine.'

Josephine, sad to say, had run off almost immediately with an Englishman, leaving my friend feeling somewhat hurt, not to say rather offended.

'Put it this way,' he put it. 'I am another Molière. I too had an unfaithful wife.'

Part of the trouble seems to have been that he and Josephine were not entirely compatible in some ways. She, apparently, liked very virile, very passionate men. Unfortunately . . .

'You see, I have something else in common with Napoleon. My. . . .'

The rest of the sentence was carried away by a sudden gust of wind. Being very anxious to learn more about a man with so many diverse talents, I was careful not to leave before I had arranged to meet him again, and we agreed to have lunch together soon, fixing our rendezvous for twelve midday precisely.

I arrived at one minute past twelve and found him tapping his watch impatiently.

'You may not have realised that I am another Louis XIV. I cannot bear to be kept waiting.'

He relented sufficiently over lunch to tell me in great detail about a serious eye infection he had been suffering from since I last saw him. Luckily the doctors had found a cure and now it had almost completely cleared up. Or as he put it, with a slight variation on the normal theme:

'I have no wish to be another Homer or Milton.'

The other news he had at this, our second meeting, was that he had managed to shake off the memory of Josephine by falling in love with another woman.

Alas, I heard some time later that she had not returned his feelings and had rejected all his overtures.

So he had shot her dead.

And they had arrested him for murder.

When he first came to court, he refused to answer any of the examining magistrate's questions.

'I am very sorry,' he told him. 'I am afraid I am another Louis XV. I do not recognise the authority of this court.'

Which did not prevent him, in due course, from coming up for trial.

I'm glad to say that this time he did speak up for himself.

'I wish to say in my defence that I am a second Attila the Hun. I am a law unto myself.'

The jury did not consider this to be an extenuating circumstance and passed sentence of death on him. The only thing that could have saved him then was a Presidential reprieve, but, as usual, our head of state was surrounded by incompetent advisers and no Presidential reprieve was forthcoming.

Poor boy. I can still remember clearly the third and last time I saw him. He came through the prison gates at dawn like a pale Pierrot, with his hands tied behind his back, his feet bound and his shirt slashed at the top in a conveniently guillotine-shaped cut. I was standing among the onlookers, and he turned round and saw me.

He smiled then, and spoke the last words I ever heard him say in that flat voice which sounded as if he were talking with his shoe-laces undone.

'I am another Jesus Christ. We were both fated to die at the age of thirty-three.'

Le Comte de Lautréamont

From *Les Chants de Maldoror*

First published, Brussels, 1869 by Paul Knight
Translation by Paul Knight published by Penguin Books, London, 1978

O rigorous mathematics, I have not forgotten you since your wise lessons, sweeter than honey, filtered into my heart like a refreshing wave. Instinctively, from the cradle, I had longed to drink from your source, older than the sun, and I continue to tread the sacred sanctuary of your solemn temple, I, the most faithful of your devotees. There was a vagueness in my mind, something thick as smoke; but I managed to mount the steps which lead to your altar, and you drove away this dark veil, as the wind blows the draught-board. You replaced it with excessive coldness, consummate prudence and implacable logic. With the aid of your fortifying milk, my intellect developed rapidly and took on immense proportions amid the ravishing lucidity which you bestow as a gift on all those who sincerely love you. Arithmetic! Algebra! Geometry! Awe-inspiring trinity! Luminous triangle! He who has not known you is a fool! He would deserve the ordeal of the greatest tortures; for there is blind disdain in his ignorant indifference; but he who knows you and appreciates you no longer wants the goods of the earth and is satisfied with your magical delights; and, borne on your sombre wings, wishes only to rise in effortless flight, constructing as he does a rising spiral, towards the spherical vault of the heavens. Earth only offers him illusions and moral phantasmagoria; but you, concise mathematics, by the rigorous sequence of your unshakeable propositions and the constancy of your iron rules, give to the dazzled eyes a powerful reflection of that supreme truth whose imprint can be seen in the order of the universe. But the order surrounding you, represented by the perfect regularity of the square, Pythagoras' friend, is greater still; for the Almighty has revealed himself and his attributes completely in this memorable work, which consisted in bringing from the bowels of chaos the treasures of your theorems and your magnificent splendours. In ancient epochs and in modern times more than one man of great imagination has been awe-struck by the contemplation of your symbolic figures traced on paper, like so many mysterious signs, living and breathing in hidden ways not understood by the profane multitudes; these signs were only the glittering revelations of eternal axioms and hieroglyphs, which existed before the universe and will remain after the universe has passed away. And then this man of vision wonders, leaning towards the precipice of a fatal question-mark, how it is that mathematics contains so much imposing grandeur and undeniable truth, whereas, when he compares it with mankind, he finds among the latter only false pride and deceitfulness. And then this saddened superior spirit, whose noble familiarity with your precepts has made him even more aware of the pettiness and incomparable folly of mankind, buries his white-haired head in his fleshless hands and remains engrossed in his supernatural meditations. He kneels before you and in his veneration pays homage to your divine face, the very image of the Almighty. In my childhood you appeared to me one May night by the light of the moonbeams in a green meadow beside a clear stream, all three equal in grace and modesty, all three full of the majesty of queens. You took a few steps towards me in your long dresses floating like mist and lured me towards your proud breasts like a blessed son. Then I ran up eagerly, my arms clenched around your white throats. I fed gratefully on your rich manna, and I felt humanity growing within me, becoming deeper. Since that time, rival goddesses, I have not abandoned you. How many mighty projects, since that time, how many sympathies which I had believed to be engraved on the pages of my heart as on marble, have been slowly effaced from my disillusioned reason by their configurative lines, as the oncoming dawn effaces the shadows of the night! Since that time, rival goddesses, I have seen death whose intention, clear to the naked eye, was to people graveyards, I have seen him ravaging battlefields fertilized by human blood from which morning flowers grow above human remains. Since then I have witnessed revolutions on this globe, earthquakes, volcanoes with their blazing lava, the simoon of the desert and tempest-torn shipwrecks have known my presence as an impassive spectator. Since that time I have seen several generations of human beings lift up their wings in the morning and move off into space with the inexperienced joy of the chrysalid greeting its first metamorphosis, only to die in the evening before sunset, their heads bowed like withered flowers blown by the plaintive whistling of the wind. But you remain always the same. No change, no foul air disturbs the lofty crags and immense valleys of your immutable identity. Your modest pyramids will last longer than the pyramids of Egypt, those anthills raised by stupidity and slavery. And at the end of all the centuries you will stand on the ruins of time, with your cabbalistic ciphers, your laconic equations and your sculpted lines, on the avenging right of the Almighty, whereas the stars will plunge despairingly, like whirlwinds in the eternity of horrible and universal night, and grimacing mankind will think of settling its accounts at the Last Judgement. Thank you for the countless services you have done me. Thank you for the strange qualities with which you enriched my intellect. Without you in my struggle against man I would perhaps have been defeated. Without you, he would have made me grovel in the dust and kiss his feet. If it had not been for you, he would have flayed my flesh and bones with his perfidious claws. But I have kept on my guard, like an experienced athlete. You gave me the coldness of your sublime conceptions, free of all passion. And I used it to reject scornfully the ephemeral pleasures of my short journey, and spurn the well-meaning but deceptive advances of my fellows. You gave me the dogged prudence which can be deciphered at every step of your admirable methods of analysis, synthesis and deduction. I used it to outdo the pernicious wiles of my mortal enemy and to attack him skilfully in turn, plunging into his entrails a sharp dagger which will forever remain buried in his body; for it is a wound from which he will never recover. You gave me logic which is, at it were, the soul itself of your teachings, full of wisdom, and with its syllogisms, the complex labyrinth of which makes it nonetheless intelligible, my intellect felt its audacious strength increasing twofold. By means of this terrible auxiliary, I discovered in mankind, as I swam towards the depths, opposite the reef of hatred, the black and hideous wickedness

which lurked amidst the noxious miasmata admiring its navel. First I discovered in the darkness of his entrails that nefarious vice, evil! superior in him to good. With the poisonous weapon you lent me I brought down from his pedestal, built by man's cowardice, the Creator himself! He gnashed his teeth and was subjected to this ignominious insult; for he had as adversary one stronger than he. But I will leave him aside like a bundle of string, in order to fly down lower . . . The thinker Descartes once observed that nothing solid has ever been built on you. That was an ingenious way of pointing out that not just anybody can immediately discover your inestimable value. In fact, what could be more solid than the three principal qualities above mentioned which rise up, joined in a single crown, to the august summit of your colossal architecture? A monument which is incessantly growing as discoveries are made daily in your diamantine mines, and with all the scientific researches carried out in your domains. O holy mathematics, may I for the rest of my days be consoled by perpetual intercourse with you, consoled for the wickedness of man and the injustice of the Almighty!

Jules Laforgue

Complainte-Epitaphe

From Jules Laforgue, *Oeuvres Complètes*, Léon Vanier, Paris, 1894

La Femme,
Mon âme:
Ah! Quels
Appels!

Pastels
Mortels,
Qu'on blâme
Mes gammes!

Un fou
S'avance,
Et danse,

Silence . . .
Lui, où?
Coucou.

Raymond Roussel

From *Impressions of Africa*

Translated by Lindy Foord and Rayner Heppenstall
Translation published by Calder & Boyars, London, 1966

In England, Soreau had learnt the following fact, reported in his *Memories of Handel* by Lord Corfield, an intimate friend of the great composer.

In 1756, Handel, who was then an old man and had already been blind for more than four years, rarely went out of his London house, where crowds of his admirers visited him.

One evening the eminent musician was in his study on the first floor, a huge, luxurious room which he preferred to the ground-floor apartments because of a magnificent organ, set against one of the panels.

Under the bright lights, a number of guests were chatting noisily, enlivened by a sumptuous meal with which the master, a great lover of delicate food and good wine, had entertained them.

Lord Corfield, who was among those present, turned the conversation on to the genius of their host and praised his masterpieces with the sincerest enthusiasm. The others chorused their agreement, and each expressed his admiration for the force of that inborn creative gift which no ordinary man could acquire even at the cost of the most assiduous labour.

Corfield maintained that a phrase sprung from a brow illuminated by the divine spark, developed by a mere technician in however mediocre a fashion could breathe life into many pages of music. On the other hand, added the speaker, an ordinary theme treated by the most inspired mind must inevitably remain heavy and clumsy and never lose the indelible mark of its origin.

Handel protested at these words, claiming that he would undertake to write a whole oratorio worthy to be included in the list of his works, on a theme which had been mechanically constructed by accidental procedure.

As there were murmurs of doubt at this claim, Handel, animated by the evening's libations, rose suddenly, declaring that he wished, at that very moment and before witnesses, to establish in a forthright manner the basis of the work in question. Feeling his way, the famous composer walked over to the fireplace and took from a vase a number of sprigs of holly left over from the previous Christmas. He arranged these in a row on the marble, drawing attention to the fact that there were seven sprigs. Each was to represent a note in the scale and to bear some distinguishing mark.

Madge, the master's old housekeeper, an accomplished needle-woman, was immediately sent for and called on to produce seven narrow ribbons of different shades.

The resourceful woman found no difficulty in so trivial a request and retired for a moment to fetch seven silk bows, one of each of the colours of the prism. Corfield, at the request of the great musician, tied a bow round each stem without disarranging the row.

This task completed, Handel asked everyone there to look for a moment at the scale represented before their eyes, and to concentrate on remembering the connection between the colours and the notes.

Next, the master, whose sense of touch was remarkably heightened by blindness, proceeded to his own minute examination of the sprigs, carefully noting any peculiarities in the pattern of the leaves or the arrangement of the prickles.

As soon as he was sure of himself, Handel put all the branches together in his left hand and, pointing to his writing desk, asked Corfield to bring his pen and inkwell.

The great man went out of the room, guided by one of his faithful disciples and was led to the staircase, where a flat, white balustrade lent itself admirably to his purpose.

Handel shuffled the branches of holly for a long time so that they kept no trace of their original order, and then called Corfield, who handed him the pen dipped in ink. Brushing them lightly with the free fingers of his right hand, the blind man picked out one of the prickly sprays, which for him had no individual character except to the touch, and, going up to the balustrade, wrote easily in ordinary letters, the note which this momentary contact had indicated.

Going one step down, Handel reshuffled the thick bunch and by the same unguided tactile means, picked out a second note, which he wrote a little further down the balustrade.

The great man continued his descent in this way, slowly and methodically. At each step he conscientiously shuffled the bundle thoroughly before selecting, with the tips of his fingers, the arbitrary indication of a given note, which he at once inscribed in perfectly legible writing.

The guests followed their host, step by step, establishing with ease the accuracy of his work by the different coloured ribbons. From time to time, Corfield took the pen and dipped it in the ink before returning it to the blind man.

Ten minutes later Handel wrote down his twenty-third note, and, from the last step, reached ground level. He went to a third seat and sat down for a moment to rest from his efforts, explaining to his friends the reason why he had chosen so unusual a method of inscription.

Feeling that his end was near, Handel had bequeathed his house to the city of London to be made into a museum. A great number of manuscripts, curiosities and *memorabilia* of every kind must already have made a visit to the illustrious abode attractive. Nevertheless, the great man was still haunted by the idea of continually adding to the attractions of a future pilgrimage. That was why, seizing a favourable opportunity, he had that evening made an imperishable monument of the balustrade by writing on it the strange and disconnected theme whose length was determined only by the number of stairs, of which he had till then taken no precise account, thus adding a further peculiarity to the mechanical and deliberate part of the composition.

Refreshed by a few moments' rest, Handel was escorted by his friends back to the room on the first floor, where the evening ended merrily. Corfield undertook to make a musical transcript of the phrase which had been worked out by no direction but that of chance, and the master promised to adhere rigidly to the

indications of the outline, only reserving the right to use his own discretion in two matters: first, that of the values of the notes, and secondly, that of register, which must be allowed to change without restriction from one octave to another.

Next day Handel set to work, with the help of a secretary who was accustomed to writing at his dictation. Blindness had never diminished the famous musician's intellectual activity.

In his hands the weirdly-shaped theme assumed a beautiful and interesting form, due to ingenious combinations of harmony and rhythm.

The same phrase of twenty-three notes recurred throughout, each time differently presented, and alone constituted the famous *Vesper* oratorio, a work of unmistakable power and serenity, still universally admired.

Gertrude Stein

From *Geography and Plays*

From Gertrude Stein,
Geography and Plays
The Four Seasons Company,
Boston 1922

NEXT.

LIFE AND LETTERS OF MARCEL DUCHAMP

A family likeness pleases when there is a cessation of resemblances. This is to say that points of remarkable resemblance are those which make Henry leading. Henry leading actually smothers Emil. Emil is pointed. He does not overdo examples. He even hesitates.

But am I sensible. Am I not rather efficient in sympathy or common feeling.

I was looking to see if I could make Marcel out of it but I can't.

Not a doctor to me not a debtor to me not a d to me but a c to me a credit to me. To interlace a story with glass and with rope with color and roam.

How many people roam.

Dark people roam.

Can dark people come from the north. Are they dark then. Do they begin to be dark when they have come from there.

Any question leads away from me. Grave a boy grave.

What I do recollect is this. I collect black and white. From the standpoint of white all color is color. From the standpoint of black. Black is white. White is black. Black is black. White is black. White and black is black and white. What I recollect when I am there is that words are not birds. How easily I feel thin. Birds do not. So I replace birds with tin-foil. Silver is thin.

Life and letters of Marcel Duchamp.

Quickly return the unabridged restraint and mention letters.

405

My dear Fourth.

Confess to **me** in a quick saying. The vote is taken.

The lucky strike works well and difficultly. It rounds, it sounds round. I cannot conceal attrition. Let me think. I repeat the fullness of bread. In a way not bread. Delight me. I delight a lamb in birth.

Thanks

Teeny Duchamp
Jacqueline Monnier,

The Elephant Trust

Richard Hollis
and Mark Thomson
for assistance with
the *mise en pages*

Dore Ashton
Ernst Benkert
Max Bill
George Brecht
Gavin Bryars
Laurence Buffet-Challé
The late Gabrielle Buffet-Picabia
The late Jindřich Chalupecký
Jean Clair
Karl Gerstner
John Golding
Jennifer Gough-Cooper
and Jacques Caumont
Hans Haacke
Otto Hahn
Richard Hamilton
George Heard Hamilton
Marion von Hofacker
Cheryl Ito
Marcel Jean
Allen Jones
Morris Kahn
The late Robert Kenedy
Lillian Kiesler
Donald Knaack
Jean-Jacques Lebel
The late François vce Lionnais
François Morellet
David Myers
Anne Picabia
Grati Baroni de Piqueras
Joseph Rykwert
Guido Rossi
Margit Rowell
Ralph Rumney
The late Shuzo Takiguchi
Mark Thomson
Yoshiaki Tono
Sarah Wilson

Acknowledgements

Annely Juda Fine Art
Arts Council of Great Britain
British Broadcasting Corporation
John Calder
Maya Deren Foundation
Faber and Faber
David Higham Associates, Estate of Gertrude Stein
Horta Museum
Library of Congress
Ulf Linde
Michael Spens, *Studio International*
Moderna Museet
Penguin Books
Philadelphia Museum of Art
Pompidou Centre
Pomegranate Press
Random House
Hans Richter Foundation
Tate Gallery
Thames and Hudson

Photography:

Annely Juda Fine Art
Ch. Bastin and J. Everard
Estate of Denise Bellon
British Film Institute
Galerie 1900–2000
Jennifer Gough-Cooper, Jacques Caumont
Nigel Haynes
Henie-Onstad Kunstsenter
Victoria Miro Gallery
Moderna Museet
Pomegranate Press
Studio Guido Rossi
Joseph Rykwert
Tate Gallery
Thames and Hudson
Yoshiaki Tono
John Weber Gallery

Translations:

Penelope Foord (Teeny Duchamp)
Nigel Gearing (Gabrielle Buffet-Picabia)
Gill Maddick (Max Bill)
Andrew Rabeneck (Otto Hahn)
Ralph Rumney (Le Lionnais)
Simon Watson-Taylor (M. Duchamp)

189